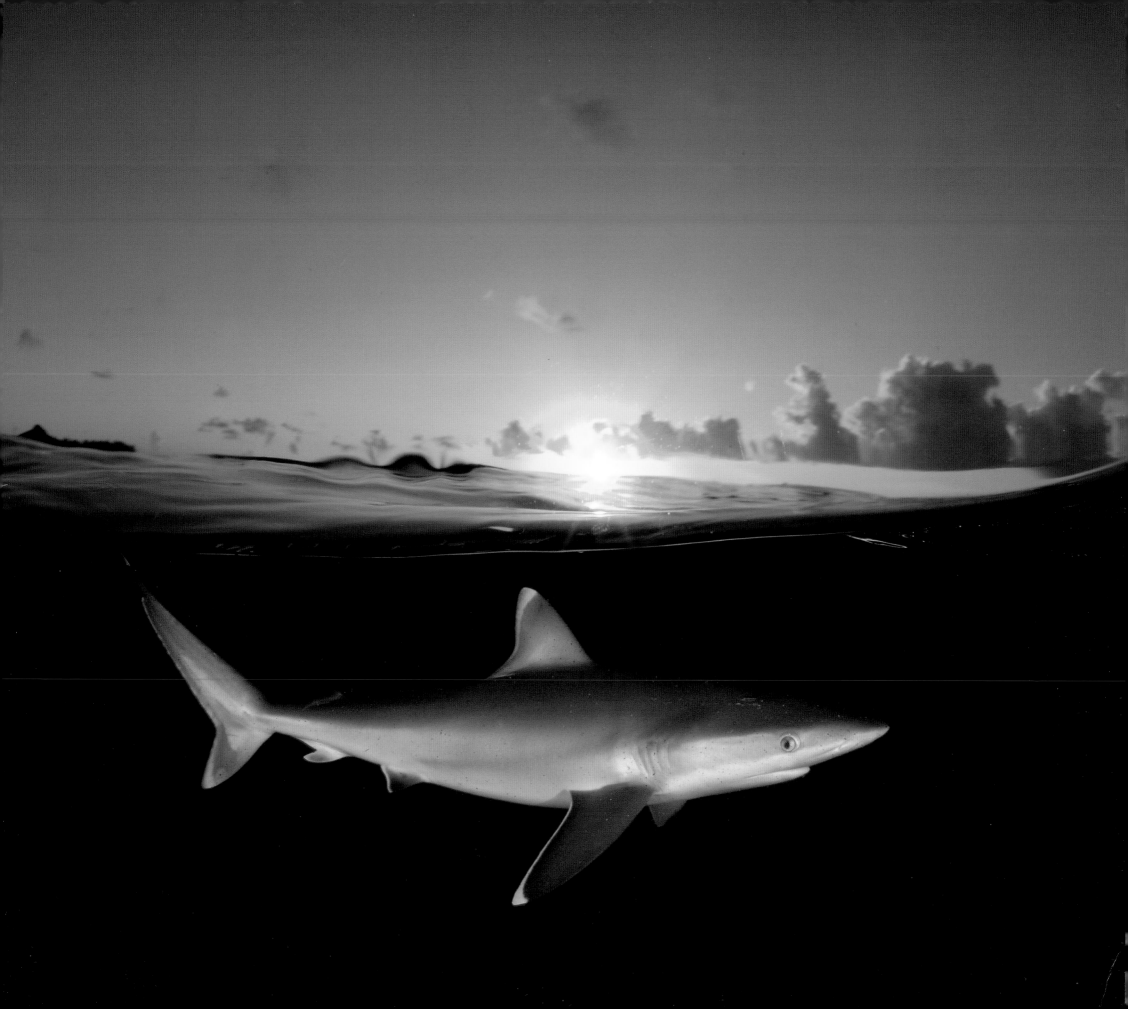

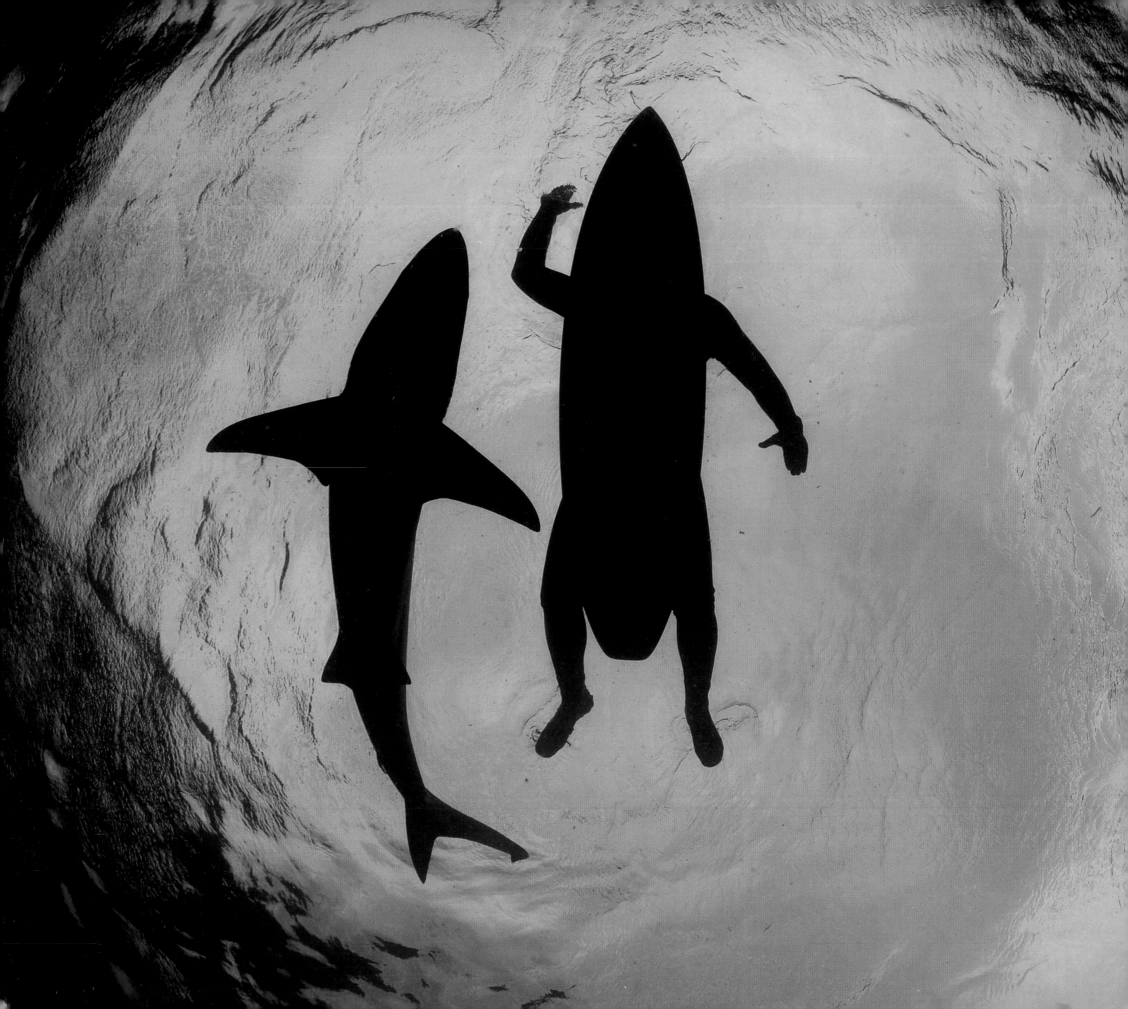

A WORD FROM THE FOUNDER

I HAVE BEEN DIVING WITH SHARKS for more than 20 years. Great whites in South Africa, tiger sharks in the Bahamas, and silky sharks in the Red Sea are just a few of the highlights. Being in the company of sharks gives me more enjoyment than any other pursuit in the world.

During my early diving expeditions in different parts of the planet, sharks were so abundant that it took little effort to find them. However, in recent years, these marine predators seem to have virtually disappeared. In their place are ghost gill nets, rubbish, and eerily lifeless patches of ocean.

It is because of this experience that I began the Save Our Seas Foundation. Our mission is simple: To support marine research, conservation, and education projects around the world. The Foundation focuses on charismatic marine megafauna, particularly sharks and rays, and is built on a common passion for and dedication to the oceans.

In 2013, the Save Our Seas Foundation celebrates its 10th anniversary. Over the past decade, a theme has emerged. In order to create the most effective conservation measures for sharks and other vital marine life, we must continue to fuel research and education projects that increase knowledge and promote understanding. There is still so much we do not know about the ocean, particularly sharks. What we do know is that they are important, yet the worldwide exploitation of sharks continues. And I hope the book you hold in your hands will change this. *Sharks & People* is one of the efforts the Save Our Seas Foundation supports to change the mindset about sharks and transform readers into avid conservationists.

THE FOUNDER, SAVE OUR SEAS FOUNDATION

For more information, please visit *www.saveourseas.com*

A WORD FROM THE FOUNDER

I HAVE BEEN DIVING WITH SHARKS for more than 20 years. Great whites in South Africa, tiger sharks in the Bahamas, and silky sharks in the Red Sea are just a few of the highlights. Being in the company of sharks gives me more enjoyment than any other pursuit in the world.

During my early diving expeditions in different parts of the planet, sharks were so abundant that it took little effort to find them. However, in recent years, these marine predators seem to have virtually disappeared. In their place are ghost gill nets, rubbish, and eerily lifeless patches of ocean.

It is because of this experience that I began the Save Our Seas Foundation. Our mission is simple: To support marine research, conservation, and education projects around the world. The Foundation focuses on charismatic marine megafauna, particularly sharks and rays, and is built on a common passion for and dedication to the oceans.

In 2013, the Save Our Seas Foundation celebrates its 10th anniversary. Over the past decade, a theme has emerged. In order to create the most effective conservation measures for sharks and other vital marine life, we must continue to fuel research and education projects that increase knowledge and promote understanding. There is still so much we do not know about the ocean, particularly sharks. What we do know is that they are important, yet the worldwide exploitation of sharks continues. And I hope the book you hold in your hands will change this. Sharks & People is one of the efforts the Save Our Seas Foundation supports to change the mindset about sharks and transform readers into avid conservationists.

THE FOUNDER, SAVE OUR SEAS FOUNDATION

SAVE OUR SEAS
FOUNDATION

For more information, please visit www.saveourseas.com

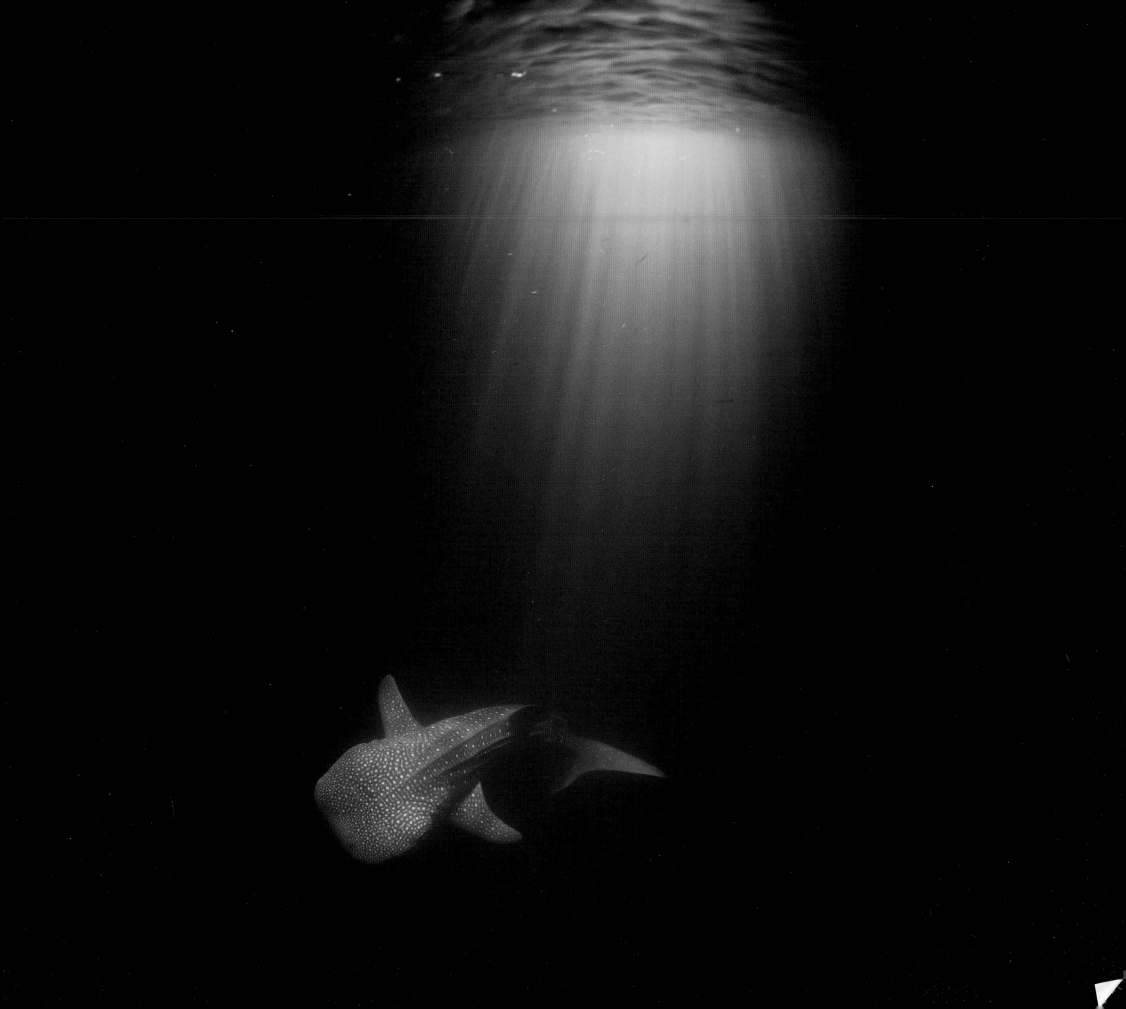

SHARKS & PEOPLE

EXPLORING OUR RELATIONSHIP WITH THE MOST FEARED FISH IN THE SEA

THOMAS P. PESCHAK

THE UNIVERSITY OF CHICAGO PRESS

CHICAGO AND LONDON

CONTENTS

For centuries Djibouti's Afar people have told stories of a large creature living in the "Pit of Demons." True marine monsters are unlikely to roam the seawater loch, but whale sharks occasionally venture up this fjord-like passage.

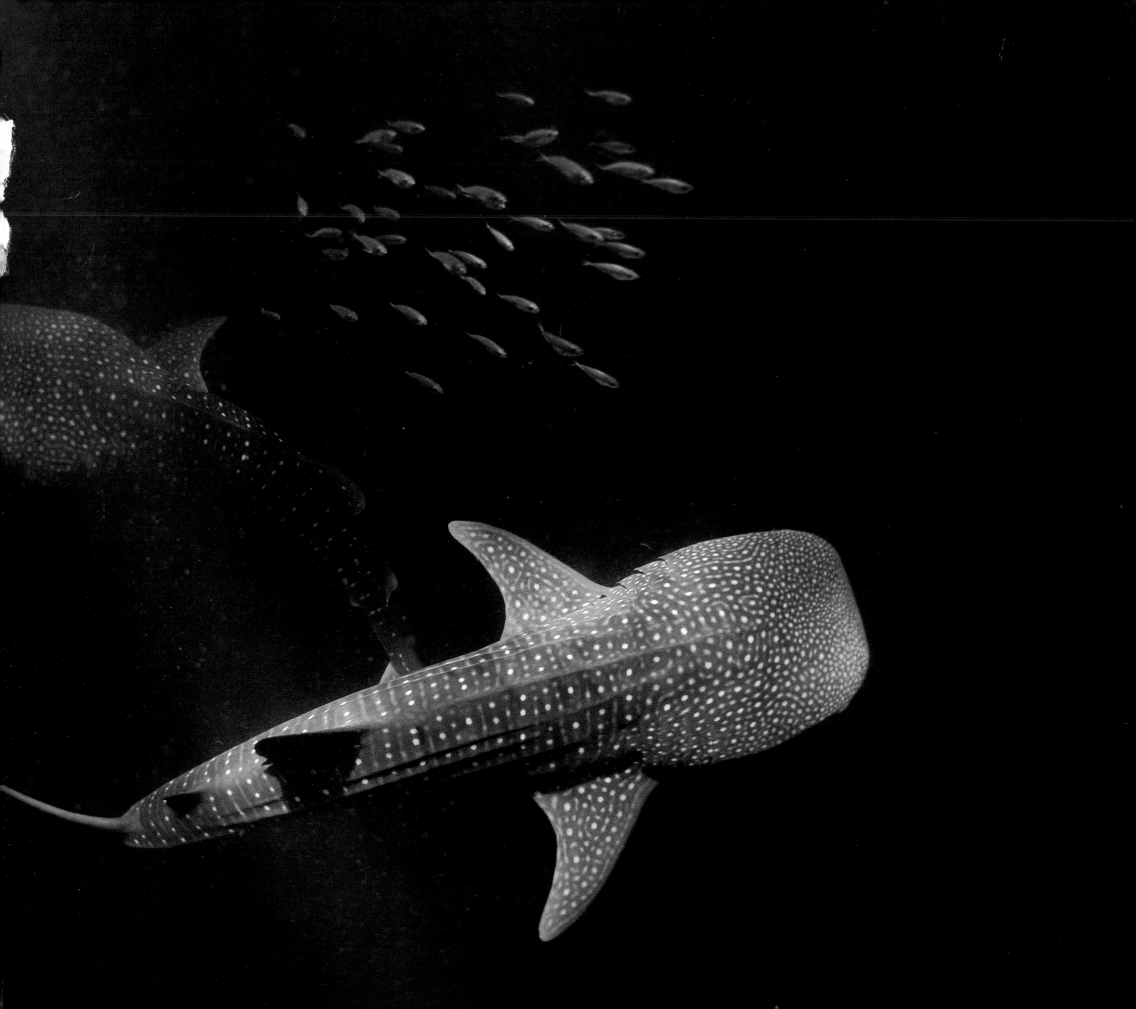

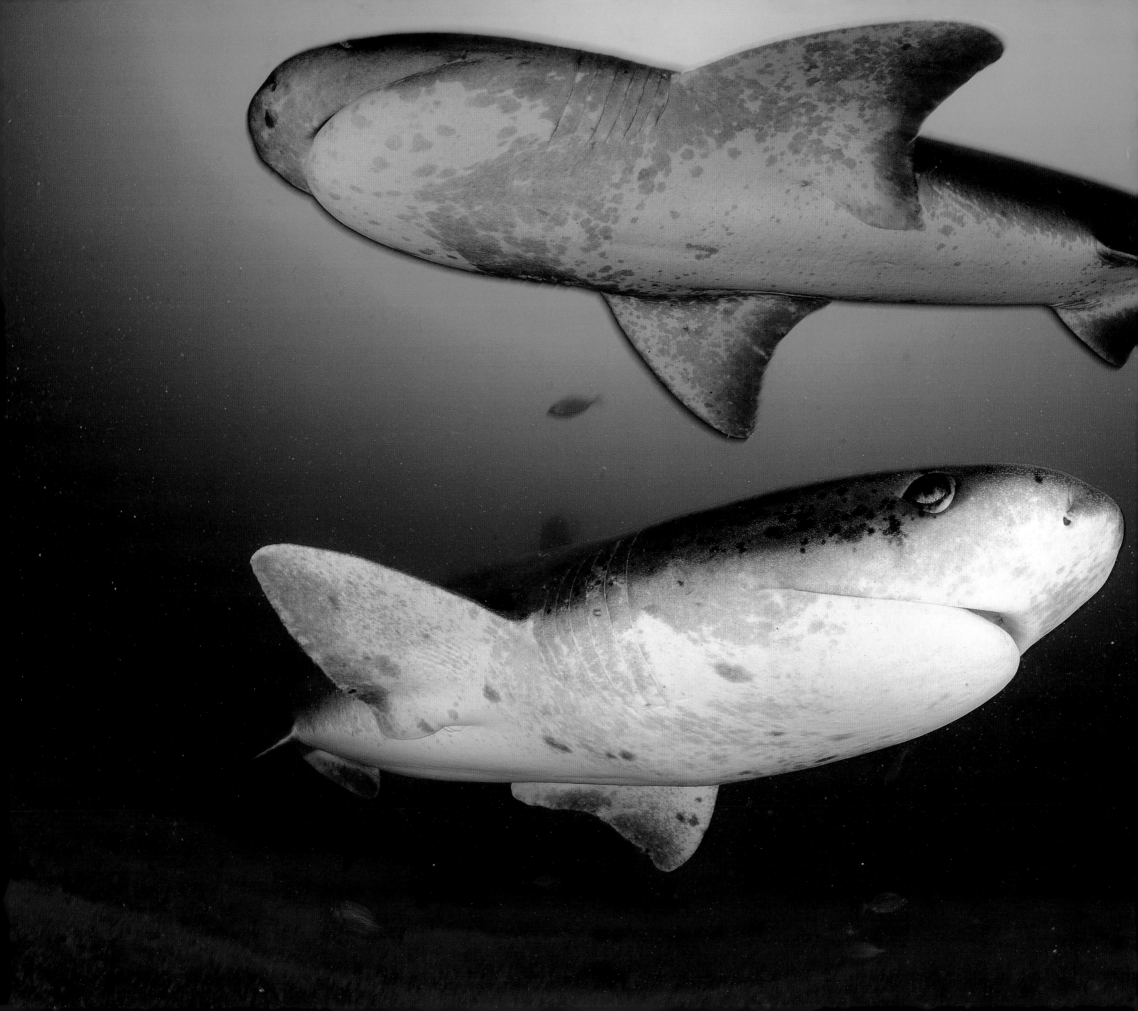

Sevengill sharks congregate in great numbers in South Africa's Castle Rock Marine Reserve. Though still being researched, the assembly is thought to be linked to social interaction and mating.

A shiver of blacktip sharks circles in the depths of South Africa's Aliwal Shoal. Instead of traveling horizontally, these sharks migrate vertically through the water column in an effort to track prey.

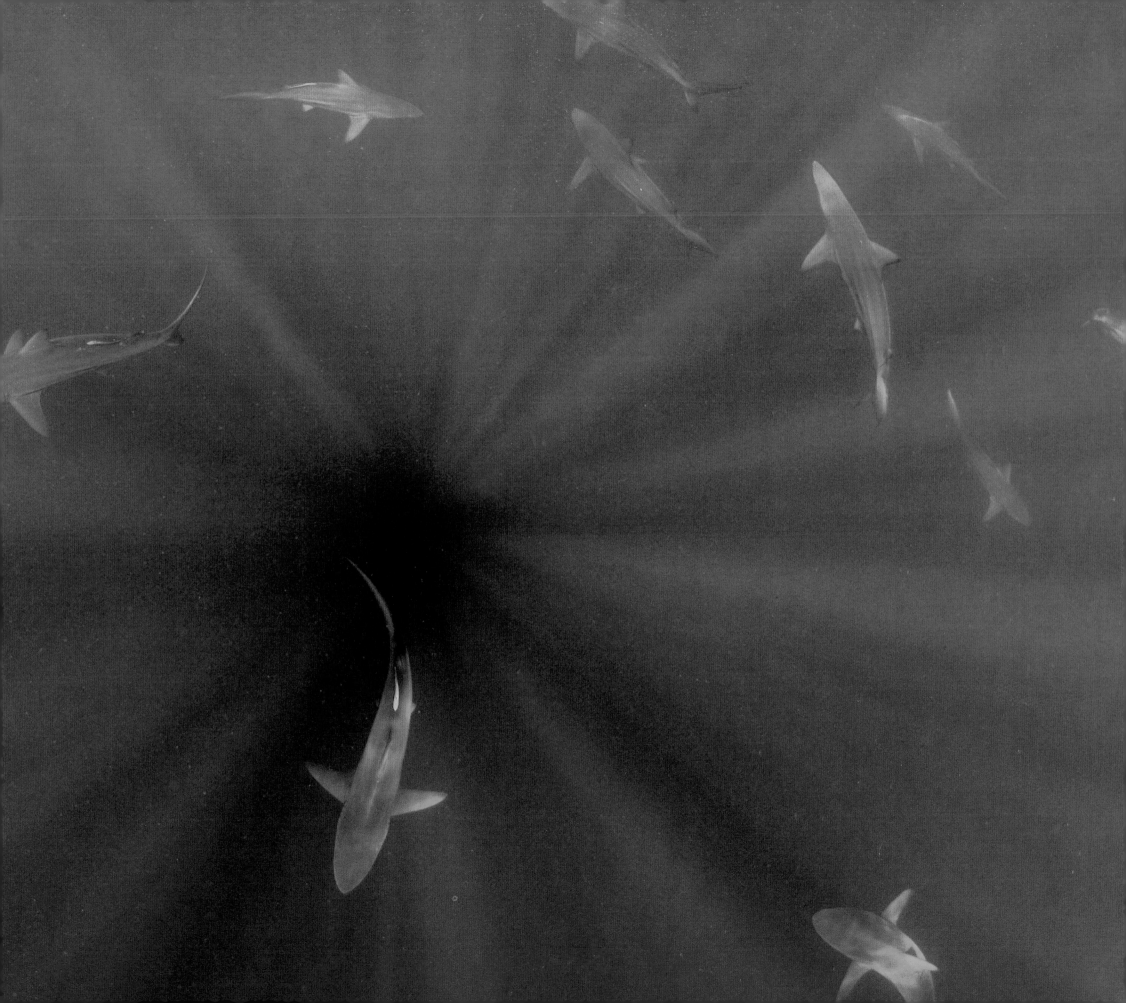

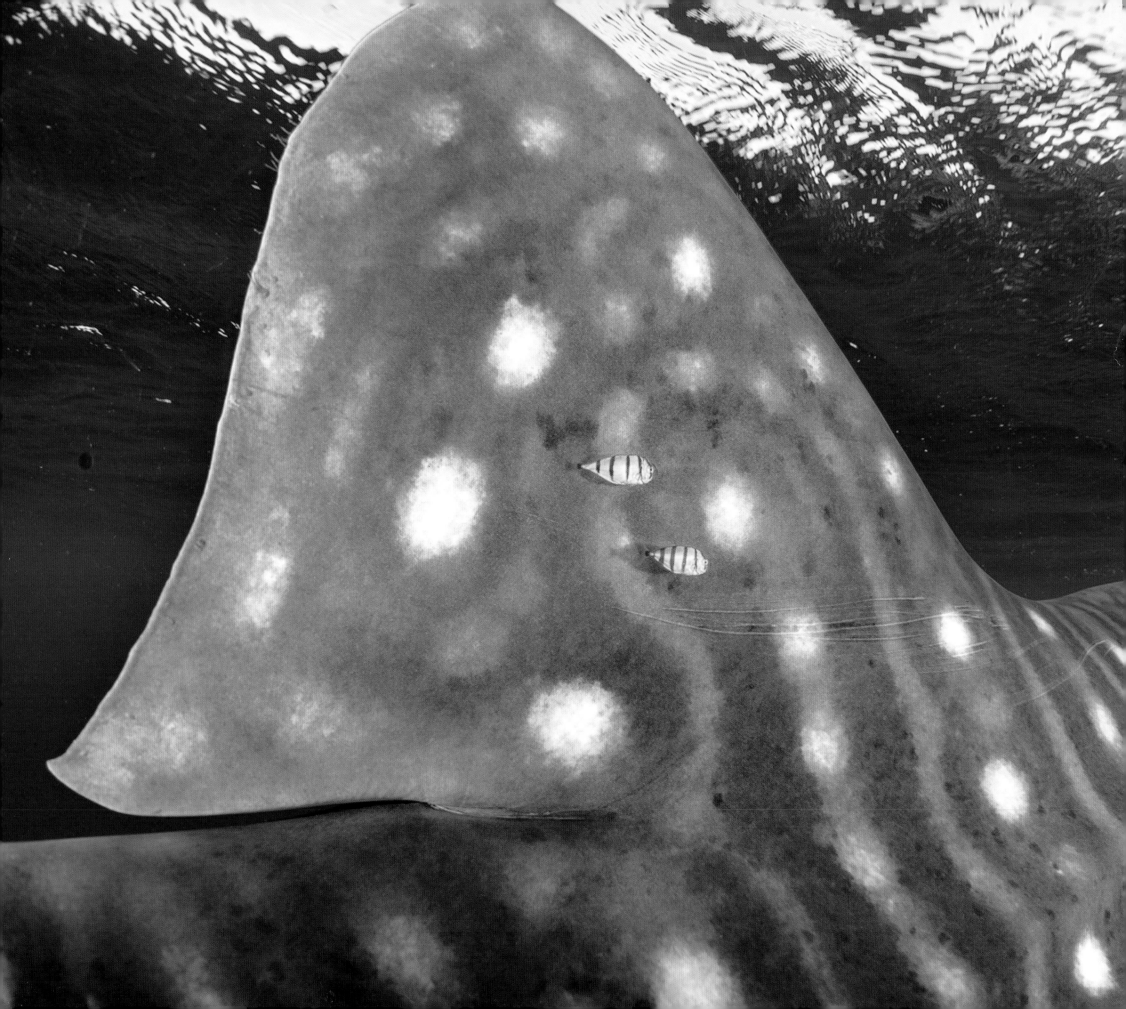

FOREWORD

MORE THAN A DECADE HAS PASSED since I met Nicole, the white shark that inspired me to develop a method to identify individual sharks. I observed that, similar to a human fingerprint, the serration patterns on the trailing edge of the dorsal fin are unique to each shark. Every year Nicole appeared in the waters off South Africa's Dyer Island in July and then disappeared in December. When the technology became available to track sharks using satellite tags, Nicole was one of my first candidates. Over the course of several months, we tracked her making a record-breaking journey from South Africa to the west coast of Australia and back again.

From my early days as a shark scientist to my current role as CEO of the Save Our Seas Foundation, sharks have remained my foremost passion. The need to research and understand these incredible apex predators is more vital now than it was 10 years ago. Although human societies have evolved in many ways, relationships with our fellow predators remain archaic. By distancing ourselves from nature we have diminished our understanding and appreciation of the intricate web of life in which we are a part. In doing so, we have unfortunately succeeded in isolating our perspective, but not our effects, on other living organisms.

Sharks & People contrasts the beauty and wonder of sharks with the globally dire state of their populations. This book does not shy away from exploring the complexities of our relationship with these prehistoric predators. Examining our history with sharks and the culture we have created around them, documenting the shark fin trade, and highlighting shark-centered tourism are just a few of the roads it travels. Sharks continue to be one of the most misunderstood animals on our planet and it is my sincere hope that *Sharks & People* will be a milestone in changing this.

Michael Scholl, CEO, Save Our Seas Foundation

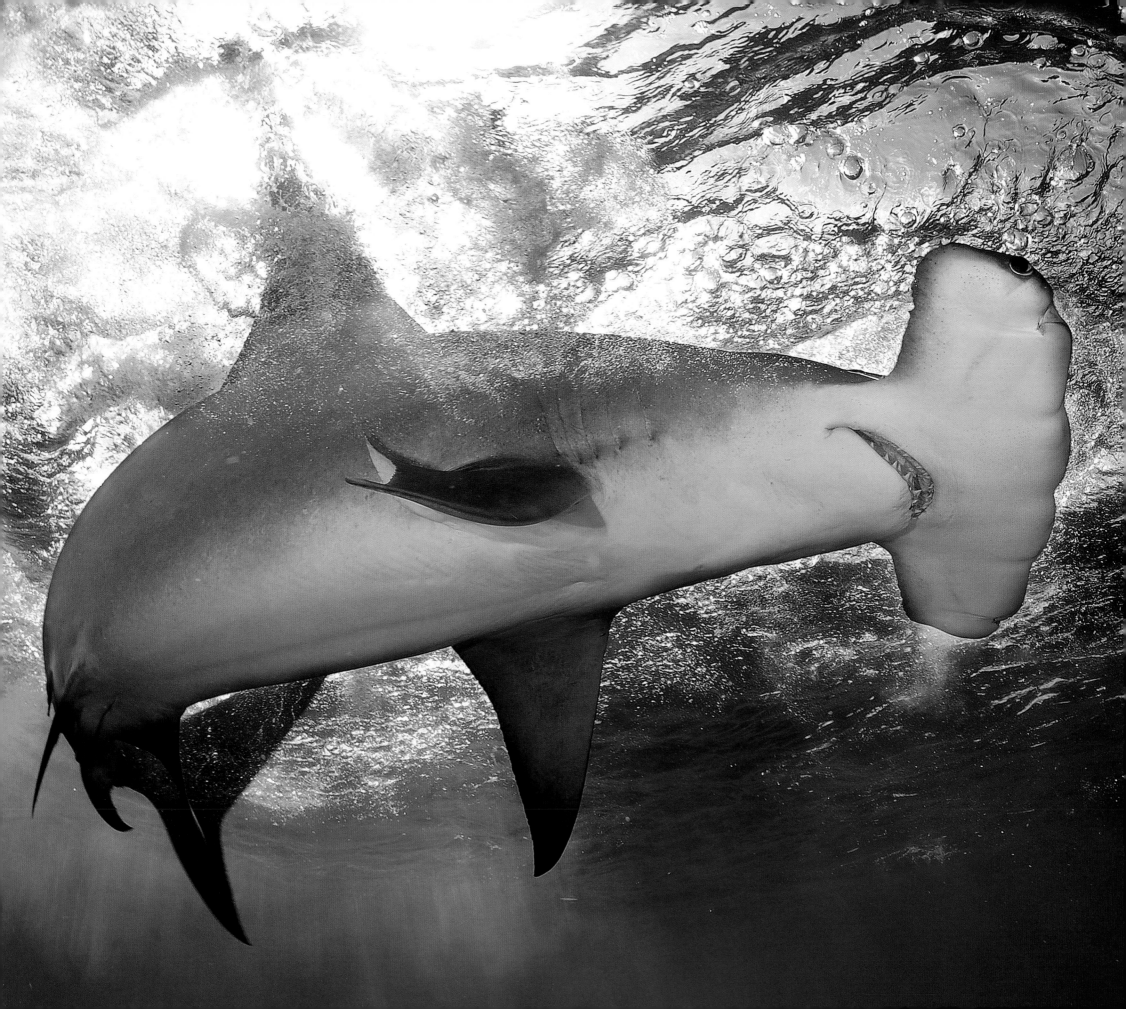

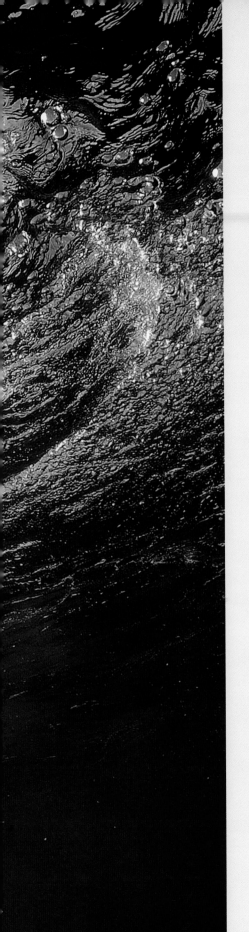

JAWS AND ME

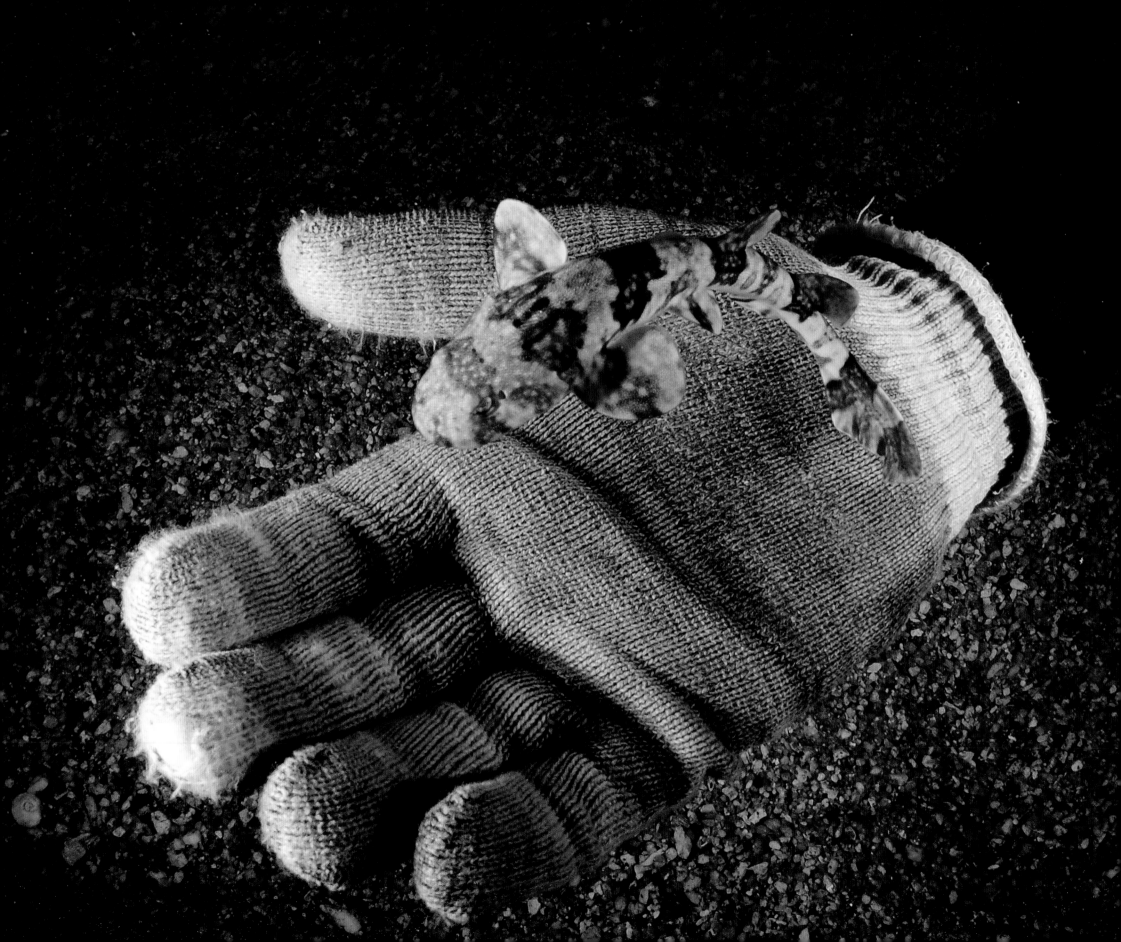

saw my first shark when I was 16 years old, drifting in the deep off the southernmost tip of Egypt's Sinai Peninsula. A huge school of barracuda circled like an overcrowded carousel along the wall of Shark Reef. Weaving in and out of the mass was a trio of blacktip sharks. I tried to get close, but the current held me at a distance. In my photographs of this first encounter, the sharks were mere specks, but the seed was planted. I wanted to get closer.

My first face-to-face (literally) with a shark occurred a decade later, in 2002. Lying face down on the swim platform of the boat I was on, my arms submerged, I gripped my underwater camera housing more firmly than usual. I was so close to the waterline that I had to raise my head to watch the towering dorsal fin pass. The 11-foot-long (3.5-m) white shark made several close passes before she stopped swimming and hovered just centimeters from me. She raised her head out of the water to inspect me and for a split second the signature hollow blackness of her eye revealed a piercing blue iris that can only be seen up close. The shark repeated her routine for almost half an hour—passing and hovering, passing and hovering. I shot maniacally until I ran out of film.

When sharks rise vertically out of the water headfirst, as she did, it's called spyhopping, a behavior more commonly seen in orcas and humpback whales. With their vision as good out of the water as in, white sharks are thought to spyhop as a way to help them assess prey, such as seals on a rocky haul-out. Despite my training in marine science, I like to remember my encounter with this shark through a more anthropomorphic lens. I wanted to believe that her actions were motivated purely by curiosity rather than by her calculating a way to knock the strange-looking seal off the swim platform. Whatever her reason, my heart still pounds with humility and maybe just a healthy smidge of instinctive fear when I remember the episode.

Historians have traced the fear of sharks back to ancient times, as far back as the civilizations of Greece and Rome. There is also compelling evidence that sharks trailed slave ships across the Atlantic and feasted on human remains thrown overboard. The shark functioned as an integral part of a system of terror utilized by the slave ship captains. The abolitionists were able to make use of shark imagery in what would become a successful public campaign against the horrors of the slave trade. Even Prime Minister Winston Churchill had an opinion about sharks: "You may rest assured that the British Government is entirely opposed to sharks."

Negative press for sharks has been par for the course since the advent of pen and paper and the printing press—until recent decades. In the 1980s, any literature on shark conservation was still a rare find. The few articles and books I unearthed in my late teens revealed the existence of cultures that held sharks in high esteem, as animals to

OPPOSITE *Endemic to South Africa's kelp forests, a juvenile puffadder shyshark hovers above a diver's hand.*
PREVIOUS SPREAD *Despite reaching lengths of over 20 feet (6 m), great hammerhead sharks maneuver with surprising speed and agility.*

be celebrated and not feared. Several years later, I visited one of those shark-revering peoples—the Solomon Islanders. In that remote parcel of the Pacific Ocean, dolphins were rounded up and killed in drive hunts. Dolphin meat was consumed locally, and their teeth were used as traditional currency, with one tooth worth two Solomon Island dollars. Sharks, on the other hand, were celebrated and believed to harbor the souls of the dead. When a shark was regularly seen along a reef near a village, it was believed to shelter the soul of a local person's recently departed relative. Floats baited with hermit crabs were set at sea, and any fish caught were fed to the shark as an offering. A local legend said that if a fisherman's boat capsized, he could call on a shark to rescue him by towing him back to shore, a task ascribed only to dolphins elsewhere in the world. Even the coat of arms of this Pacific Island nation proudly displays a shark, along with a saltwater crocodile, as the nation's protectors.

In stark contrast to the reverence displayed toward sharks in the Solomon Islands and a handful of indigenous societies, my Western culture portrays the shark as a malevolent man-eating monster. The fear of sharks has led to violent retribution against these animals, which have been pursued with everything from explosives to rifles to gill nets and hooks. As a photographer and marine biologist, I have spent many hundreds of hours in the company of the most feared fish in the sea, and they are a low rung on my ladder of danger. Compared to many large terrestrial predators, I believe sharks to be remarkably tolerant and forgiving. Every winter, when I photograph large bronze whaler sharks ripping into bait-balls of fish during the sardine run off South Africa's east coast, I'm often just inches away from the sharks as they charge into the mass of silvery fish. Now imagine running with a wide-angle lens right next to a lion as it charges and pulls down a zebra. Sharks are not as dangerous as people make them out to be, but some are truly formidable predators. Their wildness is real, and I treat each shark encounter with humility and a generous dose of respect.

Trophy sports fishermen pay handsomely to fight and land a "monster shark" with a rod and reel, but it is shark fins that make fishing for them profitable. Shark fin is the main ingredient in shark fin soup, one of the most expensive seafood dishes in the world. The demand for this "delicacy" drives shark fishermen to sail to all four corners of the planet and results in the death of more than 38 million sharks every year. Largely due to the fin trade, many species of shark are now listed as endangered, and some populations have declined dramatically. If people viewed sharks in the same way they do pandas or humpback whales, would sharks be in such dire straits? I believe that until this culture of fear can be transformed into understanding, appreciation, and respect, then sharks may be on a narrow and finite path to oblivion. For who in their right mind wants to protect something they fear?

Yet there's new hope, because a shift in the way we perceive sharks is underway. Shark tourism has matured from its pioneering days in the 1970s, now funneling tens of millions of dollars into island and coastal economies and ushering in the notion that sharks are worth more alive than dead. Through organized shark encounters, people are experiencing sharks in their natural habitat, and that has triggered a more enlightened way of perceiving these animals.

We now understand that sharks are an integral link in the ocean food web and an indomitable force in shaping the sea. There is striking scientific evidence on the vital role of sharks and the dramatic imbalance that could occur if sharks were to disappear. We humans are as dependent on thriving oceans as the myriad of sea creatures within them, and a well-balanced marine biosphere needs healthy populations of sharks.

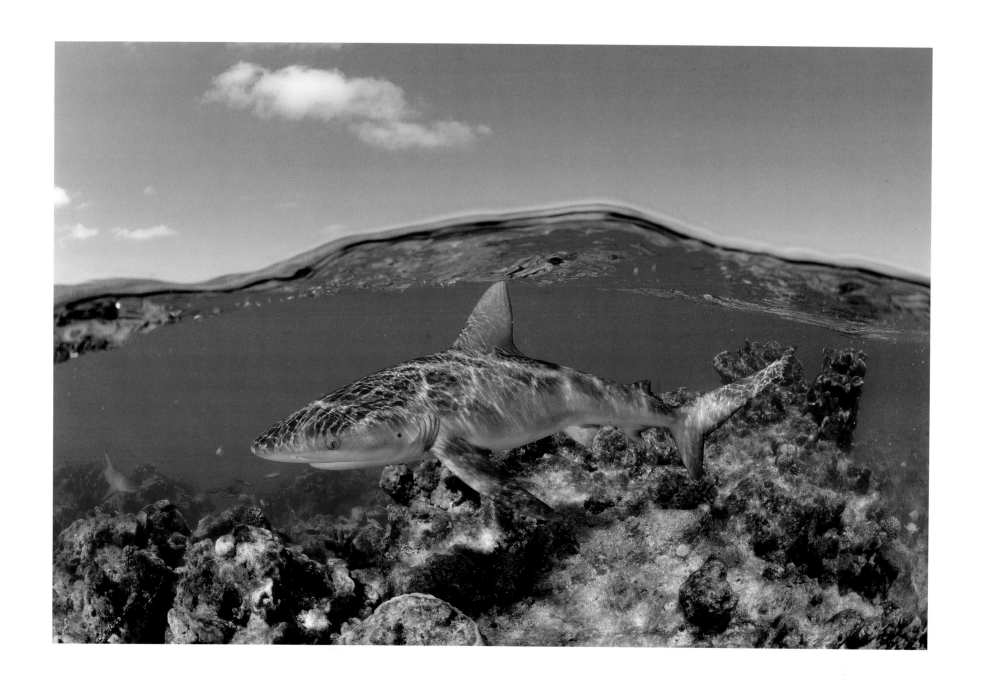

*Lured by the sounds of feeding fish, a Galapagos shark traverses
the shallow crest of a coral reef in the Mozambique Channel.*

This newfound knowledge, combined with the economic incentives of shark tourism, has led to the introduction of many shark conservation measures, from the proclamation of shark-focused marine reserves to the inclusion of shark species in international wildlife trade agreements such as CITES. As awareness of the plight of sharks has spread, public outcry has led to many restaurants and hotels taking shark fin soup off their menus. Shark trophy-fishing tournaments are less common, and many that remain operate on catch-and-release principles. Some marinas have even outlawed the landing of any sharks.

The idea for photographing and writing a book about the relationship between sharks and people came to me more than a decade ago. While sitting in a seedy bar along the South African coast night after night, I chipped away at a book I was writing about white sharks. As word spread of what I was up to, I found myself spending most of my evenings talking to people about sharks. There was a hunger for knowledge about these animals and especially how they relate to our lives. From burly bikers to grandmothers, I conversed with all types about sharks until the wee hours of the morning. I soon realized that many people have an abundant desire to talk about sharks, but there is also a plethora of misinformation, which feeds into the culture of fear surrounding these popular predators. So I set out to create a book that investigates and truthfully reports on the complex and contentious relationship between "Jaws" and us. As a marine biologist, I was compelled to tease out the latest technical knowledge about sharks hidden in the scientific literature and present it in a rigorous yet engaging manner.

But the book you hold in your hands is also a retrospective of my own decade-long photographic relationship with sharks. Traveling to the last remaining hotspots where sharks flourish as apex predators, I have had the privilege to capture rarely seen moments in their lives. I hope the images in the following pages incite or further galvanize your awe of these incredible creatures, and give you a glimmer of what most of our oceans looked like before the advent of shark fishing.

As a photojournalist, it is also my job to reflect accurately the reality of our time. Thus, I included many images that explore the darker side of our relationship with sharks—shark carcasses, piles of shark fins, and shark fishing operations. Some of these photographs are hard to look at and digest, but I encourage you to study them, for they are essential to gaining a truthful and balanced insight into the shark-and-people relationship.

One thing that I have learned during my decade documenting sharks is that they resonate in a different way with each person. To the fin dealer in Hong Kong or the fishermen on a longliner, sharks are a means of feeding their families or paying for their children's education. To the surfer whose best friend was tragically killed or to the mother whose child died in an attack, sharks are deadly beasts and symbols of loss. For the researcher, sharks are wells of biological data that have only begun to be tapped. For a child visiting an aquarium, sharks represent a window to the wild. Very few people are indifferent to sharks as they have an uncanny way of inciting our attention, often in a profound manner. To those who are already enchanted with sharks, I hope this book strengthens the bond and builds on your understanding. For the uninitiated, I hope your view of sharks transforms from that of dark menacing creatures into animals worthy of respect and protection.

*A butcher in a Sri Lankan fish market deftly severs
the dorsal fin of a bull shark.*

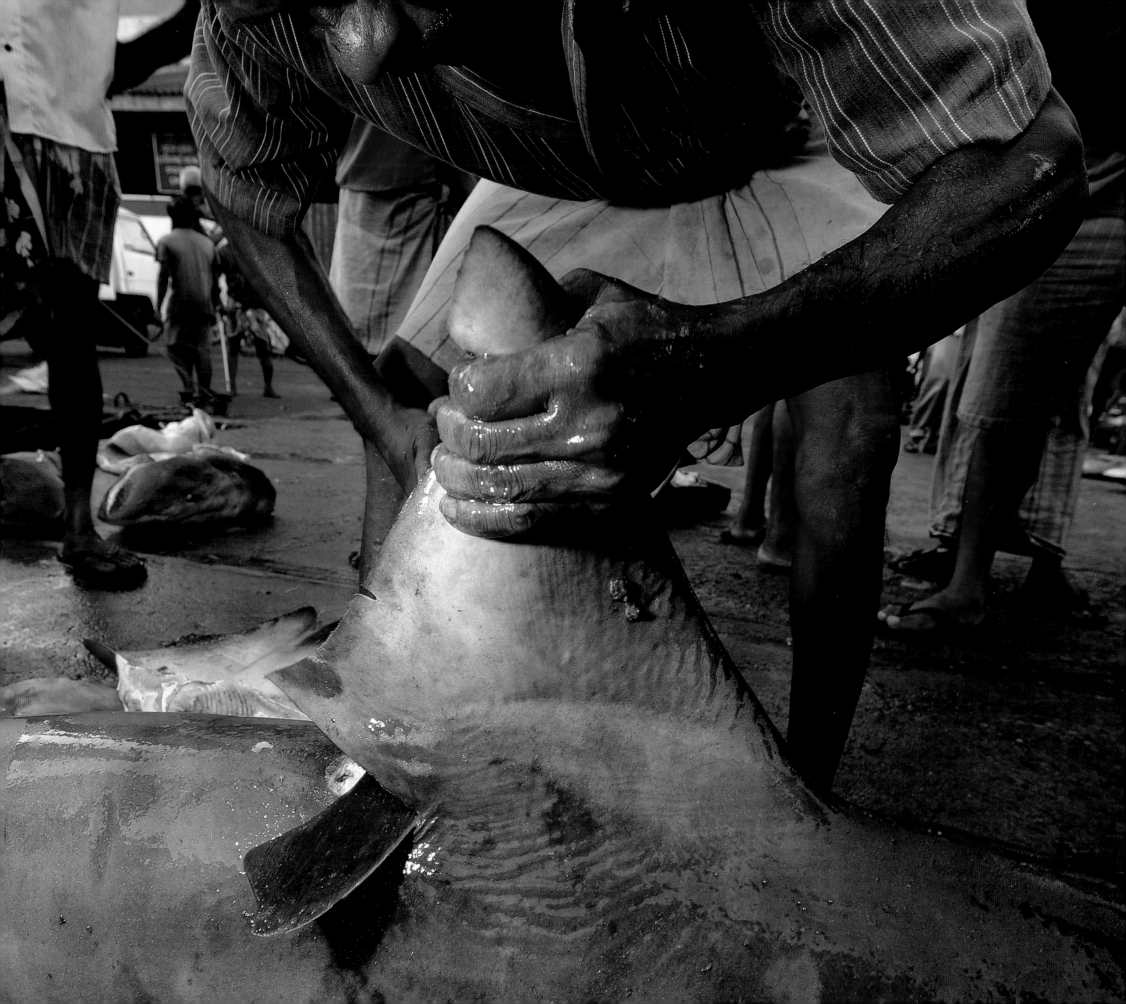

Plastic is becoming a common ingredient in the diet of most marine organisms. As filter feeders, whale sharks are prone to ingest plastic during their daily feeding sweeps through the water column.

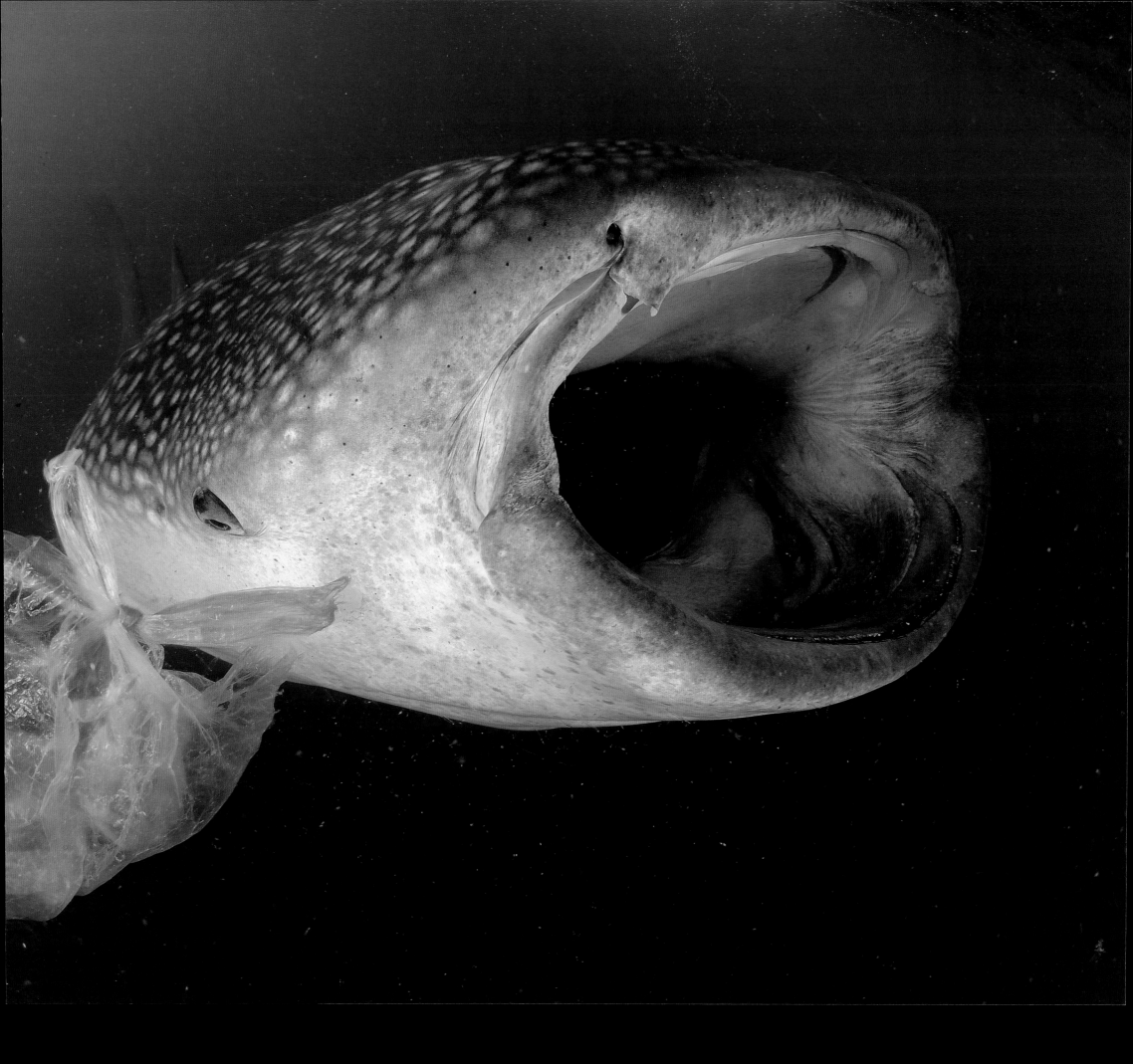

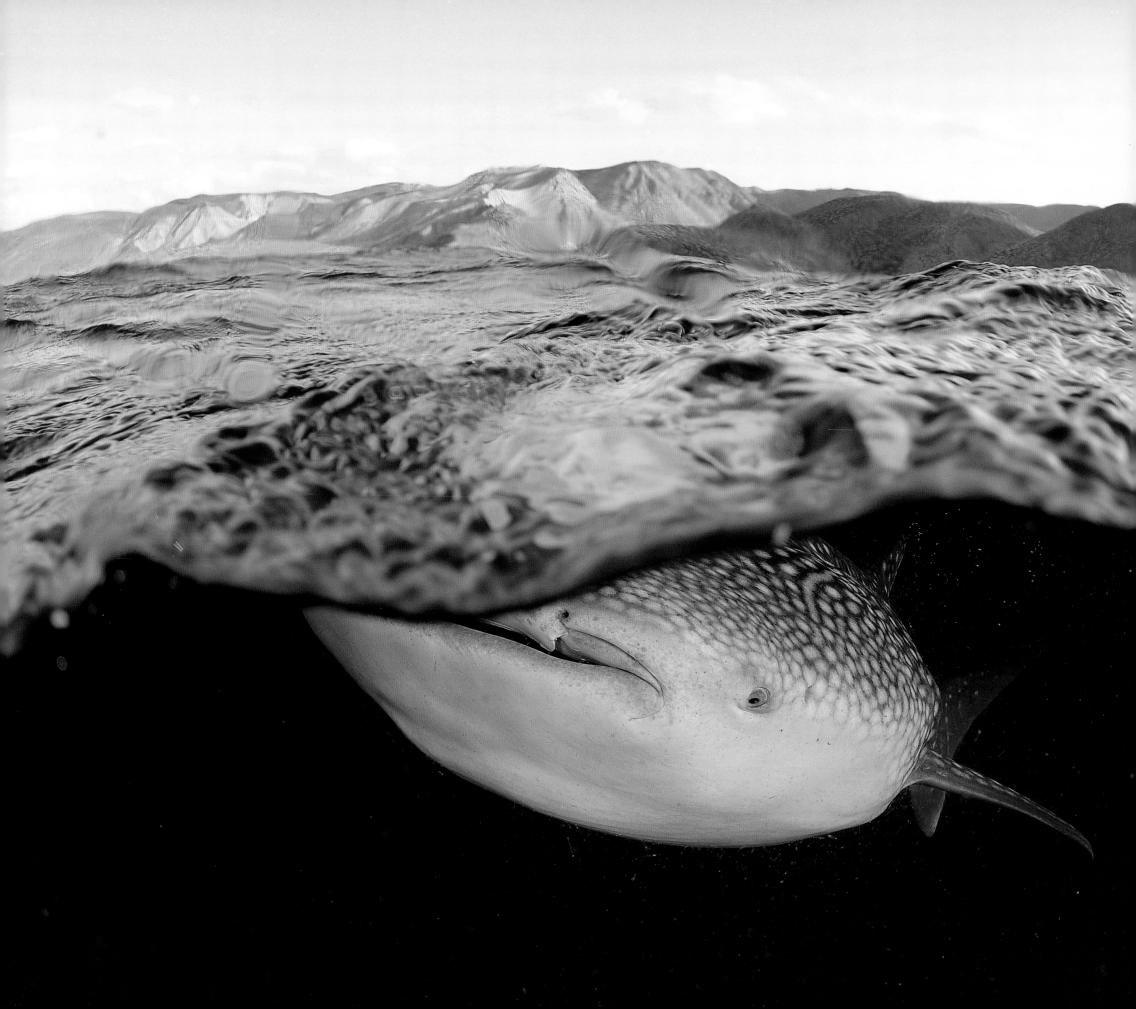

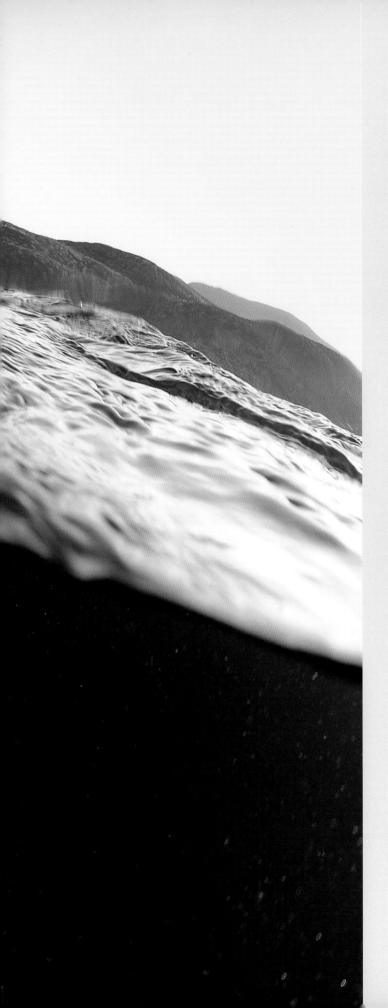

SHADOWS IN THE SEA

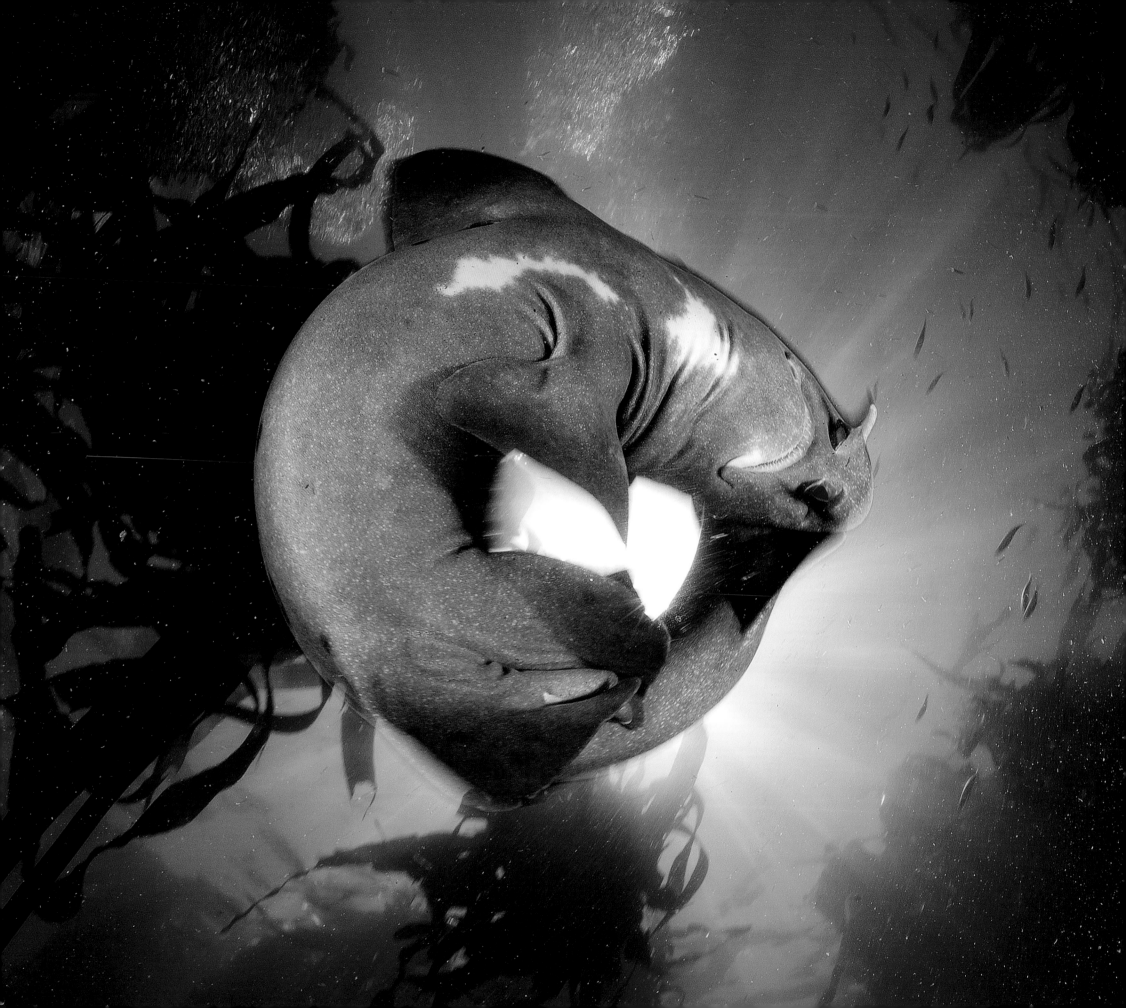

overing my face with lavender-drenched rags and smearing Vicks vapor rub under my nose fail to eliminate the vile odor. The seagulls and petrels love it, though, eagerly plunging into the greasy water and snagging small pieces of skin and blubber with shrieks of delight. The lifeless carcass of a humpback whale, likely hit by a cargo ship or oil tanker, is ushered by wind and currents out of the busy shipping lanes toward the South African coast. Large predators found the carcass days before, their attendance revealed by the missing chunks of blubber cut with surgical precision. Some of them still linger, and I make out dark shadows swimming just below the surface. Finally, one dorsal fin after the other breaks the surface. Within minutes I count five white sharks. Like a human fingerprint, each has a unique pattern of notches and tears along the trailing edge of its dorsal fin. The half-mile-long slick of oil seeping from the whale has lured the sharks with the promise of an easy meal. Despite their reputation as one of the world's most formidable predators, there is not a hint of frenzy—sharks are keen to conserve energy whenever possible. Like airplanes in a holding pattern, they line up and swim in an orderly fashion around the carcass. Smaller sharks give way to larger ones, but in the end everyone gets their turn to tear away 30-pound (14-kg) chunks of blubber. The teeth of a shark's lower jaw are narrow, designed to impale and grip a slippery carcass, while the rows of 26 perfectly serrated, triangular teeth of the upper jaw slice meat like butter. By late afternoon a quarter of the whale has been consumed. I abandon the scene, leaving the sharks to wrestle with their prize as wind and waves push the whale into the surf zone.

A little over a mile away in the lee of a headland, I jump into the sea with a mask and snorkel. I descend through a canopy of kelp and come to rest on the seabed. As the stench of whale oil and blubber leaves my body, I spot another shark, not cruising in the open water like the whites but inches away from me. A perfectly camouflaged and thumb-size puffadder shyshark rests among the pebbles. Most people associate sharks with the classic stereotype: Dorsal fin slicing through the water and a steely gray, torpedo-shape body beneath. In fact, more than half of all sharks defy this popular image, including the tiny

OPPOSITE *A shyshark assumes a unique defensive posture by using its tail to cover its eyes and head.*
PREVIOUS SPREAD *A whale shark lingers just beneath the ocean's surface, awaiting a tidal delivery of plankton.*

puffadder shyshark that now, with some coaxing, rests on my hand. Only when the urge to breathe overtakes me do I place it back on the seabed. As I ascend, its outline disappears into the maze of pebbles.

Sharks have roamed the oceans for more than 400 million years. They're the planet's oldest vertebrate predator, but this ancient pedigree doesn't mean they're primitive creatures. A steadfast adaptability to an ever-changing world has been key to their survival. Sharks began their reign as small coastal predators but gradually evolved larger bodies and the knack for colonizing deeper, offshore waters. The Carboniferous period 360 million years ago marked the golden age of sharks, when species proliferated and occupied almost every imaginable niche in the oceans.

A shark's skeleton is unique in that it is made entirely out of cartilage. Because cartilage lacks the preservation quality of bone, shark fossils are rare. So the exact morphology and natural history of early sharks have been pieced together from a mix of scales, teeth and fossilized impressions of muscles and organs. Prehistoric sharks had bizarre features, including L-shape spines, spiral jaws, and hourglass-shape dorsal fins. After an estimated 95 percent of all marine life was wiped out during the Permian–Triassic extinction event 250 million years ago, modern sharks evolved about 50 million years later in the heyday of the dinosaurs. The sharks that shared the planet with *Tyrannosaurus rex* would have been very familiar to us. They were streamlined, with two dorsal fins, a powerful vertical tail, and a flexible jaw that could thrust forward to feed.

The most famous and largest of all prehistoric sharks, *Carcharodon megalodon*, is now extinct. Megalodons were estimated to grow to 49 to 65 feet (15–20 m) long. Their dorsal fins towered 6.5 feet (2 m) out of the water, and their jaw measured 6.5 feet in diameter. It's fairly easy to imagine them swallowing a modern-day great white shark with no

problem. Impressions found on fossilized bones of whales match the dimensions of fossilized megalodon teeth (roughly the size of a human hand), indicating that early whales may have been a primary food source. Theories of megalodon extinction are contentious. Some scientists speculate that two million years ago changes in oceanographic conditions triggered whale migrations to colder waters to feed; megalodons, whose physiologies were possibly not well adapted to polar conditions, were unable to follow.

An estimated 500 species of shark (some still unnamed) survived the perils of prehistory and still roam almost every seascape in the world, from the icy seas of the North Pole to the warm tropical waters of the South Pacific. Indonesian waters harbor the highest diversity of sharks—78 species—while the northern polar seas are the most depauperate, with just eight species. The range of environmental conditions that sharks tolerate is astounding. At one end of the spectrum, the aptly named Greenland shark thrives in sub-freezing waters under the Arctic ice sheet, while the epaulette carpet shark survives in waters over 86 °F (30 °C) on sun-baked tropical reef flats. Sharks also inhabit 90 percent of the world's marine ecosystems, including kelp forests, seagrass meadows, mangroves, coral reefs, and rocky shores.

Sharks roam a vast depth range, from the reef shark of tropical latitudes, which hunts in water just centimeters deep, to the Portuguese dogfish, which has been caught at depths of 12,000 feet (3,670 m) off the coast of Ireland. To date, no sharks have been caught at deeper depths, making the abyssal and Antarctic waters the only assumed shark-free regions. Sharks also thrive across a wide salinity gradient; the milk shark of the Arabian Gulf can tolerate salinities in excess of 40 ppt (parts per thousand) during the summer months. On the other hand, bull and Ganges sharks dwell for long periods of time in fresh water and, in some cases, have been found 620 miles (1,000 km) upriver.

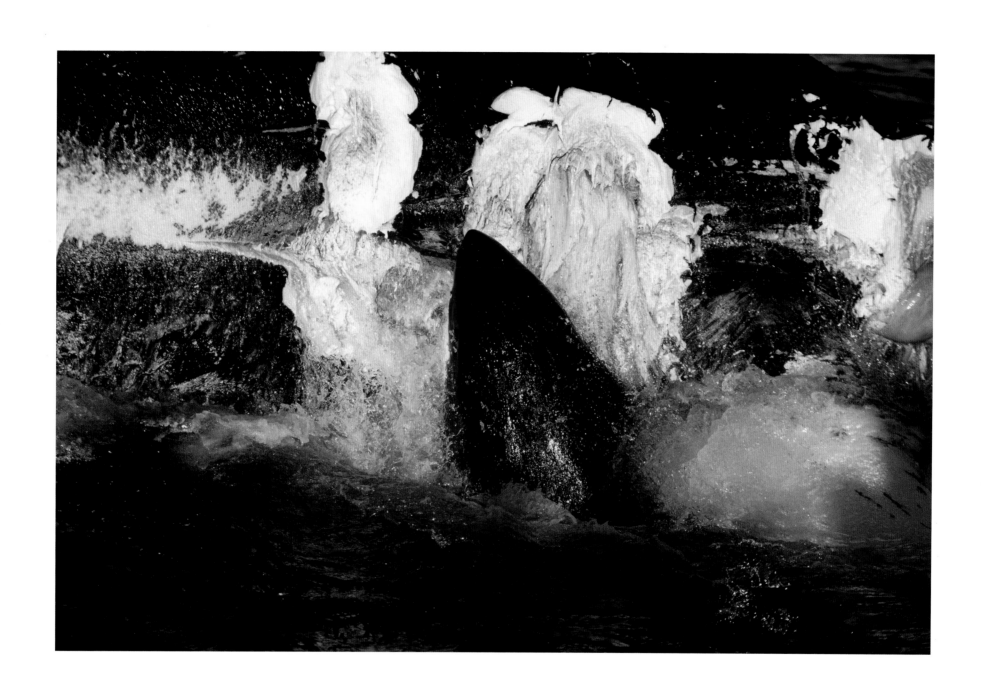

A large white shark scavenges the carcass of a humpback whale killed by a ship strike off South Africa's Dyer Island.

Sharks come in a variety of sizes. On the small end is the dwarf lantern shark, which at seven inches (19 cm) long as an adult is no larger than a megalodon tooth. Growing to 50 feet (16 m) long, the largest shark (and fish for that matter) is the whale shark. Around half of all shark species adhere to a very familiar blueprint: metallic gray skin, a prominent dorsal fin, and a jaw equipped with rows of razor-sharp teeth. Defying the stereotype, the other 50 percent of sharks are an outlandish and motley crew. There are sharks with hammer-shape heads; glow-in-the-dark skin; bodies adorned or patterned with frills, tassels, chains, spots, and stripes; and eyes the size of grapefruits.

A shark's diet is as diverse as its appearance. Toothless giants, like basking, megamouth, and whale sharks, consume miniscule plankton, while the preferred prey of great whites includes 2,200-pound (1,000-kg) elephant seals. Mako sharks can sustain speeds up of to 31 miles per hour (50 kph) and hunt some of the fastest fishes in the sea, including tuna and marlin. The less streamlined puffadder shy-sharks specialize in more sedentary prey, such as sea snails and crabs, while angel sharks simply wait for their food to come to them.

Sharks are the best known of the class Chondrichthyes, animals with skeletons made entirely of cartilage. Cartilage is not as dense as bone, allowing sharks a great degree of flexibility. They also lack a swim bladder, an air-filled structure that maintains buoyancy in many fish. Instead, they rely on their livers. Accounting for 25 percent of their body weight, their giant two-lobed livers are full of oil that is lighter than water and thus affords them buoyancy. Despite this, most sharks must swim continuously so that the lift generated by their pectoral fins will prevent them from sinking.

Sharks are covered from snout to tail by dermal denticles, or "skin teeth," an assemblage of miniscule teethlike scales. Just as owl wings are adapted for silent and efficient flight, shark dermal denticles are adapted for silent swimming. As water passes over the skin, it forms pockets between the denticles, reducing drag and allowing sharks to conserve energy and glide soundlessly through the water. Mimicking this design, some companies now specialize in fabricating Olympic swimsuits using aqua-dynamic sharkskin as a model.

Among the most characteristic features of many shark species are their jaws and teeth. The scientific name of the white shark, *Carcharodon carcharias,* originates from the Greek for "jagged tooth," an obvious homage to the animal's daunting dentition. Sharks have several rows of teeth, an adaptive feature, as their teeth fall out and break regularly. The rows move like conveyor belts, replacing teeth throughout a shark's life. The exact shape and placement of teeth depends on the particular shark species' preferred prey. The ragged-tooth shark, which can go through over 30,000 teeth in a lifetime, has very pointed teeth for impaling fish, while the tiger shark has teeth that mirror a saw. Conversely, the horn shark has flat teeth resembling those of a cow, designed to crush crabs and other shellfish. And other species like the whale shark and the basking shark have gill rakers rather than teeth to help them capture plankton.

Sharks have a 400-million-year-old sensory system to detect smells, tastes, vibrations, sights, sounds, and even low-level electrical impulses. A shark's sense of smell, like the Jacobson's organ in snakes, allows it to detect minute traces of chemicals back to the source, even if it's is miles away. A shark's taste organs, located in the mouth and throat, are used primarily to help determine whether something is edible. When a shark bites a potential food item, clusters of microscopic taste buds activate, informing the shark of the item's taste and possibly even its calorific value. A bad-tasting or low-calorie item such as a piece of plastic is often expelled, while palatable, energy-rich prey is consumed.

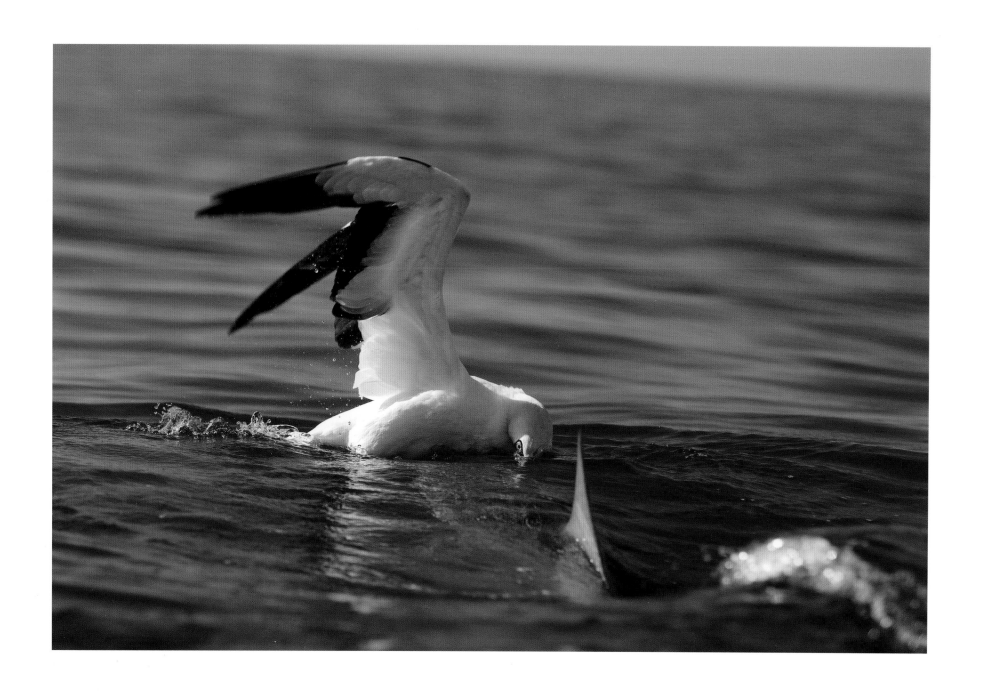

A blacktip shark and a Cape gannet lunge in competition
for sardines just beneath the ocean's surface.

A shark's hearing is very different from our own; since it is equipped only with an inner ear, all sound vibrations pass directly through its skin. A shark can also sense and pinpoint the origin of vibrations by means of its lateral line, a series of sensory pores along the sides of its body. An injured fish swimming erratically creates a series of water pressure ripples that the shark detects and targets using its lateral line. In addition to this highly developed sense of sound, many sharks have excellent vision. Like humans, sharks have two types of retina cells: rods detect contrast and movement, and cones discern detail and color. Like a lot of nocturnal predators, sharks also have a tapetum lucidum, which acts to increase the available light in low light conditions. Some species have a protective nictitating membrane, often called a third eyelid, to protect their eyes.

Sharks possess a sixth sense as well: electroreception. Multiple rows of tiny pores on the snout and head, known as the ampullae of Lorenzini, allow sharks to detect electrical currents generated by muscular activity, and that assists them in locating prey even in low light or murky conditions.

Although mysteries still abound on the topic of shark reproduction, there is a solid and growing body of knowledge. Scientists now know that many sharks tend to segregate by sex and only interact to mate. Like many animals, sharks are sexually dimorphic, meaning there are visible differences between males and females. Males have cartilaginous folds called claspers. These modified pelvic fins usher spermatophores (sperm packets) into a female's reproductive tract through the cloaca.

Many species (60 percent), including hammerhead and bull sharks, are viviparous, giving birth to live young. The eggs hatch inside the female's body and the young are nourished either by a yolk sac or through a placenta until they are born fully developed. Some of these species, like sand tiger sharks, are also oophagous, meaning the first-born or more dominant offspring gains nourishment by eating unfertilized eggs or their siblings in utero. The remaining 40 percent of shark species, including zebra and catsharks, are oviparous: Their eggs are deposited and anchored onto the seabed to hatch many months later. The empty egg casings, often found on beaches, are commonly known as "mermaids' purses."

Gestation periods range on average from nine to 12 months, but the frilled shark wins the gestation endurance prize at approximately 3.5 years. It surpasses the African elephant's gestation period by more than a year, making it one of the longest gestations of any vertebrate on Earth. These long gestation periods, combined with the fact that many species take several years to reach sexual maturity and produce small numbers of offspring, make sharks particularly vulnerable to overfishing.

With all of these remarkable adaptations, sharks are one of the most evolved groups of animals on the planet. They hunted alongside dinosaurs in a seascape devoid of humans and still survive today on a planet teeming with seven billion people. The challenge for the future is finding a balance that will ensure humans and sharks don't simply survive alongside each other, but thrive.

A silky shark offers a close-up look at its ampullae of Lorenzini, a network of jelly-filled pores used to detect the electrical impulses emitted by other organisms.

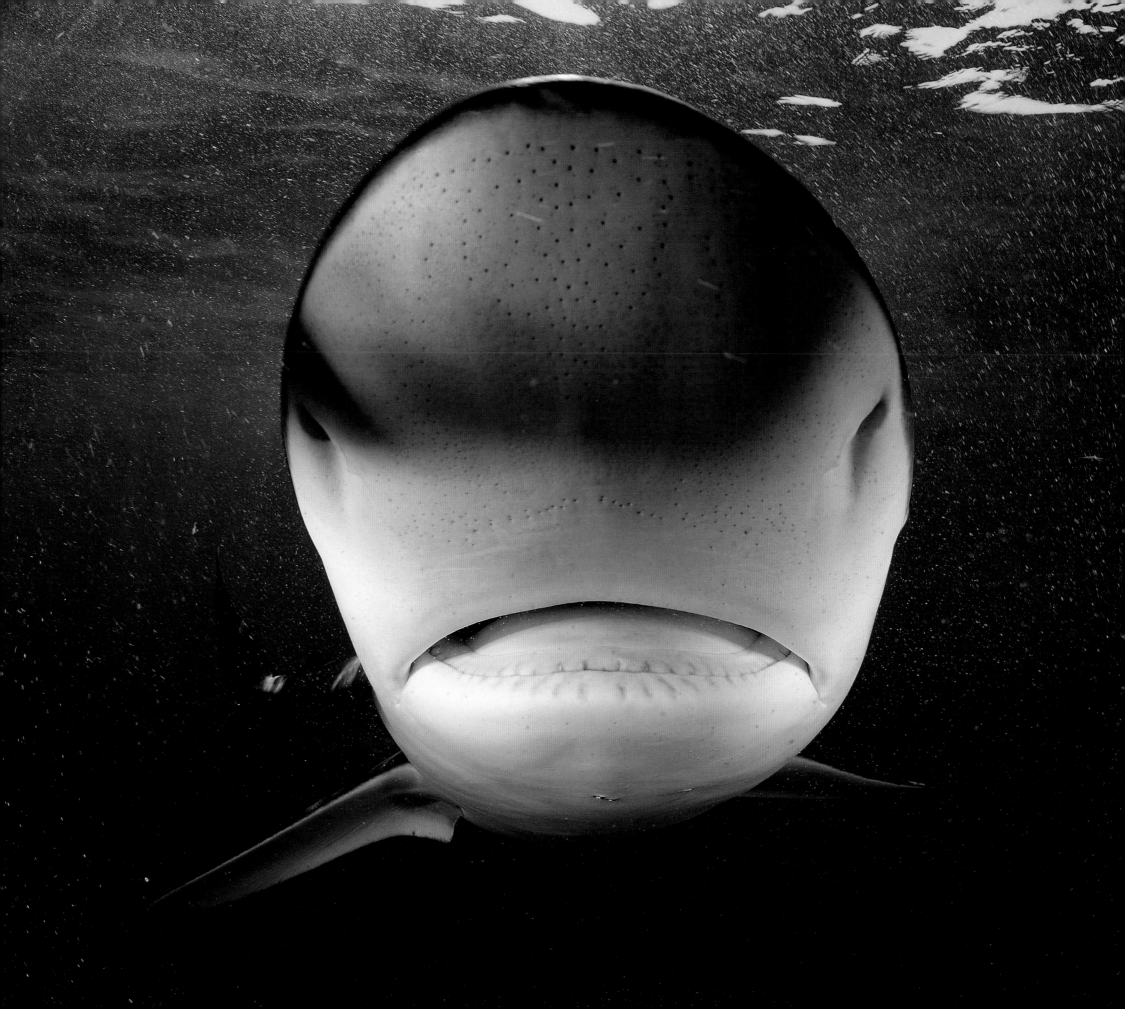

A Galapagos shark speeds across a coral reef looking for a meal in the Mozambique Channel. Juveniles prefer reef fish and graduate to a diet of rays and other sharks as adults.

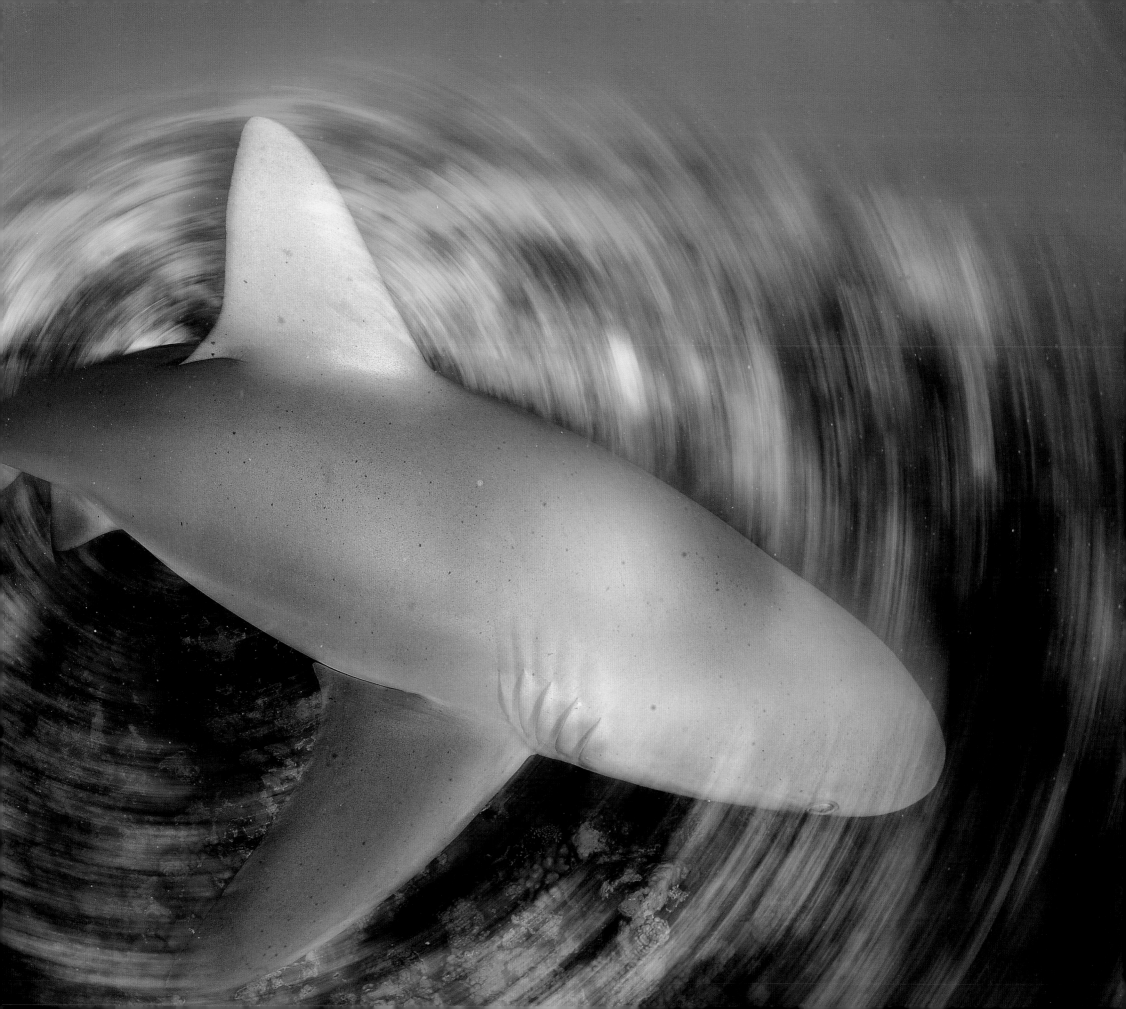

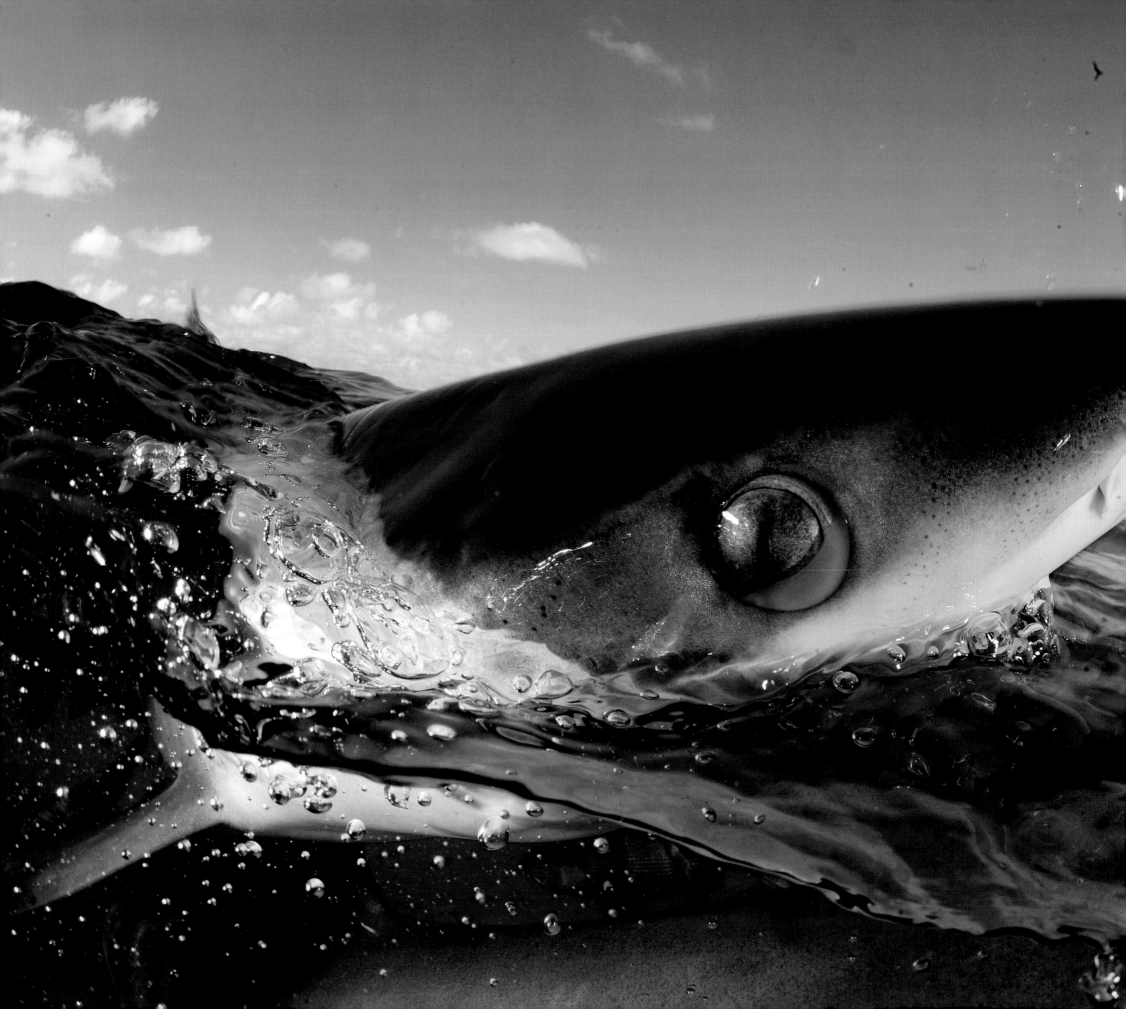

A Galapagos shark spyhops, exposing its nictitating membrane, a "third eyelid" that horizontally covers the eye.

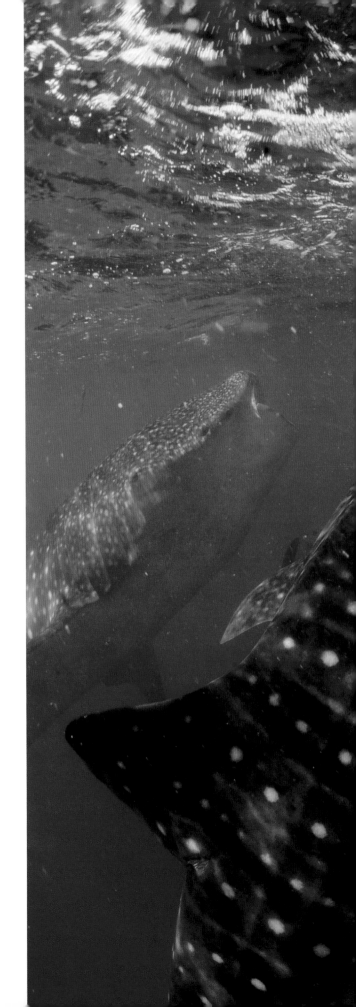

Seasonal wind-induced upwelling in Djibouti's Gulf of Tadjoura fuels plankton blooms that attract large numbers of whale sharks. A recent expedition identified over 100 different sharks in just 11 days.

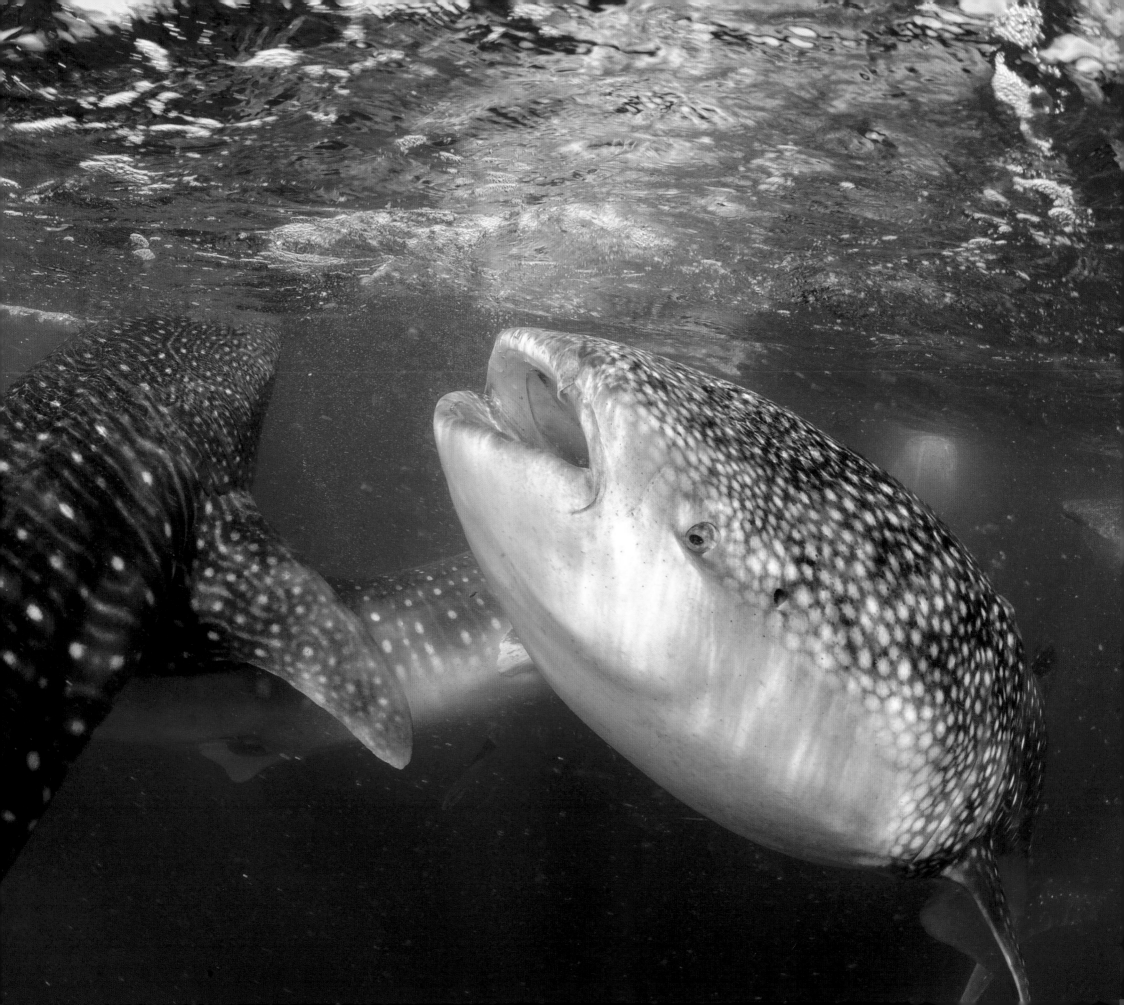

MEET THE NEIGHBORS

RAYS EVOLVED FROM SHARKS around 200 million years ago. These close cousins, with their disk-shaped bodies and winglike pectoral fins, have a unique, yet familiar outline. Best known are the mantas, the largest marine rays in the world, with a wingspan up to 23 feet (7 m) and a weight of almost 3,000 pounds (1,300 kg). Despite their size, they feed mainly on plankton, using their prominent cephalic lobes to fan plankton into their cavernous mouths. These lobes resemble horns and have earned mantas the popular name "devilfish." In order to take advantage of abundant areas of food, mantas make seasonal migrations and form mass feeding aggregations of 300-plus individuals. Until recently, it was thought that only one species of manta existed, but taxonomic detective work over a number of years suggests there may be two. The larger, the giant oceanic manta (*Manta birostris*), is migratory and more commonly sighted along oceanic island groups and offshore pinnacles, or seamounts. The other species, the reef manta (*M. alfredi*), is smaller and more often sighted inshore around coral reefs and bays.

The spectacle of manta ray aggregations generates a multimillion-dollar tourism industry for island nations like the Maldives and Micronesia. But mantas are also highly sought after by some Chinese medical practitioners for their gill rakers, which filter out nutritious plankton from the water. Known as *peng yu sai*, or fish gills, these are said to boost the immune system and purify the body when consumed. Despite the $11-million industry that the medical application of gill rakers has created, the practice does not appear to be endorsed by any of the key traditional Chinese medical texts. Yet it is the continued demand for gill rakers that drives global manta ray fisheries and has resulted in population declines, notably in Sri Lanka, Indonesia, Mexico, and Thailand.

Manta rays spend most of their time in the water column or near the surface, while stingrays are creatures of the seabed. Like some species of sharks, stingrays are bottom-dwellers and have an opening on the top of the head called a spiracle, which prevents mud and sand-ridden water from entering their gills. As the name implies, stingrays are best known for their serrated stinger, a modified dorsal spine situated at the tip of their whip-like tail. Used as a defense mechanism, many stingray spines have been found embedded in the jaws of great hammerhead sharks, a major predator of stingrays. Most stingray injuries to

OPPOSITE *As the monsoon rages above, a manta ray glides below, lapping up the plankton-rich waters.*

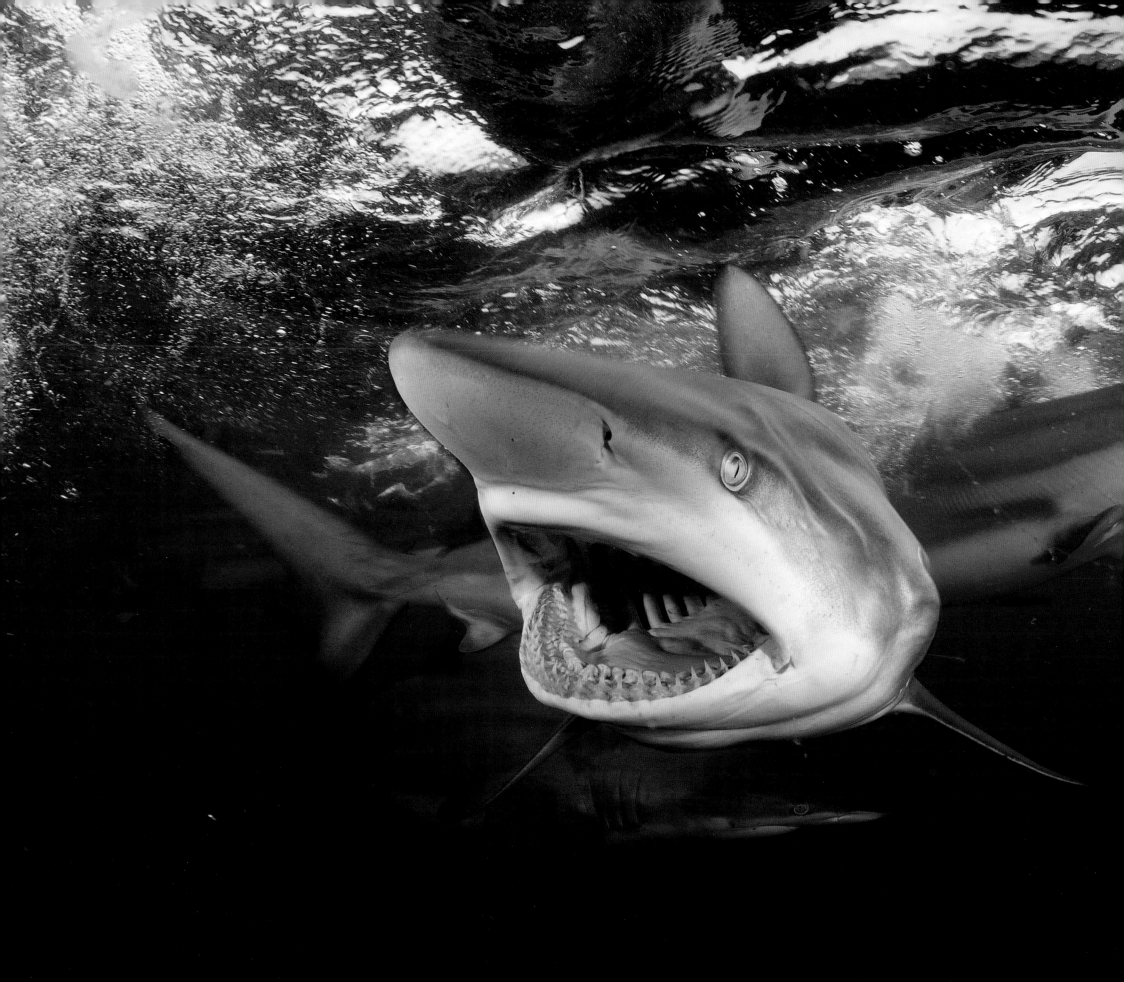

people occur when a swimmer or wader accidentally steps on a ray, causing it to act reflexively, lodging its spine into the foot or lower leg of the unfortunate victim. The stinger injects a protein-based toxin into the wound, causing immediate, intense pain. In some cases, it can cause muscular paralysis and cardiac failure. One of the most publicized human encounters with a stingray ended fatally. In 2006 Australian naturalist and TV personality Steve Irwin died after being stabbed in the heart by a cowtail stingray on the Great Barrier Reef. But such deaths by stingrays are rare, with less than 30 documented cases in all of history. This is an impressive figure considering the thousands of snorkeling tourists who feed stingrays each day. In fact, it appears that humans pose more of a threat to rays. Research shows that ray populations in frequent contact with tourists have weaker immune systems and higher rates of parasites than rays with little or no human contact.

Related to rays and within the order Pristiformes, which comprises only seven species, the sawfish has earned its place in popular culture due to its novel appearance. Up to 23 feet (7 m) long and weighing over 5,500 pounds (2,500 kg), it sports a rostrum, a beaklike appendage nearly seven feet (2 m) long adorned with sawlike projections lined with modified teethlike structures called denticles. Because sawfish live in murky water, their ecology, especially the exact function of the saw, has only recently begun to be deciphered.

Like sharks and rays, sawfish have sensitive electroreceptors, and experiments have shown that the saw is used for both detecting and capturing prey. The underside of the rostrum is lined with receptors that give sawfish the ability to scan the seabed for signs of prey. It was thought that the saw was also used to rake through the sandy bottom in search of buried prey, but it seems that sawfish use the underside of their saw to pin prey to the bottom and then swallow it. The rostrum also has electroreceptors on its upper side, allowing sawfish to employ a very different feeding strategy. Able to detect prey in the water column with the electroreceptors, the sawfish then uses rapid lateral swipes of the saw to kill the prey. This movement can rip a fish in half, impale it, or sweep it onto the seabed. The sawfish then deftly aligns the fallen fish with its saw and swallows it in a headfirst position. Sawfish also use the rostrum defensively to ward off predators, like large sharks.

For thousands of years sawfish have been culturally important to many native societies around the world. Considered symbols of strength and spirituality, they are widely revered. Certain clans of Australian Aborigines believe them to be supernatural beings that used their rostra to carve rivers and create landscapes. In the Arab world, rostra are placed on roofs to wards off evil spirits. Far more prosaically, rostra are used as bar decorations in the Florida Keys. But all seven species of sawfish are critically endangered, in part because their saws can become easily entangled in fishing nets, but also as a result of habitat destruction. In North America the range of the smalltooth sawfish has diminished by 90 percent because the species prefers the cloudy waters of nearshore and estuarine zones, which are often the first to be drained and bulldozed for coastal development.

Like sharks and so many other species, rays and sawfish are finding it increasingly difficult just to sustain healthy populations. With the human population estimated to reach nine billion in the next 40 years, there is an urgency to renegotiate our current exploitative relationship with these ancient relatives of the shark.

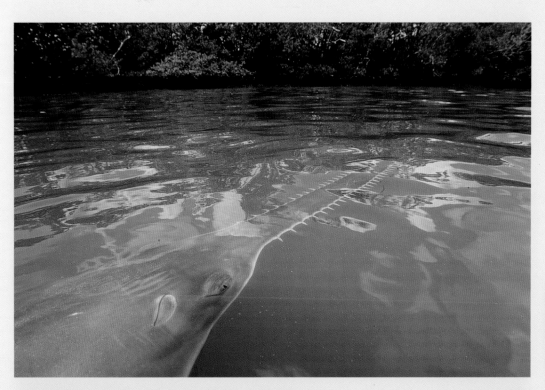

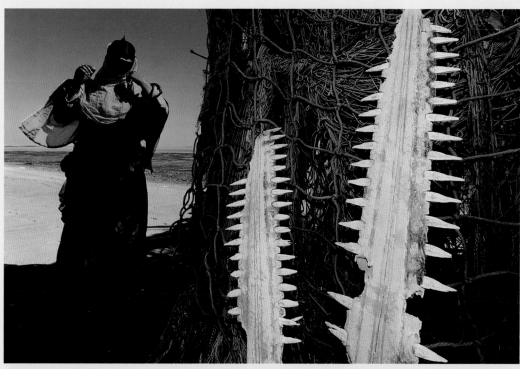

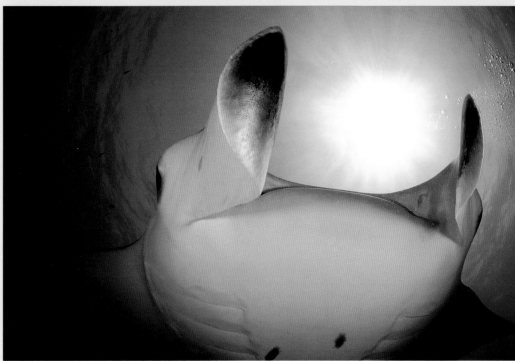

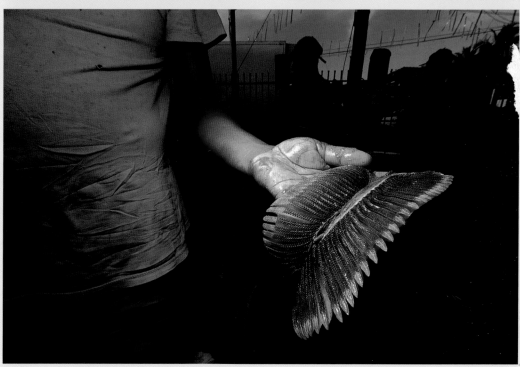

CLOCKWISE FROM TOP LEFT *A juvenile sawfish is at home in the murky channels of Florida's mangrove forests. In some remote islands in the Arabian Sea, sawfish rostra can still be found on the roofs of houses as protection from evil spirits. Manta rays are harvested for their gill rakers, which are used in the Chinese Medicine Trade. Though manta rays are giants with wingspans of up to 20 feet (6 m), they are filter feeders.*

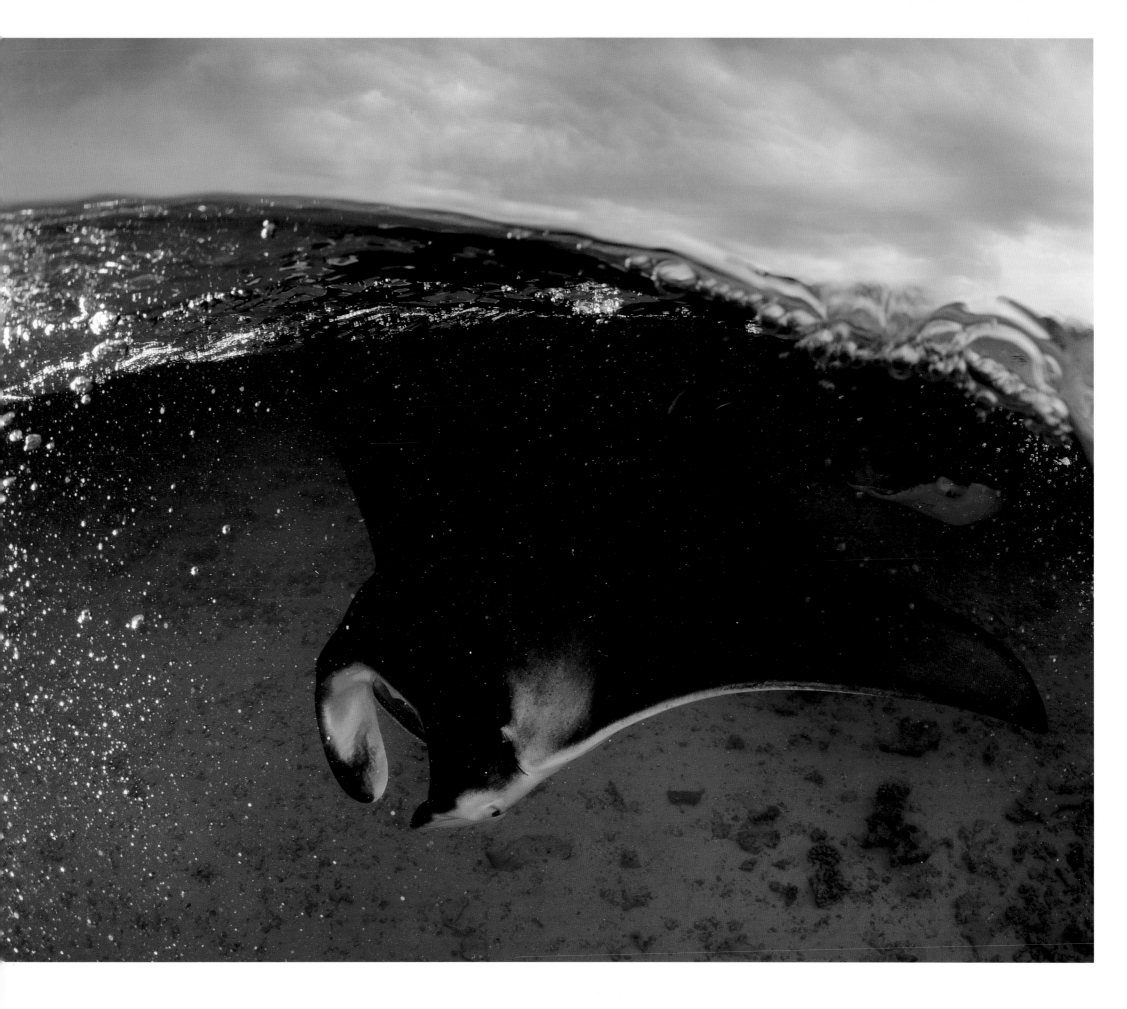

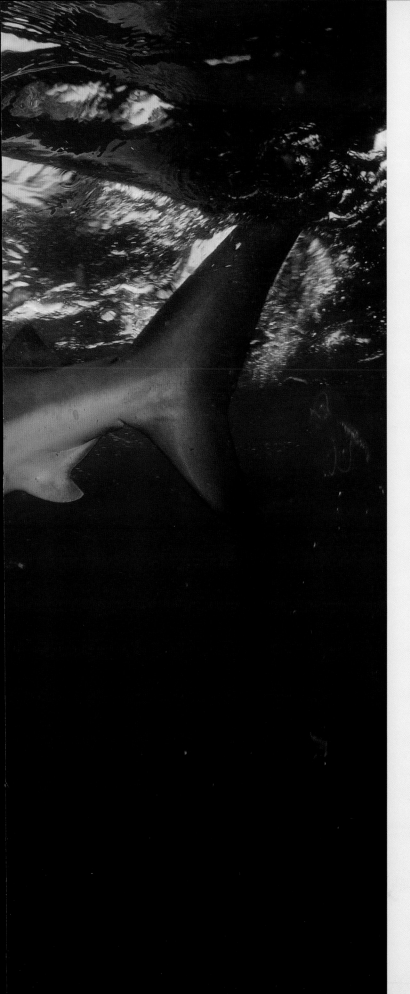

DEMON FISH

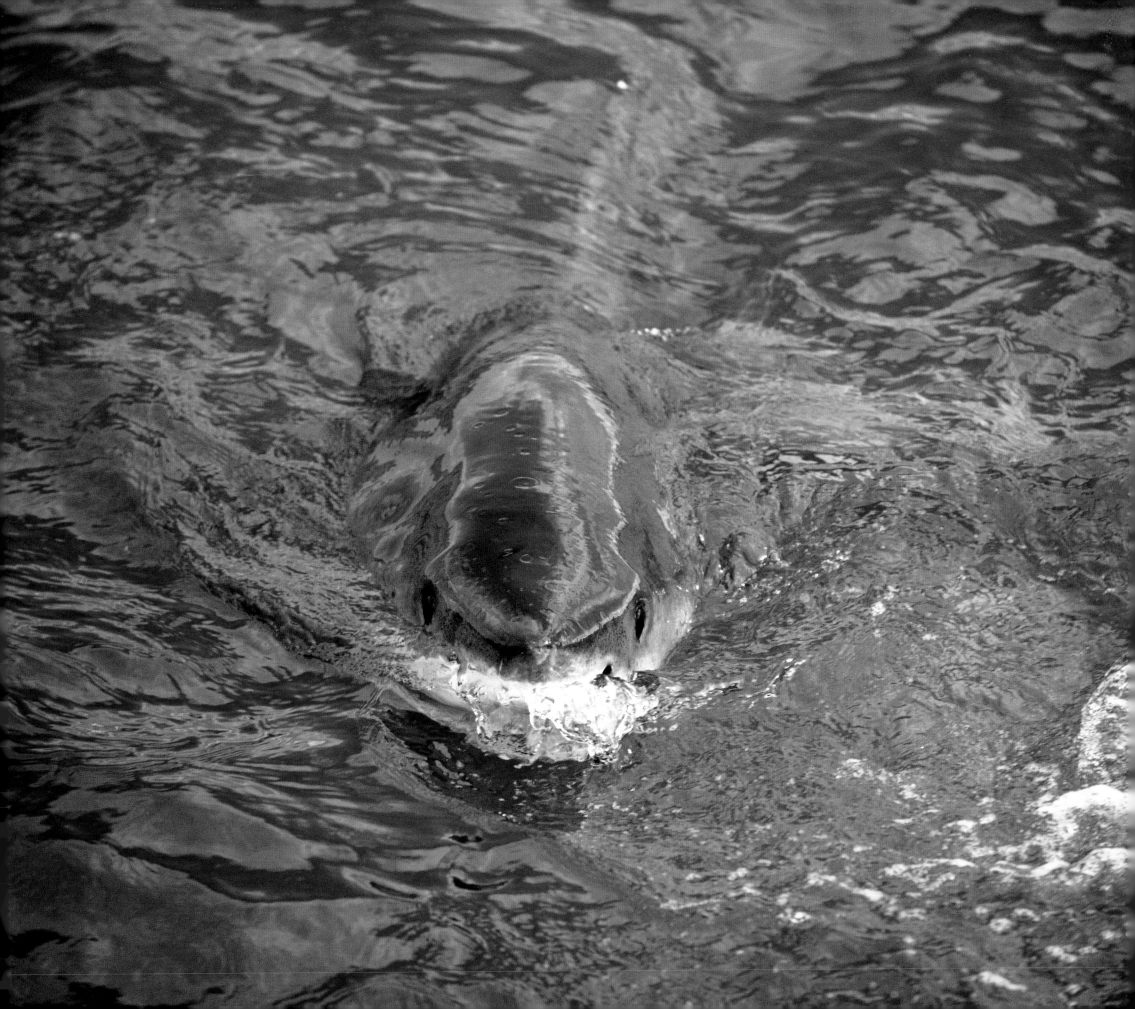

Ambulance doors shut and muffle the piercing screams from within, but they are still forever emblazoned on my mind. For what seems like an eternity, the agony of pain drowns out the sound of waves breaking onto the shore. Though I do not personally know the young man inside the ambulance, we share a mutual fascination with sharks. While diving at an offshore shoal, he was approached from below by a dusky shark, and with a single bite it almost severed his leg below the knee. I walk over to the boat that brought him to shore. Small pools of blood and red-soaked rags cover the deck in a macabre still life. As his screams grow more and more anguished, I become nauseous. I no longer care that lightning, toasters, and falling coconuts kill more people than sharks do. Information I preach religiously about the statistical probabilities of shark bites suddenly becomes irrelevant and hollow to me.

It is touch-and-go for 48 hours, but the young diver survives. His leg is amputated below the knee, and his relationship with sharks changes forever. So does mine. Now never again will I dismiss shark bites as inconsequential accidents that happen to a few unlucky or negligent strangers. It's true that shark bites are rare, but they have a disproportionate impact on the people involved and the larger surrounding community. Just like shark finning, shark worship, and shark diving, shark bites are part of the fabric that makes up our precarious relationship with these animals.

Sharks are one of nature's great evolutionary success stories. Their blueprint is so near perfect that they have remained almost unchanged for at least a hundred million years. For most of their time on Earth, sharks roamed the oceans without crossing paths with humans. Then,

as our species settled along the coasts more than 100,000 years ago, encounters with sharks became inevitable. But it has only been in the past 2,000 years that these encounters have been documented and our history with sharks recorded. Just like lions and tigers, predatory sharks have etched themselves into human consciousness and culture. However, there is a difference between the fear of being attacked by a shark and the fear of being stalked by an equally formidable terrestrial predator like a cougar or bear. On solid ground, a well-aimed rifle shot transforms us from hunted to hunter in a fraction of a second. In the ocean, though—an alien, hostile environment for us—the tables are turned. We can't breathe and most of our senses are impaired. But this is the shark's natural domain, and we often can't detect its approach until too late. With little aquatic agility and nowhere to hide, we are the land equivalent of a fish out of water.

Animal phobias (zoophobias) are common and reactions can range from feelings of anxiety in the presence of a certain animal to a panic attack at a mere photo of a specific species. The technical term for the fear of sharks is selachophobia or galeophobia. No applied research on this fear has been conducted, so we rely on an extensive body of work on snake phobia to elucidate the fear mechanism. Studies by psychologists show that we are not born with a fear of snakes or any other living creature, but that these fears are acquired during early childhood through the display of emotions of people in our immediate surroundings. Through negative conditioning, it's possible to imprint a fear of almost anything, but of course the fear of snakes and other dangerous animals is easier to acquire than a fear of harmless things like puppies or flowers.

OPPOSITE White sharks are thought to spyhop in order to inspect seals on their haul-outs.
PREVIOUS SPREAD A blacktip shark gapes and displays 15 rows of teeth designed to aid its predation on schools of small fish.

There is a vast collection of folklore about sharks, with tales and legends from almost every continent and ocean. Some cultures chose to celebrate and worship sharks, while others demonized them as the most feared dwellers in the sea. The first known illustration of a shark bite was on a vase excavated on an island off Naples, Italy. The vase depicts a man being attacked by a large fish and is dated 725 BC. The first written account comes from the Greek historian Herodotus, who in 492 BC recounted how sea monsters (likely sharks) feasted on ship-wrecked Persians: "It is said indeed that the number of the ships destroyed was three hundred, and more than twenty thousand men; for as this sea which is about Athos is very full of monsters, some were seized and devoured by these and so perished." Greek poets also told tales of deadly sharks. Leonidas of Tarentum described a sponge diver, Tharsys, who made it back to the surface after freeing his stuck anchor, but just as his companion reached out to heave him onto the boat, a shark tore away the lower half of his body.

The 1975 release of the film *Jaws* has been called the defining moment in the relationship between humans and sharks. It was supposedly *Jaws* that introduced on a large and sensationalized scale the notion of sharks stalking, attacking, and eating people. The real-life events that inspired the movie occurred in 1916 in New Jersey. Despite the early stories from ancient Greece and tales from island atolls, there were only a few dozen recorded incidents of shark bites before those events in New Jersey. Incidents most certainly occurred, but due to the lack of media, the rest of the world was none the wiser. There was no real mechanism to create a widespread culture of fear. In fact, before 1916 many of the leading authorities on sharks—museum directors, ichthyologists, and fisheries commissioners—believed that shark bites were a rare phenomenon that occurred in the remote tropics. The prevailing belief was that sharks never attacked people in the temperate realm, where most of Western civilization lay. One eminent expert also stated that he did not believe a 30-foot (9-m) great white shark had the power to sever a human arm or leg.

Experts also promulgated the idea that a human was more likely to be struck by lightning than bitten by a shark. At the end of the 19th century, millionaire banker Hermann Oelrichs even offered a $500 prize for the first authentic case of a person attacked by a shark in temperate waters. The award was never claimed. Then, in July of 1916 there were four shark bite fatalities in 12 days along the New Jersey shore. Major newspapers around the world ran front-page stories, relegating the normally dominant coverage of World War I to the inside pages. "New Jersey Coast Infested with Man-eating Monsters" read one of the headlines. In the nation's capital, a New Jersey congressman introduced a bill to exterminate all sharks along the Atlantic coast, while President Woodrow Wilson considered a plan to use the U.S. Coast Guard to declare a "war on sharks."

The notion of sharks as dangerous beasts was reinforced during World War II. On July 30, 1945, the Navy cruiser USS *Indianapolis* was torpedoed halfway between Guam and the Philippines by a Japanese submarine and sunk in just 12 minutes. Approximately 300 of the almost 2,000 men on board died as the ship went down. The remaining men drifted in the ocean, awaiting rescue. But rescue was delayed because the *Indianapolis*'s exact whereabouts were unknown; it was on a classified mission to deliver parts for the three atomic bombs destined to be dropped on Hiroshima and Nagasaki one week later. When pilots finally pinpointed the ship's coordinates, it had already sunk, but they reported seeing sharks attacking survivors. When help finally arrived, there were only a few hundred men left. The exact number that perished in the jaws of oceanic whitetip sharks is not known, but high estimates are around 500, while more conservative scholars suggest 80,

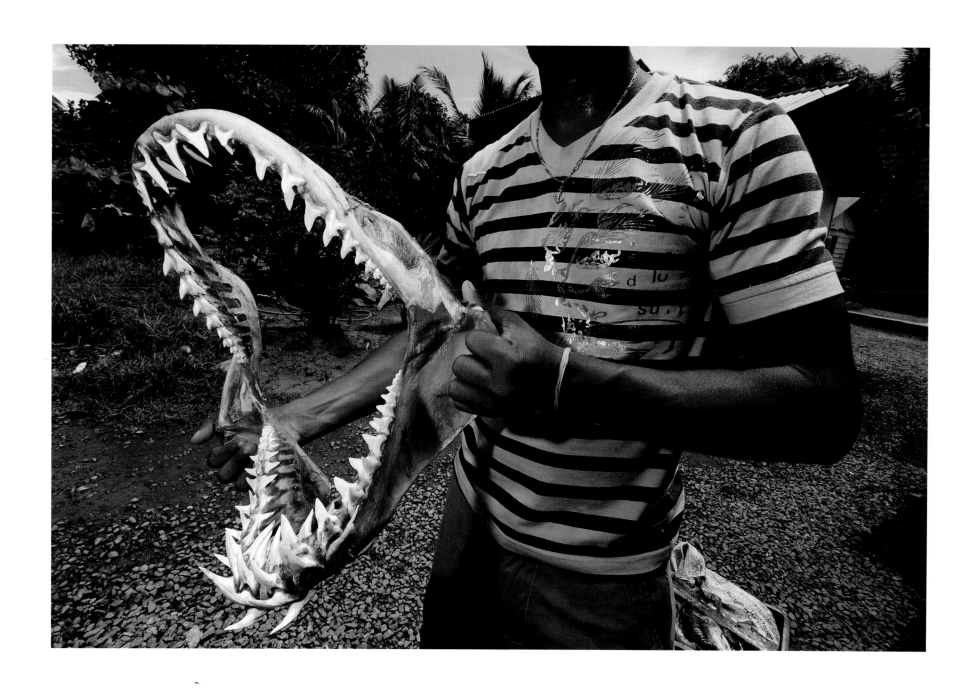

A Sri Lankan fisherman displays the jaws of a large mako shark he caught
offshore with the intention of selling them as a curio to tourists.

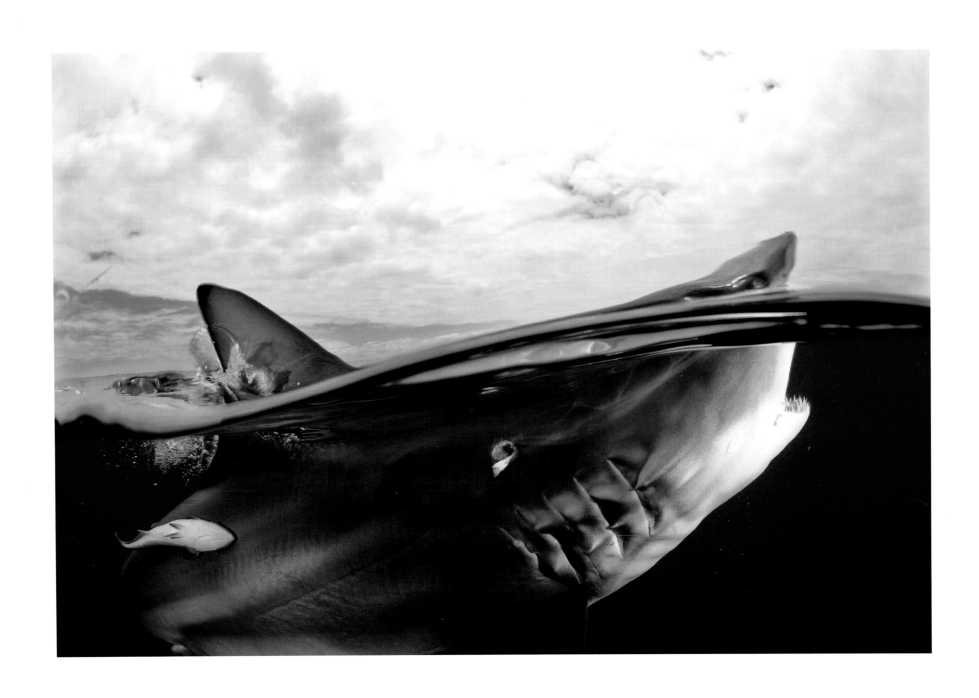

Off South Africa's east coast, blacktip sharks are known to steal fishermen's catches. Flesh wounds on the shark's flanks are often signs of retaliation.

with the rest dying from sun exposure, drinking seawater, or drowning. Considered the worst naval disaster in U.S. history, this event continues to influence the public perception of sharks.

In addition to these terrifying real-life events, the publication of the book *Jaws* by Peter Benchley in 1974 and the release of the Spielberg film in 1975 fanned the flames of fear. Reaching a massive audience, it was the first film in history to bring in over $100 million, creating the first "summer blockbuster." It took the image of a man-eating shark to all but the most remote corners of the globe. The tagline "Don't go near the water" was taken literally by many people, who reportedly hesitated about going into swimming pools, let alone rivers, lakes, or the ocean. From coast to coast, American beach towns reported a downturn in tourism following the release of *Jaws*, while deep-sea fishing and shark trophy hunting skyrocketed.

So where do things stand today, 40 years after *Jaws*, 68 years after the USS *Indianapolis* and almost a hundred years after the New Jersey shark attacks? Mass media today have the ability not only to reflect popular views, but also to influence conservation measures and policies. A recent study investigating the social framing of sharks in major newspapers in the U.S. and Australia between 2000 and 2010 shows that shark attacks were the topic of more than half of all articles on sharks, while shark conservation featured in only 11 percent. Despite evidence that many shark species are at risk of extinction, most media coverage focused largely on the risks sharks pose to people instead of on the risks that people pose to sharks. Great white, tiger, and bull sharks were featured almost 10 times more often than species of sharks that are endangered, such as hammerheads. If media, as is often said, both reflect and mold social opinion, then they have engendered an unfavorable environment for the creation and enforcement of shark conservation measures. It appears that even the Dalai Lama is afraid of sharks. "The

fear now is that I never learnt to swim so if my plane crashes on water, I would immediately go deep under the sea and be enjoyed by a shark."

The most fatalities attributed to a single shark occurred in November of 1993 along the southeast coast of Madagascar. In an ironic twist, more than 95 people died after eating the meat of a bull shark, and an additional 120 severely ill people were admitted to hospitals after their nervous systems were attacked by a toxin found in the animal's liver. Carchatoxin is similar to ciguatera, a toxin that originates in algae and bio-accumulates up the food chain to apex predators, like barracuda.

Statistically, the risk of being bitten by a shark is minute. In 2008, with the world population soaring to 6.7 billion people, there were only 58 documented shark bites, of which four were fatal. In comparison, 253,000 people died from drowning that same year. Between 1999 and 2008 there was an average of 64 unprovoked shark bites per year. The number of shark bites has increased since records began. For example, in the 1900s there were less than 30 recorded, and in the 1950s the number increased. Over 500 bites were documented in the 1990s and over 600 in the first decade of the new century. This has less to do with sharks becoming more vicious and more to do with our behavior: The number of shark bites correlates directly to the number of ocean-goers, and that has greatly increased over the past hundred years (as has the global human population). Overall, the U.S. has the highest number of incidents, accounting for 67 percent of shark bites worldwide. Australia is next with 12.4 percent and South Africa and Brazil follow with 5.5 percent and 3.6 percent respectively.

Although several theories abound, no one can say for sure why sharks bite people. Given the low number of documented shark bites and the dearth of knowledge on the behavior of these apex predators, we have little understanding of their primary motivations. Despite such uncertainty, experts have put forward several theories as to why people

are sometimes bitten by sharks, and these theories do help shed light on at least some of the incidents. It is commonly believed that when sharks approach humans, they are motivated more by curiosity than by predatory instinct. Sharks are often observed calmly circling unfamiliar objects at a distance before moving in closer to investigate. If they are unable to identify the novel object visually or through electroreception, they may resort to a taste test. A shark's taste organs are situated in the roof of its mouth, and it can gather data by giving the unidentified object a light nip. Injuries after such bites are usually minor, resulting in superficial skin or soft-tissue injuries.

Sharks have roamed the oceans for millions of years, and their sophisticated array of senses have evolved to keep up with such prey as fish, turtles, dolphins, seals, and whales. Humans are relative newcomers to the planet, with known fossils of the earliest *Homo sapiens* dating back less than 200,000 years, and it is only in the past 50 or so years that we have developed the technology to enable us to spend extended periods of time in cold water. Relative to the sharks' traditional prey, which has been around for over 20 million years, human divers, surfers, and bathers are quite unfamiliar to most sharks. Sharks have an extraordinary array of senses and can detect the presence of a person in the ocean long before the person is able to detect the shark. Humans send out a different sense signature from those of fish and seals. But it is easy to imagine a situation in which marginal visibility combined with the background noise of waves and the presence of other prey might confuse or overstimulate a shark. Its mouth is lined with an array of microscopic taste buds, which are believed to identify basic combinations of flavors. When a shark bites a person but expects a sardine, seal, or turtle, it should receive an immediate and clear signal that it has made a mistake and is not getting its preferred prey. This may account for many of the cases in which people have sustained serious but non-fatal bites.

As far as we know, sharks do not communicate through sound but rather through a social repertoire of body posturing and biting. While research on the social behavior of sharks is in its infancy, experts think that sharks are not territorial and do not defend a fixed space of ocean real estate from competitors. But they may defend their personal space as well as prey within it. For example, when two great white sharks meet at a food source, the smaller and/or less dominant shark will usually give way to the larger and more dominant individual. The same behavior has been observed in tiger sharks. If the smaller shark does not retreat, threat displays like jaw gaping and circular swimming have been reported in the larger individuals. If this fails, then one of the sharks, presumably the more dominant one, will attack, bite, or rake its teeth across the other shark's body. Most of the time, injuries resulting from social bites are minor. It is therefore plausible that a human who intrudes into a shark's realm and fails to withdraw from the area might trigger a defense bite from the shark. Although most humans would be unlikely to interpret a shark's body language correctly, a victim would also be unaware of a shark's presence until they were bitten.

Incidents in which sharks unleash successive predatory strikes and/or consume their victims are rare. Are these sharks old or injured and simply taking advantage of easy prey? Can sharks develop a taste for humans and become repeat offenders? All evidence points to the contrary, but because such incidents are rare, scientists have little, if any, opportunity to truly understand why they happen.

A bull shark stirs up a cloud of sand as it forages along the seabed. This species is well adapted to inhabit coastal areas and murky estuaries.

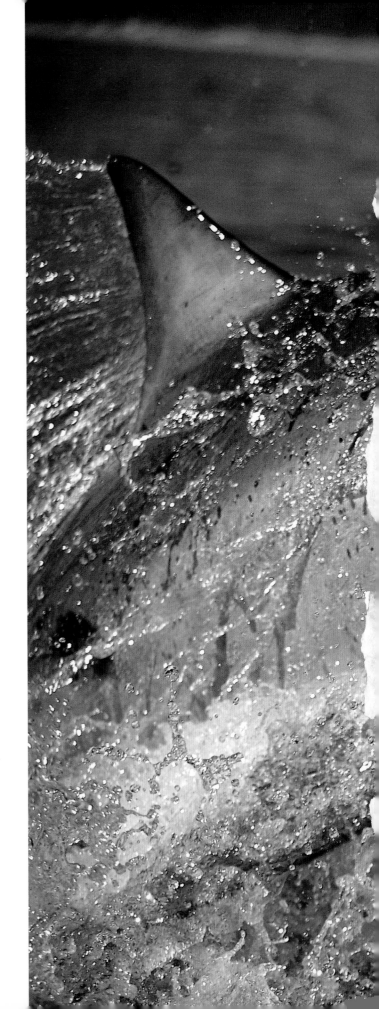

Breaching is part of South Africa's white sharks' hunting strategy. When a seal is spotted on the surface, the shark bolts up from the seabed and the momentum causes it to become temporarily airborne.

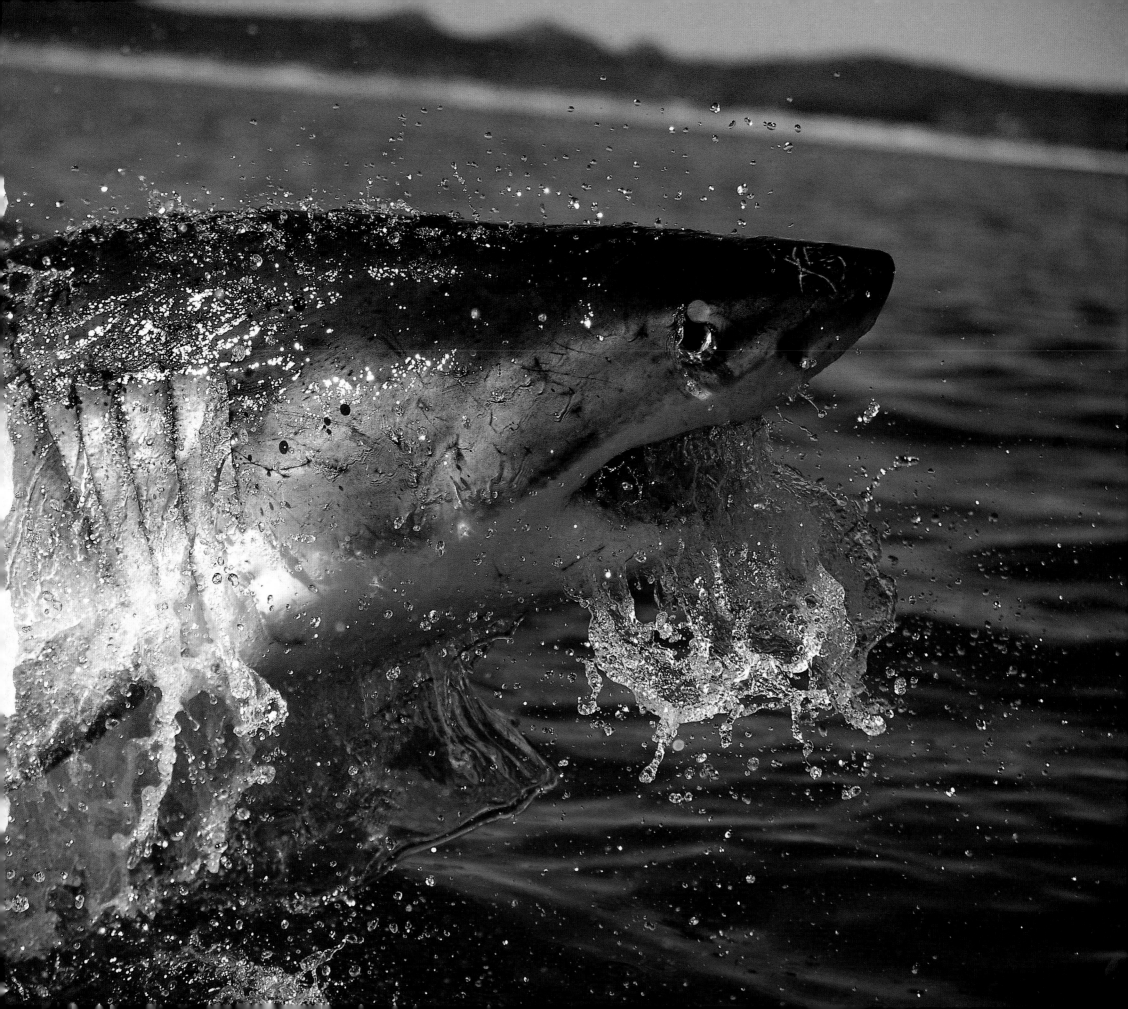

A blacktip shark re-enters with a splash after breaching. The behavior is thought to either get rid of pesky remoras or to be a diversionary tactic for escaping larger predators.

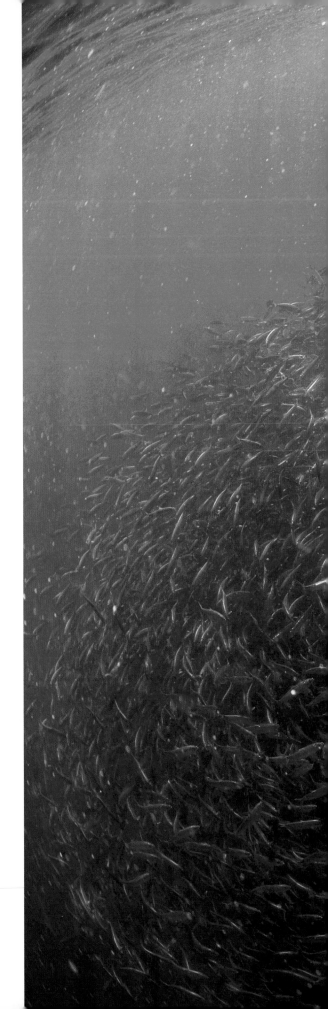

A lone bronze whaler shark approaches a shoal of sardines off South Africa's Wild Coast.

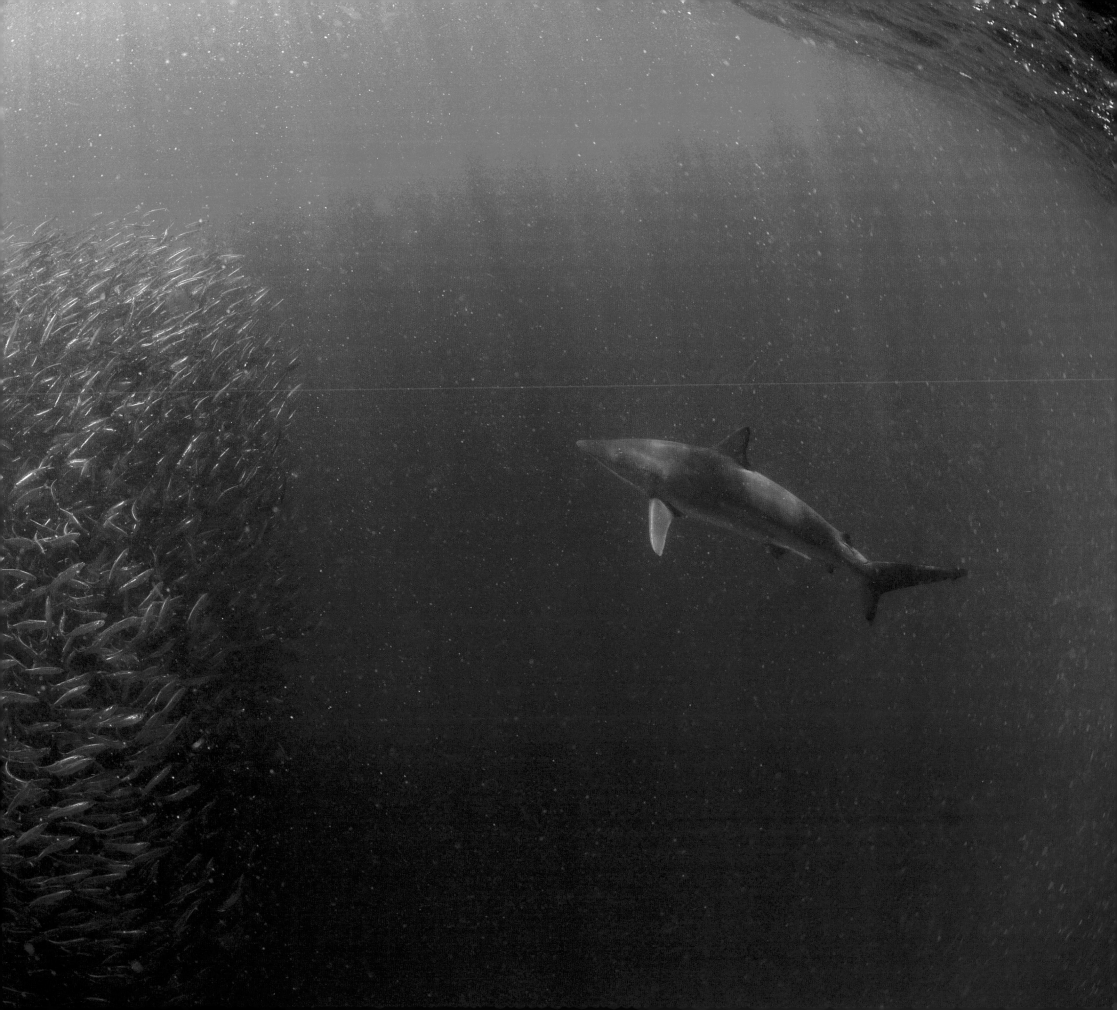

THE BEACH

ALONG SOUTH AFRICA'S EAST COAST some people still live in small villages nestled among steep hillsides. Every day they herd cattle and harvest mussels from the rocks at low tide. Over the past two to three decades tourism has transformed one such village, Port St. Johns, into a small town. Second Beach, one of the world's most beautiful beaches, is the town's pride—a white expanse of sand flanked by dramatic rocky headlands painted with lush tropical vegetation. Shark encounters were never an issue there in the past, with only one recorded bite dating back to 1954. It was a minor laceration to the leg, quickly stitched up by the local doctor. Looking at the history of the town, nobody could foretell the turn of events that began on January 14, 2007, when a lifeguard put on his fins and headed out to sea for a training swim. He never came back, but one of his fins washed up showing the telltale bite marks of a shark. Two years later another lifeguard went for a swim and was killed by what is believed to have been a bull shark. Two months later, in March 2009, a 16-year-old was surfing with friends when a shark grabbed his calf as he was paddling and pulled him off his board. Somehow he managed to get back on the board and return to shore but died later at a local clinic. On December 18, 2009, another lifesaver took a paddleboard out to patrol the area behind the waves. At around midday, a shark pulled him off his board. Witnesses say they saw his hands in the air before he disappeared in water stained red with blood. His body was never recovered. On January 15, 2011, a 16-year-old swimmer was repeatedly bitten while bathing in shallow water. Onlookers say he fought with the shark for several minutes before someone came to his rescue; he died of his injuries en route to the hospital. The most recent incident occurred on Christmas Day 2012 when a 20-year-old swimmer was killed by a shark in shallow water close to the beach.

With seven attacks in seven years, and a 100 percent fatality rate, Second Beach has become, statistically, the most deadly beach in the world for shark bites. In all but one of the attacks, bull sharks were implicated. In every case the shark seems to have fed on the person, delivering repeated bites. Many people, including veteran surfers, were so shaken that they refused to surf at Second Beach. The lifeguards were nervous to set out to sea even on jet skis or in small boats. This extraordinary situation led people to concoct a wide range of theories to explain what happened. Some chalked it up to a curse, others blamed the attacks on the ritual sacrifices of goats or chickens performed on the beaches by *sangomas* (traditional healers);

OPPOSITE *In Port St. Johns, South Africa, a young surfer opts for shallower waters in the wake of recent fatal shark bites at Second Beach.*

ABOVE Bathers take an evening swim off Port St. Johns Second Beach, considered the most dangerous beach in the world.

50 and 60 large sharks over 230 pounds (100 kg), with the heaviest weighing in at over 660 pounds (300 kg). Tony always knew when the bull sharks had returned in summer, as any hammerheads he hooked would be bitten in two before he could land them. He kept meticulous fishing records, showing that most of the large bull sharks were caught between November and April, a timeframe coinciding with the recent spate of shark bites, all of which have happened between December and March. Tony's experience indicates bull sharks are not newcomers to Second Beach and had frequented the waters decades before the shark bites on humans began. The mighty Umzimvubu River enters the ocean just a couple of miles from Second Beach and is one of South Africa's most important nursery grounds for these sharks. Every year pregnant females swim into the mouth or up the river and give birth to their young; the juveniles mature in freshwater and return to the sea as adults.

The sharks patrolled the deeper waters here for eons, but in the past the indigenous people of the Wild Coast weren't swimmers or surfers, and there was no tradition of using the ocean beyond the waist-deep intertidal zone. Then, Western influences in the form of backpacker hostels and visiting surfers introduced a new kind of ocean lifestyle to the local population. At Second Beach the regular use of deeper water by surfers and lifeguards only began in earnest in the 1990s and peaked around 2005. Once humans began spending time in deeper water, the sharks suddenly had something new on their radar. But why are the attacks so frequent, violent, and often fatal? Scientists are researching the answer to these and other questions about shark behavior in this area, but it could be years before any patterns emerge to help find solutions that protect both the human and the shark communities that populate this corner of the planet.

the animal blood running into the sea could have attracted the sharks, or maybe it was the loud music (low bass tones) played by the nearby taxis.

Another, more rational theory postulated that bull sharks had migrated only recently into the area, and that's when the shark bites began. But are these sharks really newcomers to Port St. Johns? Among the last pictures taken of one of the young surfers before the attack on him shows him waiting for a set of waves. In the background sits an ominous, rocky buttress separated from the cliffs by a small gap. For many decades, shark fishermen had climbed down a rickety ladder to cross that gap and access one of South Africa's most renowned shark-fishing spots. Tony Oates, among the country's most prolific shark fishermen, fished "The Gap" from 1966 to 2008 and caught between

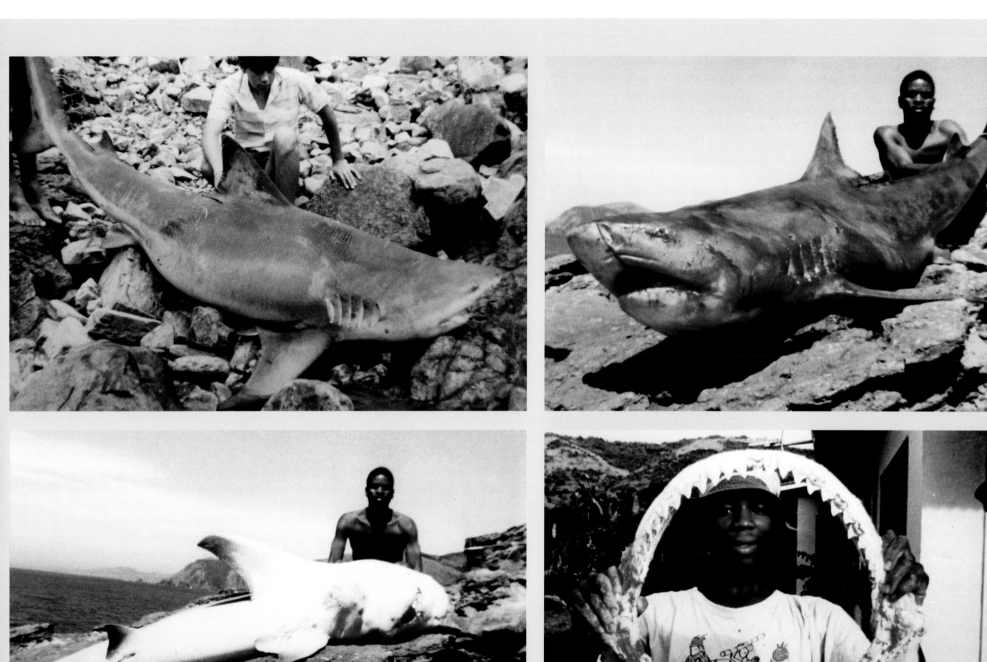

ABOVE Some of the bull sharks caught over a 20-year period from a fishing spot known as "The Gap", adjacent to Second Beach.

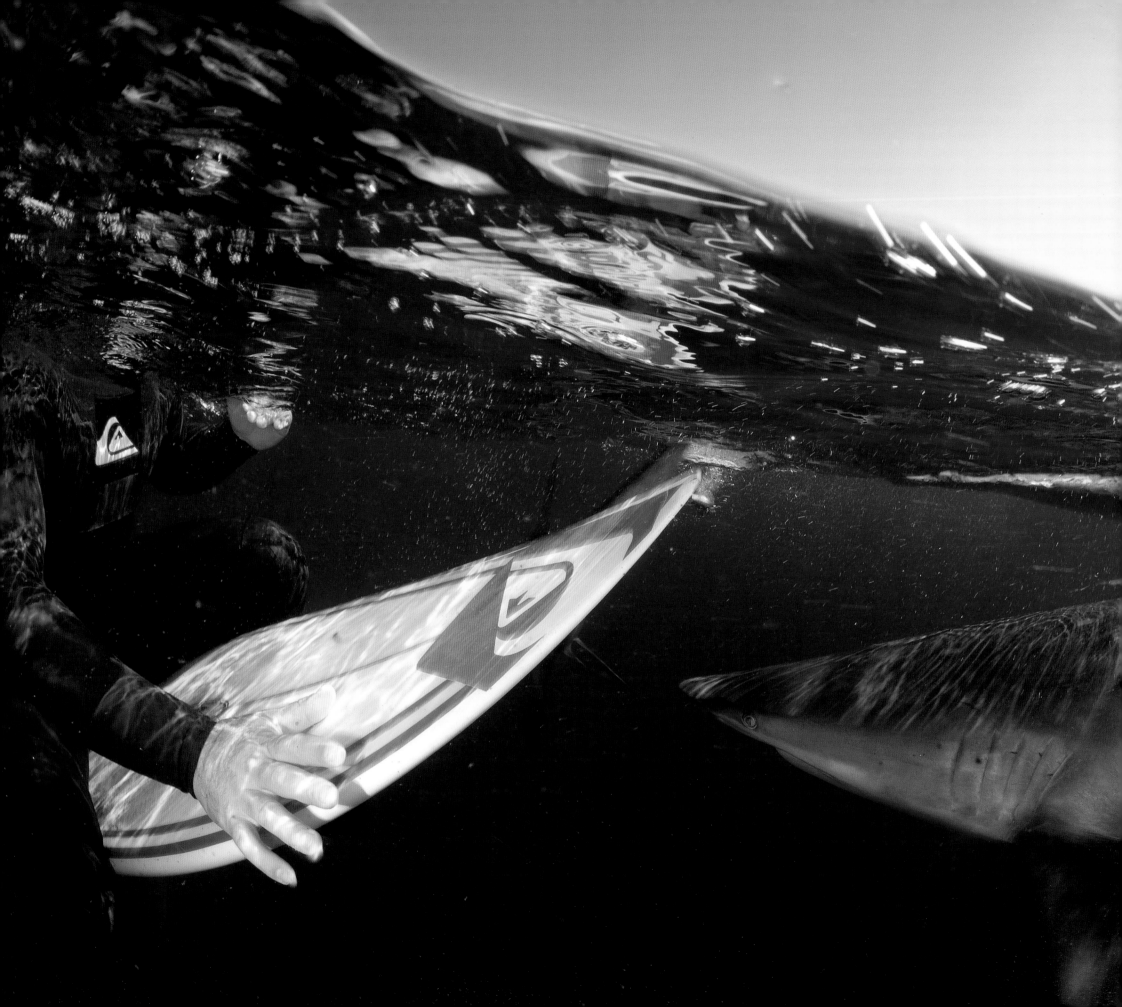

SHARK CONTROL

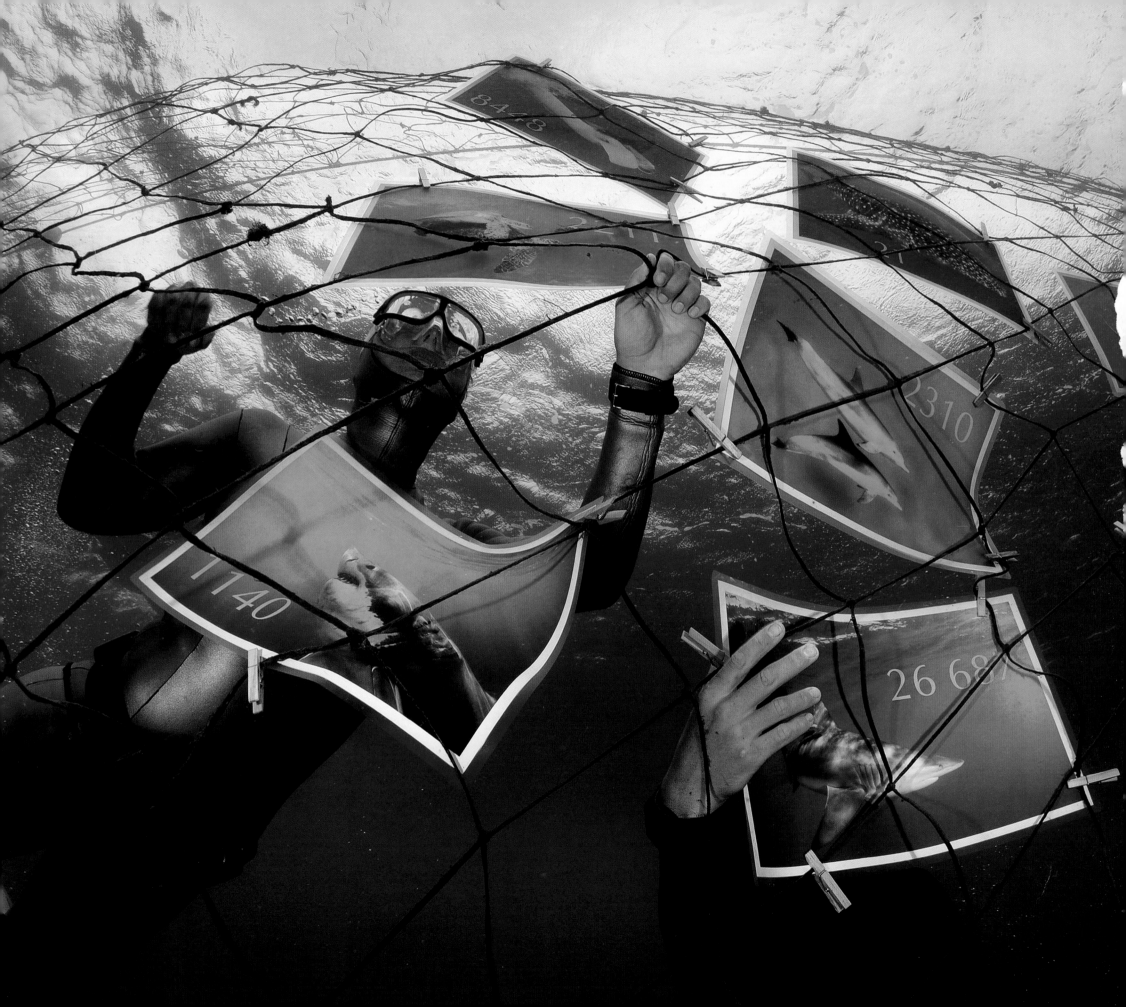

On January 6, 1958, the popular South African holiday resort of Margate wakes to rumbling explosions. After scrambling onto balconies and rooftops, residents and tourists are greeted by the sight of the 20-foot-high bow of the SAS *Vrystaat* slicing through the glassy summer sea. Running the navy frigate parallel to shore, Capt. Terry-Lloyd orders the release of depth charges at 9:24 a.m. Cascades of seawater 50 feet high rocket into the air, sending out shockwaves that are felt several miles away. Forty-eight depth charges are released in just 30 minutes, resulting in thousands of fish with ruptured swim bladders floating to the surface. On the bow a gunnery squad armed with high-powered rifles fires on anything moving at the surface. The target this warship is after is not a stealthy Russian submarine or foreign combat swimmers. It's sharks.

In a few short weeks during the dusk of 1957 and dawn of 1958, the Indian Ocean off the KwaZulu-Natal (KZN) coast is transformed from a beachgoing playground into a sea of fear and death. On December 18, 1957, a 16-year-old amateur lifesaver is bodysurfing off Karridene when a shark bites his leg. Two days later at Uvongo, a 15-year-old is bitten by a shark while standing on a shallow sandbank and succumbs to his injuries. On December 23 a man is bitten in waist-deep water off Margate and hemorrhages to death. On New Year's Eve, a teenage girl is repeatedly bitten. She survives but loses an arm in the incident. A few days later, a bather dies from a shark bite at Scottburgh. After these encounters, the life force of the seaside economy is drained, as frightened tourists abandon the south coast. This period, known as Black December, triggers the expansion of one of the world's largest shark control programs. Designed to improve bathing safety and restore the confidence of the tourist population, the program targets and reduces local shark populations.

Sharks are not the first predators to be hunted out of fear or retribution. The practice likely dates back to the moment humans entered the scene and began vying for the seat of apex predator. Native Americans used pitfall traps to catch wolves. The Inuit exterminated troublesome bears by hiding daggerlike pieces of whale baleen in blubber. When bears swallowed the booby-trapped blubber, it caused terminal damage to their digestive systems. Colonists in North America aimed not only to reduce but to eradicate predators by offering handsome bounties for dead wolves and cougars. They succeeded in certain regions, and wolves were practically eliminated from the eastern coast of the United States. To this day, tigers, lions, and leopards are routinely hunted and killed in India, Africa, and Asia after injuring or killing people.

Nothing, however, rivals the organized effort that goes into shark control programs around the world. The priority of shark control is to decrease the risk of shark bites and, in turn, protect the beach tourism economy. In the absence of peer-reviewed studies, anecdotal accounts provide evidence of the negative economic effects following shark bites. During the legendary 1916 New Jersey shark bites, bathing

OPPOSITE To illustrate the indiscriminate nature of shark control, conservationists attach photos of the most common catches to a shark net.
PREVIOUS SPREAD A surfer tests the reaction of sharks to a new surfboard prototype.

reportedly declined by 75 percent and resort owners lost $250,000 (equivalent to $5.3 million today). The Brazilian coastal town of Recife is said to have lost $20 million after a series of shark bites in the 1990s. Surf schools in Cape Town report dramatic drops in business following any shark bites on nearby beaches.

The series of shark bites along New Jersey's shore in the summer of 1916 heralded one of the first recorded revenge-fueled shark hunts. After the governor offered bounties, the media described what followed as the largest animal hunt in history. Hundreds of sharks were captured and killed. In the late 1950s retaliatory shark hunts in Hawaii transformed into more sustained culling operations. Between 1959 and 1976, 4,668 sharks were killed in Hawaiian waters, including 554 tiger sharks—the species believed to be responsible for most incidents. Although lauded as very effective in killing large numbers of sharks, the program did not result in a decrease in shark bites. The reasons behind this became apparent in the 1990s, when scientists studying the ecology of Hawaii's tiger sharks found not only that their home ranges are vast, but also that they spend much of their time offshore in waters 1,600 feet deep, so hunting sharks inshore was probably ineffective. The scientists also discovered that tiger sharks travel quickly, making it nearly impossible to hunt and kill those perpetrating bites on humans.

A more permanent and effective shark control solution came in the form of shark nets, basically static gill nets designed to catch and kill sharks. The rationale behind shark nets, and most other shark control measures, is that reducing the number of potentially dangerous sharks decreases the risk of humans being bitten. The nets are not particularly effective in keeping sharks from reaching swimming beaches. It seems that sharks can swim under, above, or around a shark net, the proof being that 35 percent of all sharks caught in a net are ensnared on the beach side.

Shark nets were first installed off Sydney, Australia, in 1937, after a series of fatal bites. Other adjacent locations followed suit, and today, 51 New South Wales beaches between Wollongong and Newcastle deploy shark nets. Each net is 492 feet (150 m) long and is set parallel to the coast in 30 feet (9 m) of water or about 1,300 feet (400 m) from the shore. The nets are checked every three days, and after any dead sharks have been removed, they are reset. The operating cost of this program is close to a million Australian dollars per year.

Shark nets were introduced in Queensland in 1962, but unlike in New South Wales, the Queensland Shark Control Program uses drumlines in addition to the nets. Each drumline consists of a large float with a baited hook anchored in 40 feet (12 m) of water. The idea was that sharks would bite or swallow the bait and get hooked. Today,

In Cape Town, South Africa, a surfer is captured in the outline of a flag used to signal to beach-goers that sharks have been spotted in the area.

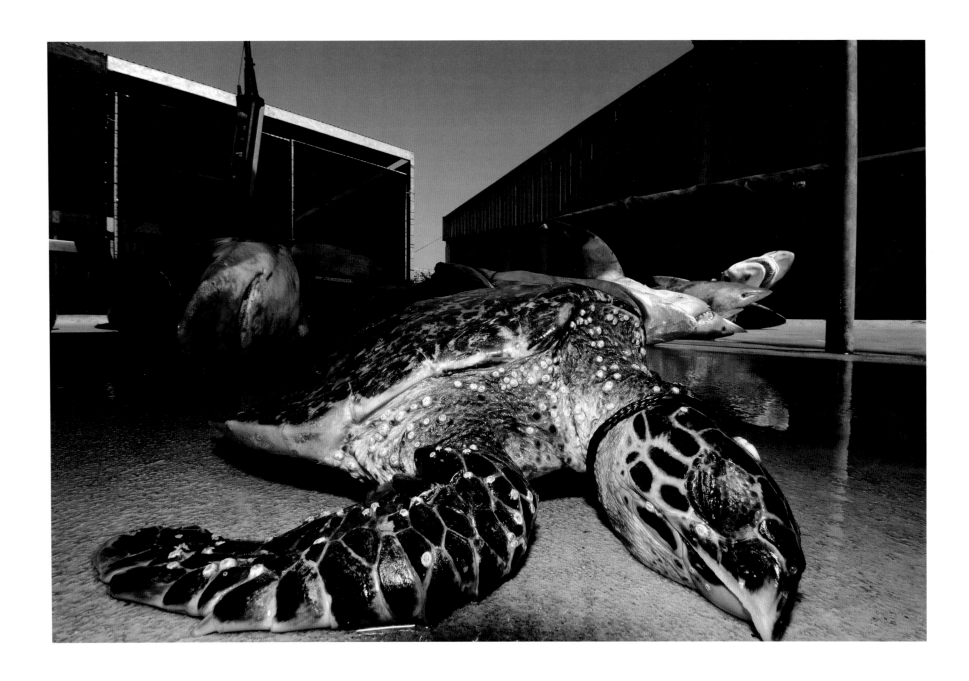

Endangered species like this hawksbill turtle are frequent bycatch of shark nets.

Queensland deploys 36 shark nets and 272 drumlines at 85 beaches along 1,200 miles (1,930 km) of coast.

In South Africa the first shark nets were installed off Durban's beaches following a spate of shark bites in 1952. After Black December, the nets expanded across the KwaZulu-Natal coast, peaking in 1992 with 44 beaches protected by an incredible 28 miles (45 km) of nets. If lined up end to end, it would take the best Kenyan marathon runner over two hours to run from one end to the other.

The introduction of shark nets in South Africa and Australia, while not foolproof, significantly reduced the number of shark bites. In New South Wales shark bites at protected beaches decreased by 60 percent, while KZN experienced a 90 percent decline. Bull sharks are suspected to have accounted for most incidents before the installation of nets in South Africa; between 1978 and 2003 this species showed a decline in catch rates, suggesting that the nets reduced some local populations. Effects on other shark species were more difficult to assess. Shark nets and drumlines catch the highest numbers of sharks immediately after installation. For example, the total shark catch in the Durban nets was 552 sharks in the first year, while in 2002 those same nets caught only 69 sharks. In 2009 the entire South African shark net installation caught only 567 sharks. There is good evidence that in their early days the nets exterminated local populations. Today's shark net catches likely consist largely of transient sharks traversing regions with shark nets.

Only 11 species of shark have been implicated in fatal bites on people and three species (great white, tiger, and bull) are said to be responsible for over 80 percent of bites. In South Africa shark nets caught 26,687 large sharks between 1978 and 2000. Out of this total, only 10.5 percent (2,816) were the dangerous target species (770 great white, 1,056 tiger sharks, and 990 bull); many of the remaining 23,871 sharks

taken as bycatch are considered relatively harmless to people, making shark nets one of the most unselective fishing methods used today.

Shark nets also catch a suite of other marine creatures, from gamefish to humpback whales. In South Africa an average of 143 demersal rays and 43 manta rays are caught every year. In Queensland shark nets are located near important sea turtle nesting beaches and ensnare an average of 119 turtles per year. Between 1962 and 1995 the nets also caught 837 dugongs, significantly impacting an already declining local population. Marine mammal catches are highest in South Africa, with approximately 54 dolphins ensnared each year. It has always been standard practice to release all live, non-shark bycatch from the nets, but survival rates vary depending on species and conditions. Rays have the highest survival chances, and depending on the species, 45 percent to 75 percent are released alive. Dolphins almost always fare the worst, and more than 90 percent drown in the nets.

The reduction of bycatch became one of the first conservation issues to be addressed by the KwaZulu-Natal Sharks Board (KZNSB). In the mid-1990s, the KZNSB, inspired by the shark control program in Queensland, conducted experiments using baited drumlines, since they have a much lower rate of marine mammal and sea turtle bycatch than shark nets. In 2007, after many years of testing, 76 drumlines replaced some of the nets along the KZN coast. The use of drumlines has also shown fewer catches of non-threatening shark species, such as blacktip, spinner, and ragged-tooth sharks. Conversely, the drumlines catch more sub-adult dusky sharks, a species that matures only at the advanced age of 20-plus years. In addition, dusky sharks have a low reproductive rate, rendering them vulnerable to fishing impacts.

In South Africa the nets' highest catches are linked to a unique seasonal phenomenon known as the sardine run. In June and July the warm, south-flowing Agulhas Current moves offshore, allowing

a tongue of cold water to lick South Africa's eastern flank. Localized and intermittent countercurrents develop and appear to assist the sardines in their northward journey along the Wild Coast. Marine predators of all taxonomic affinities take advantage of this annual feast. Bronze whaler sharks, Bryde's whales, long-beaked common dolphins, and Cape gannets follow the sardine shoals north. Beginning in 2000, the KZNSB began closely monitoring the advance of sardine shoals and decided to remove the nets prior to the sardine run each year, which resulted in major catch reductions of dolphins and sharks, with sharks down by 90 percent. In general, bycatch of all species has been reduced by 25 percent since this measure began.

Shark nets were embraced by the public at a time when science knew significantly less about sharks than it does today. Now conservation groups are pushing for further measures to protect sharks and ultimately the removal of the remaining nets. In 2011 New Zealand became the first country to mothball its limited number of shark nets, and similar movements are gaining strength in South Africa and Australia. Elsewhere, many authorities still believe that lethal shark control is the only practical option. Russia, for example, installed its first shark nets in June 2012 after three bites on its far eastern coast along the Sea of Japan. Shark hunts featured prominently in the Seychelles in 2011, and in 2012 Western Australia was seriously considering a multi-million-dollar cull of white sharks near bathing beaches.

Lethal shark control will end only if non-lethal alternatives, such as shark repellents and deterrents, are proven effective both in reliability and cost. Few people realize that the search for a shark repellent dates back more than 60 years. Although the incidents of shark bites during wartime were statistically few, the fear of sharks was so great that it affected the morale of sailors. And thus, the search for a shark repellent commenced.

After testing everything from toxic gas to cyanide, the U.S. Navy settled on a mixture of copper acetate and nigrosine black dye and called it "shark chaser." The black dye aimed to mimic the ink screen of an octopus as a visual deterrent, while the copper acetate was thought to inhibit the shark's feeding response. If stranded at sea, the soldier could tear open the envelope and become immediately surrounded by a dark cloud of repellent, which was designed to dissolve over time, affording three to four hours of protection. But shark chaser was developed in haste under the pressure of war, and reports of its ineffectiveness surfaced after hostilities ceased. More rigorous testing revealed that its effectiveness was inconclusive, and its use was discontinued by the U.S. Navy in the 1970s.

Research continued, though, with a focus on natural, marine-based repellents. Biologically active compounds from marine life ranging from sponges to sea cucumbers were tested, and the most promising was found in a fish from the Red Sea. The Moses sole is a flat fish that secretes a milky substance containing the protein pardaxin, which repelled sharks in both laboratory and small-scale field tests. Unfortunately, pardaxin could not be harvested in large enough quantities to be beneficial, and it was difficult to synthesize. Scientists had found that pardaxin behaved like a detergent, foaming in water and reducing surface tension, so tests were begun on components of commercial soap. Some, like sodium dodecyl sulfate, were found to be even more effective than pardaxin in repelling sharks. Apparently, these compounds attack the cell membranes of the gills, causing a large influx of salt ions from the seawater, a process that appears to distress sharks. Unfortunately, currents and waves dilute the repellent too rapidly, and it has to be administered directly into a shark's mouth to be effective.

A repellent needed to be significantly more potent than that to withstand the complex open-ocean environment. For decades fishermen

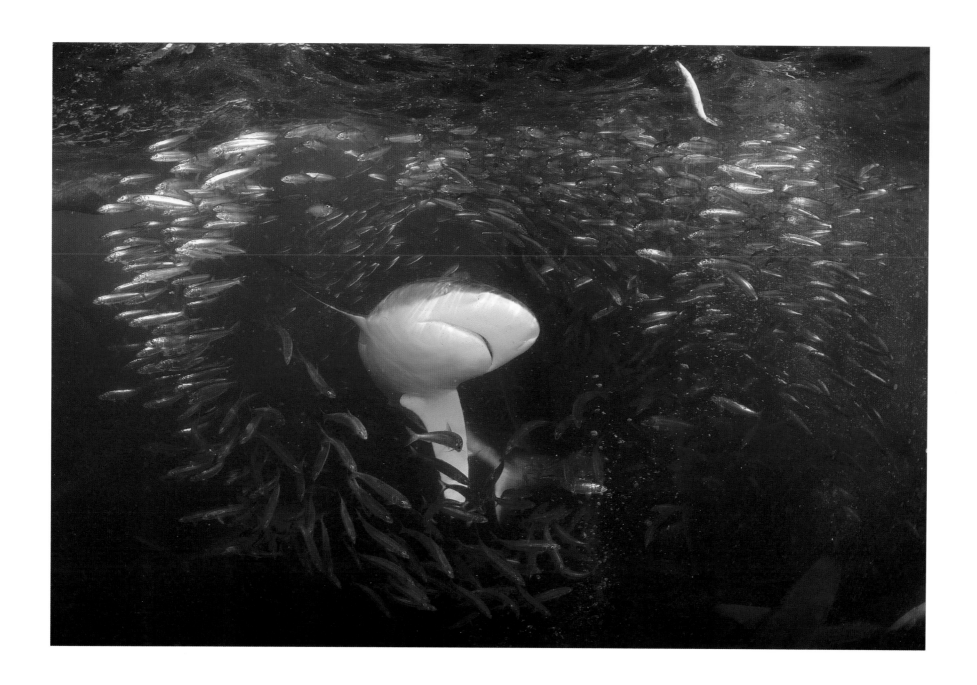

A dusky shark catches little more than a mouthful of water as it bursts through a shoal of sardines. One of the slowest growing and latest to mature of all shark species, the dusky is also one of the most frequently caught sharks in South Africa's shark control program.

have claimed that sharks are repelled by the scent of a dead shark. The mechanism behind this lore was unknown until 1938, when the Austrian scientist Karl von Frisch reported the existence of a chemical he called *Schreckstoff* (*Schreck* is German for fear). This chemical is released into the environment when an animal is injured or killed, and if other individuals detect it through their olfactory systems, it triggers a flight response.

In 2000 chemists began to investigate ways to use such semiochemicals as shark repellents. Initial tests involved spraying the chemical combinations into the nostrils (nares) of sharks while they were in tonic immobility (a semiconscious state that occurs when some species of sharks are placed in a dorsal-side down position). They had the effect that smelling salts do on an incapacitated human, and the sharks came out of their trances within seconds of exposure and tried to bolt away. Semiochemicals were also deployed as a cloud test, where the repellent was broadcast on wild-feeding Caribbean reef and blacknose sharks. Immediately after the broadcast, the sharks stopped feeding and left the area. The hope is that semiochemicals will eventually be commercially available for surfers, divers, and swimmers as an effective, non-lethal shark repellent. Incorporating these chemicals into sunscreen or bathing suit fabric is science fiction at this point, but these possibilities and other recent discoveries aim to decrease our reliance on lethal shark control.

In the waters around the Cape Peninsula and False Bay in South Africa, 29 unprovoked shark bites, most attributed to great whites,

were recorded between 1960 and 2012; six were fatal. Yet despite this, the City of Cape Town is initiating new ways to co-exist with sharks. In 2004 a pioneering shark safety program known as Shark Spotters was created in response to the public's appeal for an alternative measure to shark nets. This community-funded initiative employs spotters to scan the waters off popular swimming beaches for signs of sharks. The mountainous shoreline of the Cape Peninsula provides ideal vantage points to detect approaching white sharks and, equipped with radios, the spotters sound the alarm and raise the shark flag if they spot something, signaling everyone to exit the water. Between 2004 and 2009 the spotters recorded 619 great white sightings, mostly between September and April. In that same period, the alarm was sounded and the water cleared 276 times when sharks came too close to beaches. There have been only two shark bites at a monitored beach since the shark-spotting program began. One victim was a swimmer who repeatedly ignored warnings by the spotters, and the other bite occurred when spotting was difficult due to poor water clarity. The aim of the program is to reduce the risk of shark bite and the associated negative impacts for both humans and sharks. Instead of eradicating great white sharks, Cape Town chooses co-existence through ecologically sound prevention. This wise and pioneering strategy should be celebrated and emulated wherever topography and water clarity allow, as it is one of the few viable alternatives to such lethal shark control measures as nets, drumlines, and bounties.

A Caribbean reef shark is caught on a longline hook. Fortunately, it was later released as the hook belonged to researchers in the Bahamas trying to assess shark populations.

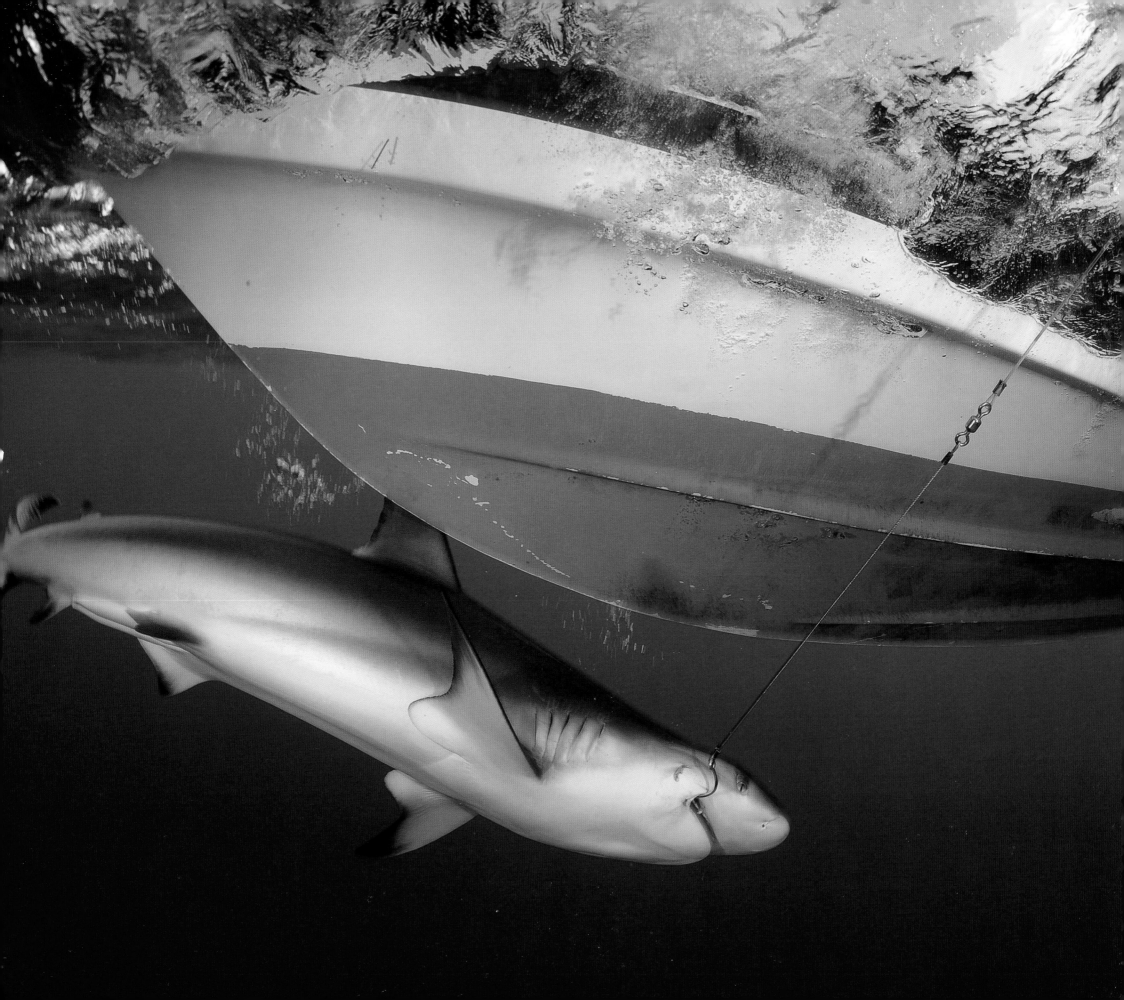

During the summer months along South Africa's southwest coast, white
sharks move inshore, presumably hunting fish or engaging in social behavior.
They can sometimes be seen swimming in water less than six feet (2 m) deep.

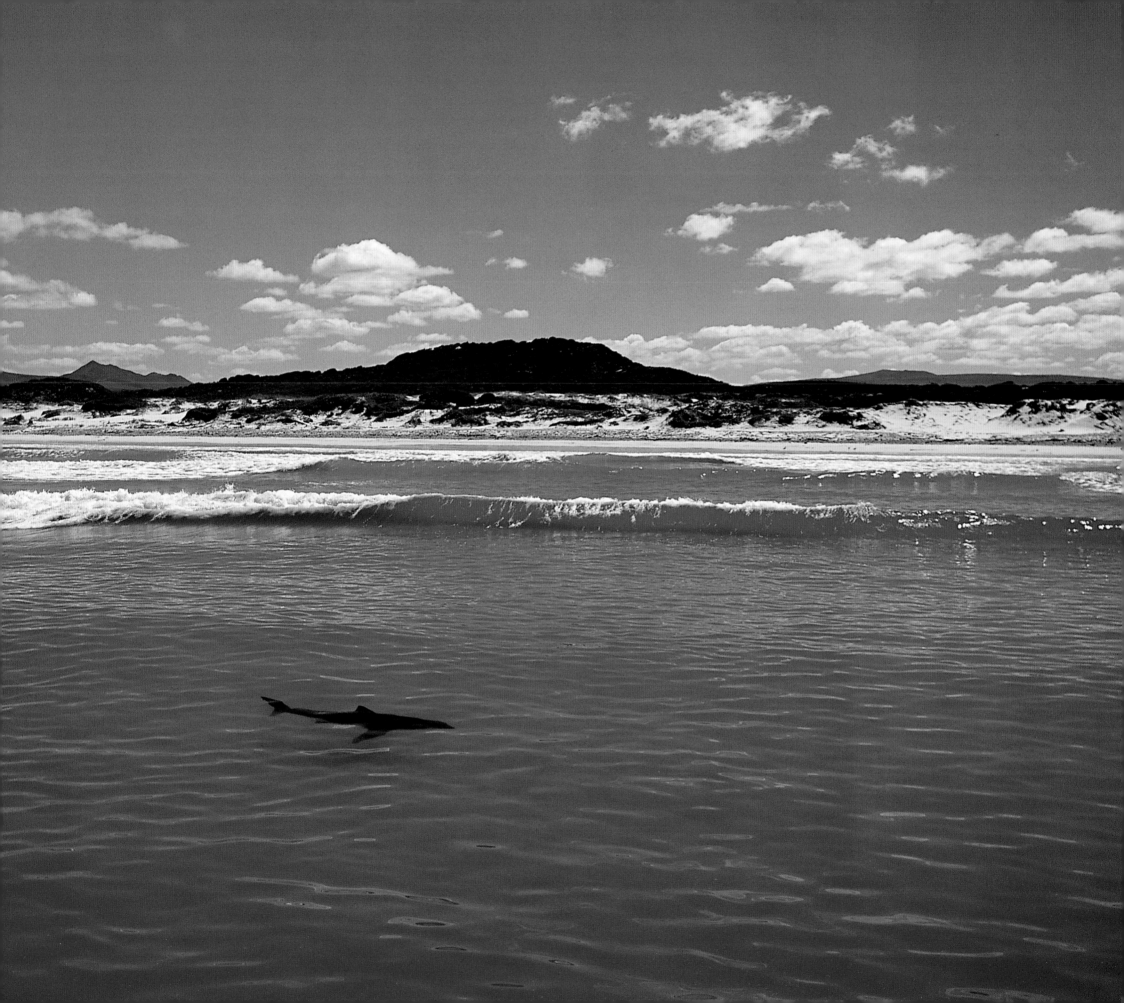

Despite their size and formidable reputation, white sharks can be surprisingly perceptive and calm. This 11-foot (3-m) female hovers just inches away from the tentacles of a delicate box jellyfish.

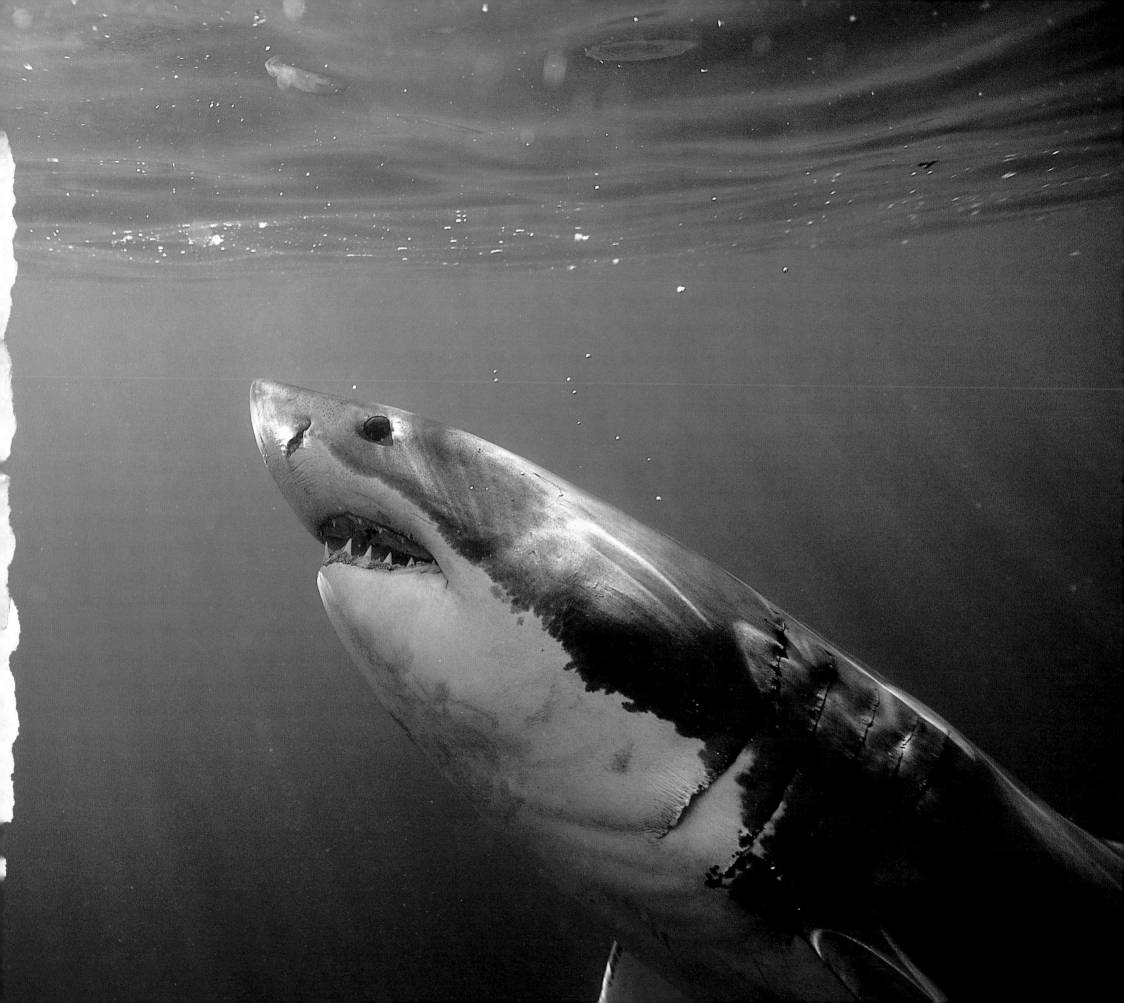

A SURFBOARD THAT SHOCKS

SINCE SHARKS ARE CAPABLE of detecting weak electromagnetic fields, South Africa has pioneered the use of electricity to deter sharks. In 1958 the Council for Scientific and Industrial Research (CSIR) and the Oceanographic Research Institute launched a study to investigate the use of electric barriers to prevent sharks from approaching bathing beaches. They developed a system consisting of an insulated cable that emitted powerful electrical pulses, which interfered with the animal's nervous system, and tested it in aquariums, where sharks darted away after approaching the electrical field. The cable system was first tested in the field at the St. Lucia Estuary in northern KwaZulu-Natal, with a barrier four feet (1.2 m) wide and 19 feet (6 m) high extending from the seabed to the surface; at least one bull shark was reportedly repelled by the electronic force field. A larger-scale experiment was conducted at Margate beach in the 1970s, but it was determined that maintaining an electrical deterrent in exposed surf conditions was too costly. Surf continually abraded the insulating material, and sharks were found

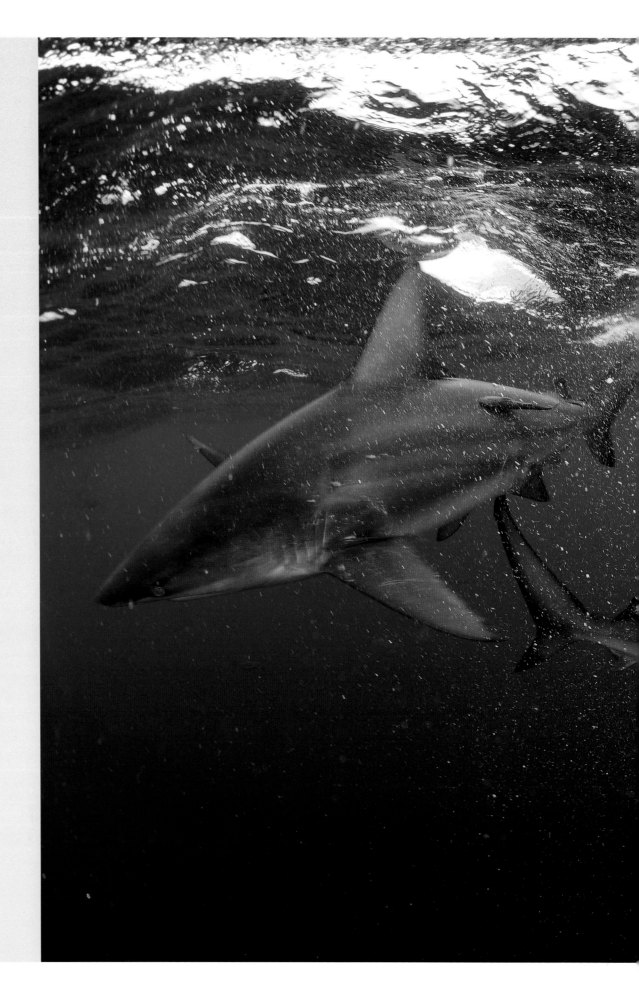

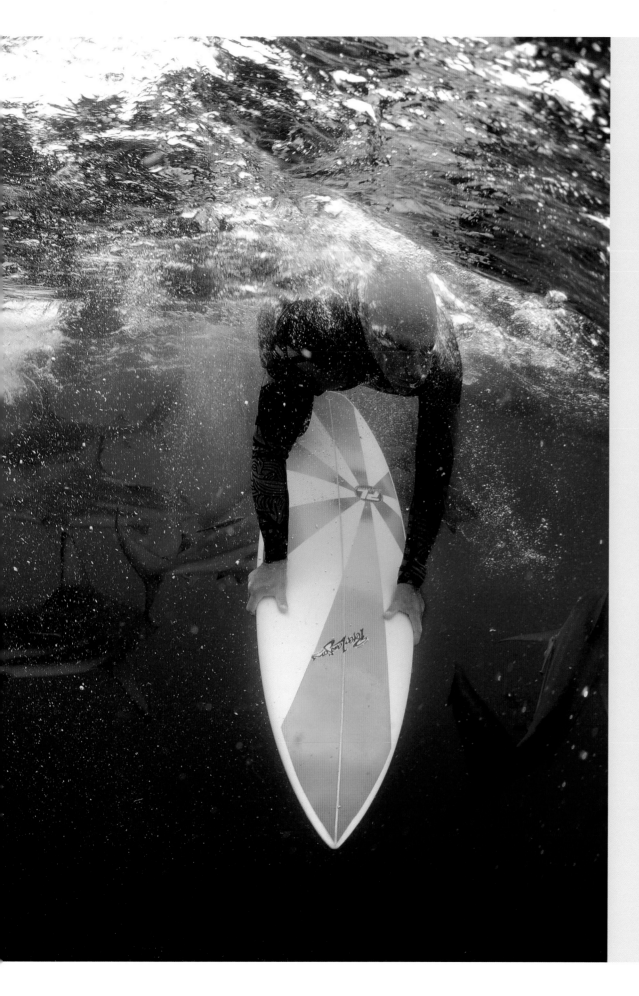

inshore of the cable, unhindered by swimming through the field; the program was discontinued in 1988. As a result, research on electronic repellents was scaled down from beachwide protection systems to personal protection systems.

In 1995 the KwaZulu-Natal Sharks Board invented one of the world's first personal electronic shark deterrents, the SharkPOD. Scuba divers could easily attach one electrode to their tank and the other to a fin or ankle. The device emits a three-dimensional electrical field that is believed to repel sharks by overstimulating their sensitive ampullae of Lorenzini. When the shark swims into the field, its muscles begin to spasm, causing it to flee the area. (Think of fingernails dragging down a chalkboard and you'll get the idea.) The original field testing of the SharkPOD was carried out at South Africa's Dyer Island, one of the world's great white shark hotspots. The test involved attaching a piece of bait directly to a SharkPOD, and monitoring shark bites. With the SharkPOD, there was an 80 percent decrease in the probability of a white shark biting the bait in a specified period.

Some years later an Australian company used the existing SharkPOD technology to develop a modified device called a Shark Shield, which became the most popular personal electronic shark deterrent on the market. Yet, between 2002 and 2012 there were still three incidents in which divers equipped with Shark Shields were bitten by great white sharks in Australia. Subsequent inquests revealed that in at least two of these instances the deterrents were either off or not being used correctly. Nonetheless, the bites prompted an independent scientific study on the effectiveness of the Shark Shield, and in

LEFT *A shark expert tests a surfboard with a built-in electronic shark deterrent by duck-diving through a shiver of blacktip sharks.*

ABOVE *A surfboard shaper in Durban, South Africa, carves an inset to fit an electronic shark deterrent.*

OPPOSITE *A shark's view of the deterrent surfboard as a surfer prepares for a trial run.*

2012 the units were tested on great white sharks in both Australia and South Africa. The first set of tests was conducted with white sharks near Neptune Island off southern Australia. In these static experiments the electrical deterrent was situated about six feet (2 m) away from a 13-pound (6-kg) piece of fresh tuna. In these trials the bait was eaten 78 percent of the time regardless of whether the unit was switched on or off. But when the unit was on, the sharks took twice as long (from two to four minutes) to act and made more investigatory passes before committing to biting the bait. More dynamic tests with the Shark Shield involved the unit being towed underneath a seal-shaped decoy through white shark hunting grounds at South Africa's Seal Island. When the Shark Shield was switched on, the number of breaches (incidents when a white shark leaped out of the water in pursuit) decreased from 16 to zero, while the number of surface interactions decreased from 27 to two. From a real-world perspective, the extra time and multiple approaches exhibited by the sharks when the device was switched on would give a diver significantly more opportunity to spot the shark and exit the water. The 100 percent reduction in breaches during the two experiments also offers peace of mind to those unable to see and spot an approaching shark from the surface.

While both the SharkPOD and Shark Shield were embraced enthusiastically by divers, surfers (who are the most bitten of all types of ocean-goers and who use the Shark Shield) were less enthusiastic. Not only were they repeatedly shocked when one of the anodes was mistakenly exposed to the air, but the long leash that had to be worn around the ankle or trailed behind the board was said to impact the perfomance of more advanced surfers. In response, a private individual built the first prototype

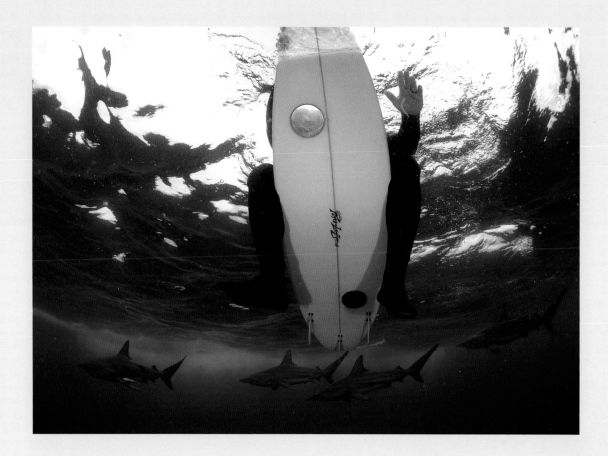

of a surfboard with a built-in deterrent in 2010. The deterrent consists of two electrodes that are inserted into two cavities on the underside of the surfboard and generate an electrical field. This eliminates the need for a leash and decreases the risk of being shocked. Initial field tests at Aliwal Shoal off Durban showed promise in keeping schools of feeding blacktip sharks at least six feet (2 m) away from surfers.

Instead of relying on government-driven, lethal shark control measures like shark nets, these personal electronic deterrents, combined with a better understanding of shark behavior and potential risk factors, allow people to take back responsibility for their own safety at sea.

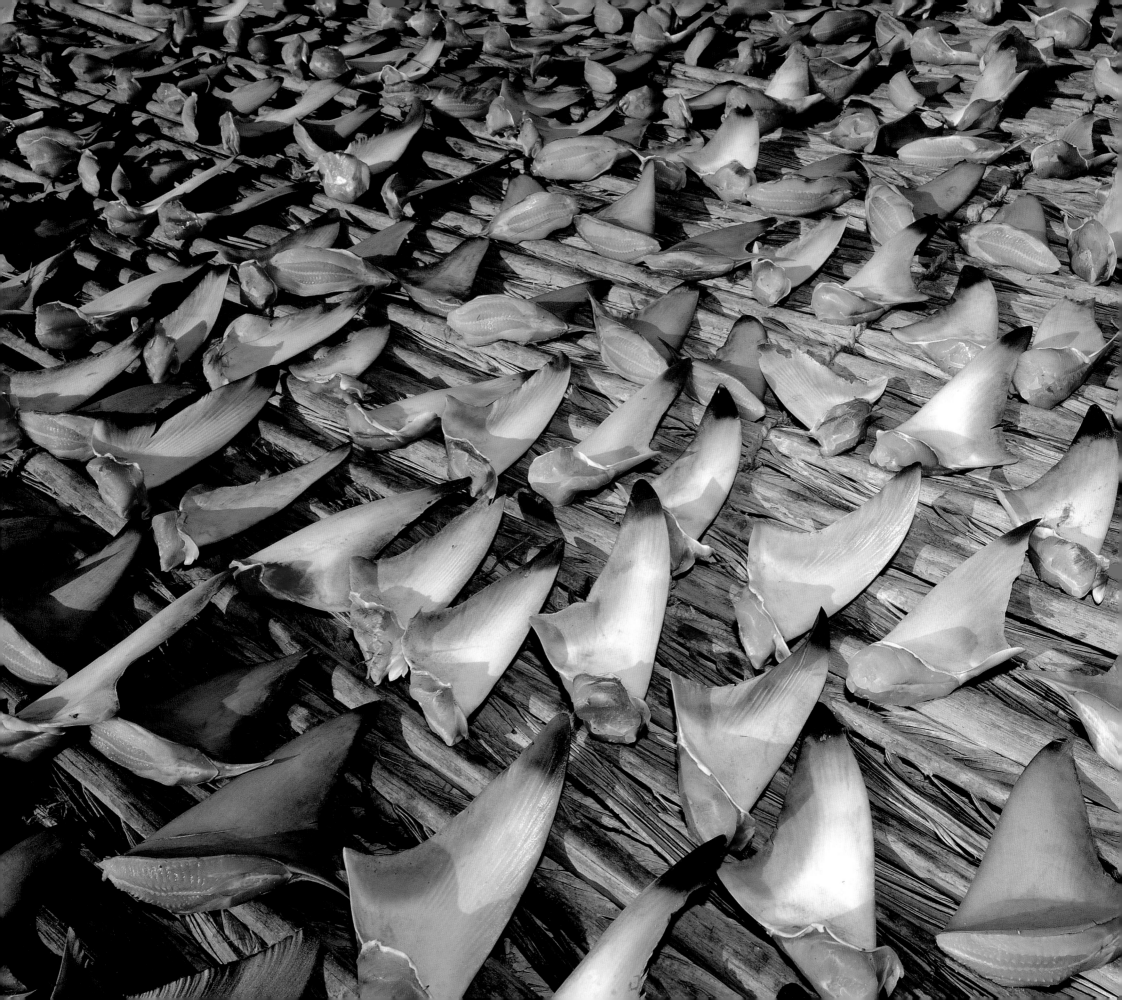

EATING SHARKS

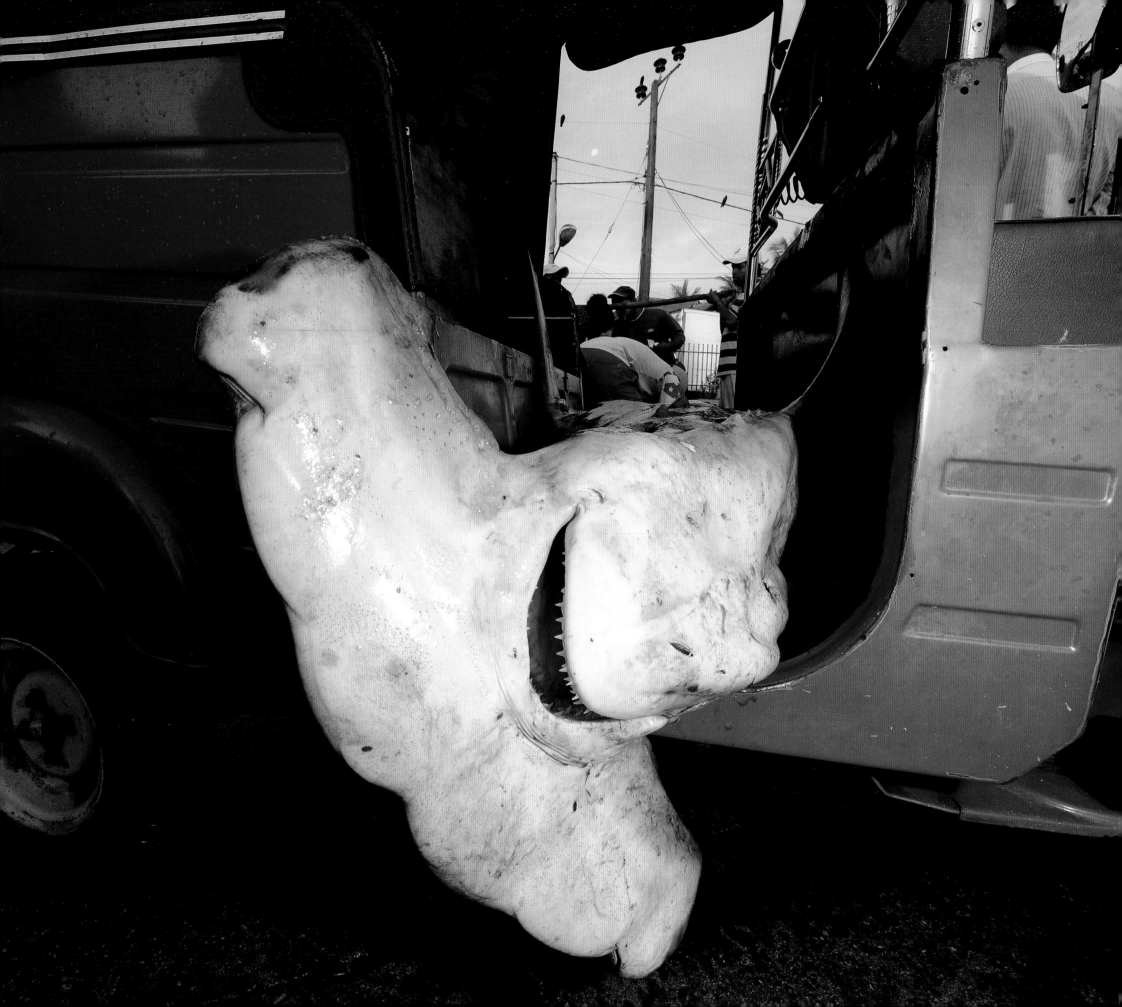

arrive at the harbor just before sunset, as the first fishing boats return from sea. Most have been away on the open ocean for months, and their hulls are full of sharks. Burly, weathered crewmen in rags crawl into the holds and hoist hammerhead, silky, and thresher sharks onto the decks. The smaller specimens are tossed from boat to boat, while the true giants, like tiger and bull sharks, have to be manhandled by half a dozen people before they reach the dock. Armed with oversize steel hooks, a duo of workers drags each shark across the harbor to a filthy concrete slab serving as tonight's auction block. Despite the overpowering chaos and color that soak the atmosphere, sharks are lined up precisely in parallel rows. Positioned on their backs, their angular puzzle of fins points to the sky, reminding me of the regimented pattern of white crosses in a military cemetery.

I hunch down to the ground in the midst of the chaos, my attention focused on the butcher in front of me. I am so close that with every cut he makes, I feel the gust of air bouncing off the blade. Each time a fin separates from the body and falls to the ground, a mix of blood and seawater spatters across my face, clothes, and camera. A well-oiled machine, the butcher and his assistants work methodically and quickly, cutting 10 fins a minute. All the sharks here have seven fins each—two dorsal and pectoral fins, and a pelvic, caudal, and anal fin. I estimate that tonight alone over 500 sharks have been processed. Their finless carcasses will be shipped to developing countries where shark meat is a staple. In contrast, the fins receive royal treatment. Each one is carefully trimmed of excess meat, weighed and exported to Hong Kong and Singapore for princely sums.

The essence of what I witnessed at this shark-landing site on the Arabian Sea is not new to me, or to history. People have hunted and eaten sharks for more than 5,000 years. The earliest records were unearthed during archaeological excavations on Canada's west coast. Large

OPPOSITE A scalloped hammerhead shark awaits transport by motorized rickshaw from the fish market. The fins of this species are among the most sought-after and valuable ingredients of shark fin soup.
PREVIOUS SPREAD Shark fins are laid out to dry in the sun before being packed and shipped to buyers.

quantities of the fossilized dorsal fin spines of spiny dogfish—small, naturally abundant sharks—were found near the remains of campsites of early Native Americans. On the other side of the North American continent in Florida, sharks were also an important resource. Some 2,000 years before vacation condos lined the beaches, Calusa Indians put out to sea in canoes and used rudimentary nets and wooden hooks to catch Atlantic sharpnose sharks. They also targeted tiger and bull sharks for their teeth, which were traded into the interior as important cutting and carving tools.

According to solid archaeological evidence and more recent historical accounts, indigenous people in Oceania have been hunting sharks for 4,000 years. When European settlers first arrived in Australia in 1788, they found Aborigines catching sharks for their meat and liver, which were boiled and made into a traditional food called *buunhdhaarr*. The settlers followed suit and adopted shark meat as an important staple of their diet.

The beginnings of commercial shark fisheries developed in the northeast Atlantic in the early 1800s, but larger-scale enterprises were not established until the 1920s. These early fisheries supplied the market with shark livers, whose oil is the richest known natural source of vitamin A; the oil was also used to waterproof boats and fuel lamps. To meet the demand for shark oil, fisheries sprang up around the globe—for basking sharks in Norway and Scotland, whale sharks in India, and sixgill sharks in the Maldives. But in the 1950s, when researchers found a way to chemically synthesize the vitamin, these fisheries collapsed.

The first commercial fishery for shark meat was established in the 1930s to supply the newly burgeoning market for cheap protein in developing nations. With the exception of spiny dogfish and mako, porbeagle, and thresher sharks, shark meat is considered inferior to that of bony fishes by developed nations, because its high urea content gives it a pungency. Nonetheless, until the 1980s the shark's principal commercial value lay in its meat. Then dramatic changes swept through the Far East, as personal wealth increased and with it, conspicuous consumption. Shark fin soup became one of the most ostentacious delicacies of the newly affluent.

It's often claimed that shark fin soup was an integral part of Chinese culture for thousands of years, but apart from in Guangzhou province, it was never widely served, except to emperors and other nobility. In fact, during the regime of Mao Tse-tung, the soup was branded a bourgeois relic and banned. But in 1987 that law was repealed and now, under China's free market socialism, shark fin soup has become extremely popular. With the middle class growing more affluent every year, the demand for it in China has skyrocketed. Served primarily at wedding banquets, it demonstrates wealth and honors the guests.

Shark fins are graded by their size—the longer the cartilage, the better the quality—because the cartilage is the part consumed. The dorsal fin is considered to be the highest in quality, followed by the tail fin; the least expensive are the pectoral and anal fins. Sold in frozen or dried form, the cartilage is tasteless but has a slippery glutinous texture resembling clear noodles and is said to bring out and enhance the flavor of other ingredients. It's regarded as a tonic food that strengthens the internal organs and delays aging. Some also consider the dish to be an aphrodisiac.

Since the late 1980s increased demand has more than doubled the price of shark fin soup: A single bowl of premium soup can cost upwards of $300, and processed fins have become one of the world's highest value marine products, in excess of $700 a kilogram. Only almas caviar, made from the eggs of Iranian sturgeon from the Caspian Sea, is more expensive, with a kilogram running $25,000—but then again it comes packaged in an exclusive 24-karat-gold tin. Today, the minimum market value of the shark fin trade is $400 million per year.

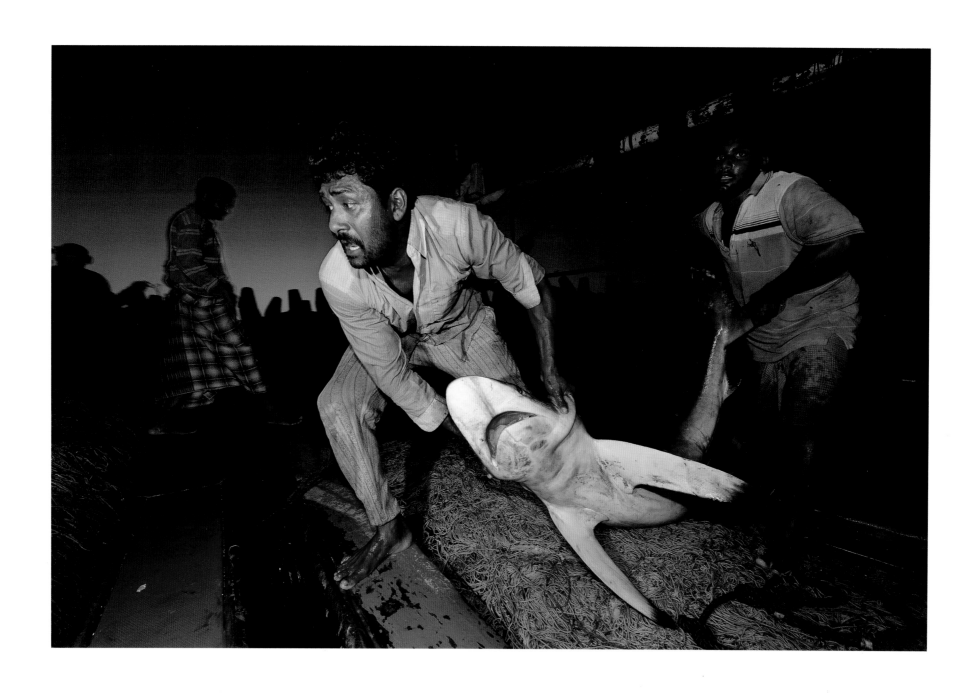

In an Arabian Sea port, this blue shark is one of hundreds of sharks offloaded by fishermen each night.

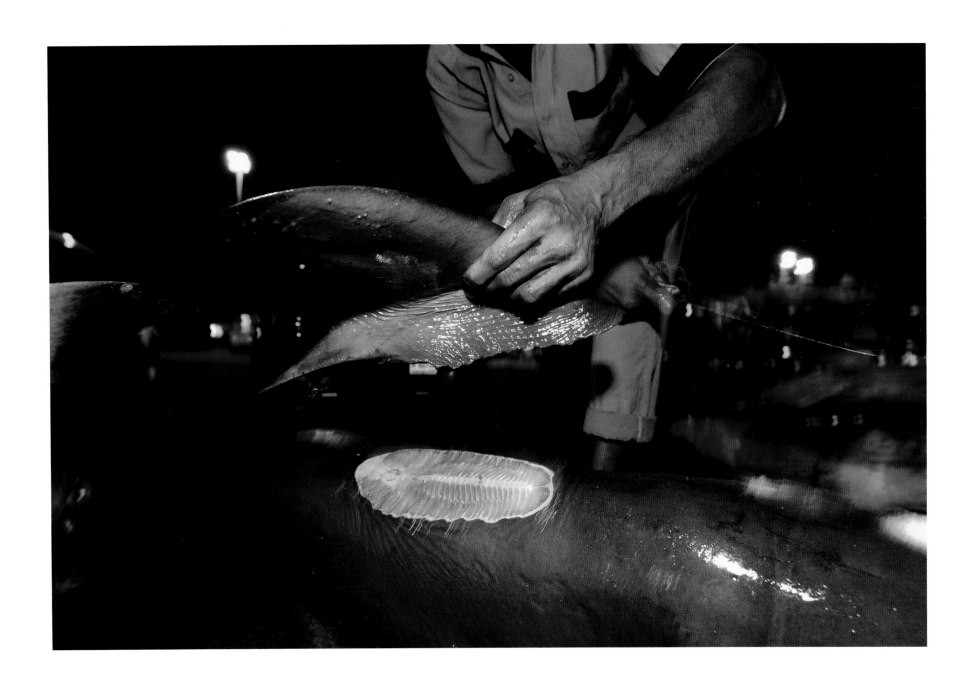

A fish market butcher severs the dorsal fin from a shark carcass.

Prior to this newfound demand for shark fins and apart from the earlier dedicated fisheries for liver oil and meat, sharks were considered a nuisance bycatch by the more lucrative swordfish and tuna fisheries. But the extremely high current value of fins, along with the depletion of many tuna and swordfish stocks, has resulted in many fisheries finding the shark bycatch a desirable addition to their income. In fact, some vessels now go out of their way to increase their shark "bycatch" by attaching to their hooks steel lines that sharks can't bite through. In Spanish and Portuguese pelagic fisheries, the bycatch of oceanic sharks rivals or exceeds the amount of the target catches. Shark bycatch can now make up as much as 70 percent of the total landings. In 1991 the percentage of sharks killed by U.S. longline fisheries operating in the Pacific Ocean was approximately three percent; by 1998 that percentage had jumped to 60 percent, before falling again with the advent of a finning ban.

Sharks are hunted primarily with arrays of long lines (often hundreds of kilometers long) and baited with more than 1,500 hooks. Indonesia is the world's leading shark-fishing nation, followed by India and Spain. Together these three countries account for more than 25 percent of all reported shark catches. The top 20 shark-fishing nations, which include the U.S. (eighth), Japan (ninth) and the UK (19th), make up 80 percent of the total declared catches. Many nations, especially Spain, China and Japan, have fleets of hundreds of vessels that catch sharks on the high seas or in the unregulated waters of developing countries.

The exact number of sharks taken by fisheries every year, however, is surrounded by great uncertainty. In 1950, the total catch reported to the UN's Food and Agriculture Organization (FAO) was around 200,000 tons. Fifty-four years later, in 2004, the reported landings increased fourfold to over 800,000 tons. Annual global landings data show that shark catches rose steadily until the early 1980s, when they began to increase exponentially in direct response to the demand for shark fin soup in China. These figures are likely to be gross underestimations, as a large proportion of shark catches around the world goes unreported. Due to the lack of data from many countries, FAO statistics are not comprehensive, so the accuracy and quality of information vary greatly.

A clearer picture of the global shark catch was captured by observing shark fin auctions and analyzing trade records. Every year around 10 million kilograms of shark fins are imported into Hong Kong, the international hub of the shark fin trade. This mountain of fins, which weighs as much as 2,000 African elephants, comes from more than 87 countries, with Spain, Singapore, Indonesia, and the United Arab Emirates responsible for the lion's share of exports. Depending on size and species, 10 million kilograms of fins equates to roughly 26 to 73 million sharks each year, with a median of 38 million—almost three times as much as is reported to the FAO. If lined up head to tail, the total of all sharks caught in just a 10-year period since the 1980s would stretch across the entire diameter of the sun. Only 14 species make up 40 percent of this mammoth catch, with blue sharks contributing 17 percent, followed by scalloped/smooth hammerhead, silky, and mako sharks.

In the past, most industrial fisheries returned to port with the entire shark and sold both the meat and fins. But now the stark discrepancy in value between the fins and the meat, combined with the strong demand, creates incentive for the wasteful practice known as shark finning, in which the fins are cut off the animal and the shark is then thrown back into the sea. If still alive at the time, it usually dies by drowning or starving. Instead of devoting valuable space on the boat to low-value shark meat, the fisheries arrive back with only high-value fins. Apart from being cruel, finning is also incredibly wasteful, with

less than five percent of the animal used. It's equivalent to hunting a rabbit or a pheasant and cutting off one ear or part of the foot and dumping the rest of the carcass to rot in a field.

To date, more than 60 countries, including the member states of the European Union, and most regional fisheries bodies have banned finning. Many of these bans, however, include exceptions and loopholes. For example, the normally conservation-enlightened New Zealand allows the finning of dead sharks. More important, in many countries and under all current international bans, fins can still be removed on board and then stored separately from the carcasses. This makes it easier to deceive inspectors, who can't readily keep track of whether the numbers of fins and carcasses match. The assessment of shark fins and carcasses per boat is in most cases based on weight, with a set fin-to-carcass ratio (the percent weight of fins to the total body mass). However, most of these ratios are either excessive or ambiguous, leaving wiggle room for fishermen to fin at least one shark for each declared one. Using weight ratios to enforce finning bans also hampers the collection of species-specific catch data, because sharks are much more readily identifiable when their fins are still attached. In response, some countries have passed laws requiring sharks to be landed with fins attached, but some enterprising fishermen are said to have gotten around that by arriving at the docks with as many as 20 fins tied with wire to a single carcass. New and proposed legislation often reads that fins have to be attached by "natural means" and yet resistance to closing these loopholes remains formidable.

Frequently, there are links between shark finning and the criminal underworld, with Asian syndicates bribing corrupt government officials to ignore conservation and fisheries regulations. In Costa Rica the mafia has much influence over shark fishing and finning activities and operates private docks and drying facilities that resemble fortresses, complete with barbed wire and armed guards. A close connection with the drug trade became apparent in 2009, when sharks stuffed with cocaine were found on a Costa Rican fishing boat. Similar crime syndicates have been involved with the shark fin trade in many other parts of the world, sometimes with deadly consequences. In the 1980s, gangs from Hong Kong murdered rival syndicate members in a fight to control the shark fin trade in South Africa.

In just a few hundred years, shark fishing has been transformed from a subsistence fishery carried out by aboriginal coastal peoples to a technologically sophisticated global enterprise. These days, with fishing fleets combing nearly every inch of ocean, there are few places left in the world where sharks are not at risk. Without these apex predators, the ocean's biodiversity becomes misshapen, with the gravest consequences for the planet's marine ecosystem.

A trader empties a bag of dried fins onto a sidewalk to attract buyers.

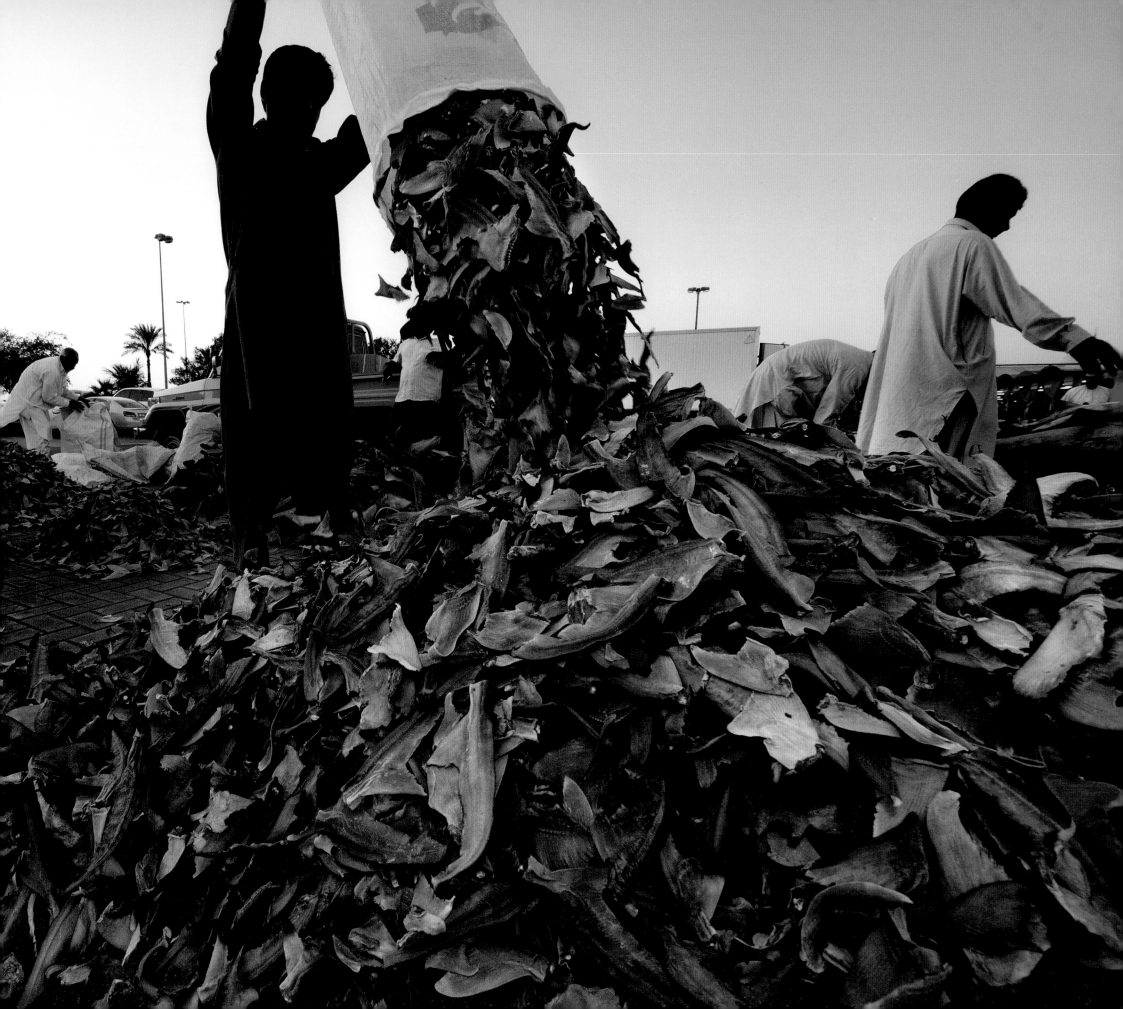

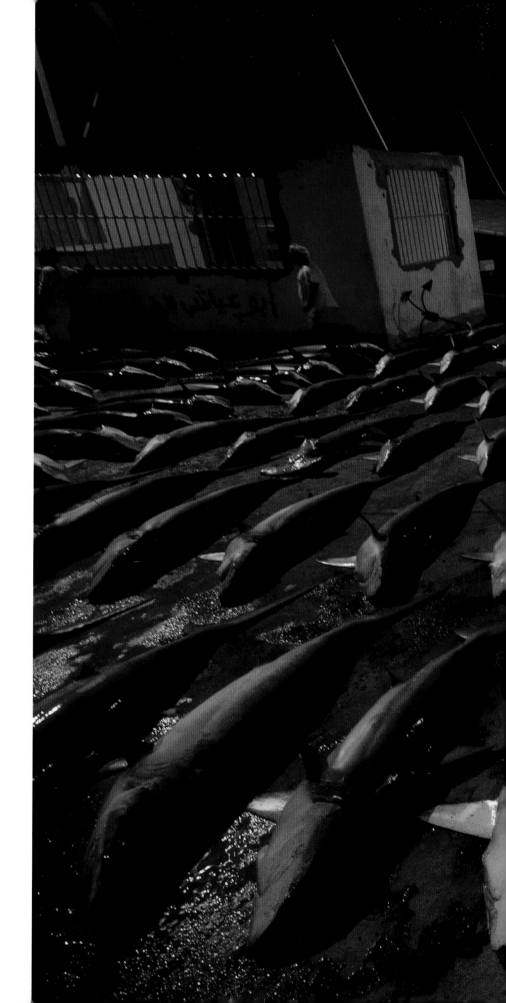

Awaiting auction, a single boat's catch of silky sharks is laid out in an orderly grid.

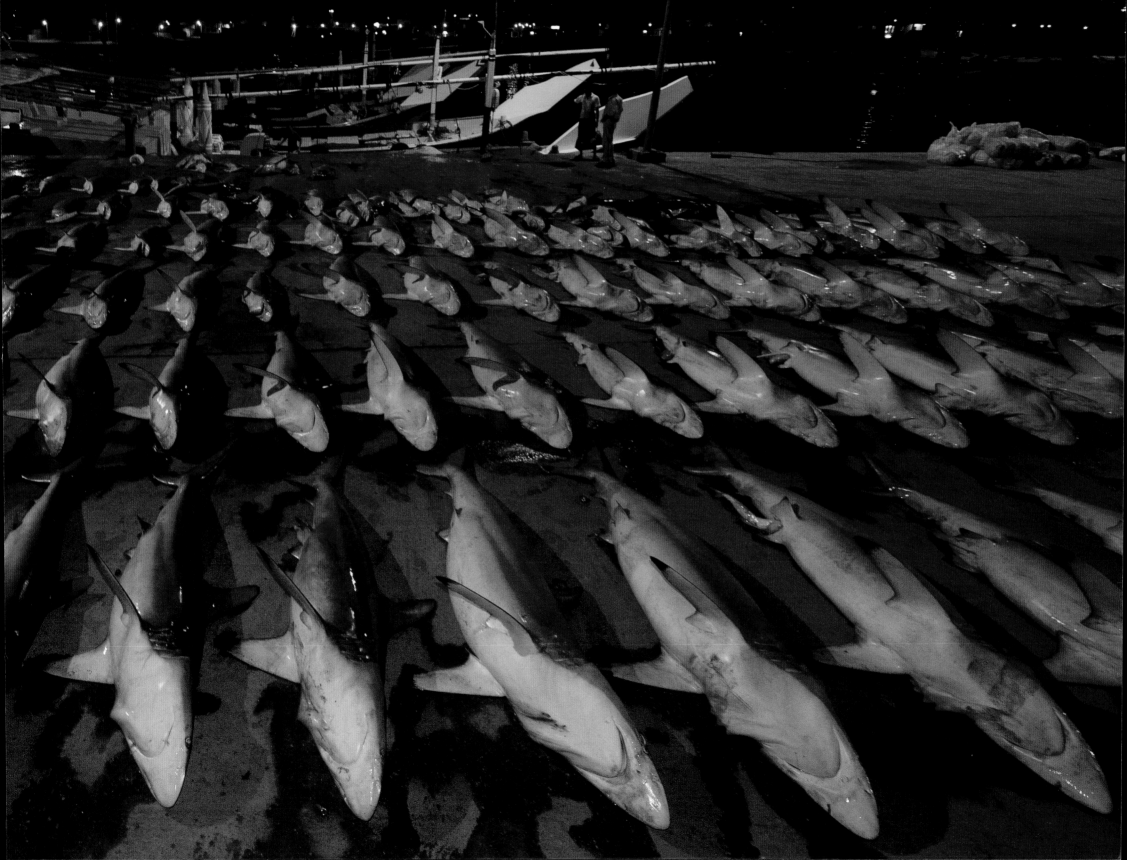

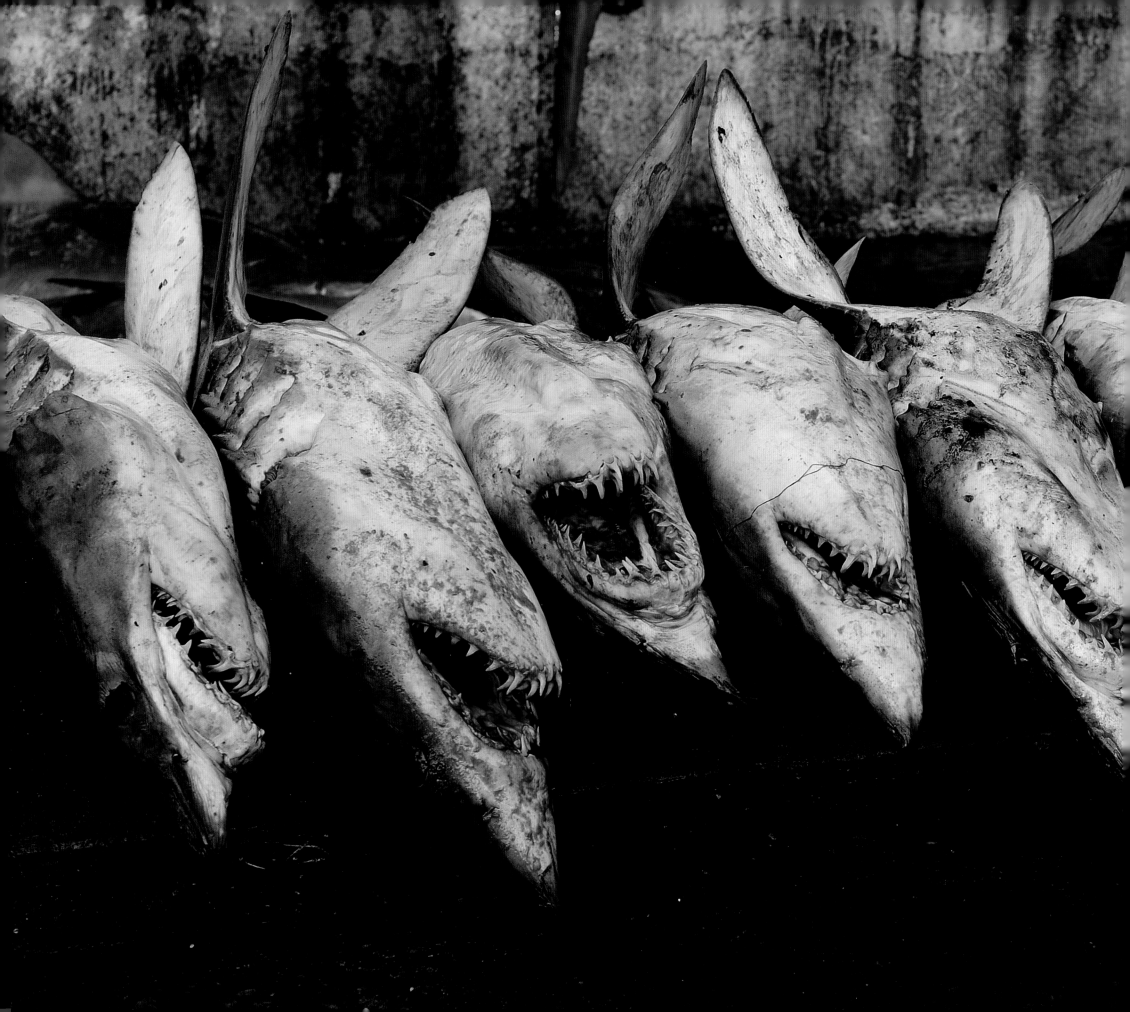

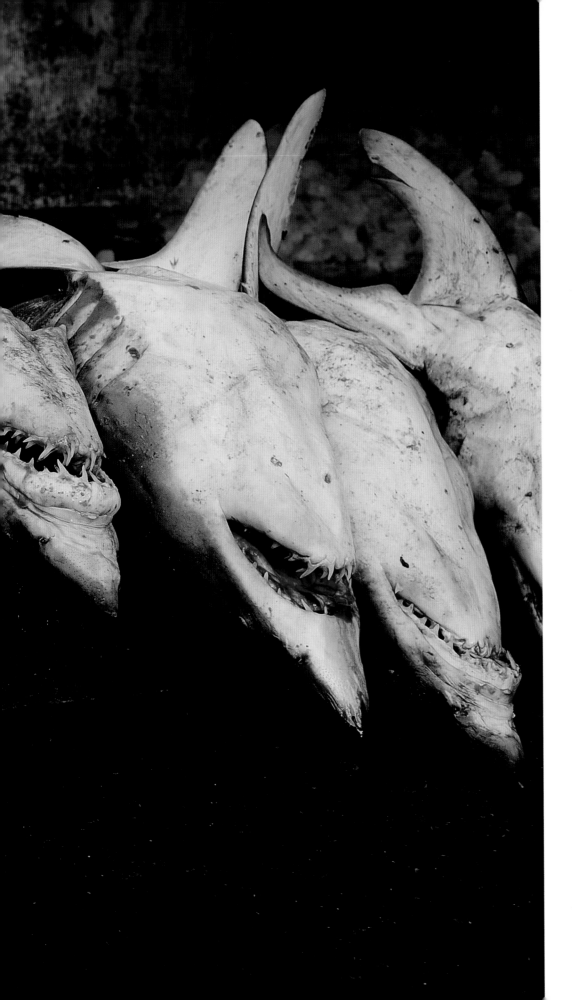

Mako shark carcasses lined up for auction at the Dubai fish market.

TOXIC SHARKS

SHARKS TRULY ARE ONE OF the most dangerous animals in the world, but only if you eat them. Their mercury-laden meat and fins are more harmful to us than their razor-sharp teeth. This is because of biomagnification, a process in which toxins become more concentrated as they move up the food chain, transferring from prey to predator. Algae-grazing fish sit low on the food chain and therefore carry lower concentrations of toxins than a predatory fish like tuna. Sharks sit at the very top of the food chain, can live for 50 years or more, and eat many predatory fish during their lifespan. As a result, sharks are laced with a highly toxic cocktail of heavy metals, including mercury concentrations that can be 10,000 times higher than in the surrounding environment. Sharks appear to tolerate high concentrations of heavy metals with little or no negative impacts, but human physiology is much more sensitive. When people dine on shark meat or slurp shark fin soup, they dump the shark's lifetime accumulation of toxins into their bodies.

Mercury is one of the most dangerous poisons known. Small amounts of inorganic mercury, catalyzed through volcanic eruptions, occur naturally in the environment, but the majority comes from industrial pollution. It enters the atmosphere through the chimneys of coal-fired power plants and eventually finds its way into the ocean. In the sea, microorganisms metabolize the inorganic mercury into organic mercury, which is more absorbable and a thousand times more toxic.

The most distressing revelation of how mercury affects human health occurred in Minamata, Japan. Between 1932 and 1968 a chemical fertilizer factory released large quantities of mercury into the ocean, which bio-accumulated in shellfish and fish stocks in Minamata Bay and the surrounding Shiranui Sea. It was not until 1956 that the first cases of what would later be known as Minamata disease surfaced in the surrounding fishing communities, affecting both humans and domesticated animals. People showed symptoms that included numbness in their extremities; visual, hearing, and speech impairment; and difficulty walking. This was followed by convulsions and eventually death. It took researchers more than three years to conclusively link the illness to severe mercury poisoning from the chemical plant's discharges. In the end, there were 2,265 victims, of whom 1,784 died. The legacy of Minamata is being felt to this day, as many affected women had children with cerebral palsy and severe birth defects. Not only does mercury penetrate the placental membrane that normally separates the mother's bloodstream from the embryo, but it also concentrates in the fetus.

A persistent toxin that does not degrade in the environment or in the human body, mercury inhabits fatty tissue. Some of it exits the body, but slowly and in small quantities. It is estimated that, after mercury exposure, it takes the body 60 to 80 days to rid itself of half its mercury load.

When the meat of blue sharks in European markets was tested for organic mercury, a single serving contained 67 times more than a safe daily exposure for a human, by U.S. standards. Shark fins fared no better, with 86 percent of tested fins showing detectable levels of heavy metals, including mercury. The

OPPOSITE Not unlike a line worker in a factory, a man stacks hundreds of cuts of shark meat.

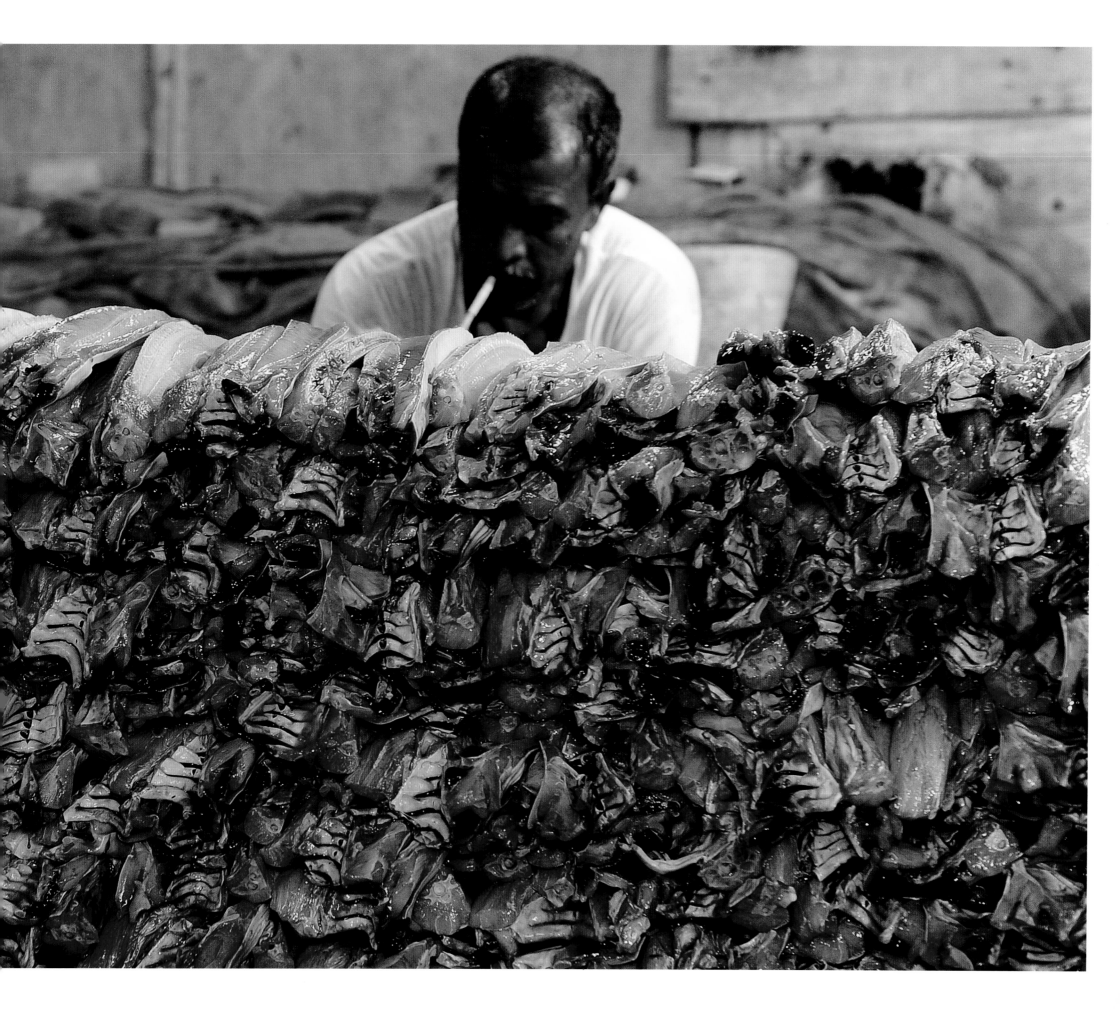

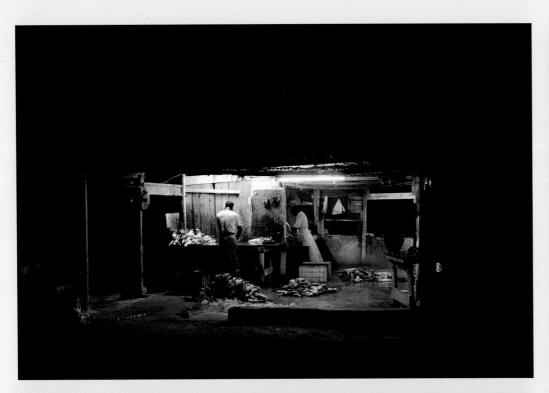

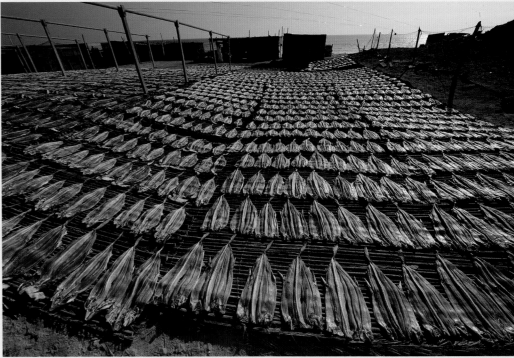

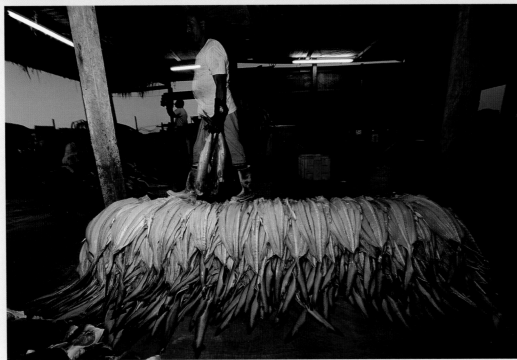

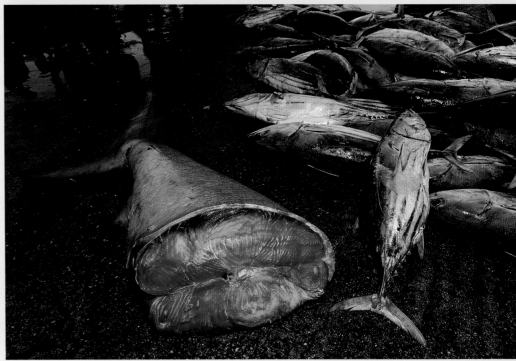

CLOCKWISE FROM TOP LEFT *Along Oman's coastline, numerous shacks specialize in processing small shark species for the shark meat trade. Dried shark meat is a vital source of protein for local communities in the developing world. The meat of large predatory sharks is high in methyl mercury and other neurotoxins. Cleaned and filleted shark meat is sold at a much lower price than that of fins.*

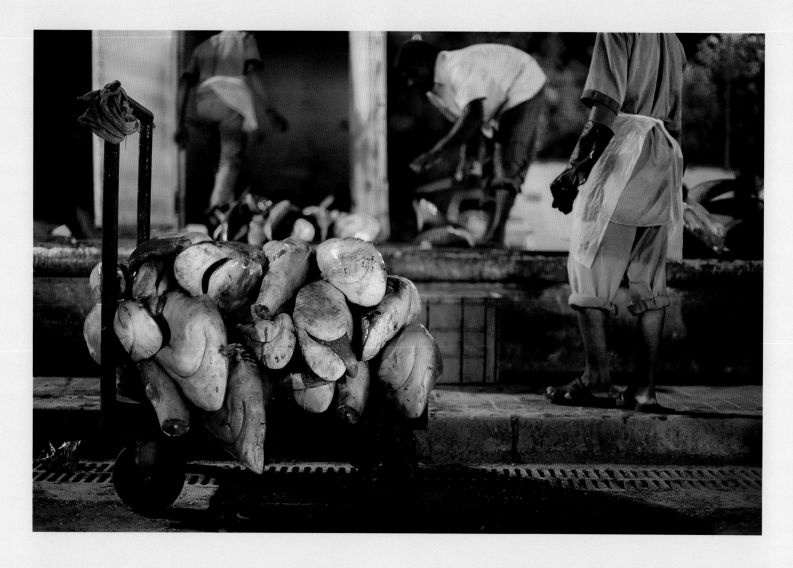

LEFT Finless shark car-casses are stacked and carted off for export to developing countries.

standards for safe levels vary from country to country. Hong Kong is considered to have one of the more liberal standards, and yet a notable 45 percent of fins tested exceeded the safety levels for mercury, as well as those for lead and arsenic. Singapore has much more conservative standards, and 93 percent of all fins tested would have been illegal to import or sell.

Because of the high concentrations of mercury found in sharks, authorities warn against consuming shark products more than once or twice a month, as they can lead to cancer, neurological damage, and male infertility. Pregnant women are advised against eating any shark. Nonetheless, the National Academy of Sciences in the U.S. estimates that more than 60,000 children born each year in America suffer neurological damage caused by mercury exposure during pregnancy.

Choosing not to consume mercury-rich shark products is simple in the developed world, as there are so many safer culinary alternatives. In the developing world however, especially in locations like Sri Lanka, India, East Africa, and Indonesia, shark meat is a cheap and accessible protein staple. While the elite of Asia consume shark fin soup to showcase their wealth, the poorest of the poor eat mercury-laced shark meat because they cannot afford anything else.

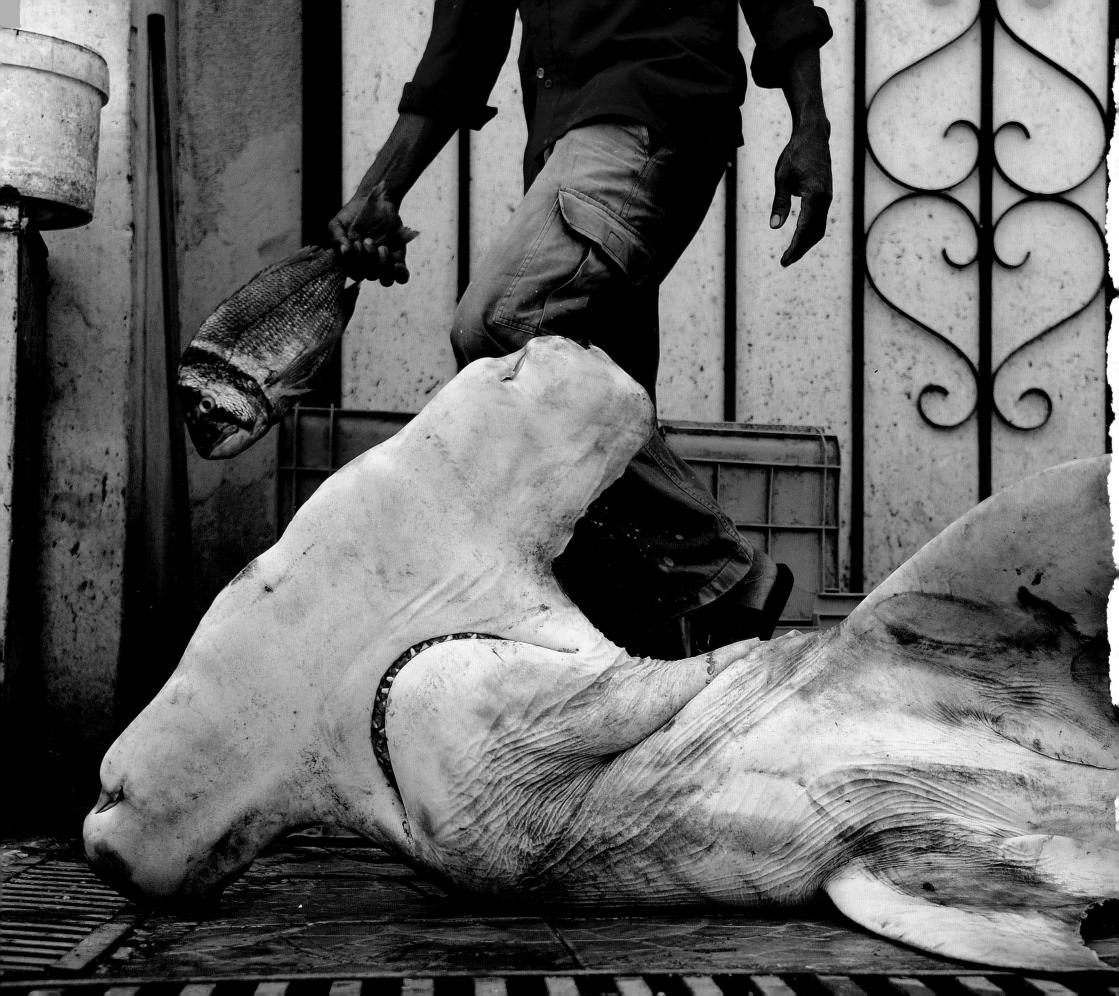

SHARKS IN TROUBLE

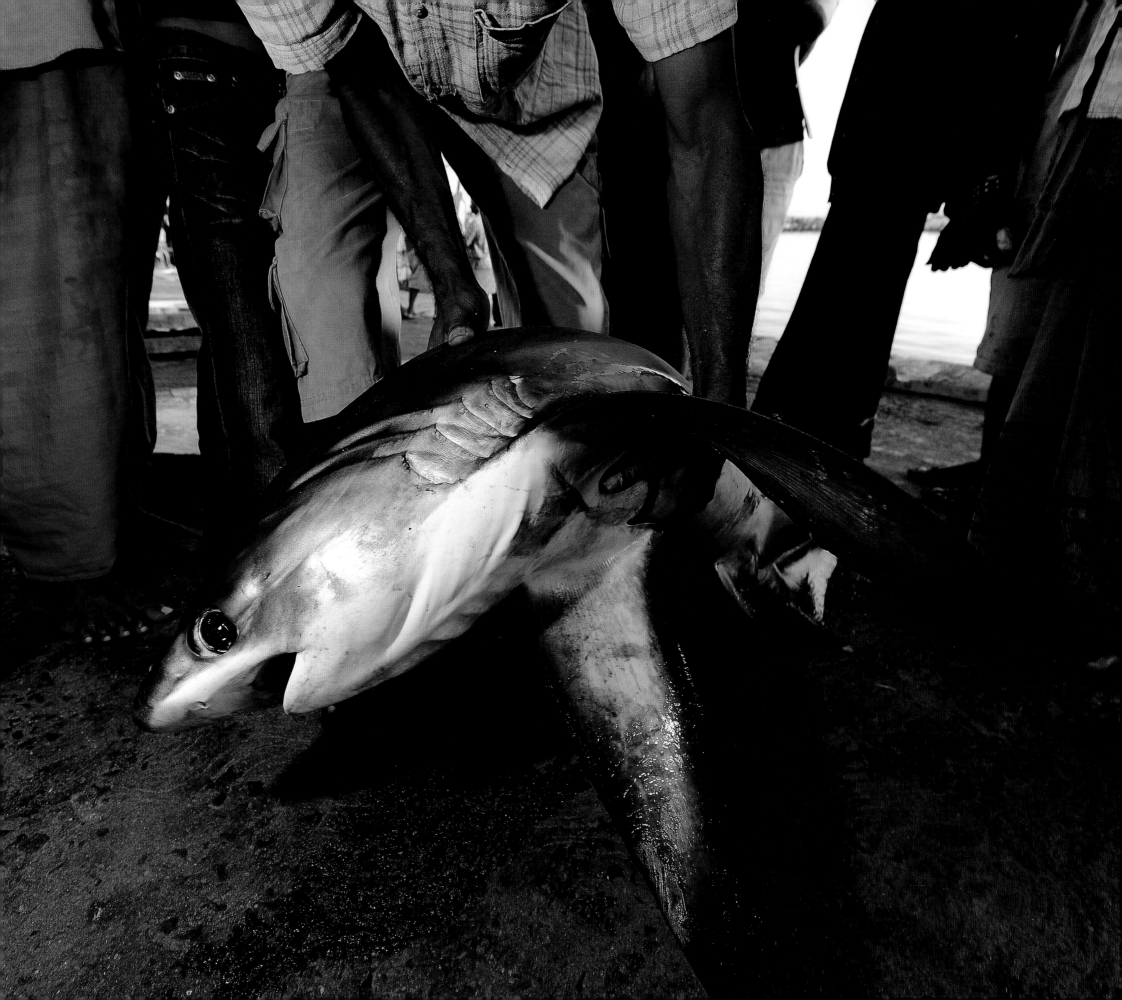

This place has all the ingredients of shark paradise: Rich ocean currents, a bountiful food supply, and remoteness. Historical accounts of ships sailing these waters tell of an ocean so full of sharks that one could walk on their backs across the sea; of hammerheads the size of whales and schools of reef sharks so vast that, seen from underwater, they blocked out the sun. But my first sight as I descend is not of a shiver of sharks but of a massive gill net draped over a reef like a deflated balloon. A purple triggerfish beats its winglike fins but is going nowhere, the net ensnaring it in a deadly embrace. I take a few photographs to document the scene then cut the fish free with my dive knife. In just one hour I observe a dozen nets drifting in and out of view, as the current relentlessly propels me past steep walls, over coral gardens, and around undersea pinnacles. The underwater landscape is majestic but seemingly absent of sharks and other big fish.

The ghost fishing nets become my constant companions for days on end. An entire week of diving passes before I see the first shark—a juvenile reef shark barely the length of my forearm entangled in a discarded gill net. The net is sea-beaten and worn but still able to inflict damage. The shark is alive, vigorously fighting the net's clutches as I approach. The scientist I'm diving with skillfully disentangles and releases the shark. But the odds of this little shark reaching adulthood are slim;

it will likely be caught in another fishing net, as they are so profuse and pervasive. The old historical accounts of masses of sharks and ones of enormous size are relics of the past, disappeared not just from this site but also across much of the world. Abundance is now the exception and a dearth of these apex predators the rule.

While archaeological and historical accounts provide anecdotal snapshots of past populations of sharks, science has no way of ascertaining how many sharks roamed the ocean before the advent of commercial fisheries. It's even very challenging to approximate current shark populations, as all of the scientific means of assessing them are limited to some degree. Scientists, fishermen, and conservationists argue at length about how many sharks are left and how quickly their numbers are declining. However, they rarely dispute the fact that many shark populations around the world are indeed declining at an alarming rate. No species of shark is known to have gone extinct due to human-induced pressure so far, but many species have disappeared from parts of their known range. While pollution, climate change, and habitat destruction challenge the overall health and survival of sharks, the most immediate cause of their decline is clearly overfishing.

Some of the earliest documented evidence of shark overexploitation is from the first half of the 20th century, when fisheries targeted shark liver for industrial purposes and as a source of vitamin A. Accounts of

OPPOSITE *A Sri Lankan fisherman lifts a dead thresher shark, a species that reaches maturity at between seven and 14 years of age and whose resilience is vulnerable to fishing pressure.*
PREVIOUS SPREAD *A great hammerhead shark caught off Oman's remote Musandam Peninsula awaits transport to the Dubai fish market.*

abrupt fishery collapse are associated with porbeagle sharks off Norway, soupfin sharks off the Pacific Northwest of North America, sixgill sharks in the Maldives, and basking sharks off Ireland and Scotland, as well as other species worldwide during that time. Since target fisheries for sharks were so ephemeral, and because sharks were not as economically important as other more abundant fish, very little monitoring or assessing of shark populations was undertaken. By the latter part of the 20th century, fisheries science had evolved but was still focused on the most commercially valuable species, like cod and tuna.

In general, the most robust analyses, or stock assessments, to determine the status of shark populations are those that use information on the catch history, the biology of the species, and data on abundance trends. However, this kind of information is often not available. So instead, scientists have turned to data on shark "bycatch" to create a general picture of the status of any given species. If certain shark species were caught less frequently than in the past in a specific area, even though the same fishing methods and efforts at fishing were undertaken, then this might indicate a decline in population.

For example, data from fisheries observers on longline and purse-seine fishing vessels targeting tuna in the western and central Pacific Ocean indicate oceanic whitetip shark numbers decreased 90 percent from 1996 to 2009. And stock assessments on porbeagle sharks in the North Atlantic Ocean show marked historical extents of declines to less than 30 percent of their original abundance. Similar trends of reduced shark catches in the wake of strong fishing pressure have been demonstrated for many other fisheries around the world. Declines in the size and weight of sharks caught have also been monitored. In parts of the tropical Pacific Ocean, the mean weight of blue sharks caught declined from 115 pounds (52 kg) in the 1950s to 49 pounds (22 kg) in the 1990s.

The International Union for Conservation of Nature (IUCN) Shark Specialist Group has assessed the extinction risk of 465 species of shark, using the IUCN Red List criteria and categories. For half of those, there is not enough information about even the most basic biology and fisheries catches to assess their conservation status. Of the remaining species, 11 (2.4 percent of total species) are classified as Critically Endangered, 15 (3.2 percent) are categorized as Endangered, 48 (10.3 percent) are considered Vulnerable and 67 (14.4 percent) are Near Threatened. The remaining 115 species are classified of Least Concern and include mainly smaller, faster-growing species like catsharks and others not yet targeted by fisheries.

The IUCN Shark Specialist Group has found that highly migratory, open-ocean, or pelagic, sharks make up a particularly threatened group, with many heavily fished species like makos, threshers, oceanic whitetips classified as Vulnerable. Great hammerheads and scalloped hammerheads are categorized as globally Endangered, making them the most threatened of the wide-ranging shark species.

Why is it that fishing has had such a dramatic impact on shark populations? Much of this has to do with the life strategies of sharks, which served them well for 400 million years but are now proving to be their downfall.

Many species of sharks have life-history patterns more similar to that of a marine mammal or a human than to a sardine or flatfish. Sharks are K-selected species, characterized as having low reproductive rates as opposed to r-selected species like sardines, which have a quick turnover in population. This means sharks have certain traits that make them vulnerable to overfishing. For one thing, most sharks grow very slowly, only a few centimeters per year. And they are slow to mature and often don't begin to reproduce until their teen years or later. Some, like the dusky, reach sexual maturity at 20 years. Sharks also typically

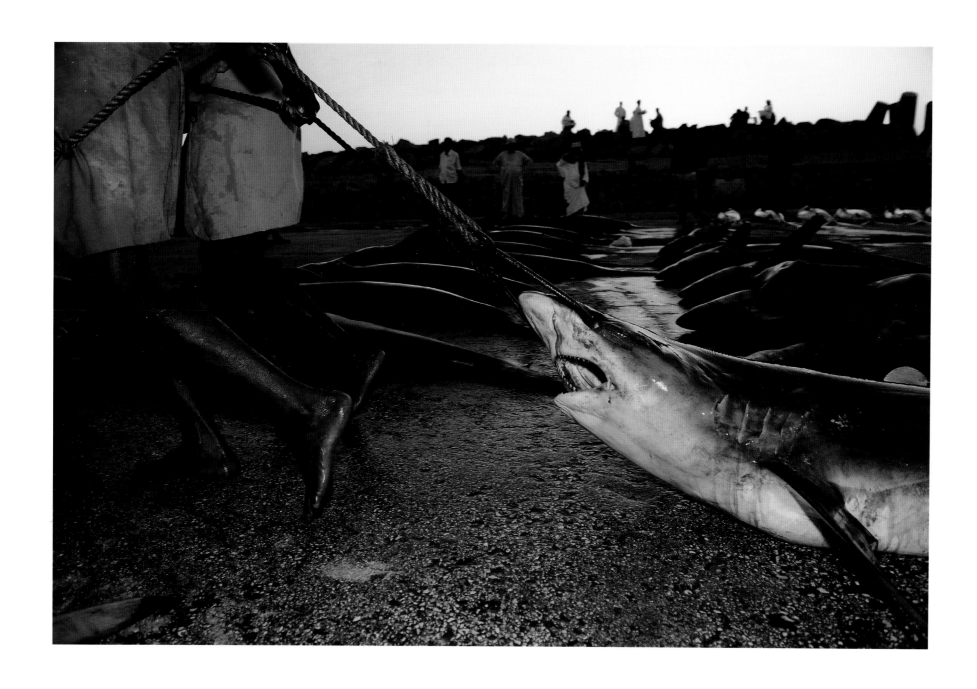

Fishermen drag a silky shark, just one of thousands that is auctioned off every night, to the slab.

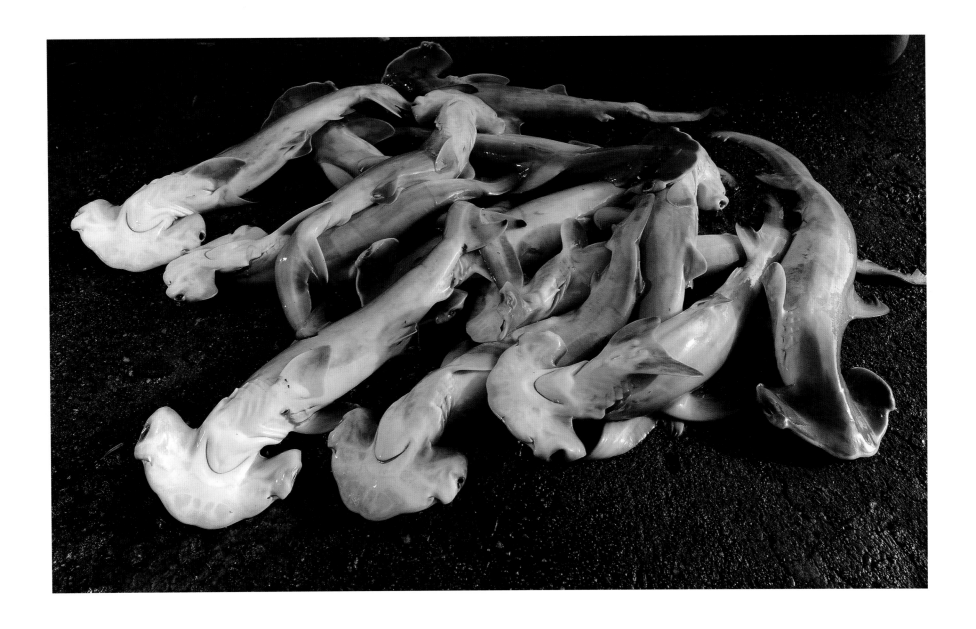

Hammerhead sharks are classified as Endangered on the IUCN Red List. The ripple effect of catching a pregnant female may be felt for generations, as one hook can wipe out her litter of up to 55 pups.

have extended gestation periods that often last longer than that of humans. Many species also have low fecundity for a fish, giving birth to a dozen or fewer pups at a time. The sand tiger shark has just one or two per pregnancy. Adding to their fragility, a few species give birth only every second or third year. This combination of traits leaves sharks vulnerable to overexploitation and slow to recover once depleted.

Many of the characteristics that make sharks vulnerable are also found in whales, several of which have made dramatic conservation comebacks. As an example, fewer than 2,000 gray whales were believed extant by the early 1900s, after decades of whaling had decimated them. But after the species gained full protection from fishing in 1946, it eventually recovered almost to its pre-whaling population of 26,000. In 1994 it was removed from the Endangered Species List. The southern right whale is a similar conservation success story. Following severe depletion due to commercial whaling, less than 300 animals were left in the 1920s. Today, after the cessation of hunting and the protection of breeding grounds, they too have made a strong recovery. They're now estimated at more than 7,000 individuals, and they currently double their population every 10 to 12 years. Given these successful interventions, what measures need to be put in place for sharks to recover in a similarly spectacular manner?

The Convention on International Trade in Endangered Species of Wild Fauna and Flora (CITES) is a global treaty signed by various countries to ensure that international trade in wild animals and plants does not threaten species survival. CITES currently has 178 member countries. If and when a species is listed on CITES Appendix I, then commercial international trade of this species is essentially forbidden. A listing on Appendix II regulates trade of the species, with permits required by exporting countries based on findings that the take is sustainable and legal. In 2012, only three shark species were listed in Appendix II: basking, great white, and whale sharks. Decisions on amending CITES Appendix I and II are made about every three years. CITES listings are proposed by countries and require a two-thirds voting majority for adoption. This is a problem for sharks, as many influential shark fishing and consuming nations, like Japan and China, are strongly opposed to any marine fish listings. At the 2010 CITES conference in Qatar, proposals were made to list eight species of threatened sharks under Appendix II, among them great hammerhead, oceanic whitetip, and porbeagle. Unfortunately, due largely to extensive lobbying by major fishing nations and their allies, none of the eight species were listed.

The shark debates at CITES are among the best-known shark conservation battles. This is not only because of the global reach and teeth of the treaty, but also because the conferences are well publicized; address a wide range of charismatic and beloved species, such as elephants and tigers; and—unlike what happens with most international fisheries bodies—culminate in a dramatic global vote.

In March of 2013 that vote finally swung in favor of sharks, when porbeagle, oceanic whitetip, and great, scalloped, and smooth hammerhead sharks, as well as manta rays, were all listed on Appendix II.

Other well-publicized conservation measures that have recently gained momentum involve local and regional shark fin bans. In 2010 Hawaii became the first U.S. state to ban the possession, sale, and distribution of shark fins, in the past a $30-million industry in Hawaii alone. Similar laws have since come into place in Washington, California, and Guam, and have been attempted in some Canadian cities. Toronto banned the possession and trade in shark fins in late 2011, but the ban was overturned by the Superior Court because the city did not have the power to impose the legislation. Such bans have faced vocal opposition from various Asian communities, who feel singled out for a part of their heritage.

To complicate matters further, there has been confusion in the minds of the public and some politicians and conservationists about the concepts of "shark fin trade" and "shark finning." Shark finning is the act of cutting the fins off a live shark and dumping the carcass at sea. But not all shark fins in the trade are taken this way. While shark fin bans have been generally popular with the public, some scientists and conservationists question their effectiveness and stress that local and regional fisheries management measures—such as shark quotas, seasonal restrictions, and restrictions on taking protected species—are also essential to prevent not only finning but shark overfishing.

In 1999 the International Plan of Action for Sharks (IPOA-Sharks) of the United Nations Food and Agriculture Organization (FAO) was established to ensure the conservation and management of sharks and their long-term sustainable use. The cornerstone of this effort is the recommended development of National Plans of Action (NPOAs) for each shark-fishing nation. After serious delays, countries are finally taking these critical tasks seriously, but NPOAs are still lacking in many major shark-fishing nations, and existing NPOAs are usually not informed by robust shark population assessments nor accompanied by binding shark-fishing limits.

In light of the life-history traits of sharks, is a sustainable shark fishery possible at all or should shark fishing be banned outright? While a global ban might seem like the simplest solution based on the long history of shark population collapses, sharks are actually key components of catches for small-scale and artisanal fishermen all over the world and putting sharks off limits would have real-life consequences for subsistence practices that might well be sustainable.

Indeed, as fishing intensity varies, so do the life-history characteristics of the more than 400 shark species. Some small-scale fisheries may not pose a threat to certain sharks; some smaller, fast-growing or naturally abundant species can withstand considerable fishing pressure. It's important to remember that, while sharks are generally more vulnerable than bony fish, the recipe for disaster comes from the lack of regulation for most shark fishing.

What is essential in both targeted and bycatch fisheries is the effective enforcement of science-based fishing limits. One good example is the gummy shark fishery in southern Australia. Thanks to government-level interest in science, management, and enforcement, only a small percentage of juveniles and sub-adults are taken, and mature adults are protected. Once seriously overfished, populations of blacktip sharks in the Gulf of Mexico and spiny dogfish off New England have also been recovering in recent years, thanks largely to the enforcement of science-based quotas.

Investment in shark science and management is key not only to devising sustainable fishing strategies, but also to determining whether plans already implemented are working as designed. Until such commitments are more widespread, examples of sustainable shark fisheries will remain the exception, not the norm.

All across the world, shark populations are in trouble, and there is no one silver bullet for their global conservation. The measures now being tried—be they shark fin bans, sanctuaries, fisheries management, or CITES—all have strengths and weaknesses, as well as advocates and opponents. Combining these safeguards could give sharks a chance to rebound the way the great whales did.

The lifeless carcasses of blacktip sharks are lined up at the Dubai fish market.

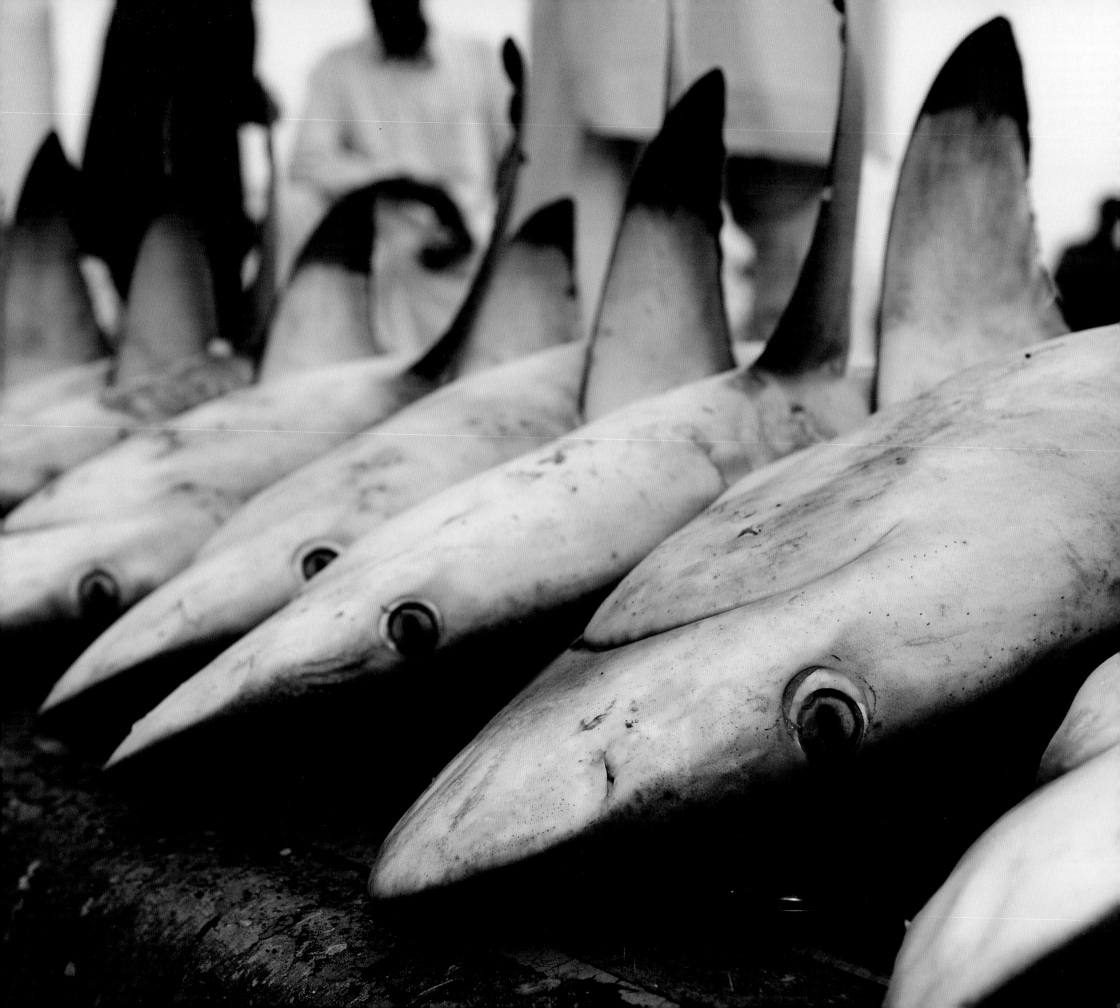

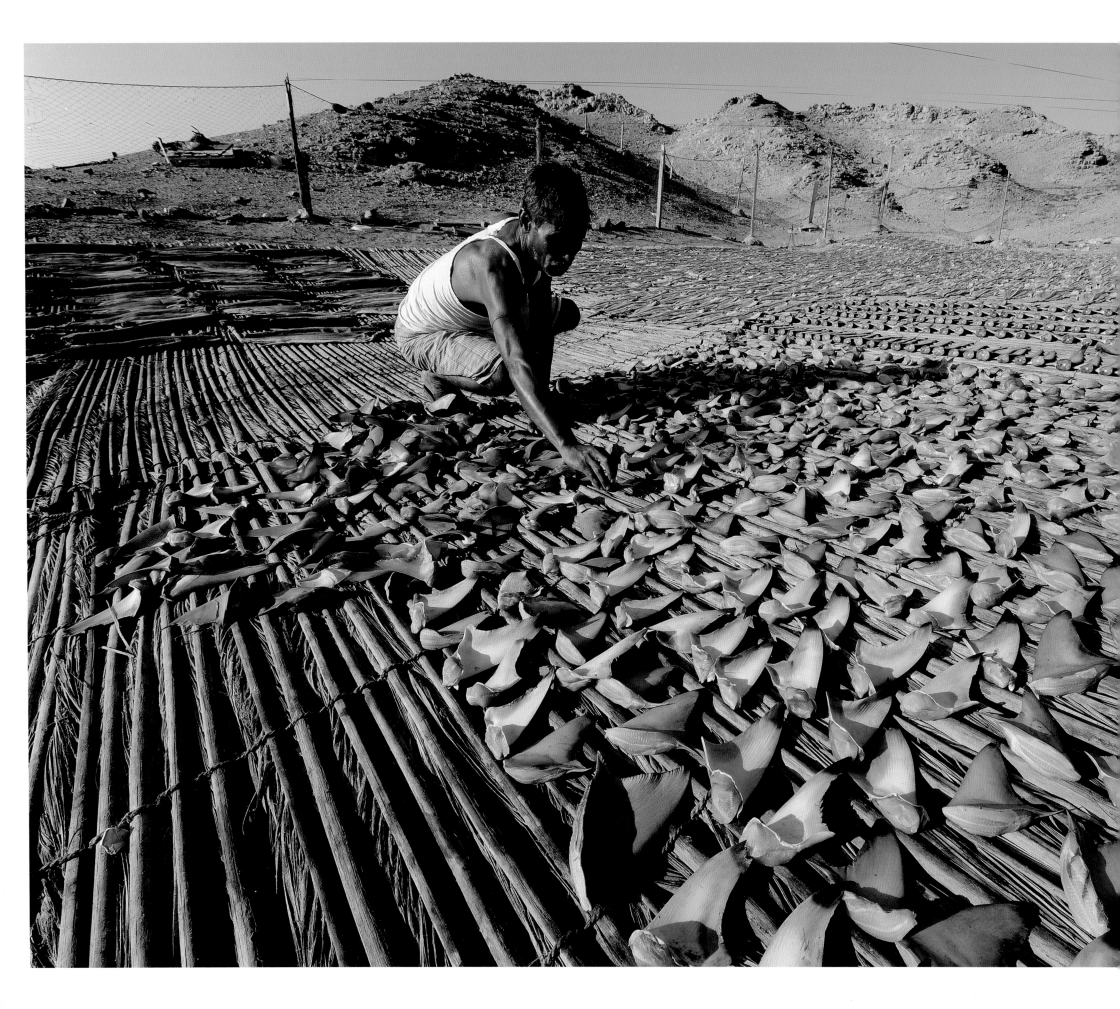

DESERT SHARKS

DESPERATE FOR SUSTENANCE, we pull into a little port town on the Arabian Sea and weave through the warren of dark streets. Getting lost would be par for the course, and sure enough, the road we are on ends abruptly at the fishing harbor. Always curious to see what fishermen are catching (especially in remote areas where photographers and biologists rarely tread), I jump out of the car. I squeeze through a dense crowd, and when it parts, I am surprised by what I find. I count 98 silky sharks on a concrete slab, each six feet (2 m) long. And this is just a single boat's catch. After they are auctioned off to the highest bidder, the sharks are loaded into freezer trucks. Within minutes, the next boat pulls up and disgorges more sharks onto the slab.

As a photographer and marine biologist, I had documented sharks and the shark fin trade for over a decade, but Arabia had never been on my radar as a major shark-fishing region. So after the episode in the little port on the Arabian Sea, I began scouring obscure fisheries reports and discovered that the area had recently become one of the major global suppliers of sharks. The most prolific catches are off Oman and Yemen, where every night, freezer trucks filled with sharks leave ports and race across the desert. Their destination is Dubai and the nightly shark fin auctions held beneath the glittering skyline of that desert metropolis. The city now ranks among the top five exporters of shark fins, all destined for the global epicenter of the fin trade—Hong Kong.

My diving expeditions along the length and breadth of the Arabian Peninsula have revealed evidence that shark fishing is ubiquitous, even in marine reserves. Shark gill nets are unselective by design; in addition to snaring sharks, they entrap many other sea creatures. Along some offshore islands in the Arabian Sea, the beaches are littered with dead green sea turtles. On one beach walk, I counted more than 10 decaying carcasses in just a mile. Whales also fall victim to the gill nets. Arabian humpbacks, one of the most endangered cetacean populations on the planet, experience high rates of mortality after becoming entangled in these nets. An analysis of scars on these humpbacks indicates that up to 40 percent are likely the result of fishing gear entanglements.

While gill nets are banned in many countries, their use in the waters off the Arabian Peninsula is epidemic. Some fishermen there voiced concern to me about the recent dramatic decline

OPPOSITE *A worker arranges shark fins at a drying compound along the edge of the Arabian Desert.*

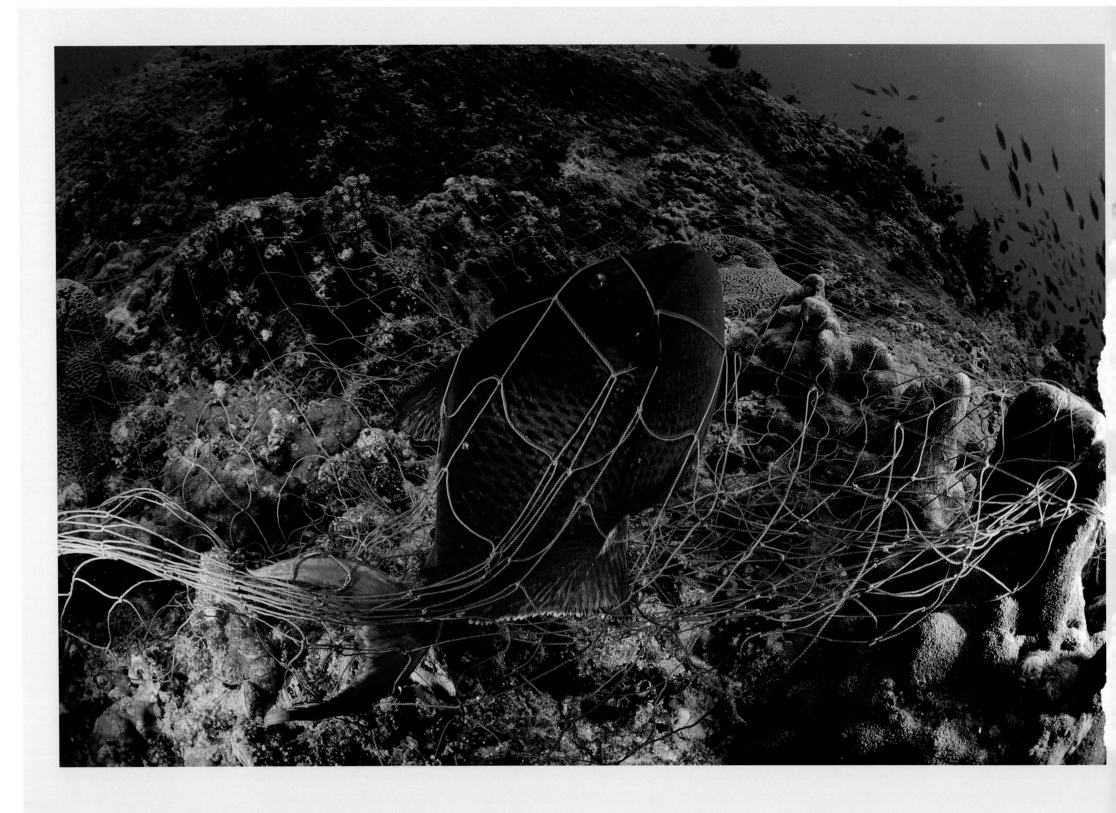

Many Arabian shark fisheries use gill nets, which have a high rate of bycatch that includes a range of victims from triggerfish to turtles.

Shipwrecks, oil pollution, and coastal development are additional threats to the region's overfished shark populations.

in the number of sharks they catch. With the exception of a few spots where sharks thrive, my expeditions in the area substantiated their concerns, as underwater shark encounters were few and far between. Today, Arabia's shark populations sit on the precipice of degradation, with overfishing, coastal development, and pollution taking their toll. Yet, the region is also home to some of the most committed marine conservationists in the world. Because of their work, I have hope for the future of

Arabia's sharks. Nations in the region are also blazing new trails. The Kingdom of Saudi Arabia prohibits targeted shark fishing in its territorial waters, and a seasonal shark fishing ban is in place in the United Arab Emirates. Oman has outlawed shark finning, and except for two species—graceful and sharpnose sharks— Kuwait has prohibited shark fishing. Can Arabia transform its reputation from being a top supplier of shark fins to a leader in global shark conservation? I like to think so.

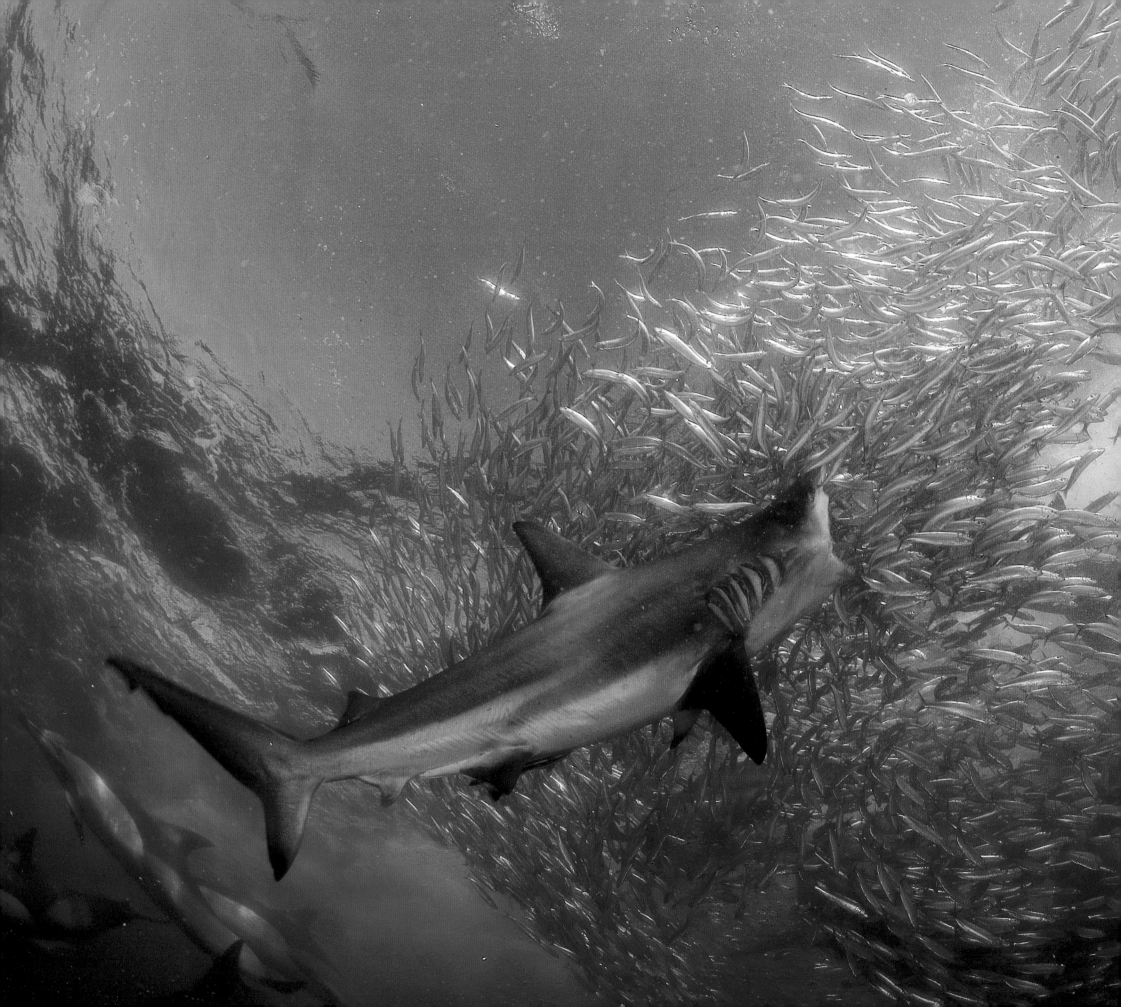

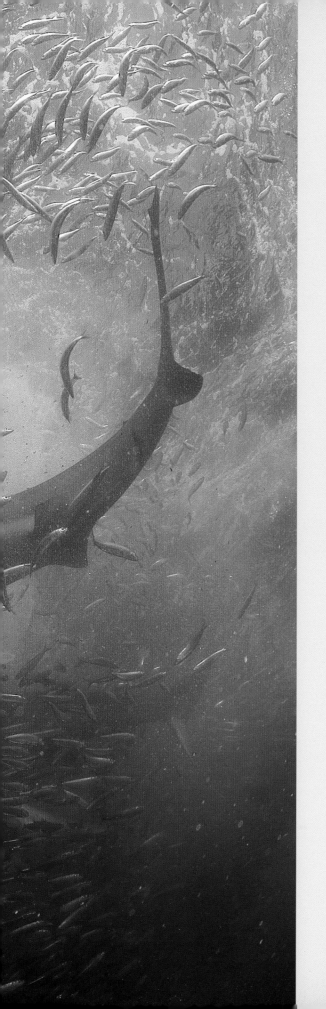

 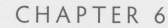

OCEAN GUARDIANS

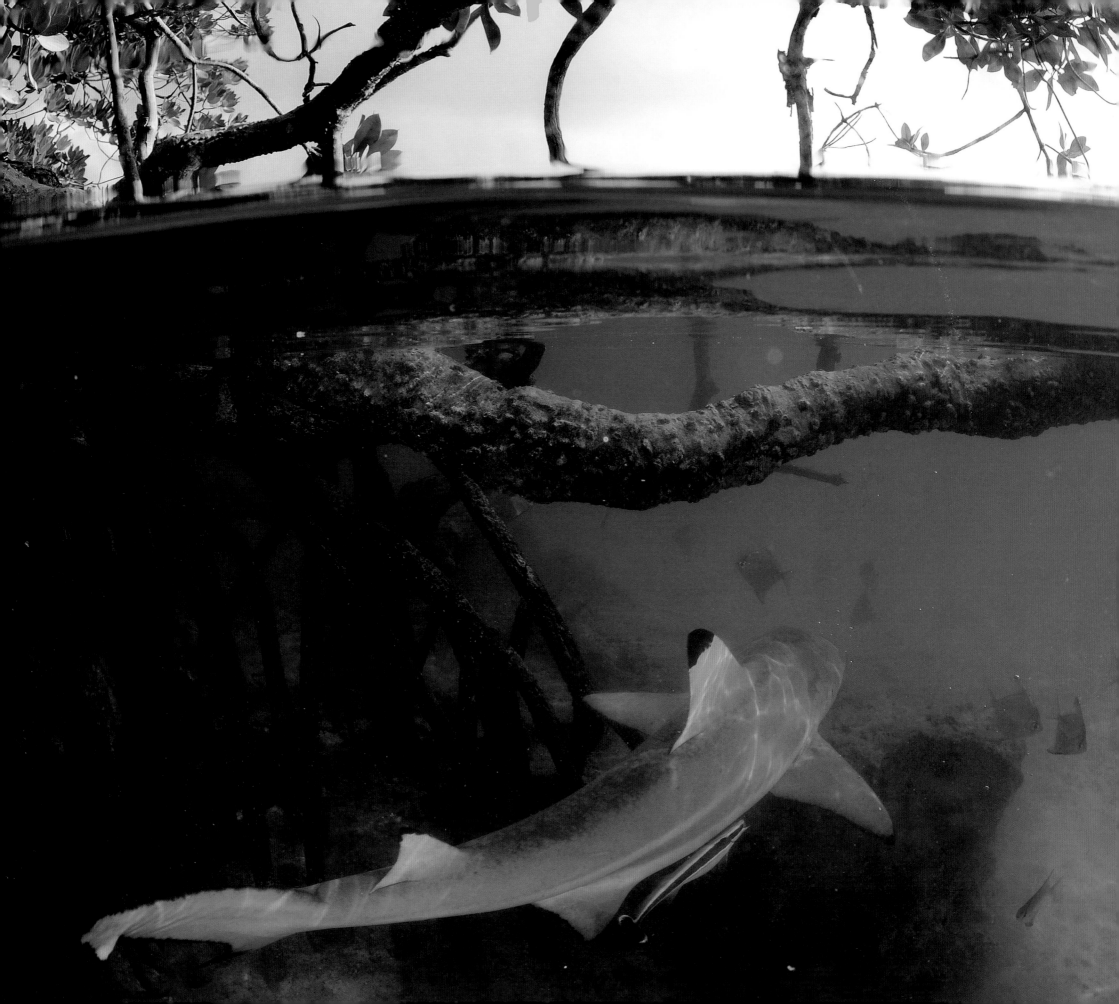

A symphony of converging winds and currents whip the ocean into such frenzy that I almost decide not to head out to sea. Then, as the sun rises, I take my chances and manage to navigate successfully though the violent shore break. Moving beyond the impact zone, I scan the horizon for life brewing beneath the surface. Far to the south I spot thousands of silhouettes—Cape gannets raining from the sky. The explosive sound of these large, arrow-shape seabirds plunging into the ocean is akin to a ringing dinner bell, luring sharks from miles away by alerting them to the presence of schools of smaller fish. The birds have stopped diving by the time I arrive. I roll backward off the boat to merge with the ocean.

Encountering wild sharks in their element and witnessing the million-year-old battle between predator and prey is a rare privilege, and as the maelstrom of frothing water dissipates around me, I see an animated jigsaw of dark shapes. I am yards away from an army of bronze whaler sharks. Numbering in the hundreds, they swim past and I instinctively fall into rank with them. Their target is a pulsating, tennis court-size shoal of sardines shimmering in the gloom. I navigate through the layers of wildly snapping hunters to the bait-ball's center, where two large sharks hang motionless. I am within a few feet of them when suddenly they burst through the wall of sardines, their mouths so full that fish heads and tails stick out like clothes from an overstuffed suitcase. A large female dusky shark circles me at close range and then, with little warning, grabs one of my fins and skitters away. Despite other sharks repeatedly knocking me about, I know I am not on the menu. I am just being subjected to the same jostling and pushing that is part of the accepted etiquette at this crowded banquet. Surveying the scrapes, bruises, and fresh scars on many of the sharks, I determine that I've gotten off lightly.

In just 30 minutes the armada of sharks culls the bait-ball to one last sardine. It is gobbled up after a short-lived refuge in my shadow. And then I am alone. The sharks depart in search of their next meal. All that is left of the once-mighty silver shoal is a shimmering dust of scales settling all around me.

Ecology has long pointed to the physical processes of climate, geology, and oceanography as the primary factors in the structure and organization of ecosystems. In the eyes of early scientists, the

OPPOSITE A blacktip reef shark weaves through the tangled maze of a mangrove forest on Europa Atoll.
PREVIOUS SPREAD A bronze whaler charges a bait-ball of sardines off South Africa's east coast.

natural world was controlled from the bottom up by nutrients and sunlight and largely driven by photosynthesis. A more recent notion is that ecosystems are regulated from the top down, with apex predators sculpting biologically diverse communities. For centuries predators have been stigmatized as either a nuisance at best or a menace at worst. The push to cull or eradicate those predators, be they wolves, lions, or foxes, was ever present. The idea of predators as vital players in their respective ecosystems was inconceivable.

Sharks, of course, have a formidable reputation as predators. But the exact nature of their ecological role is poorly understood, and the theory that sharks structure marine ecosystems is still hotly contested. Conducting ecological research in the wilds of the terrestrial realm is difficult enough, but doing so in the ocean adds another level of complexity. Many of the early marine ecological studies were therefore carried out on accessible intertidal shores and focused on such slow-moving predators as ochre sea stars, whose habitat consists of just a few square yards. Experiments in the 1960s involved removing all sea stars from some rocky shores, then monitoring those areas. Researchers found that mussels invaded and rapidly displaced the diverse communities of intertidal life that had co-existed with the sea stars. Ochre sea stars can voraciously consume up to 1,600 big mussels in their 20-year life spans, but with the sea stars gone, the mussels carpeted the lower intertidal zone and squeezed out all other life.

Unlike sea stars, predatory sharks are among the largest and most wide-ranging animals in the ocean. Some species can measure up to 20 feet (6 m) in length, and many are known to migrate over distances as great as 6,200 miles (10,000 km). Factors such as these make studying the ecological role of sharks in the same manner as the sea stars quite impossible—sharks simply can't be experimentally removed or excluded from the oceans.

Given the difficulties of analyzing the ecological role of sharks, it wasn't until the 1990s that some scientists took on the challenge. Stomach content analysis of 149 species showed that sharks are top predators and collectively occupy a trophic level above seabirds but below carnivorous marine mammals.

Due to overfishing, by then shark numbers had dwindled in many parts of the world, and some researchers saw this as having an effect similar to a large-scale removal experiment. They began to study community-level ecosystem changes in areas where shark populations were depleted. Scientists also used complex food-web computer models to evaluate the strength of interactions between sharks, prey, and their environment. Like a mathematical witch's brew, shark and prey abundance, life history, biomass, behavior, mortality, and many more parameters were added to the cauldron. Clever algorithms then revealed a variety of probabilities and degrees to which sharks affect ocean ecosystems. Because these methods are significantly less precise than the experimental protocol used with sea stars, there is a lack of consensus among scientists about the role of sharks. For now, though, the community-level observations and the computer modeling provide the few windows we have to understanding if and how these formidable predators shape the world's oceans.

With approximately 500 species, sharks are a rather diverse group of predators, and the ecological role a 20-foot-long (6-m) great white exerts will differ significantly from that of a three-inch-long (10-cm) pygmy shark. Sharks larger than 10 feet (3 m) usually function as top predators and hunt larger prey like marine mammals, sea turtles, and other sharks and rays. Smaller sharks, less than six feet (2 m) long, feed mainly on fish and squid. Finally, there are even smaller benthic sharks with diets consisting almost entirely of invertebrates, such as crabs and mollusks. There is relatively little evidence that sharks' feeding

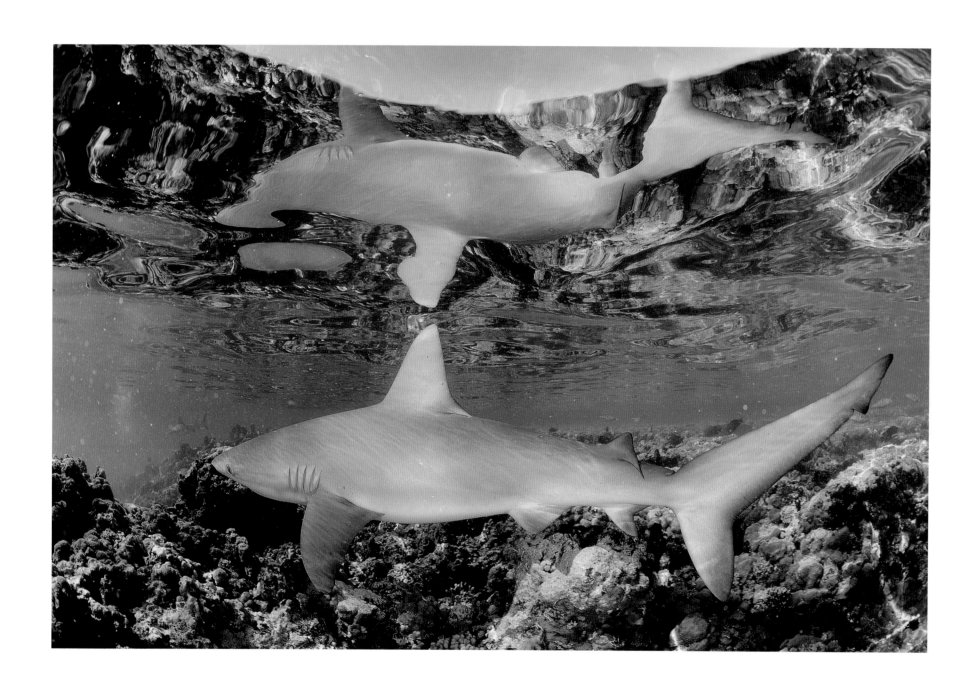

*Juvenile Galapagos sharks prefer hunting in shallow water
to avoid becoming prey to larger sharks.*

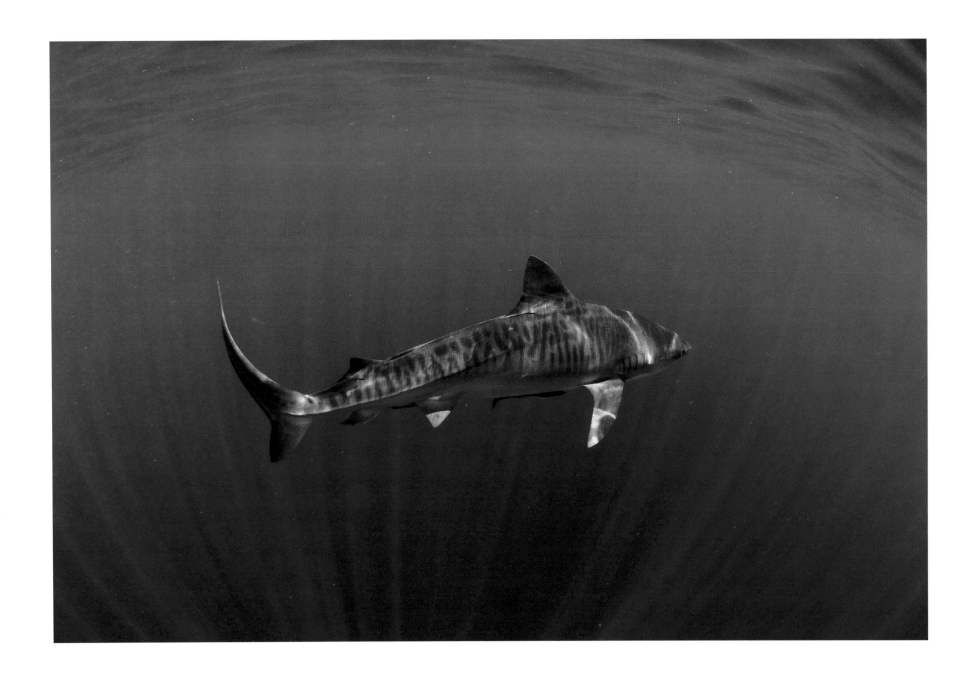

Tiger sharks, once thought to be coastal predators, are revealing that
they spend much of their time in the open ocean.

on small fish or invertebrates significantly affects the abundance of their prey. In New England, for example, mako sharks feed predominantly on bluefish, but their impact is minimal as they consume only four percent of the total bluefish population. In the same vein, salmon sharks and blue sharks appear to have minor and transient effects on Alaska's fish populations, as their consumption rates are low relative to the abundance of prey.

In ecosystems where sharks feed on bony fishes or squid, there is usually some form of predatory redundancy, for example, from tuna or billfish, which rely on the same prey as sharks. However, the ocean appears to hold less redundancy for larger predatory sharks, because other large predators—even a gigantic 18-foot (6-m) blue marlin or an 880-pound (400-kg) Atlantic bluefin tuna—are constrained by their small mouth structure. They feed only on smaller or medium-size fishes like sardines, herring, and mackerel. On the other hand, the unique jaw structure of sharks allows the larger ones to tackle prey of much greater size. These sharks feed on marine mammals, sea turtles, and other sharks and appear to have a greater influence on the populations of their larger-bodied, longer-lived, and less abundant prey.

An example are the prehistoric-looking Greenland sharks that venture up from the depths and consume nearly half of all native harbor seal pups in the waters of windswept Sable Island, off the coast of Nova Scotia. There is little doubt that these sharks regulate the growth of the seal population here. Halfway around the world, Hawaii's balmy French Frigate Shoals exhibit a similar phenomenon. After being driven to near extinction through hunting and human disturbance, a relatively small and local population of Galapagos sharks is now one of the driving forces in the decline of Hawaiian monk seals.

Sharks don't have to kill and eat to have influence. Their presence is often enough to change the behavior of their prey, thus affecting ecology. Sharks create seascapes of fear, environments where animals go to great lengths and bear significant disadvantages to avoid these primal predators. In Alaska's icy Prince William Sound, for example, the richest feeding grounds for seals are in waters deeper than 300 feet (100 m), where large walleye pollock abound. But with 23-foot-long (7-m) sleeper sharks also haunting these emerald waters, seals rarely utilize the rich feeding ground. Instead, they prey on the more dispersed and ephemeral Pacific herring shoals that congregate in the shark-free surface waters.

Australia's Shark Bay is another place where sharks have affected the ecology. This large, semi-enclosed inlet bordering the great Western Desert is home to approximately 3,000 bottlenose dolphins. The dolphins do most of their winter hunting in the shallows, where grunters and jack fish are three times more abundant than they are in deeper waters. In the warm summer months, though, large numbers of tiger sharks congregate in the shallows, forcing the dolphins to abandon their most productive feeding grounds and migrate to deeper channels where the fish are scarce—but so are the tiger sharks.

Over 10,000 dugongs also inhabit this bay and graze on the seagrass carpeting the sea floor. These close relatives of manatees feed either by cropping the grass or by excavating the more nutritious root systems. But the root digging produces a massive plume of sediment that makes it difficult to scan for predators. Since tiger sharks are abundant during the summer months, most dugongs tend to crop rather than excavate. Once shark numbers decline in the fall, dugongs use the more nutritionally rewarding technique of root excavation.

American naturalist John Muir wrote in 1911, "When we try to pick out anything by itself, we find it hitched to everything else in the universe." Research since then has borne him out. Eliminating predators destabilizes an ecosystem and leaves it biologically deficient,

creating consequences that ripple down the food chain in a trophic cascade. A good example comes from the North Pacific and centers on sea otters. After decades of being the primary target of the fur trade, sea otters had dwindled to only a handful of isolated populations by the late 1800s. In the 1970s scientists decided to monitor and compare locations where sea otter populations were still extant with ones where they were extinct.

Sea otters are ravenous predators with high metabolic and caloric requirements and can quickly reduce the local density of shellfish and sea urchins. The researchers found that in areas without sea otters, sea urchins were up to 100 times more abundant, and kelp forests were absent or stunted by the urchins' overgrazing. Without otters to regulate urchin populations, entire kelp beds were deforested, creating acres of desolate rock. The loss of kelp beds resulted in a dramatic reduction of biodiversity and in wide-ranging ecological consequences that affected everything from the diet of bald eagles to the foraging success of sea ducks—all because of the absence of one predator, the sea otter.

A study published in 2007 suggests that sharks have a similar permeating influence on the food web. Researchers analyzed data from 35 years of East Coast U.S. longline catches of large predatory sharks, such as tiger, bull, and dusky, and smaller elasmobranchs (sharks, rays, and skates) believed to be their principal prey. Over the study period, the researchers found that all 11 species of "great" sharks had suffered significant population declines of between 87 and 99 percent. During the same 35-year timeframe, 12 of the 14 surveyed elasmobranchs— often the sharks' prey—were found to have increased significantly in abundance. The largest estimated increase was a 20-fold spike in cownose rays, which the study implicated in the decline of the bay scallop, leading to the collapse of a local fishery in North Carolina. This study has been at the core of conservation campaigns warning of the dangers

of overfishing shark populations and has also been a strong basis for seafood industry campaigns aimed at developing new markets for the cownose ray. An increasing number of researchers, however, are challenging the very foundations of this study. They argue that the decline in large sharks is not as dramatic as the study illustrates. It also appears that cownose rays make up only a small percentage of the diet of many of the large sharks. Researchers also dispute the assertion that cownose rays are significant natural predators of commercially valuable bivalves and scallops, which have declined along the East Coast outside the range of the rays. Even the notion that there have been dramatic increases in cownose rays has been challenged. The life history of these rays—late maturity and a single pup after a nearly year-long gestation period—is such that they simply do not possess the productivity to stage a population explosion over a couple of decades.

The ecological implications of cownose rays and the role sharks play remain mired in scientific controversy, and that controversy points to our continued lack of definitive knowledge on the effects of sharks on marine ecosystems. What should be clear is that cownose rays share the biological vulnerability of the closely related "great" sharks, and any fisheries for these elasmobranchs must be carefully managed from the start.

Several modeling studies do point to some species of shark as drivers of trophic cascades. One model shows that a decline in tiger sharks in the northwest Hawaiian Islands could cause an increase in turtles, seabirds, monk seals, and other reef sharks. That increase would in turn lead to a rapid decline in such commercially important fish species as tuna and jack. In contrast, removing reef sharks from the same ecosystem showed little effect on the model. Reef sharks feed on fish and invertebrates that have relatively high replenishment rates compared to those of the birds, turtles, and seals consumed by tiger

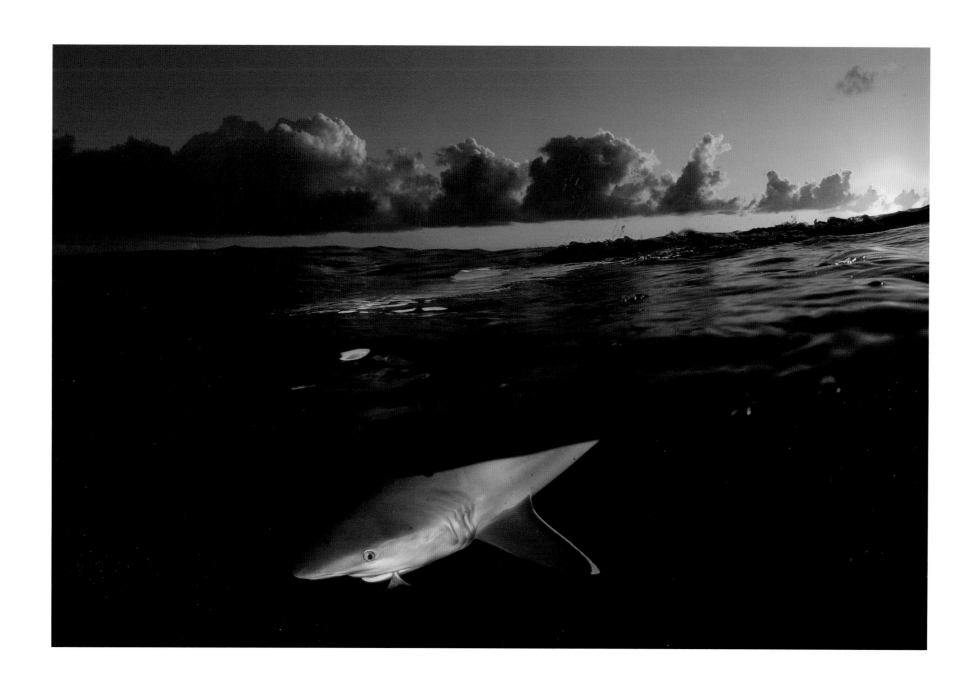

Silvertip sharks move into shallow water at dusk and patrol the edges of coral reefs, where they often prey on reef fish and eagle rays.

sharks. Moreover, jacks and other predatory fish can functionally take over the feeding role of reef sharks, whereas tiger sharks are the only major predators of turtles.

A final, intriguing, and largely unexplored aspect of the role of sharks is how they affect the evolutionary path and genetic makeup of their prey. Sharks are said to target individuals that are easier to catch because they are weak, sick, or injured—a tactic that might strengthen the gene pool of prey by reducing the proliferation of diseases from the population. This is similar to the sway that predators have on the plains of Africa. A decrease in leopards and lions due to hunting and habitat loss triggered a rise in olive baboon populations and a subsequent increase in intestinal parasites in the baboons. A shortage of natural habitat forced many of these baboons to inhabit human-dominated rural areas, which in turn caused an increase in parasite transmission to people.

All of the above studies involve time scales that date back 50 years at best. To delve deeper into the roles that sharks play, we need to travel further back in time. The earliest documented case of sharks orchestrating changes in the ocean occurred 34 million years ago, during the Eocene. As the seas cooled then, sharks became extinct in the Antarctic. In their absence, a deluge of life developed on the seabed. However, in the past half century, sea temperatures around Antarctica have risen, and scientists predict that climate change will enable sharks to repopulate the southernmost reaches of the world. It's likely that benthic life will decrease as sharks return and rewrite the rules for the Antarctic food web, offering up a new natural experiment and shedding further light on the role that sharks play in the oceans.

Studying sharks and their prey is an exceedingly difficult task, with patterns and trends often taking decades to manifest. Do sharks play a structuring keystone role in the marine ecosystem? At the moment the honest answer is that we're not sure. The evidence is not clear-cut, and many of the great minds in shark science are divided. But it would be foolish to pretend that these major predators have no structural effect on ecosystems. So until we know more, we need to take a precautionary approach to the conservation of sharks and rays, particularly given the widespread depletion of so many of these species around the globe.

A blacktip reef shark navigates a narrow canyon, making the daily commute with the tide between mangrove forests and coral reefs.

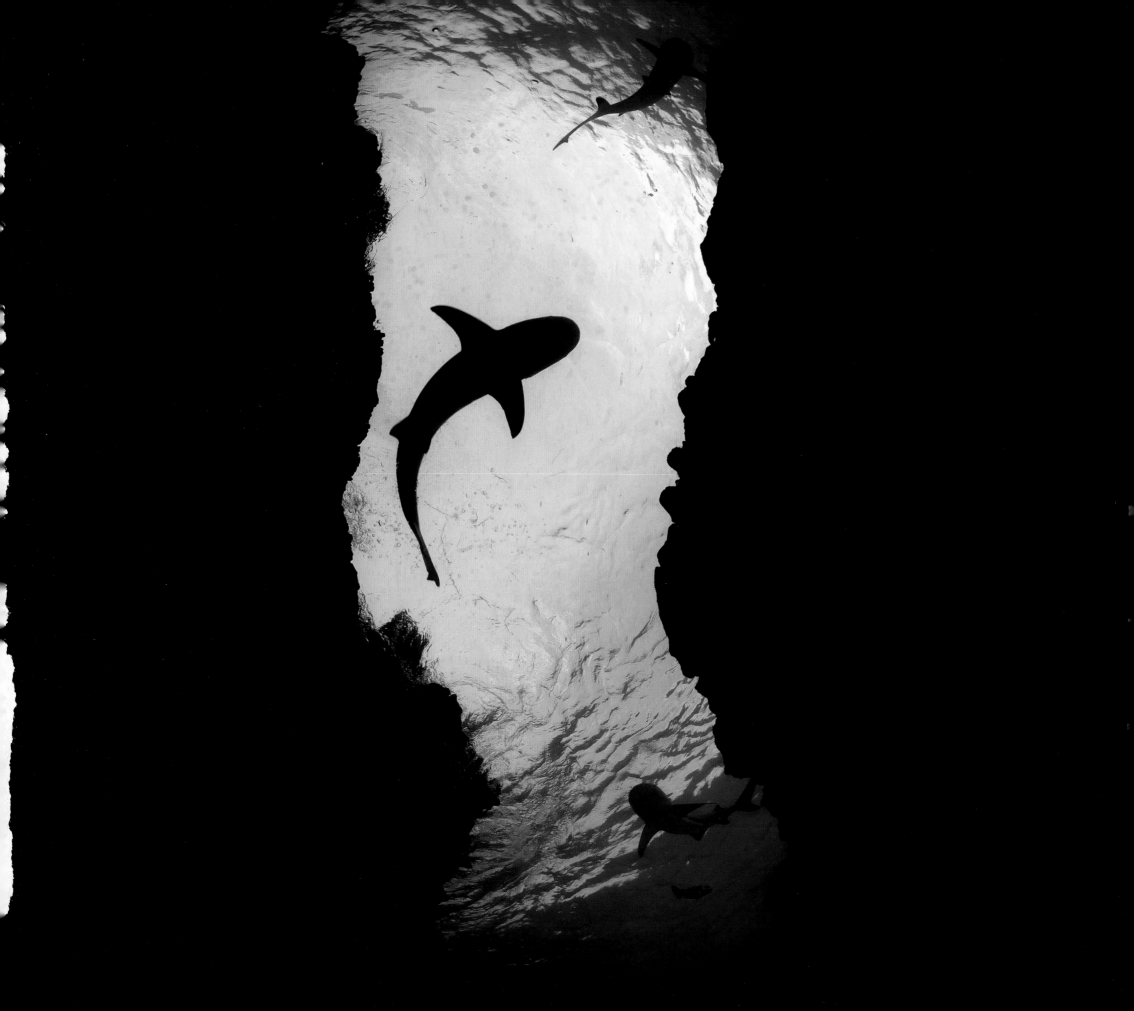

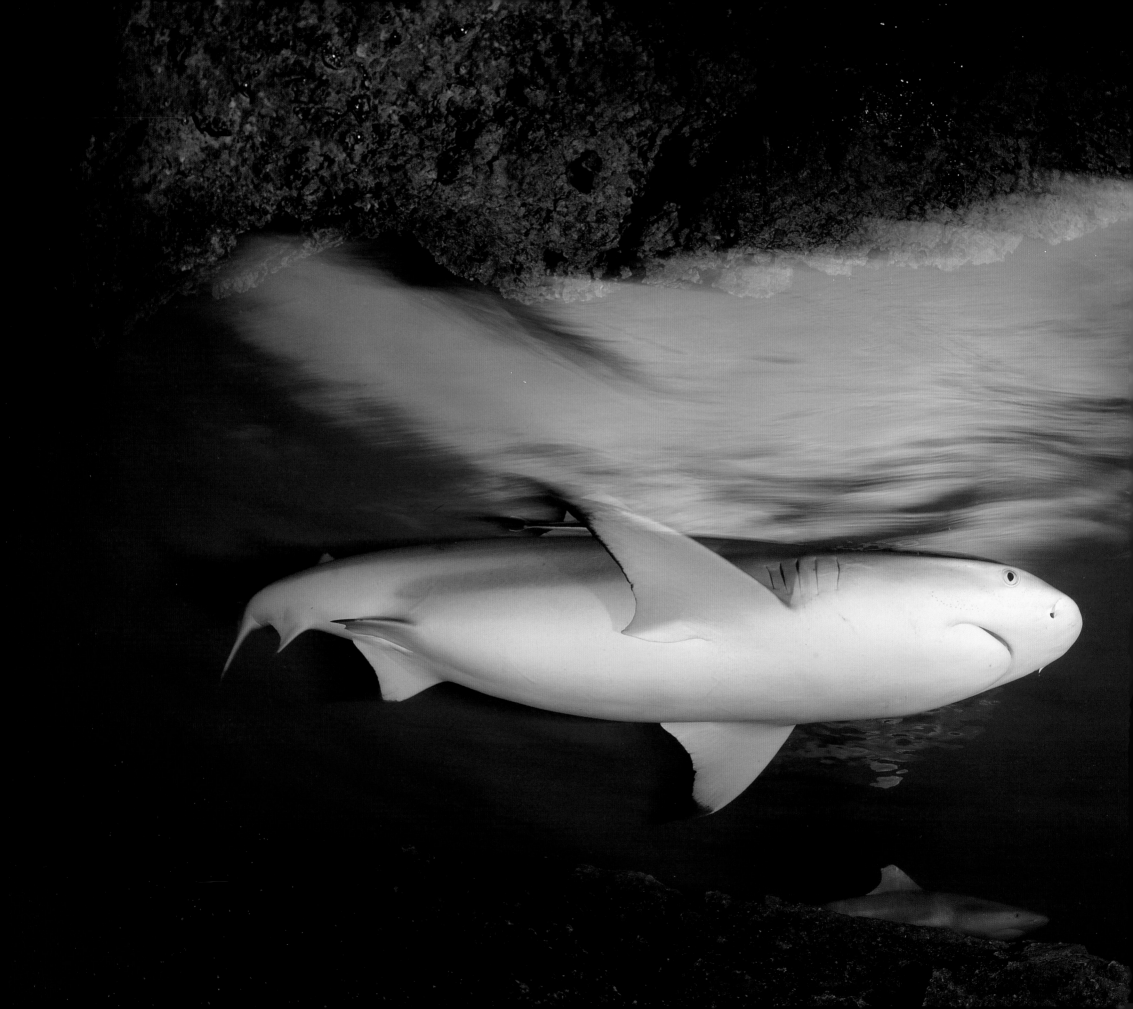

*A blacktip reef shark roams reef flats during high tide
and retreats to the edges of deep channels at low tide.*

In remote locations like Aldabra Atoll, sharks are abundant. They congregate in schools of 100 and can be encountered in water that is often only a few inches deep.

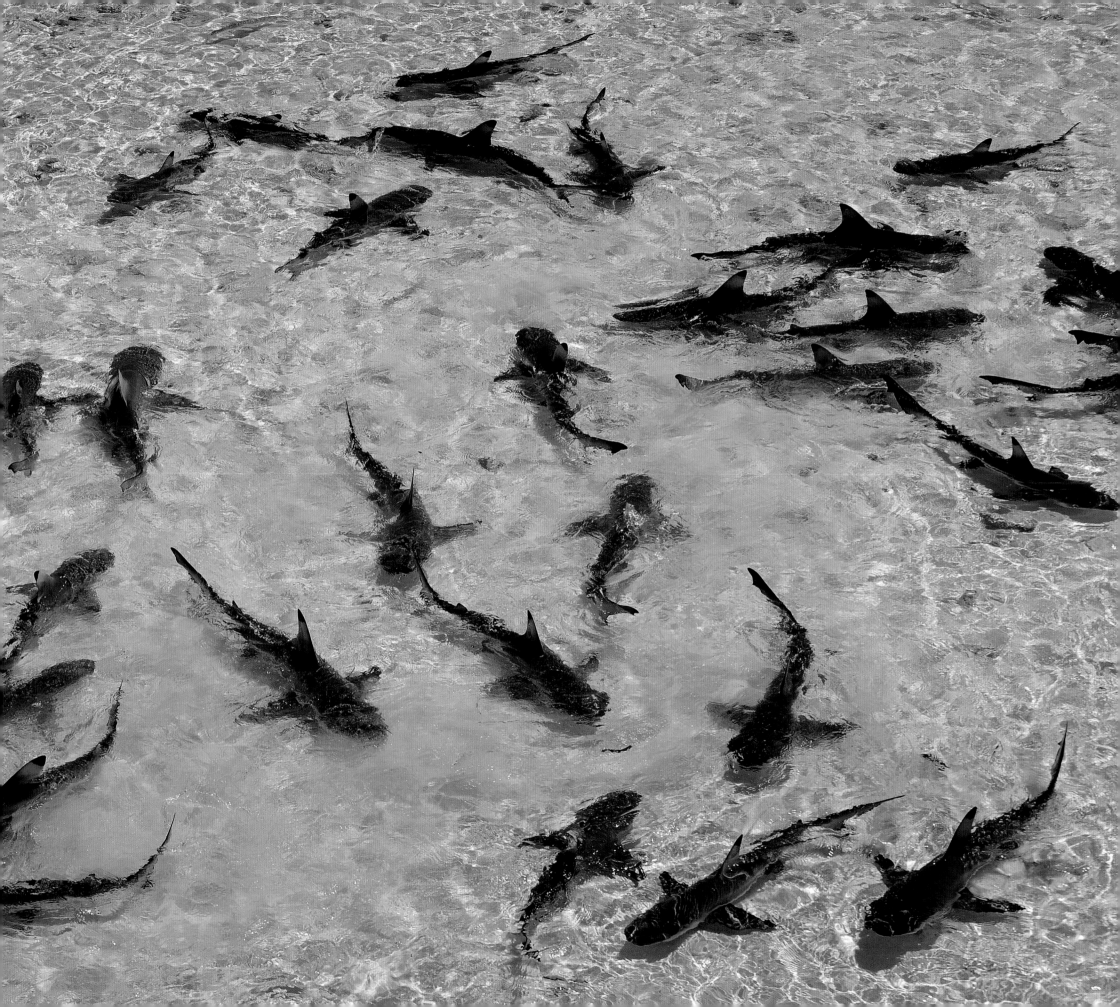

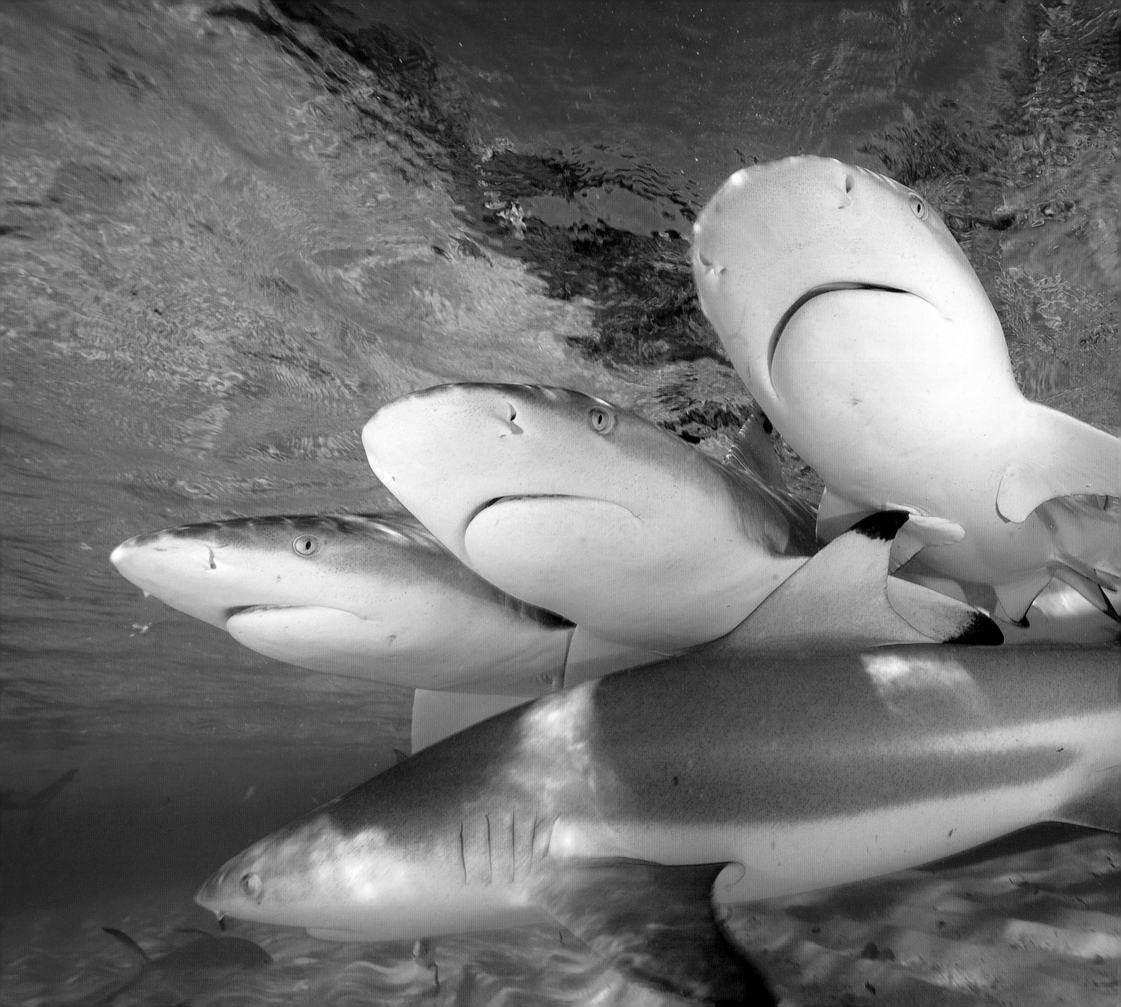

*Several species of reef sharks are known to show strong site fidelity,
sometimes living in a small area of coral reef for several years.*

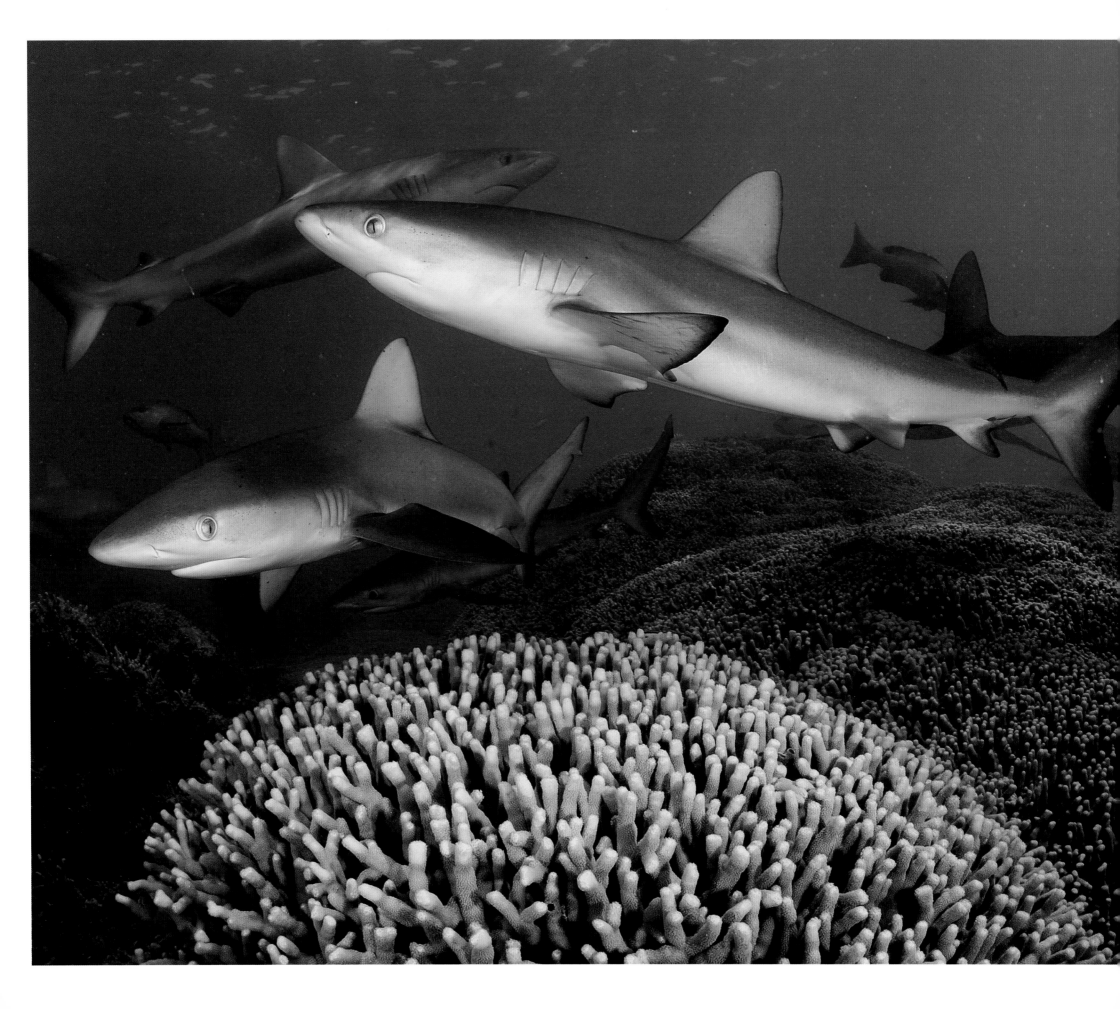

KEEPERS OF THE REEF

OFTEN CALLED THE RAIN FORESTS of the sea, healthy coral reefs abound with life. While the sheer number of plants and animals is higher in tropical forests, reefs are the most diverse biomes on the planet if measured by the number of species per unit of area. And unlike the world's tropical forests, where much of the life remains hidden in the canopy, coral reefs present a dazzling display of biodiversity. Today, though, that biodiversity and the reefs themselves are increasingly threatened by global warming and human degradation. Yet it's possible that sharks play a critical role in keeping some reefs healthy. Here's how:

In the tropical ocean, seabed real estate is at a premium, and corals and algae compete fiercely for habitat. Algae grow much faster than corals do, and reefs rely on herbivorous fish to graze algae and free up space for coral larvae to settle and grow. When grazing fish disappear, coral reefs are gradually eclipsed by algae. Caribbean reef sharks are thought to keep in check the number of such predatory reef fish as groupers and snappers, which eat the grazing fish. This natural regulatory service allows for a healthy number of grazing fish to survive. Without sharks, the system can become imbalanced.

Some of the most degraded coral reefs in the world are found in the Caribbean due to overfishing and eutrophication; in Jamaica alone, algae have smothered 90 percent of the reefs.

A recent modeling study showed that sharks play an important role in almost 50 percent of Caribbean coral reef food webs, and this is borne out by the fact that in the Bahamas and parts of Cuba, where shark populations are still healthy, so are the reefs.

That's also true for a remote outpost in the Pacific, uninhabited Kingman Reef. Considered the most intact coral reef ecosystem in the world, it's also one of the few places in the world where sharks still dominate the marine ecosystem. On Kingman, the biomass of sharks and other predators like groupers and jacks is so high that the trophic, or energy, pyramid is reversed. The bulk of animal and plant biomass is usually concentrated in the lower ranks of the food chain, but at Kingman Reef the pyramid is turned on its head. In the impacted oceans of today, less than 10 percent of marine life on coral reefs is made up of predators, but at Kingman that figure is a staggering 85 percent, and reef sharks (whitetip, grey, and blacktip) make up over 75 percent of that. The corals themselves are vibrant and healthy and their principal competitor, algae, is virtually absent. As the human impact from fishing and population growth on neighboring atolls has increased, though, the shark populations have declined and so has the health of the coral reef.

Around the great middle of the planet, where coral reefs grow, more than 450 million people live within about 35 miles

OPPOSITE Galapagos sharks patrol a reef at Bassas da India. Sharks are abundant at this remote location in the Mozambique Channel.

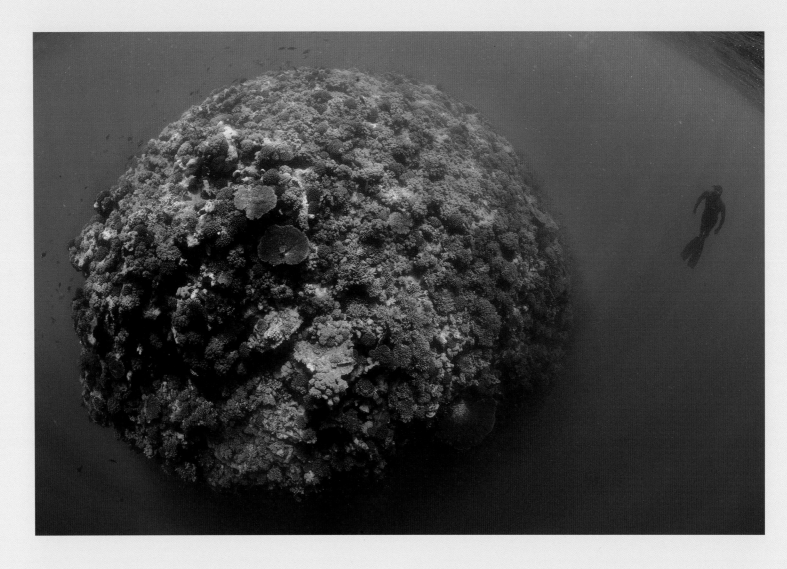

Healthy shark populations are vital for vibrant coral reefs, which are essential for attracting diving tourists.

(60 km) of coral reefs, and the majority of those humans derive, directly or indirectly, their food and income from the reefs. Properly managed, coral reefs can yield an annual average of 15 tons of fish and other seafood per square kilometer. Reefs are also a major piece of the tourism industry in many developing countries, drawing visitors who come to scuba dive and snorkel, generating worldwide a $4.1-billion industry. But coral reefs have other, less obvious benefits—as natural seawalls, they mitigate coastal erosion to the value of more than $9 billion every year and harbor a trove of medicinal compounds. Chemicals found in the likes of cone shells, sponges, sea fans, and nudibranchs are important components in new treatments for cancer, arthritis, asthma, and heart disease. The loss of a single coral reef complex, choked to death by algae, might deny humanity cures to various diseases and the opportunity to save the lives of millions of people. And reef biodiversity is an essential component to feeding the ever-growing human population. Sharks may just be a key to better reef health, and with that, a healthier planet overall.

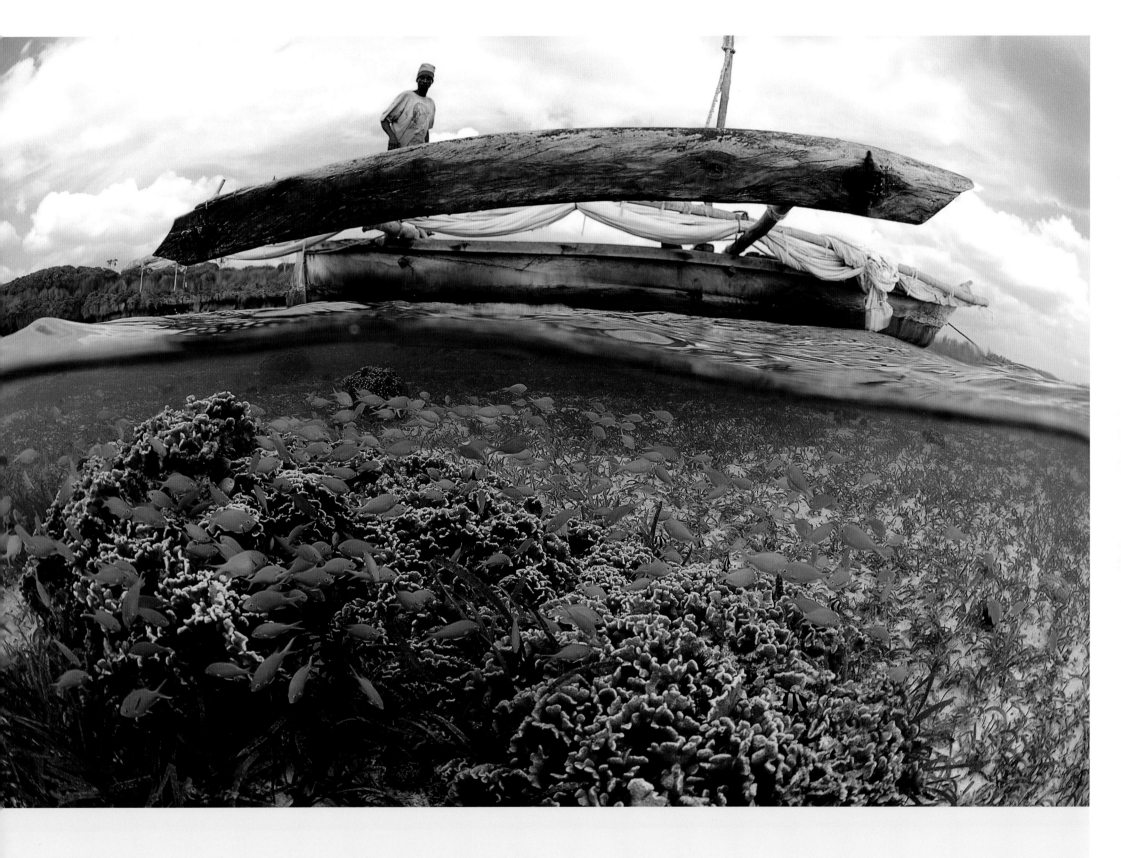

Healthy coral reefs directly influence the food security of many artisanal fishing communities.

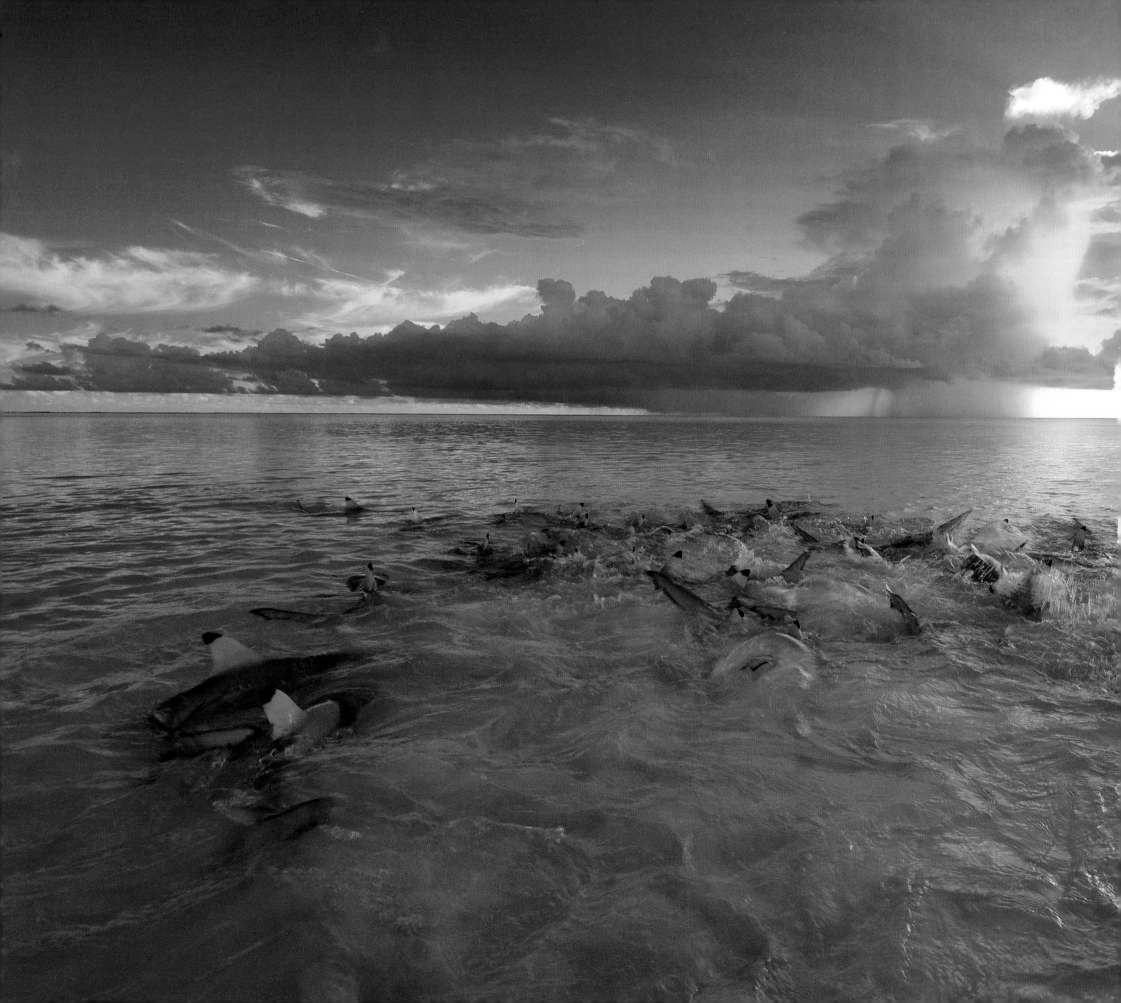

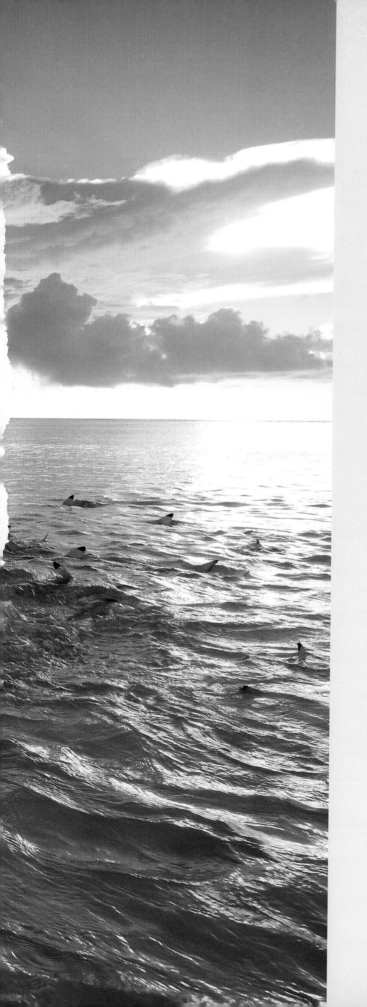

SHARK SANCTUARIES

The boat engine strains as we motor against the current that rips out of the only channel linking Bassas da India's large lagoon to the Indian Ocean. As we enter the lagoon, the distinctive dorsal and caudal fins of a big tiger shark break the surface as it passes us on its way out, probably to feed. We arrive at a coral pinnacle just as the sun dips beneath the horizon. Dusk is short-lived in the tropics and soon we are enveloped in total darkness. After a few sharp successive pulls, the boat driver coaxes the generator to hum and a jerry-rigged studio/movie light breathes its rays into the inky darkness of a nocturnal ocean. Like moths to a flame, over 30 Galapagos sharks emerge below the 400-watt light dangling precariously close to the sea surface.

As I gently slip into the water between clumps of curious sharks, the droning generator and hissing wind fade. I descend through a serene pyramid of underwater light beams. The sea is shallow here—about 30 feet (9 m)—and the light paints color and texture onto beautiful coral crowns. The sharks follow me to the reef, waltzing in and out of the light. The most visible and curious are three-foot-long juveniles.

The larger, more mature sharks loiter along the light boundary. The ocean becomes a crowded three-dimensional dance floor with close to a hundred sharks in attendance. Most reef fish retire safely into coral crevices, and only a hawksbill turtle saunters Zen-like through the rave of sharks. All too soon, after almost two hours, I exhaust my air supply and make my way to the boat. Ascending on the fumes of visual elation, I surface just after sucking up the last bit of air. Moments like this are vital sustenance for my soul and replenish my resolve to keep doing what I do. Whenever the stench of a polluted ocean or the brutality of shark finning threatens to overwhelm me with despair, Mother Nature intervenes and reminds me of the wonder that still graces our oceans.

One of the earliest protective measures for sharks was enacted in 1991, when South Africa became the first nation on Earth to make it illegal to catch and kill great white sharks. Most of the other early marine conservation measures also protected single species, such as whale sharks in the national waters off Western Australia, the Maldives, Seychelles, and Belize. The notion of creating marine reserves to protect

OPPOSITE Light shines into the depths of the lagoon of Bassas da India and attracts a gathering of curious juvenile Galapagos sharks.
PREVIOUS SPREAD A reef flat boils with sharks as a late-afternoon storm rages offshore.

a wider suite of sharks is more recent, though the concept of something like a marine protected area dates back to the practices of traditional societies of the Pacific. Today, marine protected areas (MPAs) are seen as one of the best weapons in the conservation arsenal.

Initially, reserves were implemented to protect coral reefs and commercially valuable species like lobster and abalone. Some reserves, like Aldabra Atoll in the Seychelles, Europa Island in the Mozambique Channel, and Aliwal Shoal in South Africa, have provided direct, albeit limited, benefits to sharks. But their small sizes (less than 10 miles (16 km) in diameter) offer limited security, with sharks frequently leaving their protective cordon. A more recent trend has been to proclaim much larger marine reserves specifically for sharks. The term "shark sanctuaries" is loosely applied when referring to countries that have opted to declare all or the bulk of their national waters off limits to commercial shark fishing.

Palau, a remote Pacific nation encompassing 300 islands, created the world's first dedicated shark sanctuary in September 2009, forbidding all shark fishing within its EEZ (exclusive economic zone)—a vast range of ocean the size of France (233,317 square miles or 605,000 km²). In the latter half of the 1990s, foreign tuna-fishing vessels were catching large numbers of sharks in Palau's waters. At the same time this small nation was developing a reputation as a world-class dive destination for incredible shark encounters. It was clear that both endeavors could not co-exist, as foreign longliners were killing off the future of Palau's fledgling tourism industry on a daily basis. This was rammed home in 2003 when authorities confiscated more than 1,600 pounds (725 kg) of shark fins and 10 tons of shark meat from a foreign vessel. Recreational diving revenue comprises nearly 39 percent of Palau's gross domestic product. Therefore, the proclamation of the shark sanctuary was not only visionary but ecologically and economically sound.

In 2010, soon after Palau's pioneering move, the Maldives, Indonesia, and Honduras declared shark sanctuaries, triggering a snowball effect with the Bahamas, Tokelau, Micronesia, Marshall Islands, French Polynesia, and the Cook Islands following with sanctuaries in 2011 and 2012. As of 2013, a global total of five million square miles (12.9 million km²), an area approximately the size of China and India combined, lies within declared shark sanctuaries. While this figure might sound impressive, it is important to note that the world's oceans span 140 million square miles (362 million km²) and sanctuaries are just 3.6 percent of this vast expanse.

The general public, along with a section of the conservation community, lauded the arrival of the global network of shark sanctuaries, but the real work has only just begun. "Paper parks" are conservation areas that are not meeting the aims for which they were created. Currently, many of the world's marine reserves have a hard time moving beyond the "declaration" stage and remain ideas on maps and in legislation, while in reality offering minimal protection in the water. In the Philippines, for example, only about 10 percent of the reserves are achieving their objective of habitat protection, and 80 percent of marine parks in Indonesia are considered ineffective.

Many protected areas fail because of a lack of sufficient resources, either to employ, train, and retain rangers or to purchase, maintain, and operate patrol boats. The newly proclaimed shark sanctuaries cover millions of square miles, and at present the capacity to patrol these areas effectively is severely limited. Locating illegal shark-fishing vessels in the vastness of the open ocean is like finding a needle in a haystack. Yet despite these challenges, authorities within the new Marshall Island sanctuary have already seized 1,500 pounds (680 kg) of illegally fished shark fins and 60,000 pounds (27,216 kg) of meat. To date, four cases there have resulted in successful prosecutions with fines totaling

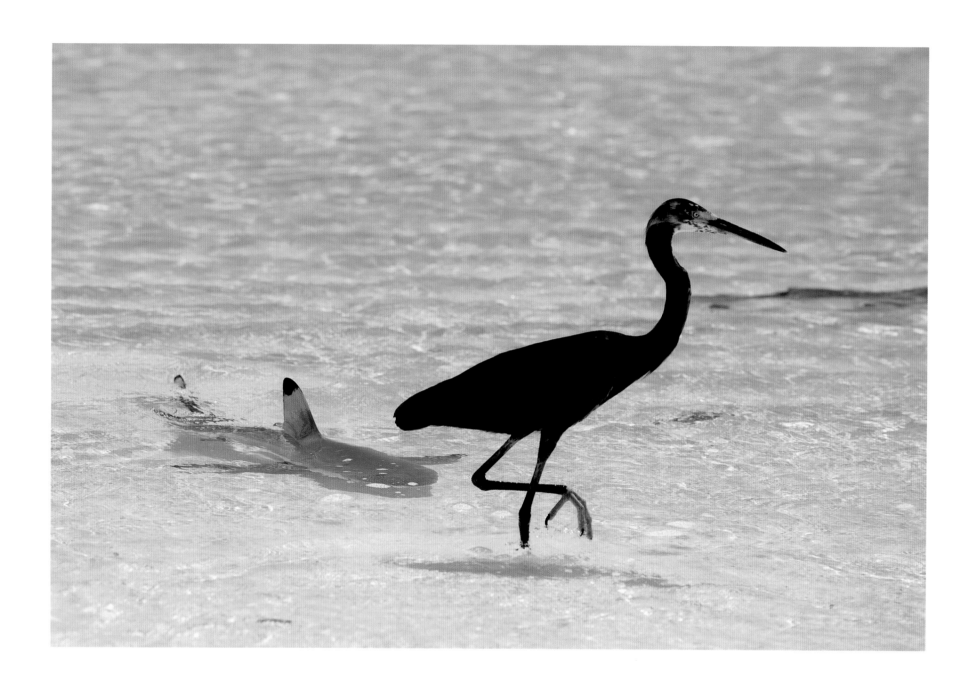

At Aldabra Atoll sharks and egrets are not on each other's menus,
but rather hunt side by side for small fish and invertebrates.

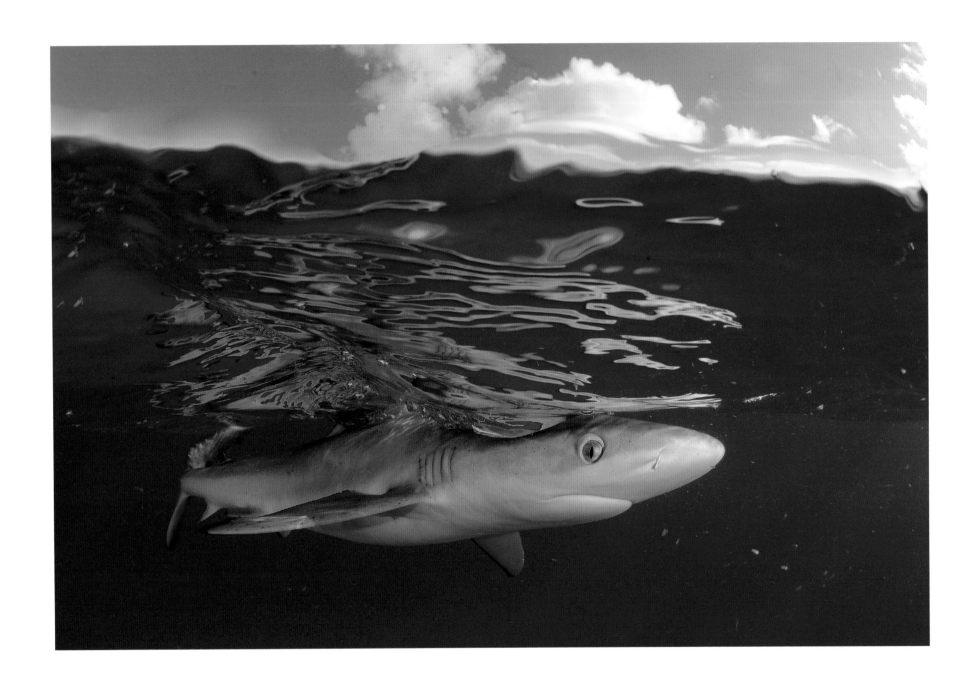

Shark sanctuaries are particularly important for juveniles, like this young Galapagos shark, that rely on abundant prey and minimal human encounters to thrive.

more than $230,000. Similar successful enforcement operations have also been carried out in Honduras and Palau. These are important but small localized victories, and law enforcement will need to be of a constant and sustained nature to truly protect these large high-seas sanctuaries in perpetuity.

Even with well-funded enforcement, without the active involvement and support of communities living in and around the sanctuary, there is little hope for sustained success. The sanctuaries' economic benefits must trickle down to the local community. Governments, scientists, business leaders, and other stakeholders must collaborate with artisanal fishermen to develop economic alternatives to shark fishing, such as training and guiding fishermen to take advantage of opportunities in the ecotourism industry.

A shining example of community investment in a marine reserve is Fiji's Shark Reef Marine Reserve, a small patch reef on the south coast of Viti Levu that is home to more than eight different shark species. Among them, the bull shark is the numerically dominant species, with more than a hundred individuals recorded. Some of these have been regular visitors to the Shark Reef Marine Reserve for over 10 years. In Fiji, reefs are seen as natural resources and as such are traditionally owned and managed by the adjacent villages. This customary marine tenure and fishing-ground management is locally referred to as *qoliqoli*. In 2002 a local dive operator began working with two villages to create the Shark Reef Marine Reserve Project, with the aim of establishing "no take" zones along the reef that would be devoted exclusively to sustainable shark diving. In exchange for a moratorium on all fishing, the two villages would receive compensation in the form of a marine park levy paid by scuba divers. In 2003 the villages were paid approximately

$10,000; by 2008 they received $20,000. In addition, members from each village received dive master training. In fact, today the majority of staff for the reserve project are Fijians from the partner villages. In 2004 the government also endorsed Shark Reef as a national marine reserve, and local villagers were trained as wardens to enforce traditional fishing rights in addition to the rules of the reserve. In 2006 another village joined and all three collectively banned shark fishing in their combined qoliqoli, creating 30 miles (48 km) of protected reef and coastline—the Fiji Shark Corridor.

There is, however, a deep chasm between creating protection for coastal sharks and protecting pelagic sharks from high-seas commercial fisheries. Fiji and other locations have shown that tourism and marine reserves can become a culturally acceptable alternative to artisanal fisheries. However, on the high seas, shark tourism opportunities are limited, and often the fishers who could benefit from the shark tourism/shark sanctuaries are not those who benefit from shark fishing. In fact, therein lies one of the major problems with holding shark tourism up as an economic alternative to fishing—the people/sectors and even nationalities (all foreign crews on many vessels) involved in fisheries are often completely different from those involved in tourism.

The etymology of the word "sanctuary," specifically as it relates to providing safe refuge for animals, dates back to 1879. For sharks, these refuges can take many forms, from small, dedicated marine reserves to massive oceanic protectorates. Regardless of how effective shark fisheries management might one day become, there will always be the need for marine protected areas that provide effective safeguards for sharks. Sharks need asylum from both small local and large-scale transnational fishing fleets if they are to survive another 300 million years.

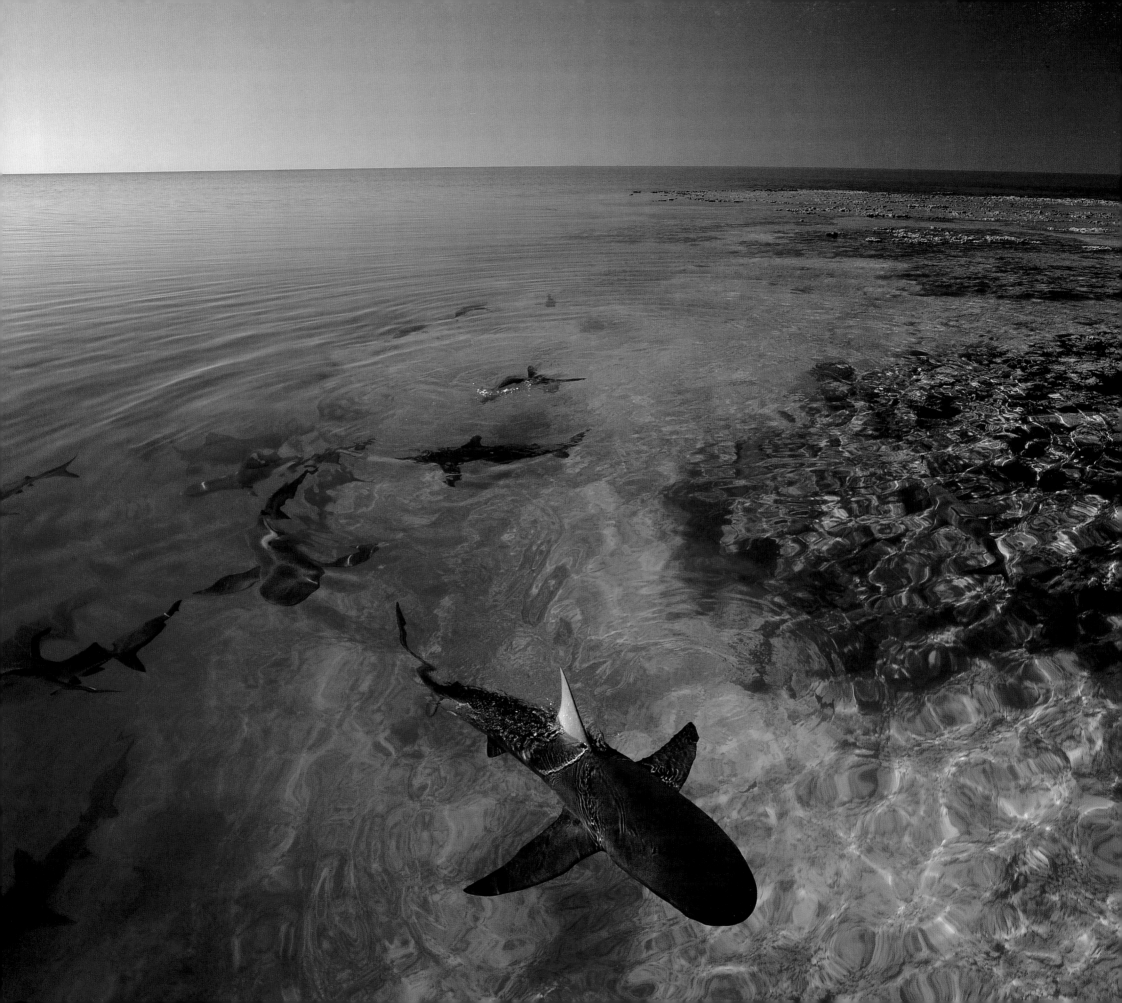

Bassas da India's lagoon is peppered with coral reefs, hosting concentrated populations of juvenile Galapagos sharks.

The boldness of Galapagos sharks is apparent as they inspect a remote camera set up to record shark diversity and abundance.

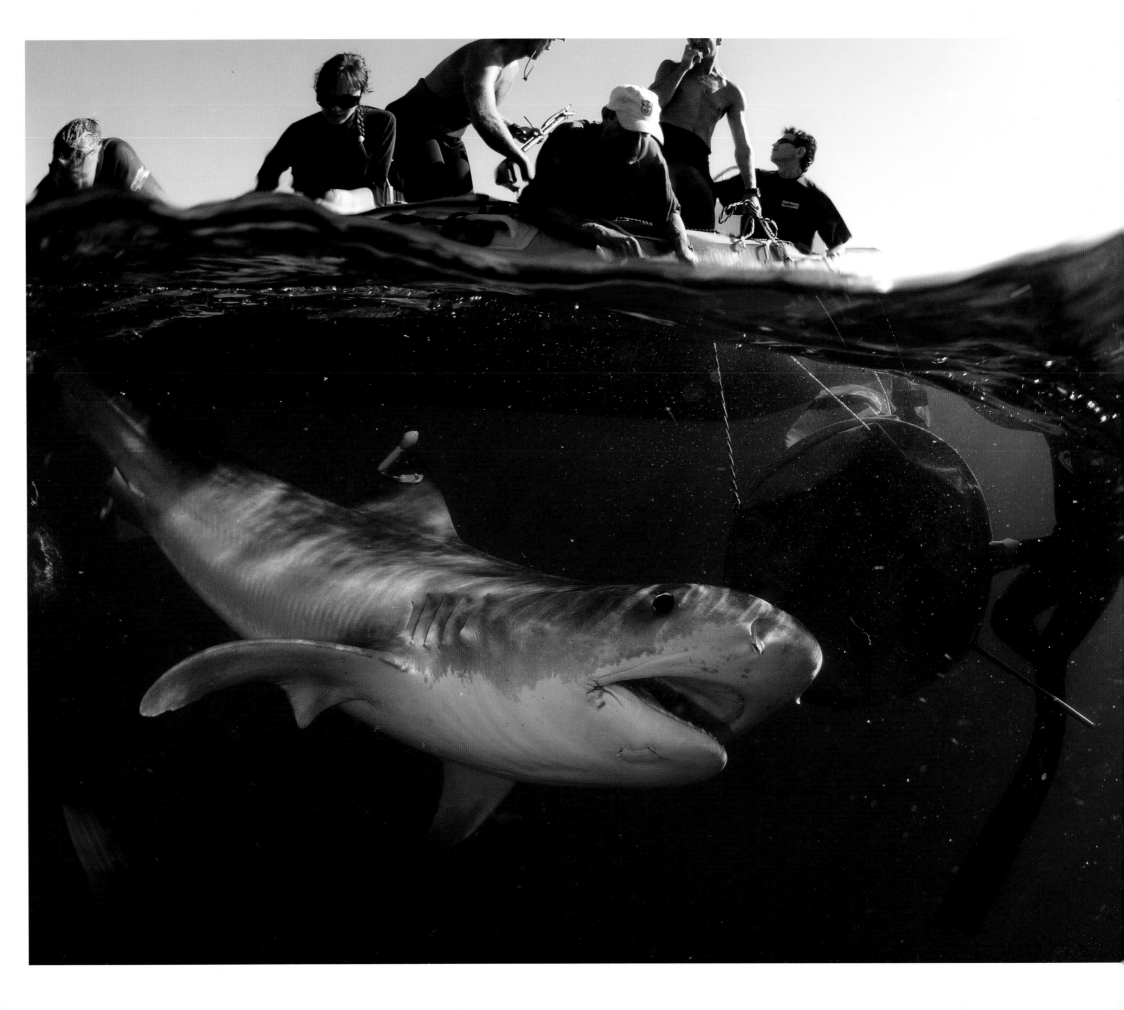

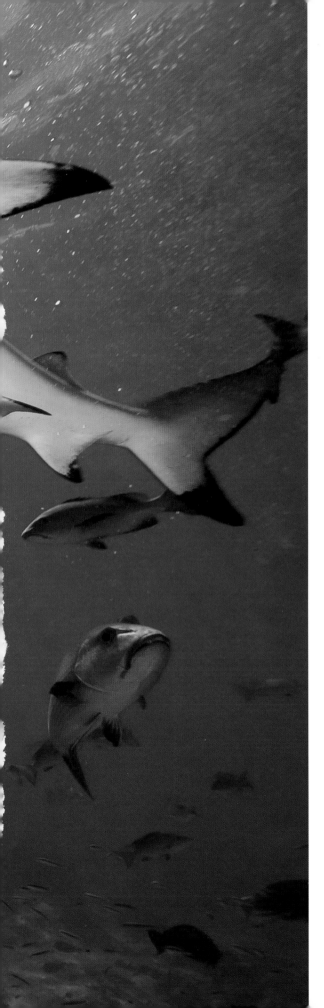

Providing sanctuary for sharks can often benefit other predators too, such as this large potato grouper at Aldabra.

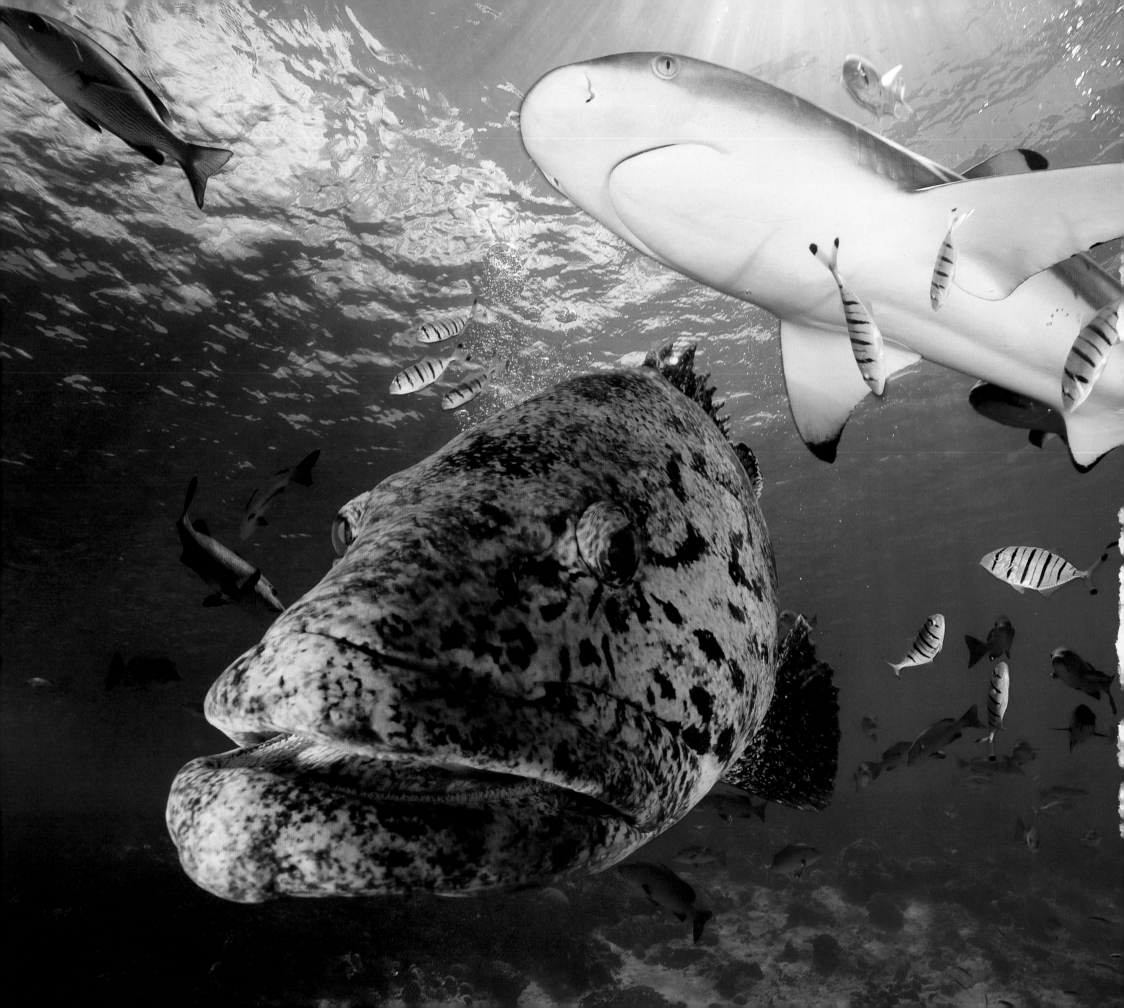

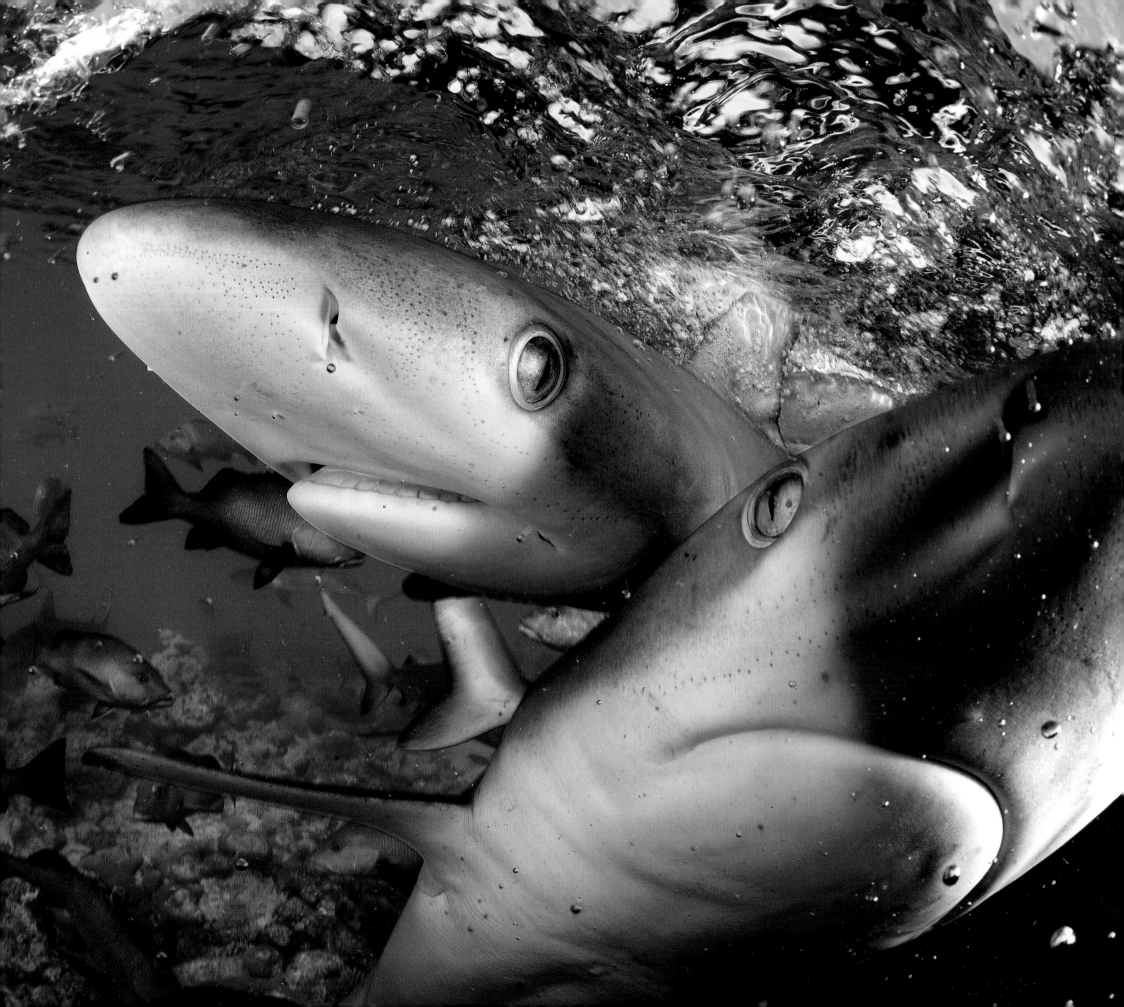

TAGGING SHARKS

ELUSIVE CREATURES, sharks spend the majority of their lives beneath the waves, which makes it challenging at best to scratch the surface of their ecology. For the past several decades, researchers have used several tagging methods to uncover more about shark movement, migration, and behavior. Initially, tags consisted of metal and plastic disks engraved with numeric codes and were designed to capture important data on distance and geography traveled. Fishermen were asked that when they captured a tagged shark, they send the tag back to the researcher, whose name and address were on it.

Advancing from these simple conventional tags, scientists began attaching electronic tags. These range from straightforward acoustic transmitters attached to the study animal and detected with receivers to collect presence/absence data to technologically more sophisticated satellite tags. For example, SPOT (Smart Position Only Transmitter) tags are attached directly to a shark's dorsal fin or towed torpedo-style behind larger sharks. Each time the tag's antenna breaks the ocean surface, it transmits a signal to an orbiting satellite, which provides real-time data on the shark's movements and environmental parameters. Another type of satellite tag is the PSAT (Pop-up Satellite Archival Tag). This tag records and stores, for a preset time interval, pressure (depth) and temperature data, along with light-level data that allow scientists to calculate an approximate longitude and latitude and reconstruct the animal's track. On the predetermined date, the tag becomes detached from the shark, floats to the surface, and sends the stored data to a satellite. The data are then e-mailed to the researcher.

Tiger sharks were some of the first sharks studied using electronic tags, and they continue to be popular subjects. When scientists started observing tiger sharks, they thought the animals spent their lives close to shore on coral reefs. Only in the 1990s did tagging studies in Hawaii reveal how extensive their offshore movements among islands really were. However, it was a recent tagging project off Bermuda that showed something really unexpected. Tagged sharks left Bermuda in winter and migrated to the warmer waters of the Bahamas. In the spring, to many researchers' surprise, they headed offshore, spending almost six months in the middle of the Atlantic Ocean. As of now, nobody knows what the sharks do there, whether they feed or mate or something else. Only future tagging efforts will reveal more about this mystery.

On November 7, 2003, a satellite tag was fitted to a 13-foot (4-m) female great white shark nicknamed Nicole off South Africa's Dyer Island. The trailing edge of her dorsal fin had a very distinctive pattern, and she was a regular visitor to the island

OPPOSITE A tiger shark is released after being fitted with a satellite tag at Aliwal Shoal, South Africa.

between July and December. Her whereabouts during the first half of the year, however, remained a mystery. Her tag was programmed to detach roughly four months later, on February 28, 2004. In the early hours of that final day, the PSAT surfaced off the western coast of Australia and began transmitting several months' worth of data. According to the data, Nicole had traveled nearly 7,000 miles (11,000 km) in 99 days—an average of 70 miles (112 km) a day. This amazing journey across the ocean from Africa to Australia was the first recorded transoceanic migration for any shark species. The data also revealed that she dove regularly to depths of 3,215 feet (980 m) and endured temperatures as cold as 38 °F (3.4 °C). And just like clockwork, on August 20, 2004, her distinctly shaped dorsal fin was again spotted off Dyer Island. In a little more than nine months she had completed an out-and-back journey between South Africa and Australia—a journey of over 14,000 miles (22,000 km).

According to other tag data, Nicole is not the only ultra-marathoner among shark species. Great white sharks in the Pacific have also been known to undertake similar epic odysseys; one male tagged along the California coast migrated to Hawaii, where he remained for nearly four months. Before the advent of high-tech tagging, basking sharks were always thought to spend their lives in cold temperate seas near Scotland, Ireland, Norway, New England, and Canada. However, tag data show that they also spend time in tropical seas. A 16-foot (5-m) female traveled 3,100 miles (5,000 km) from Ireland to Senegal in West Africa, and a shark tagged off Massachusetts spent the winter in the Caribbean and ventured as far south as the mouth of the Amazon River.

There are real world conservation benefits to tagging data; chief among them is helping researchers and fisheries managers identify regions of ocean where sharks are most vulnerable to overfishing. Tiger sharks, for example, are protected in the Bahamas shark sanctuary, but when they venture out into the middle of the Atlantic for months at a time they are in no man's land in terms of conservation. Great white sharks have been protected in South Africa since 1991, but tagging data show that they often leave the country's safe embrace and cross into unprotected international waters. Realizing that national protective measures are inadequate for great whites was crucial to their receiving a CITES (Convention on International Trade in Endangered Species of Wild Fauna and Flora) Appendix II listing in 2004.

Not everyone is a fan of tagging. Attaching SPOT tags to large species like white sharks can involve hooking the shark and exhausting it until it can be safely brought alongside the boat, which can take an hour or more. Then the tag is either fitted in the water, or the shark is raised out of the water on a hydraulic lift platform. Although its gills are constantly flushed, the shark spends many minutes out of the water. Researchers drill and bolt the SPOT tag to the shark's dorsal fin. Proponents of this method say that the stress levels experienced by the animal are within acceptable limits, while opponents believe that the hooking, exhaustion, and time spent out of the water are tantamount to animal cruelty. SPOT tags, if left on for several months, have also been shown to cause permanent damage to the dorsal fin. In contrast, 30 years ago, killing sharks was part and parcel for gathering scientific data. Now, even the risk of damaging animals through tagging invokes widespread public outcry. We've come a long way, but the age-old argument continues: What price should an individual animal have to pay for scientific research and data aimed at helping save its species all over the world?

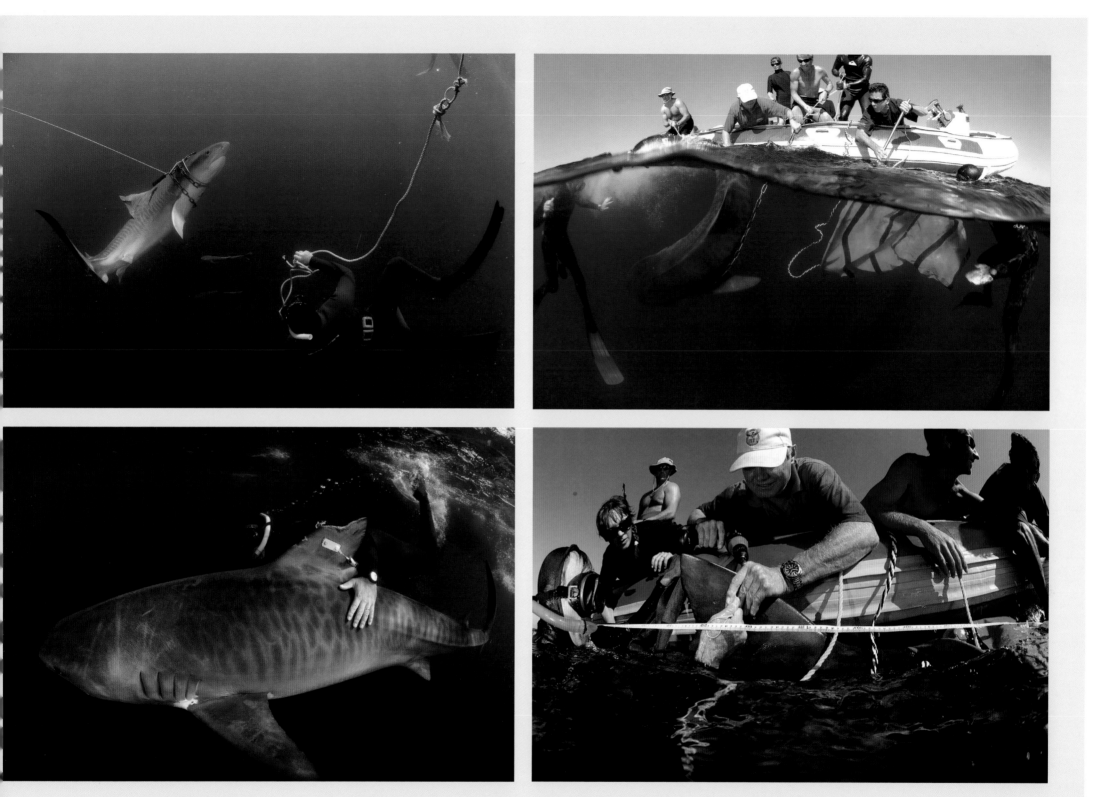

CLOCKWISE FROM TOP LEFT *A diver attempts to attach a tail rope to a tiger shark to secure it to the boat for tagging. Both above and under the water, scientists hook and corral a tiger shark towards the research boat. A satellite tag is fitted to the dorsal fin and will record the shark's location and depth. Fitted with the satellite tag, the exhausted shark is gently guided on its way until water flows over its gills and it is able to swim on its own.*

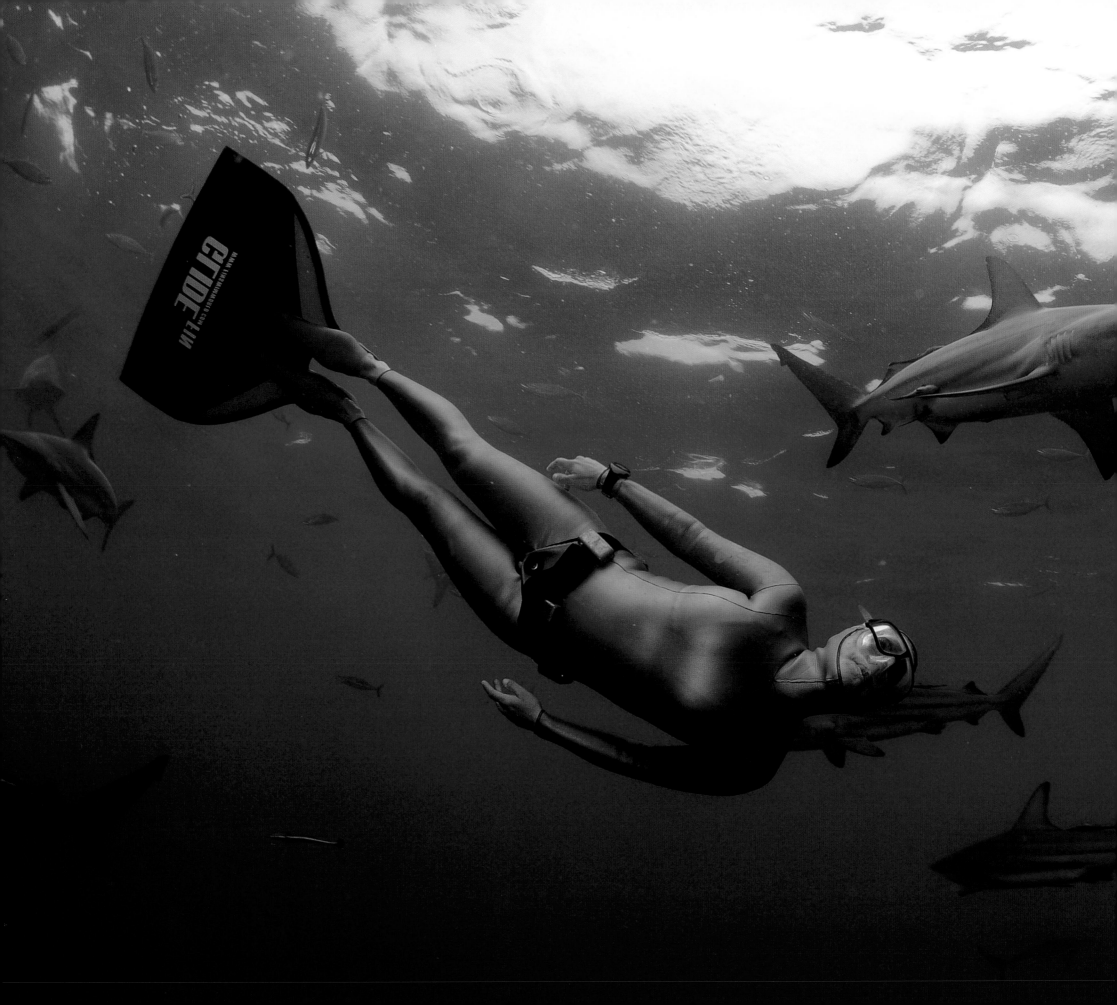

SHARK TOURISM

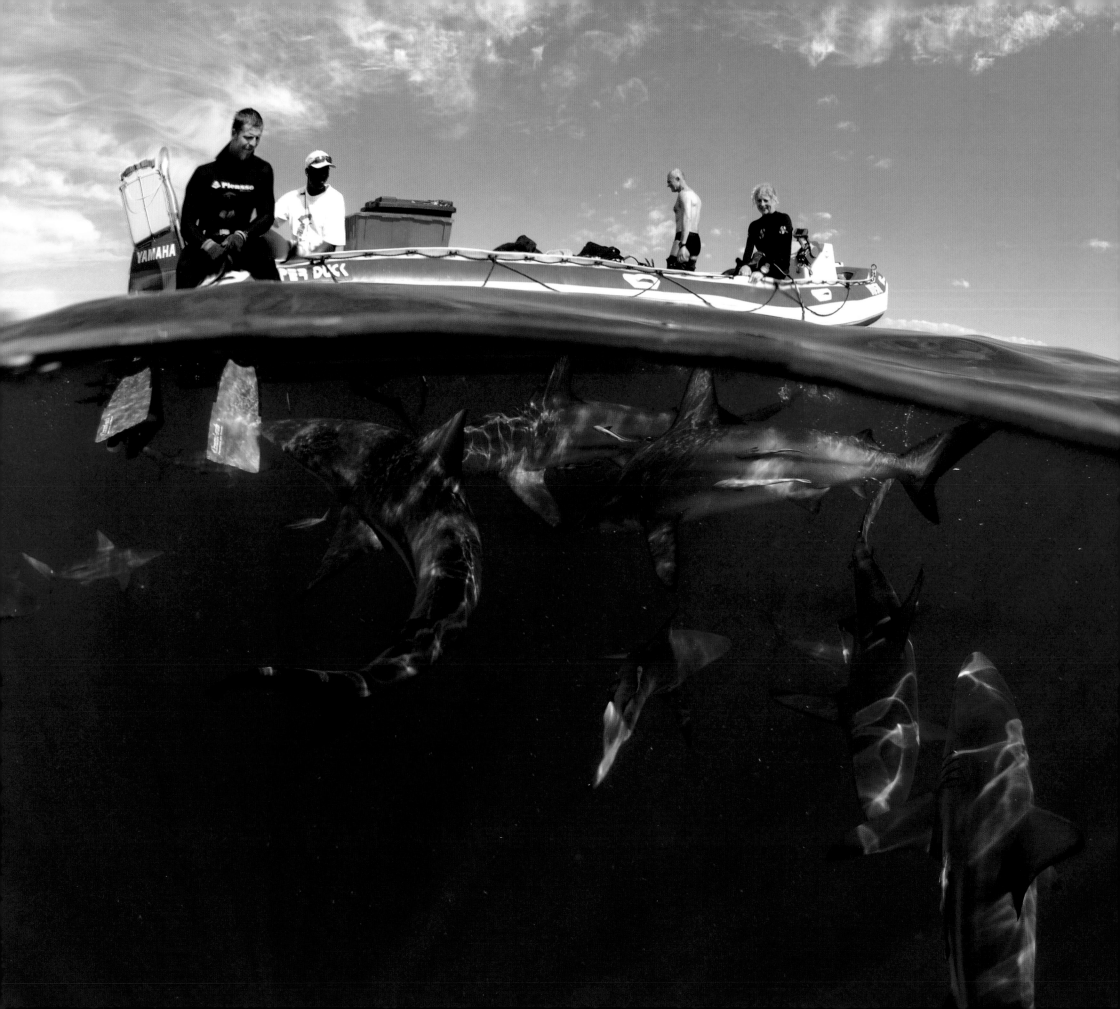

On a miserable day in the middle of winter, I push my 60-year-old mother into the icy waters of the Atlantic. Nearby, a 13-foot (4-m) great white senses the commotion and rounds to investigate. My mother faces the shark, then disappears under the choppy water for what feels like an eternity. She returns to the surface, gasping for breath … but smiling. I suppose the galvanized steel cage between her and *Carcharodon carcharias* has something to do with that.

Between 2003 and 2005 I spent over a hundred days at sea in pursuit of photographs for a book on great whites. Spending so much time in close proximity to this tribe of sharks, I became familiar with the unique dorsal fin patterns of certain individuals. In a strange way, the sharks felt like family, so it seemed natural to introduce them to mine. My parents are rational, open-minded, and well traveled, yet wary of sharks—especially the great white. Surprisingly, though, despite the shock of cold water and the close proximity to a large toothy predator, my mom did not demand a hasty exit. With each pass of the shark, her breathing slowed in all-consuming awe. After 15 minutes, her time was up. She begrudgingly surfaced and climbed back onto the boat to give someone else a turn. It had taken less than 20 minutes for the metamorphosis in her thinking; the dangerous killer shark had become a majestically beautiful predator.

For more than half a century, tourists have paid top dollar to view and photograph Africa's terrestrial wildlife. The fact that lions and elephants are now worth more alive than dead has influenced some African countries, such as Botswana, to ban recreational hunting in favor of wildlife ecotourism. Until recently, the only good or valuable shark was a dead shark, but as our knowledge and understanding of sharks has evolved, so too has our relationship with them. Shark tourism is an outflow of this changing relationship. It was pioneered in the late 1960s with a few adventurous souls feeding grey reef sharks by hand in the Maldives and others outfitting their fishing boats for cage diving with great whites off Australia. Swimming with Caribbean reef sharks in the Bahamas, diving with blue sharks off southern California, and snorkeling with whale sharks at Australia's Ningaloo Reef followed in the 1980s, but it was in the 1990s that shark diving exploded onto the global tourism circuit.

In a recent survey of scuba divers, sharks came out on top as the most desired animals to see, and many divers were willing to pay extra for this experience. Several economic analyses showed that a single grey reef shark was estimated to be thousands of times more valuable alive than dead. Over the course of the average grey reef shark's life span (15 years), it could bring in over $200,000 in tourism revenue, whereas a set of grey reef shark fins would be worth only some $50 to a local fisherman. Tiger sharks in South Africa are considered even more valuable, with each one bringing in $63,500 in ecotourism revenue every year. That means each shark is worth approximately $2 million over the course of a conservative 30-year life span.

In 2012 there were 376 established shark ecotourism businesses in 29 countries. The Pacific region hosts the highest number of shark

OPPOSITE *Blacktip sharks gather around a shark diving tourism boat off South Africa's Aliwal Shoal.*
PREVIOUS SPREAD *South African free-diving champion Hanli Prinsloo mingles with blacktip sharks at Aliwal Shoal.*

dive sites, followed by the Caribbean and North America. Some of the greatest concentrations of shark tourism operations are in Mexico (Holbox), Honduras (Utila), Belize, Australia (Great Barrier Reef), Palau, and the Maldives. In roughly half of all shark dive sites, reef sharks are the primary attraction. Whale sharks are the second most sighted sharks, making up 30 percent of encounters. From an economic perspective, sharks have become veritable gold mines for several countries. In French Polynesia dives with lemon sharks off Moorea Island earn around $5.4 million every year. The Bahamas, with over 25 years of recreational shark encounters, tops the scale. At this time wild shark viewing contributes an estimated $78 million per year to the Bahamian economy.

Shark tourism runs the gamut of practices and methods. Glimpsing silhouettes of timid hammerheads from a hundred feet below, swimming eye to eye with hand-fed bull sharks and cage diving with great white sharks are just a few of the available options. Shark tourism can be classified into two distinct encounters: natural or provisioned. In natural encounters sharks are intentionally sought out, but they're observed with as little human interference as possible. Provisioned encounters use chumming or direct feeds to attract sharks. Chumming is the act of luring in sharks by throwing a mixture of fish oils, blood, and parts into the water. This method, along with direct feeding or baiting with fish, gives sharks an incentive to be in close proximity to divers, whom they tend to avoid in a natural setting.

The practice of feeding or attracting wildlife with food is increasingly frowned upon in the ecotourism industry. However, shark tourism is an anomaly in that the practice of baiting and feeding continues to grow and is now one of the most sought-after wildlife viewing experiences in the world. Opponents of provisioning believe that baiting is unnecessary to a successful operation. Their approach is to

frequent locations with healthy shark populations and view from a safe distance. In Palau none of the dive operators bait or chum for sharks, yet shark diving generates an estimated $18 million per year, approximately eight percent of the GDP. Still, some shark diving operators feel that provisioning is essential to provide a consistent and high-quality experience to tourists, which is crucial for economic viability. Vigorous debates are ongoing about whether or not provisioned shark tourism alters shark behavior, the ecology, and ultimately the local marine ecosystem.

On the other hand, the impacts of natural shark tourism appear negligible, though there is evidence that it can affect whale sharks adversely. Because they feed on the surface, they are more easily disturbed by snorkelers and are at risk of being injured by tourist-boat propellers that come too close. However, scientific research on the impacts of shark tourism in general is still in its infancy, with less than a dozen peer-reviewed scientific papers published on the subject. Therefore, it's not surprising that results are controversial, often providing conflicting conclusions to the same question.

One site that has been studied is off the Neptune Islands in South Australia, where shark cage diving is a provisioned ecotourism industry that has undergone recent dramatic expansion, increasing operating days from 128 to 270 days every year. There is robust data on white shark behavior and ecology before these changes occurred, so the area provides a unique opportunity to examine whether tourism affects the sharks' behavior over time. After the increase in tourism, the average amount of time (residency period) sharks spent at the islands increased from 11 to 21 days. In addition, the number of consecutive days sharks spent at the shark dive site increased from two to 6.5 days. The daily activity rhythms of the sharks also began mimicking the arrival and departure of shark cage diving operators. It was observed

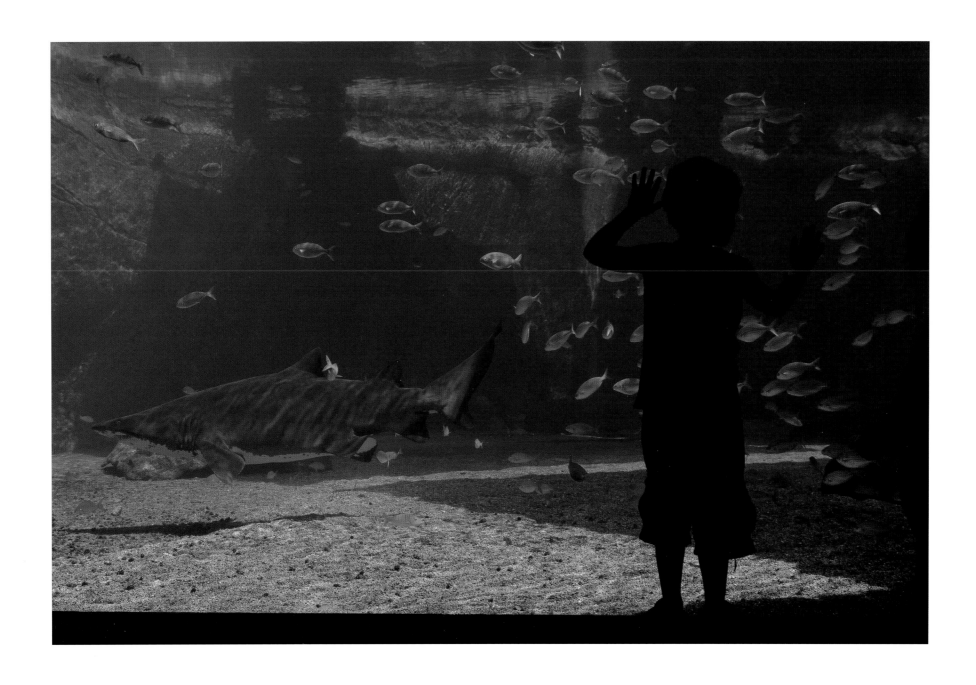

A young boy has his first shark encounter through the double-paned
three-inch-thick glass of an aquarium.

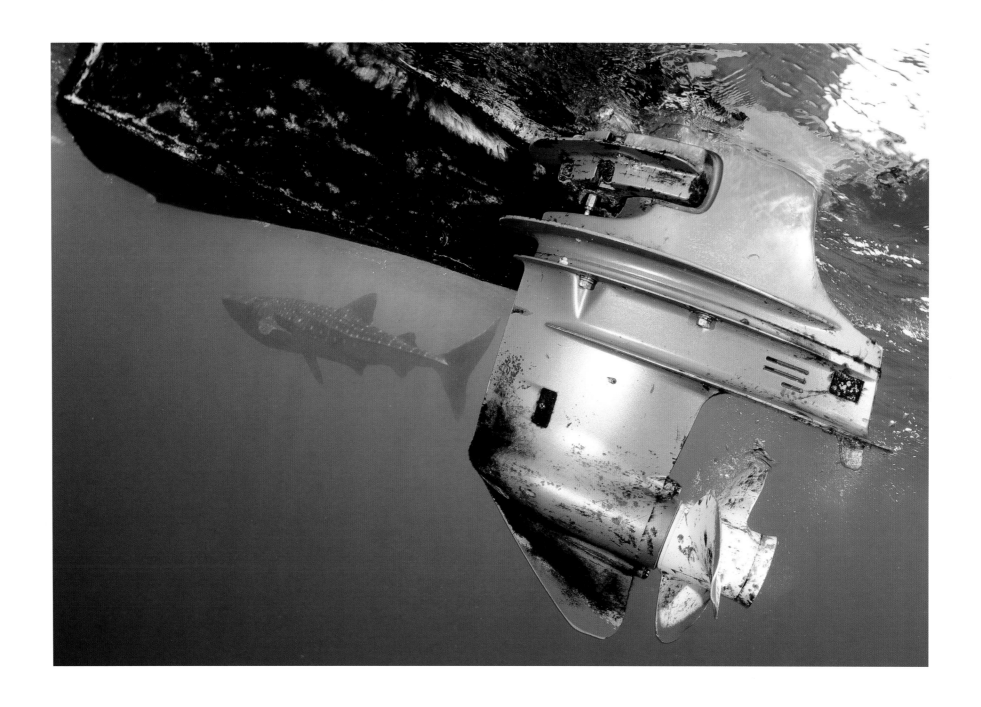

In some locations, tourism can have negative effects. Boats that come too close can seriously injure surface-dwelling whale sharks.

that this behavior took place whether cage diving happened or not. Behavioral changes in the wake of provisioned tourism were also found in whitetip reef sharks in Australia's Coral Sea. Normally, whitetips rest at a fairly constant depth in caves and crevices during the day and migrate vertically through the water column at night. However, when tourism boats are at the Coral Sea site, the sharks seem to reverse their behavior, becoming more diurnal. This daytime activity brought on by shark tourism potentially compromises reproduction, fitness, growth rates, and the overall health of the whitetips. Such impacts have never been verified for sharks but have been recorded for other species. For example, disturbances caused by whale-watching vessels was linked to reduced energy intake of up to 18 percent by killer whales.

Other impacts of provisioning on sharks, such as a greater risk of inbreeding and trophic level disruptions in the entire ecosystem, have been hypothesized but not rigorously tested. There have also been locations where few if any impacts of shark tourism have manifested. In the Bahamas, tiger sharks are attracted year round to Tiger Beach through provisioning, while in nearby Florida, shark feeding is strictly prohibited. A satellite-tagging study compared the movement of tiger sharks both in Florida and at the Bahamas shark dive site. Contrary to expectations, the study showed that tiger sharks at the provisioning site had lower site fidelity and a broader range than those in Florida. Yet some dive operators in the Bahamas claim that a resident population of sharks is present year round, with many of the same sharks identified throughout the year.

Across the Atlantic in South Africa a study on the white sharks of Seal Island showed that provisioning tourism appeared to have negligible effects on the sharks' foraging behavior. The frequency of their natural seal-hunting remained the same, and their interest in cage diving boats waned as the season progressed. At Seal Island, though, shark tourism

operates only 80 days a year, a third of the time the operators studied in Australia spend on the water. In the coming decades, it's hoped that more research into the effects of shark tourism will spawn further questions and elucidate more of the mysteries of shark behavior.

There is some evidence that shark provisioning in French Polynesia has led to increased aggression in lemon sharks during feeds and dives. These aggressive episodes are not normally directed at people but more at competitors for the provisions. With the exception of one tragic fatality and less than half a dozen serious bites, shark diving has an otherwise good safety record. Most bites are minor, the result of the feeder's bare arm or hand being mistaken for a piece of fish.

Injuries to shark-diving participants are one thing, but there's also concern that shark provisioning is creating a safety hazard for non-participants, such as divers, snorkelers, swimmers, and surfers in close proximity. Does provisioning condition sharks to associate people with food and make them more aggressive in the presence of people and boats? Are provisioned sharks more likely to bite water-goers? In Florida and Hawaii, the public has successfully used this potential connection as a platform to outlaw provisioned shark tourism.

The great majority of wild animals are naturally wary of humans, but through regular feeding, animals can quickly become habituated to the presence of people. There are numerous cases where wildlife, ranging from baboons to bears, have become unnaturally aggressive toward humans when the animals were repeatedly fed. In several national parks, these habituated animals presently pose a safety threat to visitors. Could provisioned sharks respond in a similar manner?

In experiments similar to those of Pavlov, the first trials on sharks were performed in the 1960s. In one experiment the sharks were conditioned to make contact with a plywood target to trigger a bell and be rewarded with food. Other studies have yielded similar results,

with lemon sharks conditioning up to eight times faster than domestic cats. But all research was carried out on captive sharks in a controlled environment. In the wild, things seldom run so smoothly. In his experiments, Pavlov found that the conditioned reflex was repressed if the stimulus was not always connected to food or other positive reinforcement. Something similar happened with sharks: When a shark had a bad experience, for example being startled by the introduction of a differently colored target, it would refuse to touch the target. It seemed that all conditioning was lost when the strictly controlled environment changed even slightly. In a real-world ecotourism scenario, a disturbance could be in the form of a diver, another shark, or the act of bumping into a shark cage.

Technically, while it's possible for sharks to become conditioned, is there any evidence for a direct link between provisioning and shark bites on non-participants? If South Africa is any gauge, it appears not. Provisioned white shark cage diving began in 1992 and in the 14 years before its advent, 30 white shark bites were recorded in South Africa. In the 14 years after the start of cage diving, 32 white shark bites were recorded. In False Bay and along the west coast of the Cape Peninsula, the areas perceived to have been impacted the most by this tourism, there has been a 25 percent increase in the number of bites, which correlates with the reported increase in ocean-users. If white sharks were making an association between cage divers and food, one would expect a dramatic increase in bites on people engaging in similar underwater activities. However, bites on divers have decreased by almost 50 percent, while those involving surfers have increased by 30 percent. Still,

the controversies surrounding provisioned shark tourism will continue to persist as long as uncertainty and questions remain. As scientists continue to study its effects across a continuum of species and locations, their findings will no doubt inform the way shark diving is carried out.

In a world where nature is expected to earn the privilege of not being fished or logged into oblivion, sharks, along with other fauna and flora, are finding their inherent right simply to exist challenged. It seems that wildlife associated with non-consumptive economic benefits is more likely to be protected, and sharks have become an important economic provider, worth significantly more alive than dead. From snorkeling with whale sharks to diving with great whites, these encounters provide impoverished fishing communities with income, tourists with life-changing experiences, and some countries with millions of dollars in revenue. Shark tourism also accrues crucial conservation and education mileage for sharks. Getting close to wild animals creates a unique experience and tourists of all ages and backgrounds are known to form bonds and build empathy during such close encounters.

For sharks to survive, far more people will need to know and care about the role they play in the ocean. After all, who is going to protect an animal if it's widely believed that animal is going to attack them the moment they venture into the sea? The Senegalese environmentalist Baba Dioum put it well when he said, "In the end, we will conserve only what we love, we will love only what we understand, we will understand only what we are taught." Shark diving can be the spark that ignites a deep-rooted transformation of hate and fear into awe and fascination for these magnificent animals.

The astounding size and gentle nature of whale sharks make swimming with them a sought-after tourist activity.

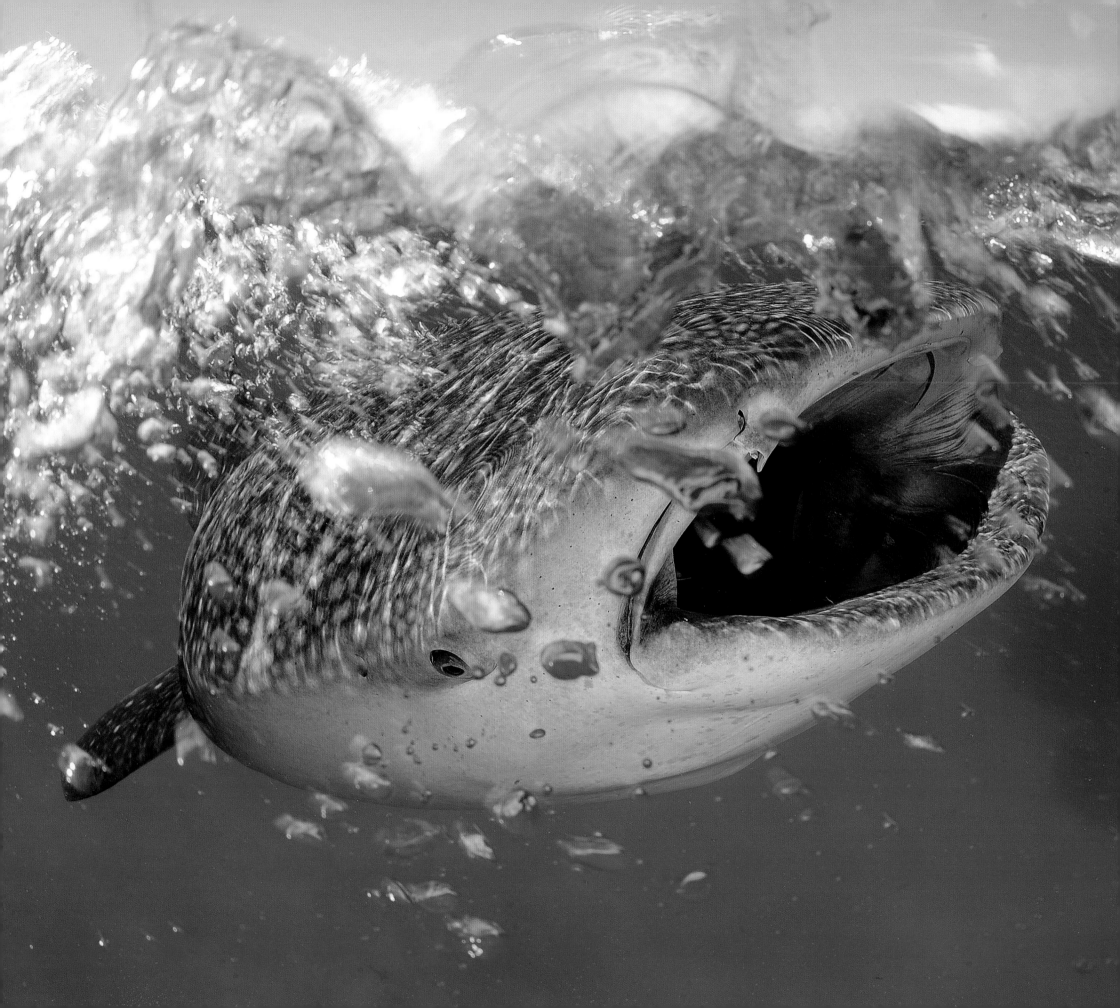

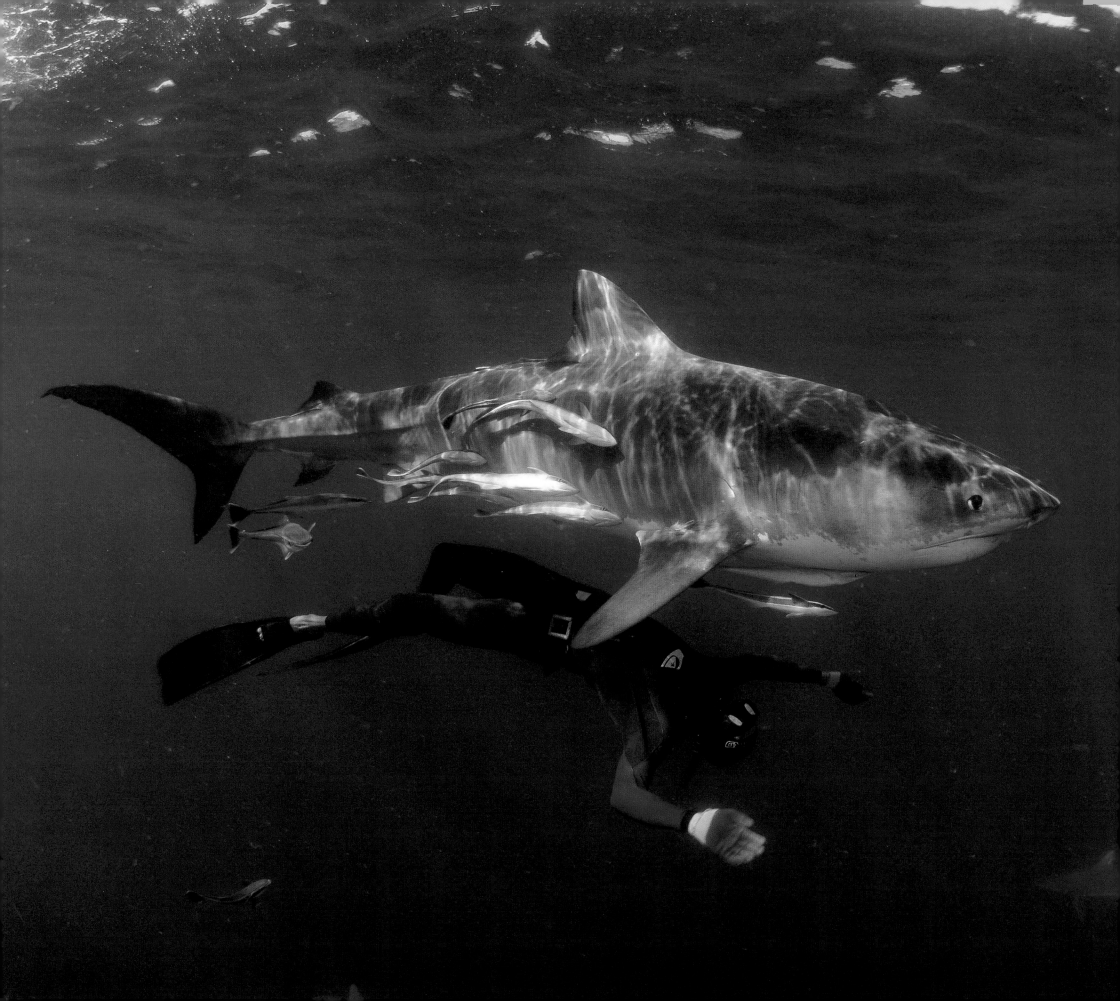

The tiger shark has garnered the unfortunate reputation of being an aggressive and dangerous species. However, the tiger sharks at Aliwal Shoal break the mold, being largely docile by nature.

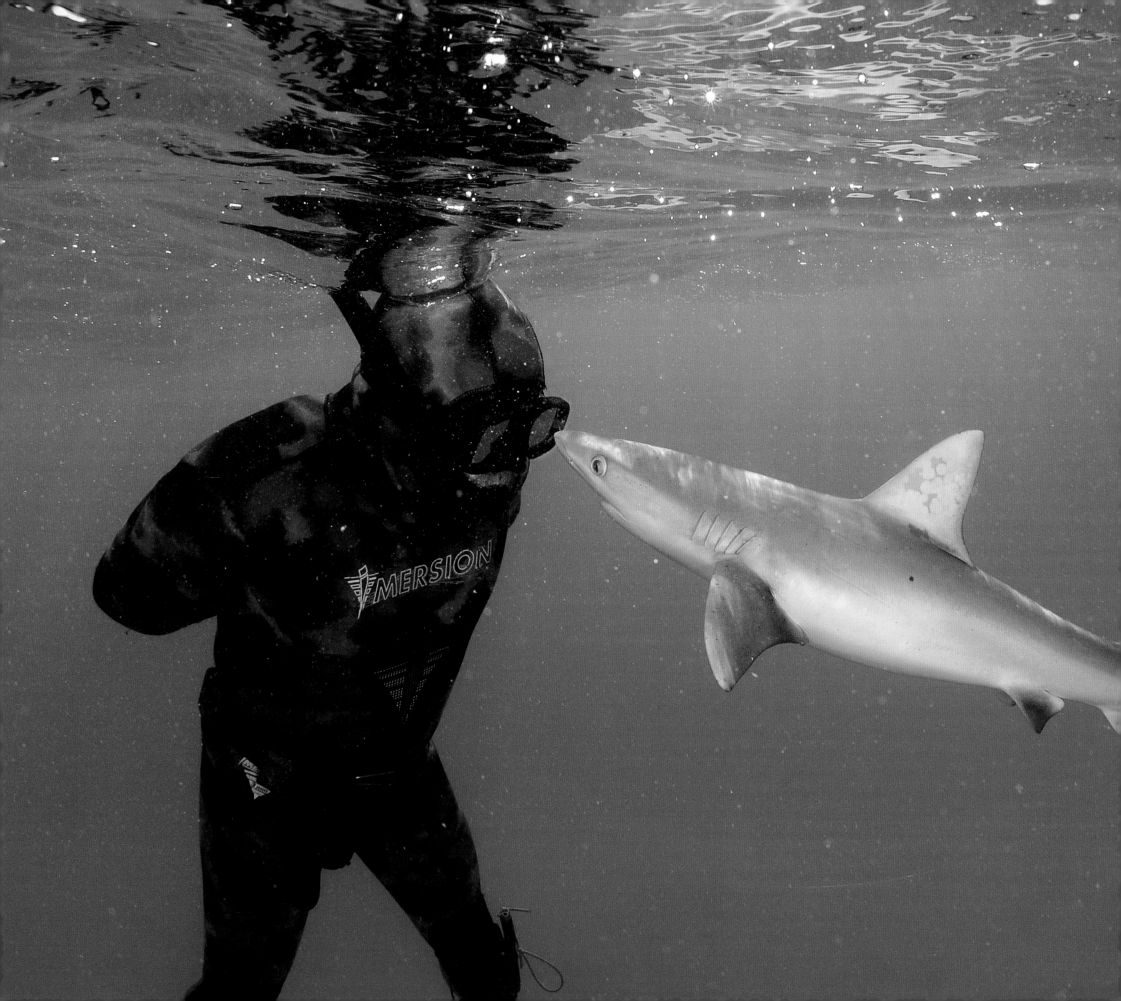

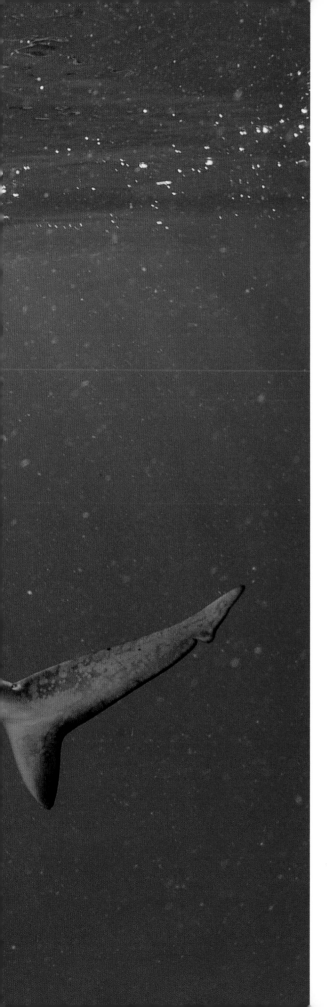

A juvenile Galapagos shark curiously and calmly inspects its reflection in the mask of a diver.

South Africa's Castle Rock Marine Reserve is one of the few locations in
the world where divers can observe large numbers of sevengill sharks.

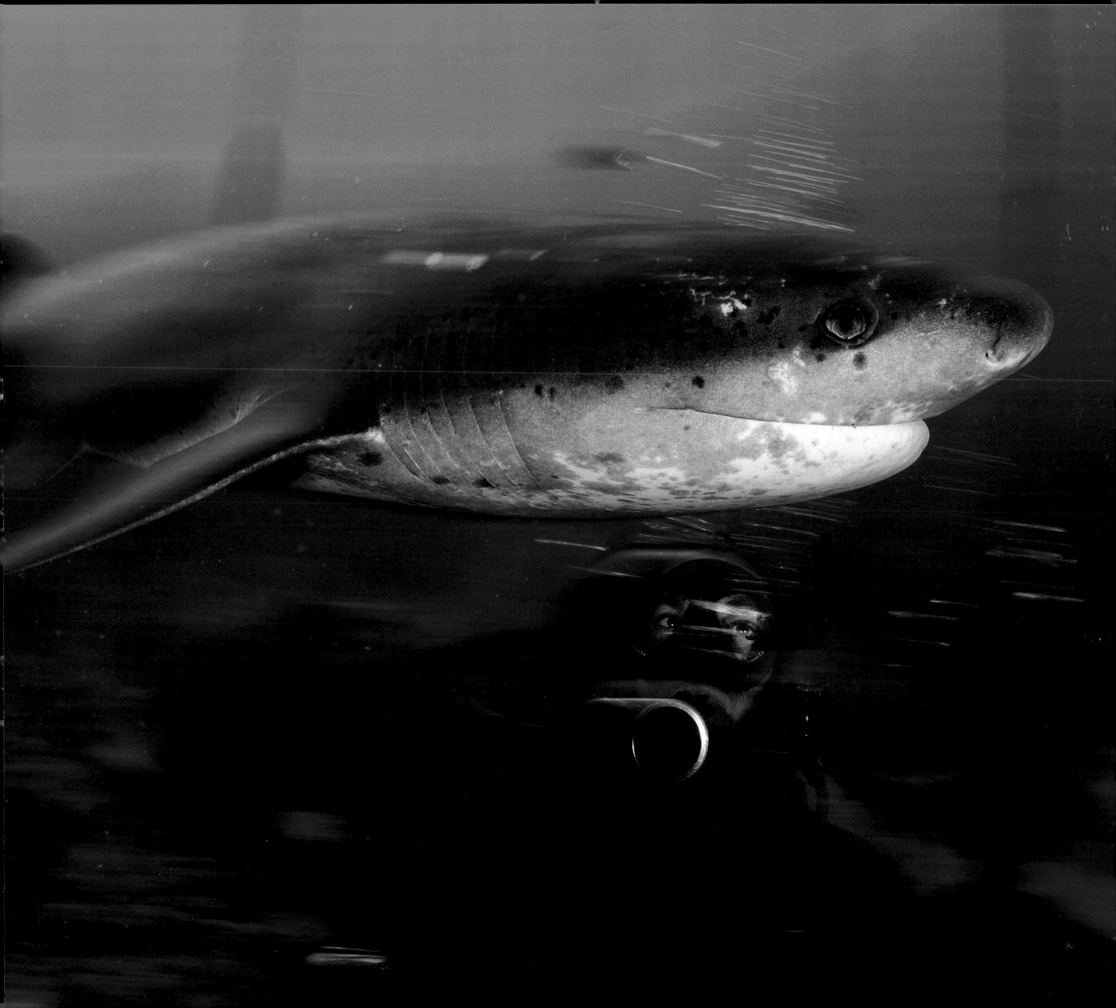

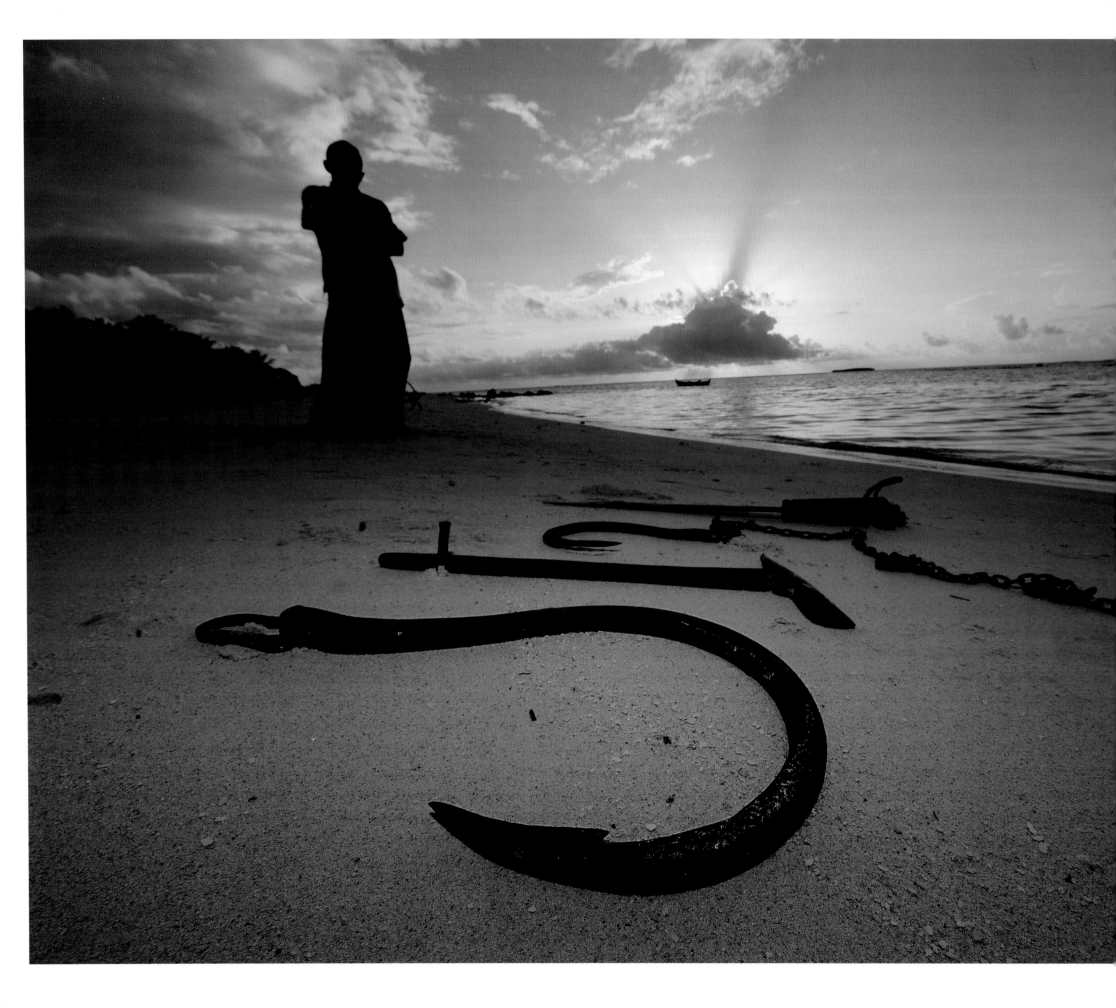

SHARK HUNTERS NO MORE

WHALE SHARKS AND MANTA RAYS have been somewhat scarce at Hanifaru Bay in the Maldives for the past 10 days. A combination of rough seas, low plankton concentrations, and neap tides is the likely reason for their absence. After a few weeks of thick clouds and torrential rain, the sun finally graces the skies and ignites the famed productivity for which these seas are known. Across much of Baa Atoll the visibility has dropped to less than 23 feet (7 m) and the water's greenish tinge signals a high density of phytoplankton. Zooplankton armies march to feast on the phytoplankton, thus forming the bulk of the manta ray and whale shark diet. In a few days' time, around the full moon, another spectacular feeding aggregation of manta rays and whale sharks will be upon us. In the meantime, I take advantage of these days of no whale sharks and visit Dhonfanu, a small island situated less than a mile from Hanifaru Bay.

Dhonfanu is one of only two communities in Baa Atoll that have a long history of hunting whale sharks and manta rays. Whale sharks were always the preferred prize; the oil in their livers—up to 53 gallons (200 litres) each—was used to seal the hulls of fishing boats from the elements. The less oily livers of manta rays were only targeted during a scarcity of whale sharks, and the manta's leathery skin was reportedly used to cover Bodu Beru drums, an important centerpiece in many Maldivian celebrations and rituals.

The end of August that year marked the beginning of Ramadan, the holy month in which the Maldive Muslims observe a sunrise-to-sunset fast. I arrive on Dhonfanu when the sun is still a few hours from the horizon, traditionally the hardest time of the fast. Despite having gone without food or water since sunrise, my hosts greet me with great warmth and hospitality. The island elders know of my interest in whale sharks and manta rays and promise to show me their old hunting implements. It takes some searching through various sheds and coral brick outhouses, but it is not long before they produce several hunters' tools of the trade. Much to my relief they are blunt and rusty, indicating that no hunt has taken place for a very long time.

Armed to the teeth with hooks, knives, and harpoons, we head down to a small beach where two wooden boats, their seaworthiness long past, are decaying at the edge of the sea. It's hard to believe that these skeletons of wood and nails were once the platforms for hunting the ocean's largest fish and ray. And then, in a moment I will never forget, the elders re-enact a whale shark hunt for me on the beach.

OPPOSITE *A former whale shark hunter stands in the shadow of his rusty tools on the beach where the giants used to be landed and butchered.*

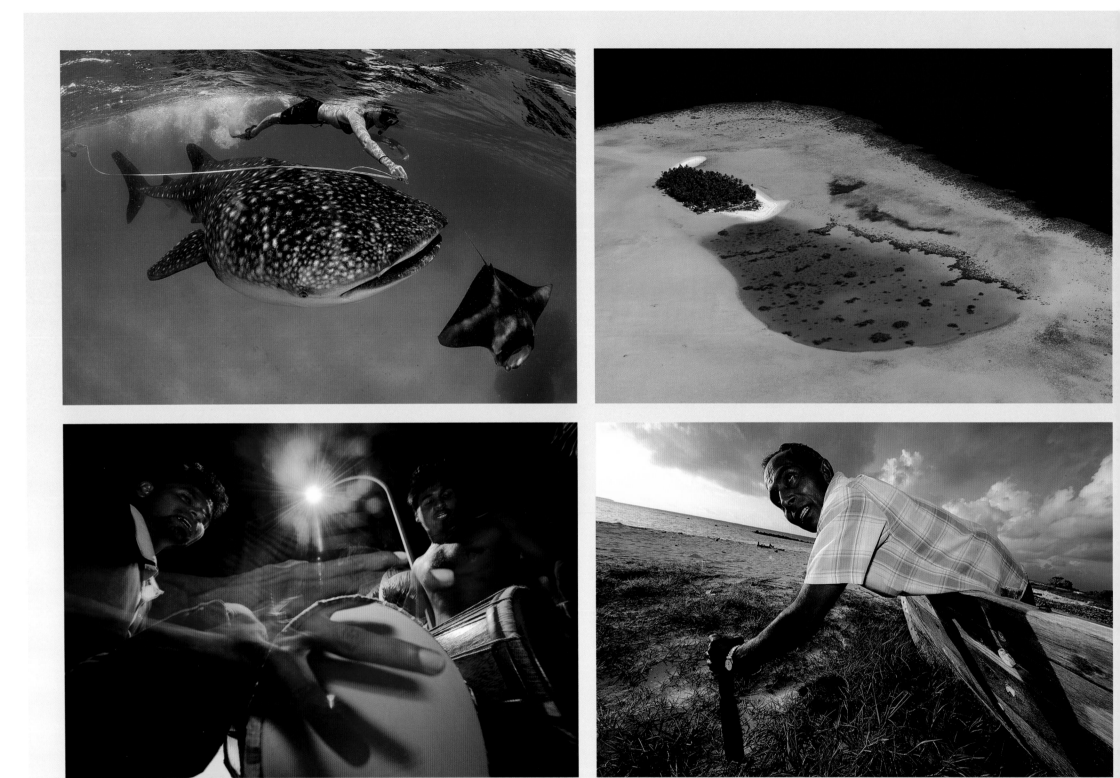

THIS PAGE, CLOCKWISE FROM TOP LEFT *Scientists measure a whale shark at Hanifaru Bay. The Maldives archipelago is made up of 1,992 islands, of which only 200 are inhabited. A former hunter uses a machete to re-enact how he used to hunt whale sharks. The drums used in traditional Boduberu music were once covered by manta ray skin.* **OPPOSITE** *An ambling whale shark feeds on plankton just below a group of onlooking tourists.*

The harpooner balances precariously on the bow and drives a detachable spearhead tied to the boat deep into an imaginary whale shark. With the whale shark in tow, the boat crew would then try to exhaust the fish by rowing as fast as they could to a sandbank at the edge of Hanifaru Bay. They would insert sharp hooks into the mouth and gills to slow the shark further. Once they have exhausted the shark and trapped it in the shallows, they would butcher it with machetes. I was told that they used only the oil, but maybe something got lost in the translation, as I couldn't imagine the meat going to waste. When whale sharks were caught, large tiger sharks also assembled around the sandbank and gorged themselves on the leftovers.

In 1992 it became illegal to kill whale sharks in the Maldives and apart from one instance in 2002, where four sharks are reputed to have been killed at Hanifaru, the old hunters of Dhonfanu have transformed into some of the staunchest marine conservationists in Baa Atoll. In fact, a recent socio-economic study by IUCN showed that this island is among the most environmentally aware and active in the Maldives. Some of the old hunters make a good living from the tourists who visit Hanifaru to experience the manta ray and whale shark feeding aggregations. One of the most persistent hunters of old is now the owner of a boat that takes guests on manta ray and whale shark safaris, with the boat crew consisting of former hunters.

For the inhabitants of Dhonfanu, whale sharks are now worth much more alive than dead. In 2009 Hanifaru Bay was declared a Marine Protected Area and in 2011 the entire atoll was listed as a UN Biosphere Reserve. This kind of status is sure to result in further economic benefits to the islanders.

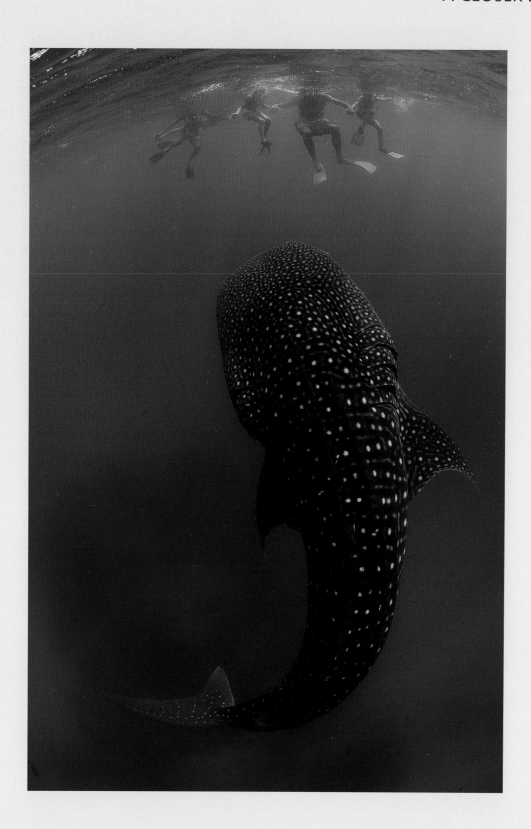

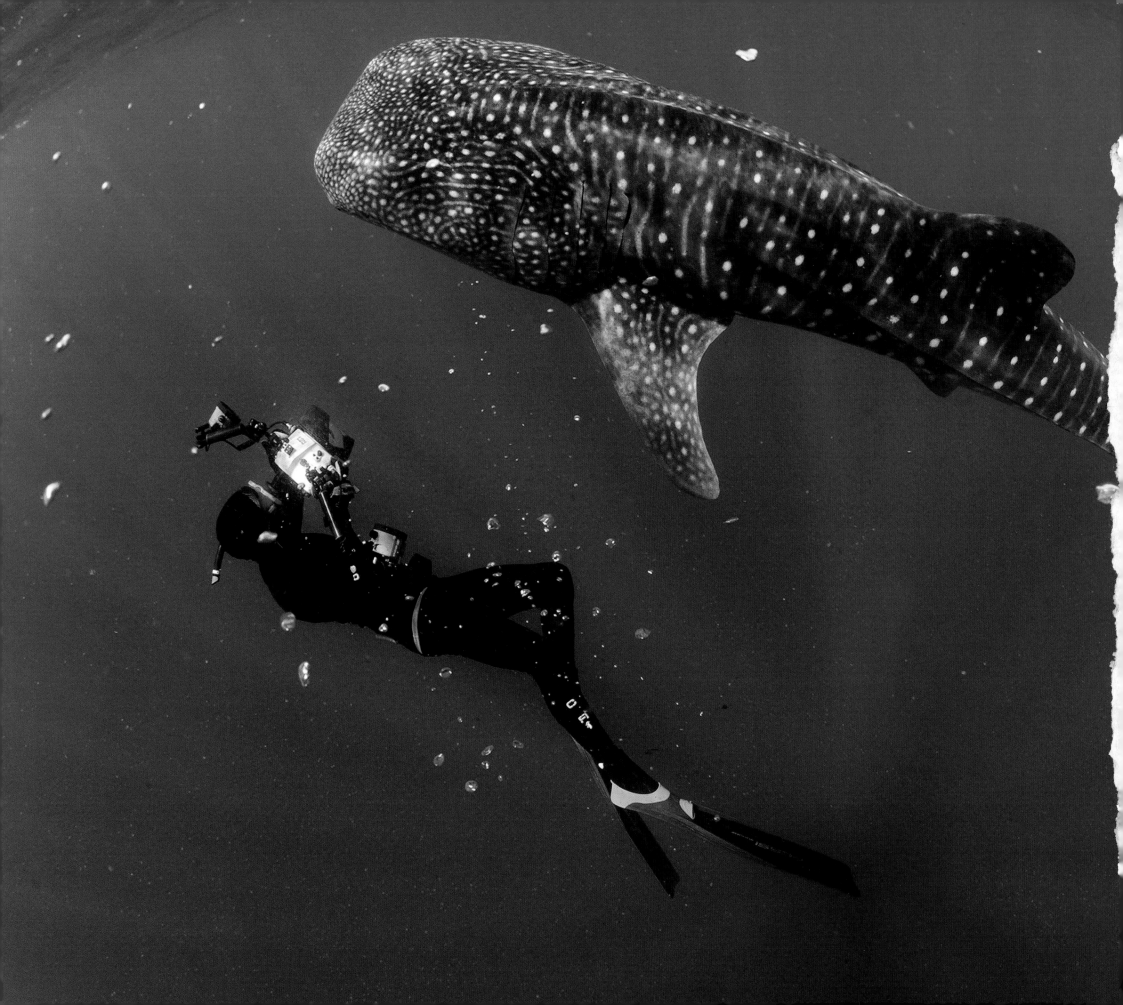

SHARK PHOTOGRAPHY

My love affair with the ocean began the moment I put my head under the water. I started snorkeling at the age of six and began diving at 12. At the same time I immersed myself in the work of Jacques Cousteau and the early underwater stories by David Doubilet in *National Geographic Magazine*. The articles and films that I remember most vividly were those featuring white sharks, tiger sharks, whale sharks, and bull sharks. The ocean, especially its large predators, was a persistent force that lured me along my life's path.

Photography has been a passion for as long as I can remember, but I actually studied marine biology, intent on contributing to ocean conservation through scientific research. From the coral reefs of northern Mozambique to the seagrass beds of Central America, I was fortunate to lead an adventurous life as a field biologist. Yet after a decade I discovered that even the most overwhelming scientific evidence doesn't necessarily lead to acts of conservation. For instance, as a graduate student I researched the impacts of South African abalone poaching, fueled by the demand from Asian crime syndicates. I discovered that the scientific data showing decimated abalone populations were not being considered in protection measures. On the other hand, the response to the photographs I took during the course of my research, which showed poaching and seascapes devoid of life, was much more visceral and immediate. I quickly realized that I could help further conservation efforts more through my photographs than through statistics. So I left behind a fledgling scientific career for the nomadic life of a photojournalist.

OPPOSITE *Surrounded by blacktip reef sharks in the shallows off Aldabra Atoll, I steal a few shots.*
PREVIOUS SPREAD *I free dive beneath a young whale shark off Djibouti, along the Horn of Africa.*

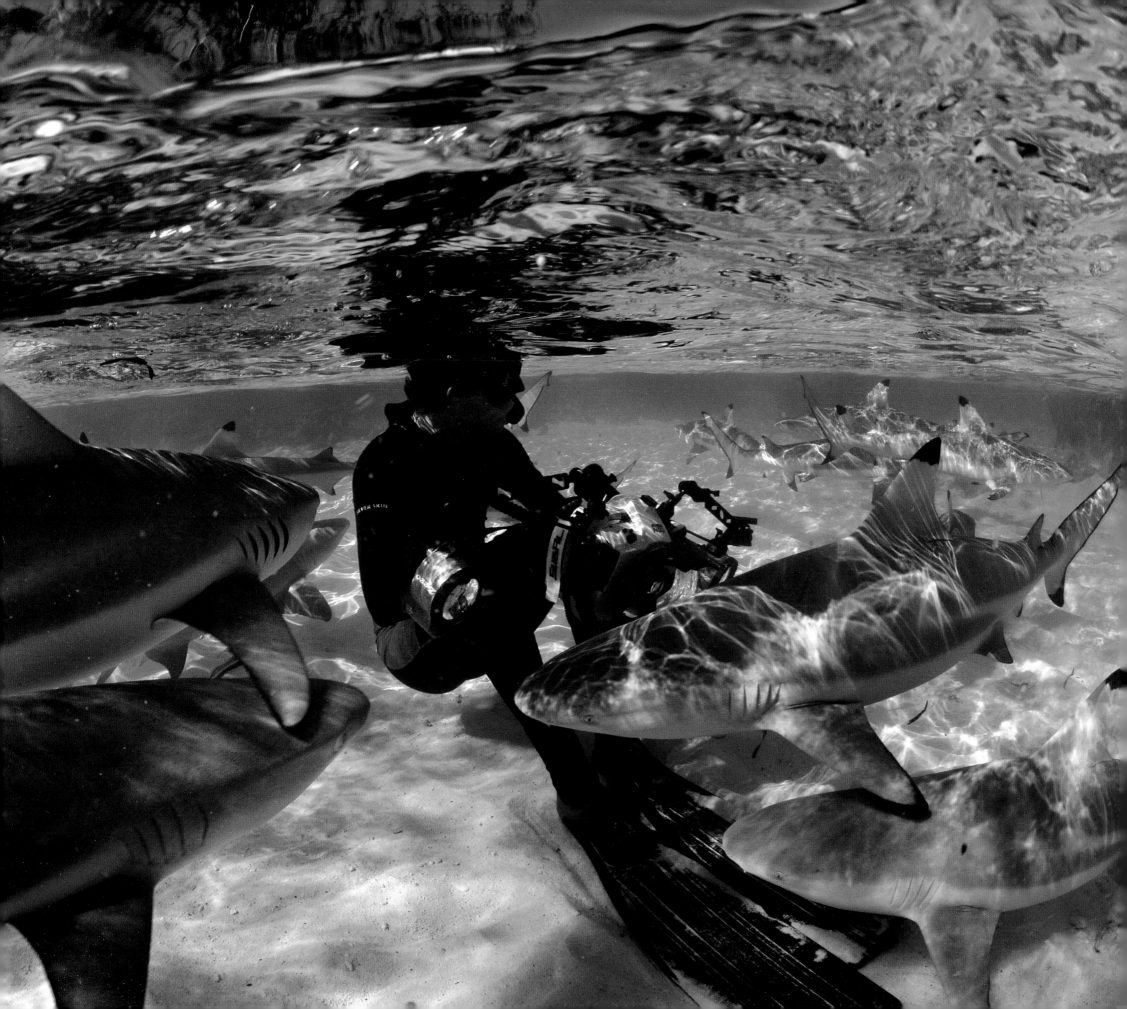

The first subject I really sunk my teeth into was sharks, and living along the South African coast allowed me direct access to the realm of the most reviled and misunderstood shark of them all, the great white. Rather than adding to the growing stock of menacing, toothy white shark photographs, I was driven to capture the more serene behavior and prehistoric perfection of these creatures. But I also became aware of the darker side of our relationship with sharks when, for example, a shark with its fins cut off washed up in a bay near my house, and teeth from protected white sharks appeared on the shelves of a local curio shop. Increasingly, I realized I wanted to go beyond creating beautiful images and capture as complete a story as possible through conservation photojournalism.

The legendary conservationist George Schaller wrote, "Pen and camera are weapons against oblivion, they can create awareness for that which may soon be lost forever." Schaller's words are my mantra and inspire me to keep working for change. Photographs, I believe, are one of the most powerful weapons in the marine conservation arsenal, and it has become my life's work to create images that inspire people to act. I spend upward of 300 days a year shooting all over the world. For half of that time I visit beautiful places and take photographs that celebrate

the ocean. I commit the other 150 days to documenting the effects of our growing demand on the sea. I take a "carrot-and-stick" approach to conservation photojournalism. I walk a fine line between disturbance and inspiration. My aim is to tell balanced and honest photo stories that encourage people to revel in the beauty of the ocean, but also to understand how human actions affect its health.

Of all the stories I've covered in my photographic career, the "sharky" ones are the ones people tend to remember. The most common questions I'm asked are about the difficulty and danger of photographing sharks. Unquestionably, sharks are challenging to photograph well, and I have made Herculean attempts to depict these predators in a fresh and intelligent way. To start with, finding sharks is difficult, getting close to them requires strategy, and taking great images often seems impossible. Therefore, it is a rare privilege when I come across healthy and curious shark populations like those in the remote atolls of Aldabra, Europa, or some islands in the Bahamas.

Two major factors in getting great underwater images of sharks are time and proximity. Because sharks are instinctively cautious, I choose to free dive for most of my shoots. Without the noisy bubbles and vibrations of SCUBA, I find that sharks appear less disturbed and

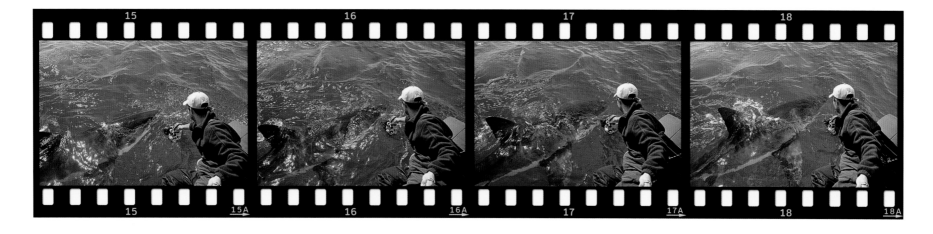

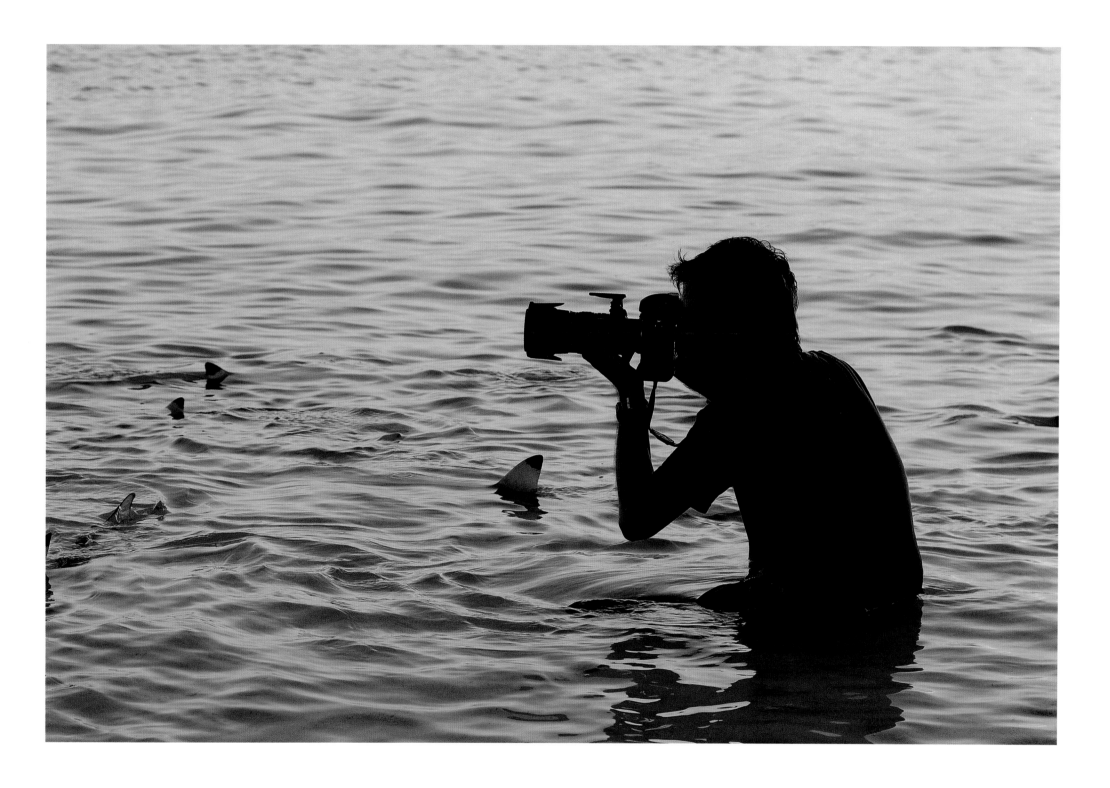

ABOVE *Partly submerged in the Indian Ocean, I photograph the fins of reef sharks hunting at dusk.*

OPPOSITE *From the swim platform of a small research vessel, I photograph a white shark at South Africa's Dyer Island.*

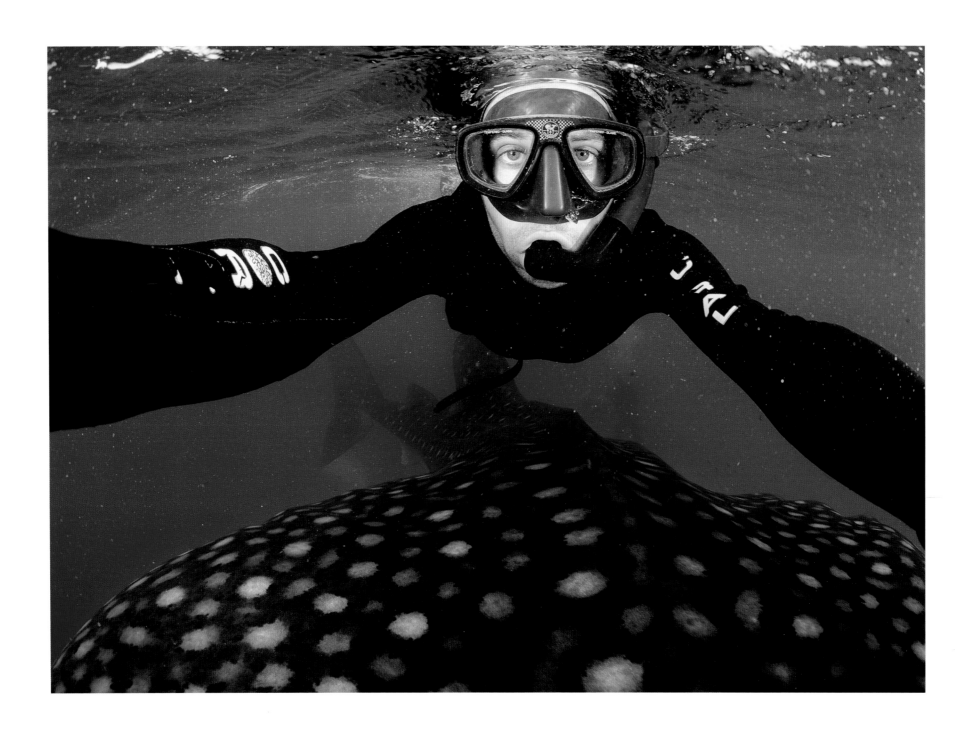

As this whale shark moved to swim underneath me, I turn the camera for a quick self-portrait.

deterred by my alien presence. Free diving also allows me to spend up to eight hours a day in the ocean. Due to the lack of light underwater, the only way to shoot powerful imagery is to get close. Nearly 90 percent of my work is wide angle, so most of my subjects are often just inches away. Therefore, in order to minimize disturbance, I have to estimate my subject animal's comfort level before I enter its personal space. I liken this to dancing with someone who speaks a different language. I must rely on sensing body language, movement, and energy.

I take calculated risks to create photographs that I hope will make a difference, but I don't believe that any image is worth getting seriously injured or dying for. The real risk comes from traveling to volatile regions, flying in airplanes held together by rubber bands, and brushing shoulders with shark fin syndicates and illegal wildlife traffickers. Statistically speaking, interacting responsibly with sharks is probably one of the safest parts of my workday.

To be successful as a conservation photographer, you have to be obsessed with creating images and telling stories that matter. It's also essential to try to make original and memorable photographs. My editor at *National Geographic Magazine*, Kathy Moran, regularly encourages me with the following words: "Show me something that the world has never seen before, or something that everybody is familiar with, but in a way so different that people will be convinced they've never seen it before."

Conservation photography can be an emotional roller coaster. It can be socially isolating, logistically exhausting, and physically demanding, yet it is also the most emotionally and professionally rewarding pursuit that I can imagine. To survive and thrive in this profession you have to be a hopeless optimist, believing that the next great picture is just around the corner, behind the next coral head or mangrove root, or … just behind the one after that.

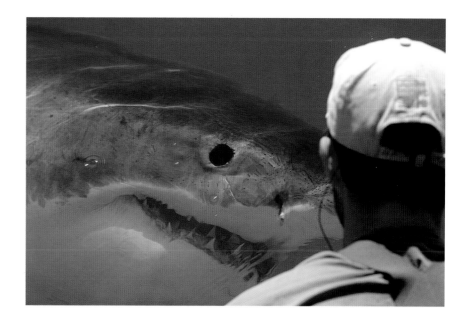

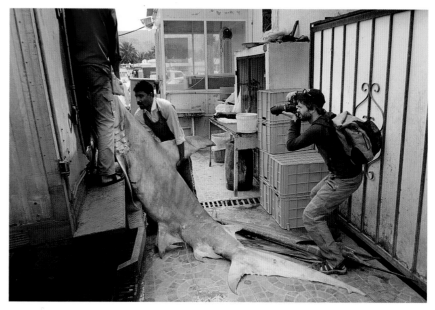

TOP *A white shark makes a close pass as I recline at water level on the swim platform.*
ABOVE *I document the loading of a massive great hammerhead shark caught in the deep waters of the Strait of Hormuz.*

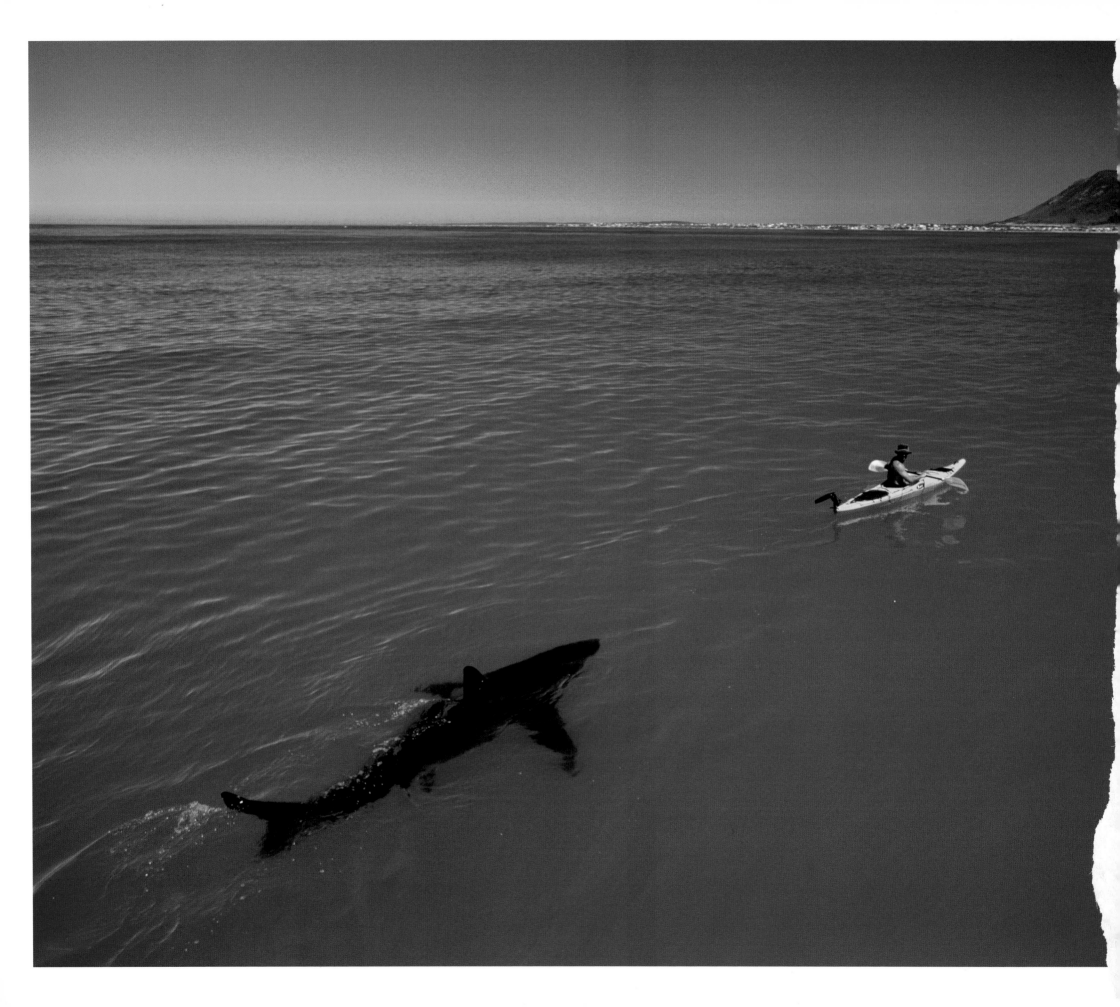

FAKE OR NOT?

WHEN I BEGAN WORK 10 YEARS AGO on a book about white sharks, I had no idea that this project would yield my most well-known image to date. For more than 10 months I worked together with Michael Scholl and scientists at the White Shark Trust to create novel images of white sharks in South Africa that would illustrate current scientific research. The team observed large numbers of white sharks venturing into extremely shallow water during the summer months. In order to figure out why, the researchers tracked and observed the sharks' movements but were regularly thwarted for two reasons. The inshore realm was treacherous, humped by rocky reefs and sandbanks that heaved the research boat precariously during an onslaught of large swells. Secondly, the sharks' behavior seemed to be affected by the electrical fields from the boat's engine.

I suggested using a kayak as both a photographic platform and a less obtrusive way to track white sharks. I was met with what I would call cautious enthusiasm, so I was voted to be the one to test the waters. Even though we repeatedly checked the sharks' reactions to an empty kayak, the first few attempts were a little nerve-wracking. It's hard to describe what goes through your mind when you're sitting in a "yum-yum" yellow plastic sea kayak and a 15-foot (4.5-m) great white shark heads toward you.

A white shark follows a researcher in a sea kayak off South Africa's southwest coast.

But white sharks, despite their bad reputation, are much more cautious and inquisitive than aggressive and unpredictable. And this proved true with our experiment; at no time did the sharks show any aggression toward our little yellow craft.

The story of this particular photograph began on a perfectly calm and glassy sea. I tied myself to the tower of the White Shark Trust research boat and leaned into the void, precariously hanging over the ocean while waiting patiently. The first shark came across our sea kayak, dove to the seabed, and inspected it from below. I trained my camera on the nebulous shadow as it slowly transformed into the sleek silhouette of a large great white. When the shark's dorsal fin emerged, I thought I had the shot but hesitated a fraction of a second. In that moment, the research assistant in the kayak turned to look behind him, and I took the shot. Throughout the day I shot many more similar images, but all lacked the connection of that first one.

I knew the photograph was iconic, but I was not prepared for the public response. When the image was first published, it attracted more than 100,000 visitors to my website in 24 hours. Many thought the photo was a digital fake, and to date there are still hundreds of websites that debate its authenticity. Not only is the image real, it was one of the last photos I took using slide film

before transitioning to digital. All magazine and print reproductions were taken from a high-resolution scan of the slide with no post-production work. Over the years the image continued to sell and just when I thought it had run its course, it resurfaced on April 1, 2006.

The French *Le Magazine des Voyages de Pêche* (*The Magazine of Fishing Voyages*) published an April Fool's Day article that told the story of professional fisherman Arnold Pointer from South Australia, who accidentally caught a large female white shark in one of his fishing nets. Instead of killing her, he set her free and named her Cindy. From that day forward, the shark followed Arnold every time he set out to sea. In the article he states, "It's been two years and she doesn't leave me alone. She follows me everywhere I go, and her presence scares all the fishes." Two years later this hoax was immortalized in a YouTube slideshow, which used my photograph, purportedly showing Cindy the white shark following Arnold in his yellow kayak. The video received nearly 1.6 million hits and introduced the white shark kayak to a new audience, albeit in an inaccurate if humorous context.

The original slide of the infamous white shark kayak photograph.

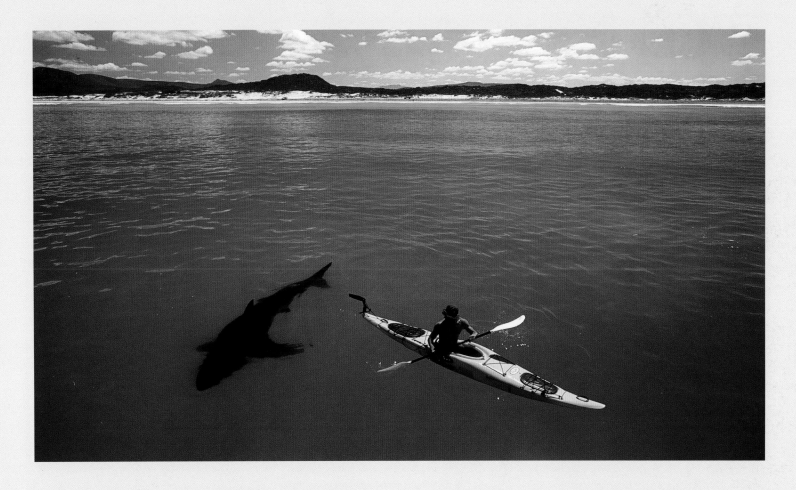

A different frame taken on the same day as the iconic white shark kayak image.

On August 21, 2011, Hurricane Irene battered the Caribbean island of Puerto Rico. I could never have imagined that my photograph would make an appearance in this context, except this time it was only the shark, minus the kayak. On August 24 the shark appeared on a social news website in the form of a photograph taken from the open window of a car driving along a flooded street. Next to the car swam "my" white shark. The image was then picked up and used in a TV bulletin on Channel 7 News Miami. A closer examination of the shark revealed that it was identical to the one following the kayak in my photograph. It appears that a crafty Photoshop artist superimposed the shark into a scene of a flooded street.

The composite resurfaced again in June of 2012, when a shark tank supposedly burst in a popular mall in Kuwait. The photo depicted two sharks (one of which was mine) swimming at the bottom of a submerged escalator.

The most recent incarnation appeared in the wake of Hurricane Sandy, which devastated the eastern coast of the U.S. in October of 2012. Again the shark appeared outside a car window in a flooded street, this time in New Jersey. I always look forward to receiving e-mails from friends and family who have spotted the same white shark in a different context. While I will probably never become a legend in my own right, at least my white shark is well on her way.

SELECTED BIBLIOGRAPHY

This book is dedicated to shark scientists everywhere; without your hard work and dedication, its scope would be quite narrow and its extent brief. To keep the text easy to read, I have not cited individual researchers and institutions within it. Instead, I wish to pay tribute to all of you in this part of the book. Though I left the world of scientific research in order to pursue conservation photojournalism, science continuous to prove positively crucial to everything I do. The following list contains a selection of the research on sharks and related subjects that enforced, enriched, and complemented my stories and images. The full bibliography can be found online at *www.sharkspeople.com*.

INTRODUCTION
JAWS AND ME

Baughman, J.L. **Sharks, sawfishes, and rays: their folklore.** *American Midland Naturalist* (1948): 373–381.

Dean, Brian and Bharat Bhushan. **Shark-skin surfaces for fluid-drag reduction in turbulent flow: a review.** *Philosophical Transactions of the Royal Society A: Mathematical, Physical and Engineering Sciences* 368, no.1929 (2010): 4775–4806.

Dicken, M.L. **First observations of young of the year and juvenile great white sharks *Carcharodon carcharias* scavenging from a whale carcass.** *Marine and Freshwater Research* 59, no.7 (2008): 596–602.

Doak, Wade. ***Sharks and Other Ancestors: Patterns of Survival in the South Seas.*** Auckland: Hodder & Stoughton, 1975.

Dudley, Sheldon F.J., Michael D. Anderson-Reade, Greg S. Thompson, and Paul B. McMullen. **Concurrent scavenging off a whale carcass by great white sharks *Carcharodon carcharias* and tiger sharks *Galeocerdo cuvier*.** *Fishery Bulletin: National Oceanic and Atmospheric Administration* 98, no.3 (2000): 646–649.

Ehret, Dana J., Bruce J. MacFadden, and Rodolfo Salas-Gismondi. **Caught in the act: trophic interactions between a 4-million-year-old white shark *Carcharodon* and mysticete whale from Peru.** *Palaios* 24, no.5 (2009): 329–333.

Frazzetta, T.H. **The mechanics of cutting and the form of shark teeth (Chondrichthyes, Elasmobranchii).** *Zoomorphology* 108, no.2 (1988): 93–107.

Johannes, Robert Earle. ***Words of the Lagoon:***
Fishing and Marine Lore in the Palau District of Micronesia. University of California Press, 1981.

Kalmijn, Adrianus J. **The electric sense of sharks and rays.** *Journal of Experimental Biology* 55, no.2 (1971): 371–383.

Köhnke, Glenys. ***The Shark Callers: An Ancient Fishing Tradition of New Ireland, Papua New Guinea.*** Yumi Press, 1974.

Peschak, Thomas P. ***Wild Seas, Secret Shores of Africa.*** Struik Publishers, 2008.

Peschak, Thomas P., and Michael C. Scholl. ***South Africa's Great White Shark.*** Struik Publishers, 2006.

Rediker, Marcus. **History from below the water line: sharks and the Atlantic slave trade.** *Atlantic Studies* 5, no.2 (2008): 285–297.

Springer, Stewart. ***Discovering Sharks: A Volume Honoring the Work of Stewart Springer.*** Edited by Samuel H. Gruber. American Littoral Society, 1991.

Taylor, Leighton R. ***Sharks of Hawaii: Their Biology and Cultural Significance.*** University of Hawaii Press, 1993.

CHAPTER 1
SHADOWS IN THE SEA

Anderson, R. Charles, M. Shiham Adam, Anne-Marie Kitchen-Wheeler, and Guy Stevens. **Extent and economic value of manta ray watching in Maldives.** *Tourism in Marine Environments* 7, no.1 (2011): 15–27.

Carlson, John K., Jason Osborne, and Thomas W. Schmidt. **Monitoring the recovery of smalltooth sawfish *Pristis pectinata* using standardized relative indices of abundance.** *Biological Conservation* 136, no.2 (2007): 195–202.

Compagno, Leonard J.V., Marc Dando, and Sarah L. Fowler. ***A Field Guide to the Sharks of the World.*** HarperCollins UK, 2005.

Grogan, Eileen D., Richard Lund, and Emily Greenfest-Allen. **The origin and relationships of early chondrichthyans.** *Biology of Sharks and their Relatives* (2004): 3–32.

Hamlett, William C., ed. ***Sharks, Skates, and Rays: The Biology of Elasmobranch Fishes.*** Johns Hopkins University Press, 1999.

Heinrichs, S., M. O'Malley, H. Medd, and P. Hilton.
Manta Ray of Hope: Global State of Manta and Mobula Rays. Manta Ray of Hope Project, 2011. *www. mantarayofhope.com*

Hodgson, Edward S., and Robert F. Mathewson. ***Sensory Biology of Sharks, Skates, and Rays.*** Tufts Univ. Medford MA Dept. of Biology, 1978.

Meyer, Peter K. **Stingray injuries.** *Wilderness & Environmental Medicine* 8, no.1 (1997): 24–28.

Peschak, Thomas P. ***Currents of Contrast: Life in Southern Africa's Two Oceans.*** Struik Publishers, 2005.

Semeniuk, Christina A.D., and Kristina D. Rothley. **Costs of group-living for a normally solitary forager: effects of provisioning tourism on southern stingrays *Dasyatis americana*.** *Marine Ecology: Progress Series* 357 (2008): 271.

Semeniuk, Christina A.D., Sophie Bourgeon, Sylvia L. Smith, and Kristina D. Rothley. **Hematological differences between stingrays at tourist and non-visited sites suggest physiological costs of wildlife tourism.** *Biological Conservation* 142, no.8 (2009): 1818–1829.

Weiss, Beatrix F., and Hugh D. Wolfenden. **Survivor of a stingray injury to the heart.** *Medical Journal of Australia* 175, no.1 (2001): 33–34.

Wetherbee, Bradley M., and Enric Cortés. **Food consumption and feeding habits.** *Biology of Sharks and their Relatives* (2004): 223–242.

Wueringer, Barbara E., Lyle Squire, Stephen M. Kajiura, Nathan S. Hart, and Shaun P. Collin. **The function of the sawfish's saw.** *Current Biology* 22, no.5 (2012): R150–R151.

CHAPTER 2
DEMON FISH

Boisier, Pascal, Gérard Ranaivoson, Noëlson Rasolofonirina, Jean Roux, Suzanne Chanteau, and Yasumoto Takeshi. **Fatal mass poisoning in Madagascar following ingestion of a shark (*Carcharhinus leucas*): clinical and epidemiological aspects and isolation of toxins.** *Toxicon* 33, no.10 (1995): 1359–1364.

Cliff, Geremy. **Shark attacks on the South African coast between 1960 and 1990.** *South African Journal of Science* 87, no.10 (1991): 513–518.

Eilperin, Juliet. ***Demon Fish: Travels through***

the Hidden World of Sharks. New York: Doubleday, 2011.

Fernicola, M.D., and G. Richard. *Twelve Days of Terror.* Lyons Press, 2001.

Gilbert, Perry W. *Sharks and Survival.* Boston: Heath, 1963.

Gore, Meredith L., Bret A. Muter, Maria Knight Lapinski, Lindsay Neuberger, and Brandon Van der Heide. **Risk frames on shark diving websites: implications for global shark conservation.** *Aquatic Conservation: Marine and Freshwater Ecosystems* 21, no.2 (2011): 165–172.

Gruber, Samuel H. **Why do sharks attack humans?** *Naval Research Reviews* XL (1) (1988): 2–13.

ISAF (2012a). **ISAF statistics for the world locations with the highest shark attack activity (2000–2011).** *International Shark Attack File.* http://www.flmnh.ufl.edu/fish/sharks/statistics/statsw.htm.

Johnson, Richard H., and Donald R. Nelson. **Agonistic display in the gray reef shark, *Carcharhinus menisorrah,* and its relationship to attacks on man.** *Copeia* (1973): 76–84.

Lentz, Ashley K., George H. Burgess, Karen Perrin, Jennifer A. Brown, David W. Mozingo, and Lawrence Lottenberg. **Mortality and management of 96 shark attacks and development of a shark bite severity scoring system.** *The American Surgeon* 76, no.1 (2010): 101–106.

LoBue, Vanessa, David H. Rakison, and Judy S. DeLoache. **Threat perception across the life span: evidence for multiple converging pathways.** *Current Directions in Psychological Science* 19, no.6 (2010): 375–379.

Löe, Jonny, and Eivin Röskaft. **Large carnivores and human safety: a review.** *AMBIO: A Journal of the Human Environment* 33, no.6 (2004): 283–288.

Martin, R. Aidan. **A review of shark agonistic displays: comparison of display features and implications for shark–human interactions.** *Marine and Freshwater Behaviour and Physiology* 40, no.1 (2007): 3–34.

Muter, Bret A., Meredith L. Gore, Katie S. Gledhill, Christopher Lamont, and Charlie Huveneers.

Australian and US news media portrayal of sharks and their conservation. *Conservation Biology* 27, no.1 (2013): 187–196.

Neff, Christopher L., and Jean Y.H. Yang. **Shark bites and public attitudes: policy implications from the first before and after shark bite survey.** *Marine Policy* (2012).

Neff, Christopher, and Robert Hueter. **Science, policy, and the public discourse of shark "attack": a proposal for reclassifying human–shark interactions.** *Journal of Environmental Studies and Sciences* 3, no.1 (2013): 65–73.

Woolgar, Justin D., Geremy Cliff, Raj Nair, Hany Hafez, and John V. Robbs. **Shark attack: review of 86 consecutive cases.** *The Journal of Trauma* 50, no.5 (2001): 887.

CHAPTER 3
SHARK CONTROL

Baldridge Jr, H. David. **Shark repellent: not yet, maybe never.** *Military Medicine* 155, no.8 (1990): 358.

Clark, Eugenie . **The Red Sea's sharkproof fish.** *National Geographic Magazine* 145 (1974): 718–727.

Davies, David Herbert. *About Sharks and Shark Attack.* Shuter & Shooter, 1964.

Dudley, S.F.J. **A comparison of the shark control programs of New South Wales and Queensland (Australia) and KwaZulu-Natal (South Africa).** *Ocean & Coastal Management* 34, no.1 (1997): 1–27.

Dudley, Sheldon F.J., and Geremy Cliff. **Some effects of shark nets in the Natal nearshore environment.** *Environmental Biology of Fishes* 36, no.3 (1993): 243–255.

Dudley, Sheldon F.J., and Colin A. Simpfendorfer. **Population status of 14 shark species caught in the protective gillnets off KwaZulu-Natal beaches, South Africa, 1978–2003.** *Marine and Freshwater Research* 57.2 (2006): 225–240.

Gribble, N.A., G. McPherson, and B. Lane. **Effect of the Queensland Shark Control Program on non-target species: whale, dugong, turtle and dolphin: a review.** *Marine and Freshwater Research* 49, no.7 (1998): 645–651.

Gruber, S.H., and E. Zlotkin. **Bioassay of

surfactants as shark repellents.** *Nav. Res. Rev.* 2 (1982): 18–27.

Nel, Deon C., and Thomas P. Peschak. **Finding a balance: white shark conservation and recreational safety in the inshore waters of Cape Town, South Africa.** In *Proceedings of a specialist workshop held,* vol.29. 2006.

Paterson, R.A. **Effects of long-term anti-shark measures on target and non-target species in Queensland, Australia.** *Biological Conservation* 52, no.2 (1990): 147–159.

Reid, D.D., and M. Krogh. **Assessment of catches from protective shark meshing off NSW beaches between 1950 and 1990.** *Marine and Freshwater Research* 43, no.1 (1992): 283–296.

Sisneros, Joseph A., and Donald R. Nelson. **Surfactants as chemical shark repellents: past, present, and future.** *Environmental Biology of Fishes* 60, no.1 (2001): 117–130.

Wallett, Tim. *Shark Attack and Treatment of Victims in Southern African Waters.* Purnell, 1978.

Zahuranec, Bernard J. *Shark Repellents from the Sea: New Perspectives.* American Association for the Advancement of Science, Selected Symposium 83, vol.83. Westview Press, 1983.

Zlotkin, Eliahu, and Samuel H. Gruber. **Synthetic surfactants: a new approach to the development of shark repellents.** *Archives of Toxicology* 56, no.1 (1984): 55–58.

CHAPTER 4
EATING SHARKS

Adams, Douglas H., and Robert H. McMichael Jr. **Mercury levels in four species of sharks from the Atlantic coast of Florida.** *Fishery Bulletin* 97, no.2 (1999): 372–379.

Branco, V., J. Canario, C. Vale, J. Raimundo, and C. Reis. **Total and organic mercury concentrations in muscle tissue of the blue shark (*Prionace glauca* L. 1758) from the Northeast Atlantic.** *Marine Pollution Bulletin* 49, no.9 (2004): 871–874.

Clarke, Shelley C., Jennifer E. Magnussen, Debra L. Abercrombie, Murdoch K. McAllister, and Mahmood S. Shivji. **Identification of shark species composition and proportion in the Hong Kong shark fin market based on molecular genetics and trade records.**

Conservation Biology 20, no.1 (2006): 201–211.

Clarke, Shelley C., Murdoch K. McAllister, Eleanor J. Milner-Gulland, G.P. Kirkwood, Catherine G.J. Michielsens, David J. Agnew, Ellen K. Pikitch, Hideki Nakano, and Mahmood S. Shivji. **Global estimates of shark catches using trade records from commercial markets.** *Ecology Letters* 9, no.10 (2006): 1115–1126.

Dickman, Mike D., Clement K.M. Leung, and Milton K.H. Leong. **Hong Kong male subfertility links to mercury in human hair and fish.** *Science of the Total Environment* 214, no.1 (1998): 165–174.

Fabinyi, Michael. **Historical, cultural and social perspectives on luxury seafood consumption in China.** *Environmental Conservation* 39, no.1 (2012): 83–92.

Gobalet, Kenneth W., and Terry L. Jones. **Prehistoric Native American fisheries of the central California coast.** *Transactions of the American Fisheries Society* 124, no.6 (1995): 813–823.

Ip, Patrick, et al. **Environmental mercury exposure in children: South China's experience.** *Pediatrics International* 46.6 (2004): 715–721.

Kozuch, Laura. *Sharks and Shark Products in Prehistoric South Florida.* Institute of Archaeology and Paleoenvironmental Studies, University of Florida, 1993.

Kurland, T., S.N. Faro, and Howard Siedler. **Minamata disease. The outbreak of a neurologic disorder in Minamata, Japan, and its relationship to the ingestion of seafood contaminated by mercuric compounds.** *World Neurology* 1.5 (1960): 370–395.

Milner-Gulland, E.J., and Trond Bjorndal. *Social, Economic and Regulatory Drivers of the Shark Fin Trade.* Centre for the Economics and Management of Aquatic Resources, University of Portsmouth, 2008.

Rick, Torben C., Jon M. Erlandson, Michael A. Glassow, and Madonna L. Moss. **Evaluating the economic significance of sharks, skates, and rays (Elasmobranchs) in prehistoric economies.** *Journal of Archaeological Science* 29, no.2 (2002): 111–122.

Smith, W. Eugene, and Aileen Mioko Smith.

Minamata. Chatto & Windus, 1975.

Travis, William. **Shark For Sale.** Rand McNally, 1961.

Vannuccini, Stefania. **Shark Utilization, Marketing and Trade.** No.389. Food & Agriculture Organization, 1999.

CHAPTER 5
SHARKS IN TROUBLE

Baum, Julia K., Ransom A. Myers, Daniel G. Kehler, Boris Worm, Shelton J. Harley, and Penny A. Doherty. **Collapse and conservation of shark populations in the Northwest Atlantic.** *Science* 299, no.5605 (2003): 389–392.

Camhi, M.D., S.V. Valenti, S.V. Fordham, S.L. Fowler, and C. Gibson. **The Conservation Status of Pelagic Sharks and Rays: Report of the IUCN Shark Specialist Group Pelagic Shark Red List Workshop.** IUCN Species Survival Commission Shark Specialist Group, Newbury, UK (2009).

Dulvy, Nicholas K., Julia K. Baum, Shelley Clarke, Leonard J.V. Compagno, Enric Cortés, Andrés Domingo, Sonja Fordham et al. **You can swim but you can't hide: the global status and conservation of oceanic pelagic sharks and rays.** *Aquatic Conservation: Marine and Freshwater Ecosystems* 18, no.5 (2008): 459–482.

Ferretti, Francesco, Ransom A. Myers, Fabrizio Serena, and Heike K. Lotze. **Loss of large predatory sharks from the Mediterranean Sea.** *Conservation Biology* 22, no.4 (2008): 952–964.

Field, Iain C., Mark G. Meekan, Rik C. Buckworth, and Corey J.A. Bradshaw. **Susceptibility of sharks, rays and chimaeras to global extinction.** *Advances in Marine Biology* 56 (2009): 275–363.

García, Verónica B., Luis O. Lucifora, and Ransom A. Myers. **The importance of habitat and life history to extinction risk in sharks, skates, rays and chimaeras.** *Proceedings of the Royal Society B: Biological Sciences* 275, no.1630 (2008): 83–89.

Hammerschlag, Neil, R. Aidan Martin, and Chris Fallows. **Effects of environmental conditions on predator–prey interactions between white sharks (*Carcharodon carcharias*)**

and Cape fur seals (*Arctocephalus pusillus pusillus*) at Seal Island, South Africa. *Environmental Biology of Fishes* 76, no.2 (2006): 341–350.

Jacques, Peter J. **The social oceanography of top oceanic predators and the decline of sharks: a call for a new field.** *Progress in Oceanography* 86, no.1 (2010): 192–203.

Luiz, Osmar J., and Alasdair J. Edwards. **Extinction of a shark population in the Archipelago of Saint Paul's Rocks (equatorial Atlantic) inferred from the historical record.** *Biological Conservation* 144, no.12 (2011): 2873–2881.

Myers, Ransom A., and Boris Worm. **Rapid worldwide depletion of predatory fish communities.** *Nature* 423, no.6937 (2003): 280–283.

Prince, Jeremy D. **Gauntlet fisheries for elasmobranchs: the secret of sustainable shark fisheries.** *Journal of Northwest Atlantic Fishery Science* 35 (2005): 407–416.

Walker, Terence I. **Can shark resources be harvested sustainably? A question revisited with a review of shark fisheries.** *Marine and Freshwater Research* 49, no.7 (1998): 553–572.

CHAPTER 6
OCEAN GUARDIANS

Bascompte, Jordi, Carlos J. Melián, and Enric Sala. **Interaction strength combinations and the overfishing of a marine food web.** *Proceedings of the National Academy of Sciences of the United States of America* 102, no.15 (2005): 5443–5447.

Bertilsson-Friedman, P. **Distribution and frequencies of shark-inflicted injuries to the endangered Hawaiian monk seal (*Monachus schauinslandi*).** *Journal of Zoology* 268, no.4 (2006): 361–368.

Burgess, George H., Lawrence R. Beerkircher, Gregor M. Cailliet, John K. Carlson, Enric Cortés, Kenneth J. Goldman, R. Dean Grubbs, John A. Musick, Michael K. Musyl, and Colin A. Simpfendorfer. **Is the collapse of shark populations in the Northwest Atlantic Ocean and Gulf of Mexico real?** *Fisheries* 30, no.10 (2005): 19–26.

DeMartini, Edward E., Alan M. Friedlander, Stuart A. Sandin, and Enric Sala. **Differences in fish-**

assemblage structure between fished and unfished atolls in the northern Line Islands, central Pacific. *Marine Ecology Progress Series* 365 (2008): 199–215.

Ferretti, Francesco, Boris Worm, Gregory L. Britten, Michael R. Heithaus, and Heike K. Lotze. **Patterns and ecosystem consequences of shark declines in the ocean.** *Ecology Letters* 13, no.8 (2010): 1055–1071.

Frid, Alejandro, Lawrence M. Dill, Richard E. Thorne, and Gail M. Blundell. **Inferring prey perception of relative danger in large-scale marine systems.** *Evolutionary Ecology Research* 9, no.4 (2007): 635.

Heithaus, Michael R., Alejandro Frid, Aaron J. Wirsing, and Boris Worm. **Predicting ecological consequences of marine top predator declines.** *Trends in Ecology and Evolution* 23, no.4 (2008): 202.

Lucas, Z., and W.T. Stobo. **Shark-inflicted mortality on a population of harbour seals (*Phoca vitulina*) at Sable Island, Nova Scotia.** *Journal of Zoology* 252, no.3 (2006): 405–414.

Murdoch, T.J.T., A.F. Glasspool, M. Outerbridge, J. Ward, S. Manuel, J. Gray, A. Nash et al. **Large-scale decline in offshore seagrass meadows in Bermuda.** *Marine Ecology Progress Series* 339 (2007): 123–130.

Myers, Ransom A., Julia K. Baum, Travis D. Shepherd, Sean P. Powers, and Charles H. Peterson. **Cascading effects of the loss of apex predatory sharks from a coastal ocean.** *Science* 315, no.5820 (2007): 1846–1850.

Paine, Robert T. **Food web complexity and species diversity.** *American Naturalist* (1966): 65–75.

Robbins, William D., Mizue Hisano, Sean R. Connolly, and J. Howard Choat. **Ongoing collapse of coral-reef shark populations.** *Current Biology* 16, no.23 (2006): 2314–2319.

Schindler, D.E., T.E. Essington, J.F. Kitchell, C. Boggs, and R. Hilborn. **Sharks and tunas: fisheries impacts on predators with contrasting life histories.** *Ecological Applications* 12 (2002): 735–748.

Stevens, J.D., Ramón Bonfil, N.K. Dulvy, and P.A. Walker. **The effects of fishing on sharks, rays, and chimaeras (chondrichthyans), and the implications for marine ecosystems.** *ICES*

Journal of Marine Science: Journal du Conseil 57, no.3 (2000): 476–494.

Wood, Anthony D., Bradley M. Wetherbee, Francis Juanes, Nancy E. Kohler, and Cheryl Wilga. **Recalculated diet and daily ration of the shortfin mako (*Isurus oxyrinchus*), with a focus on quantifying predation on bluefish (*Pomatomus saltatrix*) in the northwest Atlantic Ocean.** *Fishery Bulletin* 107, no.1 (2009): 76–88.

Worm, Boris, Brendal Davis, Lisa Kettemer, Christine A. Ward-Paige, Demian Chapman, Michael R. Heithaus, Steven T. Kessel, and Samuel H. Gruber. **Global catches, exploitation rates, and rebuilding options for sharks.** *Marine Policy* 40 (2013): 194–204.

CHAPTER 7
SHARK SANCTUARIES

Bonfil, R., M. Meyer, M.C. Scholl, and R. Johnson. **Transoceanic migration, spatial dynamics, and population linkages of white sharks.** *Science* 310 (5): 100–103.

Bruce, Barry D., and Russell W. Bradford. **The effects of shark cage-diving operations on the behaviour and movements of white sharks, *Carcharodon carcharias*, at the Neptune Islands, South Australia.** *Marine Biology* (2012): 1–19.

Brunnschweiler, Juerg M. **The Shark Reef Marine Reserve: a marine tourism project in Fiji involving local communities.** *Journal of Sustainable Tourism* 18, no.1 (2010): 29–42.

Brunnschweiler, Juerg M., and Harald Baensch. **Seasonal and long-term changes in relative abundance of bull sharks from a tourist shark feeding site in Fiji.** *PLOS ONE* 6, no.1 (2011): e16597.

Brunnschweiler, Juerg M., and Jonathan McKenzie. **Baiting sharks for marine tourism: comment on Clua et al. (2010).** *Marine Ecology Progress Series* 420 (2010): 283–284.

Carrier, Jeffrey C., and Harold L. Pratt. **Habitat management and closure of a nurse shark breeding and nursery ground.** *Fisheries Research* 39, no.2 (1998): 209–213.

Chapman, Demian D., Michael J. Frisk, Debra L. Abercrombie, Carl Safina, Samuel H. Gruber, Elizabeth Babcock, Kevin Feldheim et al.

Give shark sanctuaries a chance. *Science (New York, NY)* 339, no.6121 (2013): 757.

Chapman, Demian D., Ellen K. Pikitch, Elizabeth Babcock, Mahmood S. Shivji. **Marine reserve design and evaluation using automated acoustic telemetry: a case-study involving coral reef-associated sharks in the Mesoamerican Caribbean.** *Marine Technology Society Journal* 39, no.1 (2005): 42–55.

Chapman, Demian D.F., Ellen K. Pikitch, and Elizabeth A. Babcock. **Marine parks need sharks?** *Science* 312.5773 (2006): 526–528.

Chin, Andrew, Peter M. Kyne, Terence I. Walker, and Rory B. McAuley. **An integrated risk assessment for climate change: analysing the vulnerability of sharks and rays on Australia's Great Barrier Reef.** *Global Change Biology* 16, no.7 (2010): 1936–1953.

Davidson, Lindsay N.K. **Shark sanctuaries: substance or spin?** *Science* 338 (2012): 1538.

Graham, Nicholas A.J., Mark D. Spalding, and Charles R.C. Sheppard. **Reef shark declines in remote atolls highlight the need for multi-faceted conservation action.** *Aquatic Conservation: Marine and Freshwater Ecosystems* 20, no.5 (2010): 543–548.

Hearn, Alex, James Ketchum, A. Peter Klimley, Eduardo Espinoza, and Cesar Penaherrera. **Hotspots within hotspots? Hammerhead shark movements around Wolf Island, Galapagos Marine Reserve.** *Marine Biology* 157, no.9 (2010): 1899–1915.

Heupel, Michelle R., John K. Carlson, and Colin A. Simpfendorfer. **Shark nursery areas: concepts, definition, characterization and assumptions.** *Marine Ecology Progress Series* 337 (2007): 287–297.

Holland, Jennifer S. **Shark Eden: Sharks are in decline worldwide, yet they abound in the Bahamas. What makes this blue-water archipelago a sanctuary?** *National Geographic Magazine* 211, no.3 (2007): 116.

Jacques, Peter J. **The social oceanography of top oceanic predators and the decline of sharks: a call for a new field.** *Progress in Oceanography* 86, no.1 (2010): 192–203.

Lucifora, Luis O., Verónica B. García, and Boris Worm. **Global diversity hotspots and conservation priorities for sharks.** *PLOS ONE* 6, no.5 (2011): e19356.

McCook, Laurence J., Tony Ayling, Mike Cappo, J. Howard Choat, Richard D. Evans, Debora M. De Freitas, Michelle Heupel et al. **Adaptive management of the Great Barrier Reef: a globally significant demonstration of the benefits of networks of marine reserves.** *Proceedings of the National Academy of Sciences* 107, no.43 (2010): 18278–18285.

Palumbi, Stephen R. **Marine reserves and ocean neighborhoods: the spatial scale of marine populations and their management.** *Annual Review of Environment and Resources* 29 (2004): 31–68.

Peschak, T.P. *Lost World: The Marine Realm of the Seychelles.* Save Our Seas Foundation, 2009.

Robbins, William D., Mizue Hisano, Sean R. Connolly, and J. Howard Choat. **Ongoing collapse of coral-reef shark populations.** *Current Biology* 16, no.23 (2006): 2314–2319.

Skomal, Gregory B., Stephen I. Zeeman, John H. Chisholm, Erin L. Summers, Harvey J. Walsh, Kelton W. McMahon, and Simon R. Thorrold. **Transequatorial migrations by basking sharks in the Western Atlantic Ocean.** *Current Biology* 19, no.12 (2009): 1019–1022.

Speed, Conrad W., Iain C. Field, Mark G. Meekan, and Corey J.A. Bradshaw. **Complexities of coastal shark movements and their implications for management.** *Marine Ecology Progress Series* 408 (2010): 275–293.

Stevens, J.D., Ramón Bonfil, N.K. Dulvy, and P.A. Walker. **The effects of fishing on sharks, rays, and chimaeras (chondrichthyans), and the implications for marine ecosystems.** *ICES Journal of Marine Science: Journal du Conseil* 57, no.3 (2000): 476–494.

Techera, Erika J. **Fishing, finning and tourism: trends in Pacific shark conservation and management.** *The International Journal of Marine and Coastal Law* 27, no.3 (2012): 597–621.

CHAPTER 8
SHARK TOURISM

Anderson, Charles, and Ali Waheed. **The economics of shark and ray watching in the Maldives.** *Shark News* 13, no.1 (2001).

Carwardine, Mark, and Ken Watterson. *The Shark Watcher's Handbook.* Princeton, NJ: Princeton University Press, 2002.

Cater, Carl I. **Playing with risk? Participant perceptions of risk and management implications in adventure tourism.** *Tourism Management* 27, no.2 (2006): 317–325.

Catlin, James, and Roy Jones. **Whale shark tourism at Ningaloo Marine Park: a longitudinal study of wildlife tourism.** *Tourism Management* 31, no.3 (2010): 386–394.

Catlin, James, Roy Jones, Tod Jones, Brad Norman, and David Wood. **Discovering wildlife tourism: a whale shark tourism case study.** *Current Issues in Tourism* 13, no.4 (2010): 351–361.

Clua, Eric, Nicolas Buray, Pierre Legendre, Johann Mourier, and Serge Planes. **Behavioural response of sicklefin lemon sharks *Negaprion acutidens* to underwater feeding for ecotourism purposes.** *Marine Ecology Progress Series* 414 (2010): 257–266.

Clua, Eric, N. Buray, P. Legendre, Johann Mourier, and Serge Planes. **Business partner or simple catch? The economic value of the sicklefin lemon shark in French Polynesia.** *Marine and Freshwater Research* 62, no.6 (2011): 764–770.

Dicken, M.L., and S.G. Hosking. **Socio-economic aspects of the tiger shark diving industry within the Aliwal Shoal Marine Protected Area, South Africa.** *African Journal of Marine Science* 31, no.2 (2009): 227–232.

Dobson, John. **Sharks, wildlife tourism, and state regulation.** *Tourism in Marine Environments* 3, no.1 (2006): 15–23.

Fitzpatrick, Richard, Kátya G. Abrantes, Jamie Seymour, and Adam Barnett. **Variation in depth of whitetip reef sharks: does provisioning ecotourism change their behaviour?** *Coral Reefs* 30, no.3 (2011): 569–577.

Gallagher, Austin J., and Neil Hammerschlag. **Global shark currency: the distribution, frequency, and economic value of shark ecotourism.** *Current Issues in Tourism* 14, no.8 (2011): 797–812.

Guttridge, Tristan L., Arthur A. Myrberg, Ila F. Porcher, David W. Sims, and Jens Krause. **The role of learning in shark behaviour.** *Fish and Fisheries* 10, no.4 (2009): 450–469.

Hammerschlag, Neil, Austin J. Gallagher, Julia Wester, Jiangang Luo, and Jerald S. Ault. **Don't bite the hand that feeds: assessing ecological impacts of provisioning ecotourism on an apex marine predator.** *Functional Ecology* (2012).

Holland, K.N., B.M. Wetherbee, C.G. Lowe, and C.G. Meyer. **Movements of tiger sharks (*Galeocerdo cuvier*) in coastal Hawaiian waters.** *Marine Biology* 134, no.4 (1999): 665–673.

Laroche, Karl, Alison A. Kock, Lawrence M. Dill, and Herman Oosthuizen. **Effects of provisioning ecotourism activity on the behaviour of white sharks *Carcharodon carcharias*.** *Marine Ecology Progress Series* 338 (2007): 199–209.

Maljković, Aleksandra, and Isabelle M. Côté. **Effects of tourism-related provisioning on the trophic signatures and movement patterns of an apex predator, the Caribbean reef shark.** *Biological Conservation* 144, no.2 (2011): 859–865.

Meyer, Carl G., Timothy B. Clark, Yannis P. Papastamatiou, Nicholas M. Whitney, and Kim N. Holland. **Long-term movement patterns of tiger sharks *Galeocerdo cuvier* in Hawaii.** *Marine Ecology Progress Series* 381 (2009): 223–235.

Meyer, Carl G., Jonathan J. Dale, Yannis P. Papastamatiou, Nicholas M. Whitney, and Kim N. Holland. **Seasonal cycles and long-term trends in abundance and species composition of sharks associated with cage diving ecotourism activities in Hawaii.** *Environmental Conservation* 36, no.2 (2009): 104.

Orams, Mark B. **Feeding wildlife as a tourism attraction: a review of issues and impacts.** *Tourism Management* 23, no.3 (2002): 281–293.

Rowat, David, and Udo Engelhardt. **Seychelles: a case study of community involvement in the development of whale shark ecotourism and its socio-economic impact.** *Fisheries Research* 84, no.1 (2007): 109–113.

Topelko, Karen N., and Philip Dearden. **The shark watching industry and its potential contribution to shark conservation.** *Journal of Ecotourism* 4, no.2 (2005): 108–128.

ACKNOWLEDGMENTS

Photographing and writing *Sharks & People* would never have been possible without the great generosity, insights and enthusiasm of many people. My sincere apologies to anyone I might have mistakenly left out.

Thank you to: Dr. Ed Brooks, Jim Abernathy, Ann Luskey, Chris and Sean Guinness, the crew of the MY *Sirenuse*, Dr. Dean Grubbs, Dr. John Carlson, Dana Bethea, NOAA Sawfish team, Dr. Samuel "Doc" Gruber, Dr. Mahmood Shivji, Grant Johnson, Katie Grudecki, Cristina Zenato, Nick Dulvy, Lucy Harrison, Doug Perrine, Jennifer Hayes, Dr. Ramon Bonfil, Andy Casagrande, Kim Maclean, Al Reeve, Tariq Al-Mamari, Aaron Henderson, Andy Wilson, Simon Wilson, Rob Baldwin, Kristiaan Vallancey, Tim Vallancey, Jonathan Ali Khan, Rima Jabado, Dareen Almojil, David Robinson, Bruno Pardigon, Michel Vely, Simone Caprodossi, Mohammed Y. Al-Jaidah, Paul McCormick, Mick Norman, the crew of the MY *Save Our Seas*, Danah Divers, Geoff Flamment, Guy Stevens, Daniel Fernando, Katie Brooks, James Lea, Jon Trusler, Dr. Rupert Ormond, Mauvis Gore, Owen Bruce, Simon Clarke, Chris Clarke, Eric Webber, Dr. David Rowat, Dr Frauke Fleischer-Dogley, Thierry Perillo, Eric Vicinati, Sijmon and Debbie De Waal, Allen Walker, Hanli Prinsloo, Rainer von Brandis, Cheryl-Samantha Owen, Michael Rutzen, Morné Hardenberg, Wilfred Chivell, Yvonne Kamp, Vic Peddemors, Jenna Cains, Dr. Alison Kock, Sarah Titley, Monwabisi Sikweyiya, Mike Meyer, Trey Snow, Geremy Cliff, Dr. Sheldon Dudley, Dr. Malcolm Small, Dr. Deon Nel, Charles Maxwell, Tony Oates, Ryan and Clare Daly, Tim Whitaker, Mike Gatke, John Costello, Miguel Goncalves, Noleen Withers, Barry Skinstad, Roger Horrocks, Mike, Andrew, and Steve (ORMS Photographic), Robin, Bradley, and Angelo (Digicape), Steve and Mark (Ocean Optics), Aaniyah Omardien, Dr. Kerry Sink, Mikael Castro, Jenny Nichols, Mark Christmas, Alex Peschak, Paul Hilton, Gary Stokes, Juliet Eilperin, surfers and lifeguards of Port St. Johns, Sarah Borchert, and Hugo.

The following people deserve special mention for repeatedly going beyond the call of duty. Mark and Gail Addison of Blue Wilderness, who introduced me to the sharks of Aliwal Shoal more than a decade ago and continue to provide a home away from home on the east coast. Chris and Simon Clarke provided vital support of my vision during my time as chief photographer for the Save Our Seas Foundation. Dan Beecham, who has been a longtime and trusted travel and dive companion on many expeditions from the Bahamas to remote Indian Ocean atolls. Steve Benjamin of Animal Ocean, who provided expert boating and dive support as well as his enthusiastic spirit. Michael Scholl, who introduced me to great white sharks in 1999. It is my pleasure to reunite once again to work on shark conservation matters. Peter Chadwick, who has been a photographic companion from the west coast to guano islands and my link to remaining involved in local South African conservation issues between my overseas travels. And last but not least, Guy Stevens, fellow founding director of the Manta Trust, who provided guidance, companionship and scientific expertise for my first story for *National Geographic Magazine* on manta rays in 2009.

Many organizations have also played an important role in the creation of this book. Sincere thanks go to WWF-SA, WWF International, Seychelles Island Foundation, Wildlife Conservation Society, Marine Conservation Society Seychelles, Manta Trust, Terres Australes et Antarctiques Françaises, KZN Sharks Board, University of Cape Town, Department of Environmental Affairs (South Africa), Environment

and IUCN Shark Specialist Group, Island Development Company Seychelles, Cape Eleuthera Institute, Bimini Shark Lab, Shark Advocates International, Shark Spotters and the International League of Conservation Photographers.

The Save Our Seas Foundation must be highlighted for not only providing a grant for developing the idea for this book, but also funding a special edition, which will reach students, teachers, and others who would not normally have access to the title. A big thank you first and foremost to the Founder, the Board, former CEO Chris Clarke, and current CEO Michael Scholl for believing in conservation photography and media as powerful tools for ocean conservation.

This book was produced in partnership with a wonderful team of creative and hard-working people. Lisa Lytton spearheaded and championed the project through all the stages from negotiating the publishing deal to layout and printing. Christine Henry, Amy Krynak, and Carrie Adams at University of Chicago Press were a delight to work with and allowed me great freedom in pursuing this project. Designer Alessandro Bonora masterfully interpreted my vision and worked tirelessly on this book. Robbie Frey of Resolution Colour provided a world-class repro service. Editors Karen Kostyal and Sunnye Collins weaved their magic on the manuscript and vastly improved the text in both flow and content. Kathy Moran provided crucial input on the pacing and visual structure and her expert eye improved the book tremendously. I want to thank Cheryl-Samantha Owen, Anna Seaman, and Michael Scholl for the use of their behind-the-scenes photographs of me in the field.

I wish to record my deep appreciation to Drs. Rachel Graham, Juerg Brunschweigler, Alison Kock, Geremy Cliff, Sheldon Dudley, John Carlson and Sonja Fordham for reviewing and significantly improving the scope and scientific accuracy of the manuscript.

Over the years my photography has benefited from the wisdom of many extraordinary people. Rosamund Kidman Cox was the first to take a chance and publish my early work. Her predecessor at *BBC Wildlife Magazine*, Sophie Stafford, continued to provide amazing homes for my photographs. In 2007, Cristina Goetsch Mittermeier, then president of the International League of Conservation Photographers introduced me to a global network of like-minded and inspirational photographers and broadened my horizons immensely. Since 2008, Kathy Moran, senior photo editor at *National Geographic Magazine,* has been the key driving force in developing my photography and in helping me succeed beyond my wildest dreams. Paul Nicklen proved to be a kind and selfless soul and my achievements are a testimony to his generosity and encouragement at a critical stage in my career.

I am also supremely thankful to the entire team at *National Geographic Magazine* for giving me opportunities and believing in my ability to tell stories that matter. I wish to especially thank editor-in-chief Chris Johns, Victoria Pope, Bill Marr, Dennis Dimick, Jamie Shreeve, Ken Geiger, Oliver Payne, Kurt Mutchler, David Whitmore, Sarah Leen, Susan Welchman, Jenny Trucano, Elizabeth Grady, Tess Vincent and former director of photography, David Griffin. Fellow photographers: Nick Nichols, Steve Winter, Brian Skerry, Tim Laman, Flip Nicklin, Jack Dykinga, Joel Sartore, Christian Ziegler, George Steinmetz, Florian Schulze, Klaus Nigge, Stefano Unterthiner, Brent Stirton, Randy Olsen and David Doubilet not only provide constant inspiration through their work, but have also been generous with advice.

I want to extend an incredibly massive Thank You to my partner, Sunnye Collins. Her involvement in this book, from editing to debating picture selection, was essential. The project would have never been completed on time without her guiding hand.

Finally, I want to thank my parents for introducing me to the ocean at a very young age, and for being supportive in my unusual career choice. My nomadic lifestyle has meant that many of our conversations have been via satellite phone beamed from remote locations instead of in person, as I would have preferred.

INDEX

SHARKS & PEOPLE

THOMAS P. PESCHAK, Author and Photographer
ALESSANDRO BONORA, Designer
KAREN M. KOSTYAL, Text Editor
SUNNYE COLLINS, Assistant Editor
KATHY MORAN, Photography Advisor
LISA LYTTON, Paraculture Books
LENI MARTIN, Copy Editor

THE UNIVERSITY OF CHICAGO PRESS
CHRISTIE HENRY, Editorial Director, Sciences
CARRIE OLIVIA ADAMS, Publicity Manager
AMY KRYNAK, Editorial Associate

The University of Chicago Press, Chicago 60637
The University of Chicago Press, Ltd., London

Text and photographs © 2013 Thomas P. Peschak
www.thomaspeschak.com

Additional images: Cheryl-Samantha Owen: 176-177, 178-179; Michael Scholl: 180, 183 (top);
Anna Seaman: 183 (bottom)

Reproduction by
Resolution Colour (Pty) Ltd
Cape Town, South Africa

Printed in China

ISBN-13: 978-0-226-04789-8 (cloth)
ISBN: 0-226-04789-X (cloth)

Library of Congress Cataloging-in-Publication Data

A cataloging-in-publication record for this book is available at the Library of Congress.

∞ This paper meets the requirements of ANSI/NISO Z39.48-1992 (Permanence of Paper)